Ecstatic Worlds

Leonardo

Roger F. Malina, Executive Editor

Sean Cubitt, Editor-in-Chief

See <http://mitpress.mit.edu> for a complete list of titles in this series.

Ecstatic Worlds

Media, Utopias, Ecologies

Janine Marchessault

The MIT Press
Cambridge, Massachusetts
London, England

This book was set in ITC Stone Sans Std and ITC Stone Serif Std by Toppan Best-set Premedia Limited. Printed and bound in the United States of America.

Library of Congress Cataloging-in-Publication Data

Names: Marchessault, Janine author.
Title: Ecstatic worlds : media, utopias, ecologies / Janine Marchessault.
Description: Cambridge, MA : The MIT Press, 2017. | Series: Leonardo book series | Includes bibliographical references and index.
Identifiers: LCCN 2016053947 | ISBN 9780262036467 (hardcover : alk. paper)
Subjects: LCSH: Mass media--Technological innovations. | Mass media--Social aspects.
Classification: LCC P96.T42 M355 2017 | DDC 302.23--dc23 LC record available at https://lccn.loc.gov/2016053947

10 9 8 7 6 5 4 3 2 1

Contents

Series Foreword

Leonardo/International Society for the Arts, Sciences, and Technology (ISAST)

Leonardo, the International Society for the Arts, Sciences, and Technology, and the affiliated French organization Association Leonardo, have some very simple goals:

1. To advocate, document, and make known the work of artists, researchers, and scholars developing the new ways in which the contemporary arts interact with science, technology, and society.
2. To create a forum and meeting place where artists, scientists, and engineers can meet, exchange ideas, and, when appropriate, collaborate.
3. To contribute, through the interaction of the arts and sciences, to the creation of the new culture that will be needed to transition to a sustainable planetary society.

When the journal *Leonardo* was started some fifty years ago, these creative disciplines usually existed in segregated institutional and social networks, a situation dramatized at that time by the "Two Cultures" debates initiated by C. P. Snow. Today we live in a different time of cross-disciplinary ferment, collaboration, and intellectual confrontation enabled by new hybrid organizations, new funding sponsors, and the shared tools of computers and the Internet. Sometimes captured in the "STEM to STEAM" movement, new forms of collaboration seem to integrate the arts, humanities, and design with science and engineering practices. Above all, new generations of artist-researchers and researcher-artists are now at work individually and collaboratively bridging the art, science, and technology disciplines. For some of the hard problems in our society, we have no choice but to find

new ways to couple the arts and sciences. Perhaps in our lifetime we will see the emergence of "new Leonardos," hybrid creative individuals or teams that will not only develop a meaningful art for our times but also drive new agendas in science and stimulate technological innovation that addresses today's human needs.

For more information on the activities of the Leonardo organizations and networks, please visit our websites at http://www.leonardo.info/ and http://www.olats.org/. Leonardo Books and journals are also available on our ARTECA art/science/technology aggregator: http://arteca.mit.edu/.

Roger F. Malina
Executive Editor, Leonardo Publications

ISAST Governing Board of Directors: Nina Czegledy, Greg Harper, Marc Hebert (Chair), Gordon Knox, Roger Malina, Tami Spector, J. D. Talasek, Darlene Tong, Joel Slayton, John Weber

Leonardo Book Series Editor-in-Chief: Sean Cubitt

Advisory Board: Annick Bureaud, Steve Dietz, Machiko Kusahara, José-Carlos Mariategui, Laura U. Marks, Anna Munster, Monica Narula, Michael Punt, Sundar Sarukkai, Joel Slayton, Mitchell Whitelaw, Zhang Ga

Acknowledgments

Ecstatic Worlds grows out of my many years of working on public art projects with the Public Access Collective in Toronto, and I am indebted to the different members of the collective and to the many artists with whom I have collaborated. I am grateful to my long-time interlocutors Susan Lord, Scott Mackenzie, and Michael Zryd who generously read and commented on more chapter drafts than they probably care to remember. Kathy Daymond and Tim Pearson also read and commented on drafts of chapters. Michael Prokopow and Tyler Survant were supportive at critical points. My collaborators Michael Darroch and Monika Gagnon helped to nurture different ideas that are woven into this book. I am thankful to Christine Davis for wonderful exchanges about art, curation, and public space over the course of writing this book.

I have had the honor of interviewing legendary experimental and multiscreen filmmakers Michael Snow, Graeme Ferguson, Christopher Chapman, Roman Kroitor, Colin Low, Morley Markson, and Toni Myers, from whom I learned so much about the materiality of cinema and spectatorship. My fortunate encounters with luminaries such as Gerry O'Grady, Perttu Rastas, Anthony Vidler, Chantal Mouffe, Nikos Papastergiadis, and Fulya Erdemci at opportune moments in the book's development helped to shape several of the chapters. I enjoyed interviewing Martin Heath on several occasions, and I am deeply appreciative for having had access to his rich CineCycle archive. He introduced me to Graham Stevens's wonderful pneumatic endeavors. I have also benefited from conversations with Chip Lord and Curtis Schreier of Ant Farm, who generously discussed some of their historical projects and steered me toward some new ones. I am grateful to numerous artists for providing me with information and in some cases photographs of their work: Graham Stevens, Mika Taanila, Amy Balkin, Tania Mouraud, WORKac (Amale Andraos and Dan Wood), John

Porter, and Andrew Paterson. The painstaking work of archivists and cura-
tors is essential for researchers, and I am indebted to the following people
and archives: Carol Stewart, Patrick Geddes Papers, Archives and Special
Collections, University of Strathclyde; Tony Dykes, BFI National Archive;
the Jaqueline Tyrwhitt Collection, Archives of the Royal Institute of British
Architects; Liz Kurtulik Mercuri, MoMA: The Edward Steichen Archive; the
fonds Louis Malle, Cinémathèque française; Stephanie Cannizzo and Tracy
Jones at the Berkeley Art Museum & Pacific Archive; Paul Gordon at Library
and Archives Canada.

I am privileged to have great colleagues at York University; Seth Feldman,
Caitlin Fisher, John Greyson, Sharon Hayashi, Ali Kazimi, Brenda Longfel-
low, and Ken Rogers created a convivial and inspiring collegium. At York I
also had the pleasure of working with outstanding graduate students whom
I encountered in various courses, conferences, and research endeavors. In
particular, Jessica Mulvogue, Aimée Mitchell, and Clint Enns contributed to
research in significant ways. I am deeply thankful to Nick Fernandes who
helped in acquiring images and reproduction rights. Marina Kuznetsov
and Jess Marchessault worked patiently to track down some pesky archi-
val sources. Several aspects of the book were supported by grants from the
Social Science and Humanities Research Council of Canada, as well as a
Research Fellowship from the Trudeau Foundation.

It is an honor to have *Ecstatic Worlds* included in the Leonardo book
series at the MIT Press. Series editor Sean Cubitt has been a significant
inspiration and a profound influence on my thinking for many years. The
series reflects the breadth and originality of his engagement with media art.
Working with Doug Sery has been a tremendous opportunity; he guided
the book through to publication with intellectual rigor and sage advice. I
am most thankful for the detailed comments and thoughtful suggestions
that I received on the manuscript from the anonymous reviewers. I took
most if not all of their suggestions into the final revisions of the book.
Susan Buckley, Noah Spring, Matthew Abbate, and Paula Woolley were a
pleasure to work with. Their attention to detail and their editorial skills
made the production process not only seamless but enjoyable! I thank Tim
Pearson for indexing this book.

Finally, I would most like to acknowledge my husband, Phil Hoffman,
for his incredible support through thick and thin. His boundless love and
friendship enabled me to finish this book, which I dedicate to him.

Introduction

Ecstasy is communication between terms (these terms aren't necessarily defined), and communication possesses a value the terms didn't have: it annihilates them. Similarly, the light of a star (slowly) annihilates the star itself.
—Georges Bataille, *Guilty* (1988)

The exigencies of intercultural communication and the imagining of a common world have taken on great urgency in the twenty-first century as we figure out how to adapt to the ecological realities brought about by anthropogenic climate change. The term "Anthropocene"[1] describes a new geologic age, evidenced by a massive acceleration in the geohistory of the earth. For some, this notion provides a rallying point, a productive means to critically rethink our entanglements with nature, resource use, consumption, social and ecological inequities, and our damaged planet. For others, the new universalizing discourse of species introduced by the Anthropocene places the white human subject of Enlightenment back in the center, and as Donna Haraway has underscored, enforces a new individualism that avoids the real culprit, the Capitalocene—that is, the relationship between the commodification of the earth and the new geologic age.[2]

These debates are critical as we rethink the future of global citizenship, which depends on our capacity to communicate across cultures and species to reimagine the worlds we share. *Ecstatic Worlds: Media, Utopias, Ecologies* maintains that cinema and media artists, as well as an interdisciplinary approach to our common twenty-first-century problems, have much to contribute to this discussion. The book argues that in the present context there is an urgent need to engage with the complex meanings of world images, especially those produced by contemporary forms of media. Images of one world or of the whole planet have particular resonance for us today

as technologies of data visualization mobilize new understandings of the earth, producing a "digital earth" and along with it, new forms of knowledge, power, and objectivity upon which decisions about the future of the planet will rest.[3]

By looking back at several cinema and media experiments of the twentieth century, this book tells the story of intercultural and interspecies communication through specific examples and case studies. It suggests the complex meanings of world images through concrete analyses of projects that range from the representation of the human community as one "family" to encounters with nonhuman life in the deepest recesses of the oceans, from world's fairs and microcinemas, to the creation of planetary archives based on one man's life. These projects represent a nuanced range of world-building projects in the period after World War II.

Each of the projects I discuss is *utopian*. The conceptualization of utopia in this book is plural and process-oriented, and owes much to the work of the Hungarian-born sociologist Karl Mannheim. His definition of "utopia" as a spatial but historically grounded projection is no doubt related to his own experience of exile from Hungary to Germany, where he wrote *Ideology and Utopia*. Certainly, as opposed to Karl Popper, who saw the darker totalitarian side of utopia as strictures imposed on people from above, Mannheim recognized the importance of utopianism in the creation of historically conscious citizens. A utopian mentality helps to situate the world in space and time—it opens up the sphere of possibility to include the impossible. "The disappearance of utopia brings about a state of affairs in which man himself becomes no more than a thing," Mannheim argued.[4]

Ecstatic Worlds poses the question: Do we live in one world or many? It answers this question by examining how photography, film, video, and digital media have been used to imagine and record the world as common ground and collaborative entanglement. More specifically, I look at how these media have fostered forms of participatory spectatorship, public spaces, and collective simultaneities. The book is divided into three parts— "Earth," "Worlds," and "Planet"—each of which offers contiguous and overlapping postwar histories of world image projects. These projects present a sense of *earth* as a shared ecology (Edward Steichen and Jacques Cousteau), of multiple *worlds* (the Festival of Britain, Expo 67), and of the *planet* (Mobile Cinemas and Planetary Archives). Pivotal to these explorations are debates about anthropocentrism, ontology, plurality, universality, history,

sustainability, and (post/trans) humanism. These questions are grounded in the phenomenological thinking and media theories of Siegfried Kracauer, André Bazin, Alfred North Whitehead, Jakob von Uexküll, Patrick Geddes, Maurice Merleau-Ponty, Georges Bataille, Marshall McLuhan, Susan Sontag, Jean Baudrillard, Buckminster Fuller, Donna Haraway, Rosi Braidotti, Catherine Malabou, Félix Guattari, Isabelle Stengers, and Mary Louise Pratt. These scientists, critics, and philosophers, as well as the exhibitions, films, and media examined here, provide a rich canvas through which to consider aspirations to forms of worlding, both as ideal and as empirical actualities that enable new kinds of political assemblies.

The notion of the common necessarily involves translation as a crucial aspect of communication, and it is central, both as process and as problem, to all the world-building projects studied in this book. As Zygmunt Bauman maintains, translation is the fundamental issue of the global age.[5] Étienne Balibar builds on Bauman's ideas by foregrounding a new understanding of translation as a daily practice that enables us to reconceptualize a community of citizens.[6] *Ecstatic Worlds* locates the idea of translation within the realm of photographic and digital images. It engages with the differences and integral relationships between words and images in terms of how they function as language. This book is not a survey of world projects but rather situates itself within a history of a desire to create world images, like Albert Khan's *Archives de la planète* or the theoretically and aesthetically rich, translocal and global web projects initiated by curator Steve Dietz.[7] Though these are not examined in the book, they represent the opposite poles of the book's reach, from traditional analog photography to digital media platforms, and from a banker's aspiration to create a shared archive of world images to a program of artists creating interactive works on digital media platforms in the early years of web art.

Each chapter of *Ecstatic Worlds* concentrates on a specific medium while engaging a comparative-media methodology within the context of expanded media studies. One of my aims is to develop a series of historically grounded studies (portraits or exhibits) of individuals, groups, and interconnected contexts involved in world-visioning projects, technologies, and festivals, several of which are not part of any official histories. This approach allows me to provide close readings of theoretical and philosophical ideas, especially around phenomenology, alongside an examination of particular artistic engagements with media technologies, all the

while maintaining a technological materiality that is never subsumed by theory. My study examines the cultures that arose immediately after the Second World War that engaged with aspects of globalization, technological innovation, popular culture, and artistic experimentation as a means to build world communities through the power of media or media events. This historical situatedness provides insight into the shifting geopolitical meanings of world images and the historical basis of liberal humanist ideas about technology in specific places over a fifty-year timespan.

Another aim of this book is to draw attention to the singular and collective contributions of the artists and thinkers examined herein. While the efforts of Edward Steichen and Jacques Cousteau are well known, they are often reduced to Cold War media; and in fact, there has been no serious examination of Cousteau's work. The placement of Steichen and Cousteau side by side in part I enables certain insights into their commonalities and their differences. I read their work dialectically and underscore the fact that each was complicit in national and imperial projects in the United States and France in the mid-1950s, and that their work circulated through the new global culture networks that were a product of World War II. The collaborative undertakings of others in this book, however, are still not well understood (or else remain unknown: for example, Humphrey Jennings, Norman McLaren and Evelyn Lambart, Jaqueline Tyrwhitt, Wells Coates, Roman Kroitor and Colin Low, Graham Stevens, Martin Heath, and others). Many of these creators and writers were involved in some way with Montreal's international world's fair, Expo 67, which serves as a historical centerpiece for the book. The two chapters in part II stand as a before-and-after to Expo 67, although as I discuss below, this book is not strictly chronological and works to trace overlapping histories, allowing for different perspectives on one moment in history.

These two approaches—the historical and the individual—contribute to our understandings of the twentieth century's technological humanism as it emerged in England, France, the United States, Canada, and Finland after the Second World War. This limited focus on these particular countries allows me to get at details of technological humanism, approaches to the phenomenology of media, and notions of common culture, which are all too often presented in a caricatured form as a simplistic liberal humanism. To be sure, technological humanism receives expression in neologisms such as the "global village" and the "global theatre" popularized by McLuhan in

the 1950s and 1960s—and Expo 67 was dubbed "McLuhan's fair." But for McLuhan, the global village reproduced village-like conditions complete with violent clashes, paranoia, and vicious exchanges. The global village is not a peaceful place. Nevertheless, this idea, like Teilhard de Chardin's "noosphere" articulated earlier in the century, is without doubt utopian and deeply humanistic in its aspiration. It carries with it the potential for a common experience through the senses. For McLuhan, this is a human-centered endeavor, but for some of the writers and artists in this book, the aspiration includes the broader ecological mandate that Merleau-Ponty explored through his notions of "chiasm" and "flesh" developed in his posthumously published book *The Visible and the Invisible*. Merleau-Ponty and Bataille were working with highly scientific notions of the biosphere. Similarly, Whitehead's valuation of the critical role played by "aesthetic apprehension" emphasizes the "aesthetic character of experience" (a large influence on Siegfried Kracauer, Merleau-Ponty, and McLuhan). As Whitehead tells us, "When you understand all about the sun and all about the atmosphere and all about the rotation of the earth, you still miss the radiance of the sunset." Whitehead was interested in art as a training ground for sensory perception: "Art is a special example ... to draw out habits of aesthetic apprehension."[8]

The limits of secular humanism are visible as scars on many bodies, as Mary Louise Pratt has underlined: "Among humanism's most conspicuous and intractable limits are the structures of otherness without which modernity remains indecipherable to itself. These realize themselves in familiar hierarchies of privilege and inequality, and in continuous claims for inclusion."[9] Yet Pratt also suggests appropriating the term and finding a novel discursive affordance to build a vital common culture to address the ecological challenges that are upon us.

One of the things that artists do is to visualize possible futures and develop blueprints for unforeseen structures and expanded modes of being together. This book is about new ecological approaches to cinema and media, the reimagining of interfaces, and the exploration of the natural world—"elemental media," to borrow John Durham Peters's terminology[10]—which were defined by new geopolitical and ideological missions in the postwar period. The projects explored in *Ecstatic Worlds* can be framed in terms of their expansion of cinema and media, as well as their ambitions to increase audience participation and the interface between media and environment.

Some of the ecological ideas that artists/architects drew upon were developed through town planners such as Patrick Geddes or architects like Buckminster Fuller who inspired generations.

Ideas about future politics and collective affects, the creation of new forms of sensibility and empathy through art, are taken up in the final part of this book, which engages with the planetary and the concepts of archives, time capsules, and space travel. I draw my definition of the planetary from Neil Brenner and Christian Schmid's manifesto for "Planetary Urbanization" where they argue that urban studies requires a foundational reconceptualization in its scale and focus:

> Extensively urbanised interdependencies are being consolidated within extremely large, rapidly expanding, polynucleated metropolitan regions around the world to create sprawling "urban galaxies" that stretch beyond any single metropolitan region and often traverse multiple national boundaries. Such mega-scaled urban constellations have been conceptualised in diverse ways, and the representation of their contours and boundaries remains a focus of considerable research and debate.[11]

Brenner and Schmid seek to expand the boundaries of the urban to include processes of urbanization beyond the limitations of "the city," to broaden the object of analysis to a much greater and more flexible scale. Similarly, *Ecstatic Worlds* seeks to expand the boundaries of cinema and media studies to take the materiality and ecology of the earth into account. In this sense, the book belongs to growing research in the area of ecomedia.[12] In its examination of a variety of films (still and moving) and media exhibitions, installations, and interventions, this book is indebted to Anne Friedberg's extensive interdisciplinary discussion of the architectonics of screens in *The Virtual Window* (2006).[13] In her final chapter on "The Multiple," Friedberg provides an overview of multiscreen experiments in which she discusses some of the Expo 67 projects that I also take up here. *Ecstatic Worlds* also builds productively on Fred Turner's two highly original investigations, *From Counterculture to Cyberculture* (2006) and *The Democratic Surround* (2013), which form an interconnected history.[14] The first book offers a detailed account of Stewart Brand's cultural influence in the context of American Cold War ideology, experimental art, and capitalist media, while the second examines a time prior to that, of American liberalism's more radical social, democratic, and aesthetic vision of the 1940s and 50s expressed through institutions like the Museum of Modern Art in New York, the New Bauhaus in Chicago, and Black Mountain College in

North Carolina. Turner provides a unique cultural history of democracy and media which is critical to *Ecstatic Worlds'* engagement with a history of twentieth-century media.

Nigel Clark points out in *Inhuman Nature* (2011) that the earth sciences, long ignored by the humanities and social sciences, are moving center stage to underscore and create new dynamic cartographies of the biosphere, and this is a direct and urgent response to our planetary crisis. The new discourses of global nature need to make room, Clark argues, for a relational materiality and for a geophysical materiality with an integrity of its own.[15] *Ecstatic Worlds* seeks to understand what this geophysical materiality looks like across a diversity of media productions. While the focus of the book is mostly on historical projects that grow out of the post-World War II context, the artist projects examined in the final chapter of this book share some similar utopian sensibilities in that they approach the planetary with an emphasis on the particularities of localized experiences. All three of these projects were "launched" after 2012: the satellite time capsule *The Last Pictures*; the site *A People's Archive of Sinking and Melting*, an open archive of objects and statements from people around the planet; and the multimedia project *World of Matter*, initiated in 2013 as an open-access archive on the global ecologies of resource exploitation and circulation.

Ecstatic Worlds

This book is concerned not only with the "world as picture" as the "fundamental event of modernity," as Martin Heidegger phrased it in 1938,[16] but also with the particular ontologies of photographic and digital images of the world. Most people live in and through a dynamic ecology of intermedia, which are of the world and render the world legible in particular ways. I understand images as environmental—we live in a world drenched in dynamic ecologies of discontinuous and discrete images, a mosaic of fragments that interact with one another as assemblages, and that augment physical and virtual environments. Images are ubiquitous, yet we hold them dear; they are anonymous, yet they are also shocking and we take them personally. They create forms of empathy that are disconnected from action. This apparent contradictoriness highlights a phenomenological dimension that necessarily accompanies any ecological approach to studying media.

Not simply visual, images offer auditory and tactile experiences as well—they are acoustic and intricately bound up with embodied experience, with others and with places. While they can take us out of ourselves, they also affect our bodies. In other words, media are not discrete objects or products of single artists; they are deeply embedded in the cultural fabric from which they emerge, in which they are performed, screened, and consumed.

My understanding of ecstatic worlds begins with Georges Bataille. His reflections on eroticism, sacrifice, and ecstasy, and his notion of expenditure resonate deeply in the twenty-first century. From his editorship of the surrealist periodical *Documents* (1929–1931) to his last book, *The Tears of Eros* (1961), he sought to understand the affective relationship between images and bodies. For him, everything begins and ends with laughter; laughter is a central interest. Indeed, laughter provides the bridge between the short period of devout Catholicism in his life to his most profound criticisms of Christianity and his theory of religion via Nietzsche. For Bataille, laughter has many faces: "When all is said and done, I have more than one face. I don't know which is laughing at which."[17] Indeed, laughter is fundamentally a matter of different kinds of communication, and Bataille distinguishes between two experiences of laughter. The first is a communication "linking up two beings." A mother tickling her child, for example, elicits ordinary, unmediated laughter. The second is a "communication, through death, with our beyond." This is what Bataille identifies as "infinite laughter," a communication with "our beyond ... (which I sometimes call *the impossible*, that is: what can't be grasped [begreift] in any way, what we can't reach without dissolving overselves, what's slavishly called God)." This can also remain "in an undefined state (in ordinary laughter, infinite laughter, or ecstasy in which the divine form melts like sugar in water)."[18]

According to Bataille, communication takes place between the poles of ecstasy and community, with each giving rise to and constituting the limit of the other. Philosopher Jean-Luc Nancy locates what is original in Bataille's concept of community in the erasure of community—the notion that community is founded on disappearance and the impossible: "Bataille is without doubt the one who experiences, most acutely, the modern experience of community as neither a work to be produced, nor a lost communion, but rather as space itself, and the spacing of the experience of the outside, of the outside-of-self."[19] Being, for both Bataille and Nancy, is

"being with." As Nancy expresses it, "you (are/and/is) (entirely other than) I" (*toi [e(s)t] [tout autre que] moi*). Or again, more simply, "you shares me." This tension—a sharing that is always incomplete and dislocated—drives communication; it is the creation of the "between," not as "juxtaposition, but as exposition," that rejects any simple notion of "intersubjectivity" or communication as "bond."[20] This "unemployed community" or "inoperative [*désoeuvré*] community" offers new models for thinking about the world as a plural community made up of people who have little in common.

Indeed, in his prefatory note to the English edition of *The Creation of the World*, Nancy remarks that there is no translation for *mondialisation*, which came into usage in French after the Second World War and "evokes an expanding process throughout the expanse of the world of human beings, cultures and nations."[21] Thus, *mondialisation* is expressed in English as "world forming"; it is "the horizon of a 'world' as a space of possible meaning for the whole of human relations." It is a conceptualization of the world that is not simply open but, as this book will show, includes the idea of an outside, which, as Nancy has explained, is "exteriority and contingency"; it is "a 'nature' that is 'outside' us, to which we are exposed and without which our exposition would not take place."[22] By contrast, globalization has a very linear direction (*sens*): it is an "enclosure in the undifferentiated sphere of a unitotality."[23] Globalization is a reduction of the world to the technological and economic, it is the "unworld" (*immonde*) that translates the world into a global idiom or representation in Heidegger's sense of the "world as picture." Globalization, once the universalizing project of the West, has been subsumed into a capitalization of the world where the relativity of norms and values cannot be judged.[24] It is here that we come to the end of the world, Nancy argues: "In the end, everything takes place as if the world affected and permeated itself with a death drive that soon would have nothing else to destroy than the world itself. … The fact that the world is destroying itself is not a hypothesis: it is in a sense the fact from which any thinking of the world follows, to the point, however, that we do not exactly know what 'to destroy' means, nor which world is destroying itself."[25] Yet it is at this precise juncture that the possibility of rethinking the world, of questioning, emerges: "[W]e must ask anew what the world wants of us, and what we want of it, everywhere, in all senses, urbi et orbi, all over the world and for the whole world, without (the)

capital of the world but with the richness of the world."[26] While opposed, these two modalities—*mondialisation* and globalization—are not opposites and, indeed, as we will see in *Ecstatic Worlds,* they are often deeply interconnected.

Nancy thus proposes a way of thinking through the diversity that singularly constitutes the relations of humankind. Central to this idea is the recognition of the "outside," which, as Nancy puts it, means "the outside-of-self." This notion is at the core of what I take to be the ecstatic world—a concept inspired by Bataillean ecology—not the world in which we live, but a world that is present as potentiality. Finally, then, this study is framed by the radical ontology Nancy proposes in *Être singulier pluriel* (*Being Singular Plural*), which argues that being is always a question of "being with," thus breaking down the opposition between the one and the many.

Part I: Earth

The world projects examined in *Ecstatic Worlds* are informed, in various ways, by the tension Nancy locates between globalization and *mondialisation,* between the end of the world and the creation of the world. They came into being in contexts created by World War II (though World War I is also important to this incarnation), with the new destructive capacity of the atom bomb and the extensive reach of communications technologies (in particular, radar and sonar) that enable control at a distance. Satellite technology, too, was a product of the militarism of World War II. Postwar geopolitics shattered the world into pieces just as it rendered that world and its oceans increasingly visible through technology. Boundaries broke down here and were erected there. Earth appeared to be both smaller and more fragmented, conceptualized and experienced as integrally tied to human existence and yet separate from it. Such images of the world do not come into being out of nowhere through technology but are inextricably tied up in ideologies and preexisting belief systems. Denis Cosgrove has traced the long history of Western images of the globe:

From the joint inheritance of Aristotelian humanism, Alexandrian and Augustan imperialism, and Judeo-Christian monotheism the West has forged a flexible but deeply resistant sense of the missionary telos: to redeem the world *ad termini orbis terrarum.* ... In projecting ideas and beliefs forged in one locale across global space, the liberal mission of universal redemption is inescapably ethnocentric and

imperial, able to admit "other" voices only if they speak and are spoken by the language of the (self-denying) center. Desire for a perfect, universal language has been a persistent companion of Western globalism.[27]

Ecstatic Worlds explores this desire for a universal language by focusing on the utopian discourse of universal communication that underpins the history of writing about photography and cinema. The first section of *Ecstatic Worlds* is devoted to the notion of "Earth," terrestrial earth, which exists both above and below the oceans, as visualized in popular media after World War II. The first two chapters are concerned with the use of photography and film as language that encompasses all languages enabling communication and connection. We can locate this notion in early accounts and debates about the artistic merits of photography. We also find it in realist paradigms in film history—in Siegfried Kracauer's writings and in André Bazin's criticism, particularly—where film does not simply represent but also translates the world to the world, creating an intersubjective and intercultural sphere. *Ecstatic Worlds* explores cinematic ontology and phenomenology in terms of the concept of communication in all its complexity and ideology, in its capacity to create connections between people and in its ability to create community through forms of perception and representation.

The two projects considered in part I are Edward Steichen's 1955 exhibition "The Family of Man" and Jacques Cousteau and Louis Malle's monumental underwater film *Le monde du silence* (*The Silent World*), completed in 1956. Both are expressions of the complex interaction between *mondialisation* and globalization, the United States and France, after the Second World War, articulated through the very contradiction at the core of capitalism—to create and to incorporate the outside. Both undertakings give us a view of the social world of the human and the biological world of nature beyond the human.

Chapter 1 examines Siegfried Kracauer's reading of Steichen's photographic exhibition in terms of how it offered a future direction for photographic media, making visible "the elementary things which men in general have in common."[28] Both Steichen's exhibition and Kracauer's reading of it might well have been influenced by their experiences of the war. A shared fear of catastrophe is reflected in the central image of the "Family of Man" exhibition, a color photograph (the only color photograph in the exhibition) of an atomic explosion. Unquestionably, the threat contained in

this image—and its reality—drove Steichen to create an exhibition that, through hundreds of photographs, framed the earth as a human community. This image is central to my reading of the exhibition, along with Steichen's more ecological and biospheric engagements with art that we see in his 1936 exhibition "Edward Steichen's Delphiniums" at the Museum of Modern Art (MoMA) as well as in his earlier engagements with photography, ecology, and natural forms of processing images. It is perhaps not surprising that Steichen's humanist exhibition has received more favorable readings in the twenty-first century, reevaluated for its democratic potential[29] and its ontological and universalist aspirations at a time when there is a need to seriously rethink our global connectivity. "The Family of Man" has been read both as an expression of the United States' new power and position in the world and as an attempt to combat the threat of communism by promoting a vision of American openness and of consumer culture as embracing the cultural diversity of the world.

Like Edward Steichen, Jacques-Yves Cousteau was a naval officer in World War II. Both were "captains," and both insisted on this appellation throughout their respective careers. Both also developed pioneering photographic technologies that served new forms of militaristic surveillance—aerial in Steichen's case and underwater in Cousteau's. Yet unlike Steichen, who went on to use photography with the intention of uniting the peoples of the world in a single human community (and thus making the world smaller), Cousteau was intent on opening up another world—the ocean—an invisible ecology that he would explore in more than 120 films and television programs as well as 50 popular books over his long career. Cousteau's films contributed to the popular imaginary at a time when consumers of popular media, in North America and Western Europe especially, were "hungry" for images of and stories about the sea. This was also a time when governments were expanding their sovereign powers over the ocean floor (revising the longstanding law of the seas), and capitalizing upon previously hidden resources. Chapter 2 considers the way in which Cousteau's expeditions in the 1940s and 1950s made the Mediterranean visible and wondrous. At least part of the wonder that Cousteau and Malle's film *The Silent World* generated, I argue, was due to a combination of advanced technology (Cousteau's boat, *Calypso*, equipped with both radar and sonar, was a technologically advanced movie studio and scientific lab) and Cousteau's persona, split between the more militaristic "Captain" and

the hybrid futuristic "l'homme poisson." The latter figure (a being at one with the ocean and its inhabitants), which helped to mediate new, never-before-seen cinematic images beneath the ocean, accounts for the affective and phenomenological aspects of his films. I argue that Maurice Merleau-Ponty's notion of flesh, which he developed in his working notes for *The Visible and Invisible*, contributes to aesthetic and ecological interpretations of the experience of the film. Merleau-Ponty, in turn, was influenced by Jakob von Uexküll's work on umwelts, the subjective perceptual worlds of humans and nonhuman animals that help to concretize Nancy's concept of the "singular plural."

I argue, then, that "The Family of Man," when read as foregrounding human solidarity in the face of a common danger (the atom bomb), can be understood more broadly in terms of a postwar brand of humanism and specifically in relation to Steichen's pacifist desires. On the other hand, Cousteau's underwater films present an entirely different response to the war and its aftermath. They can be read as a naïve yearning to escape the horrors of the war and the military occupation of France, and as expressing a humanistic and phenomenological commitment to the planet's oceans through the popular culture of cinema. They can be seen as expressions of France's imperialistic ventures into unexplored territory, and as a quest for control of untapped resources in the context of a decolonizing world.

Steichen and Cousteau shared a common view of how media (photography, film, and television) could enable a popular type of environmental pedagogy and facilitate forms of global community and solidarity by representing previously hidden relationships and bonds. In this sense, and despite the differences between their projects, both Steichen and Cousteau augment our perceptions of the planet through their emphasis on limits (Steichen's apocalyptic vision of the end of the world) and expansion (Cousteau's underwater films). Each created specific kinds of mobile interfaces (the photographic exhibition and the undersea documentary) that traveled around the world and consolidated a global audience.

Part II: Worlds

The story of whose imagining of the world makes it into World History is inextricably bound not only to empire and imperialism but also to the

history of representation. The world projects implicit in Edward Steichen's "Family of Man" and Jacques-Yves Cousteau's underwater films can be seen as responses to the Second World War as well as to major geopolitical shifts in world power. One of the biggest shifts visible after the war was the status of the British Empire, which went from controlling a quarter of the world's population and land-ocean mass at the end of the nineteenth century to a crumbling nation by the mid-twentieth. This shift in power had begun several decades before the war. Charles P. Kindleberger has argued that "the Great Depression of the 1930s was a consequence of the global shift in power from Britain to the United States, one that left Britain incapable of managing the world economy and an inexperienced United States unwilling to do so."[30] After the war, however, the United States was more ready to assume such a role. The Marshall Plan (1948), officially designated the European Recovery Program (ERP), was crafted by US Secretary of State George Marshall in order to restore and rebuild the national economies of the war-ravaged nations of Europe. In so doing, the program helped to secure the postwar dominance of the United States over world markets.

Part II is devoted to "Worlds" in the plural. It takes its cue from Uexküll's umwelt theory to focus on smaller utopian projects and events—The Festival of Britain and Expo 67—examining the design and cultural architectonics of their utopian articulations, each of which constitutes, in effect, a space of projection into the future. The design and cultural topographies of these two national undertakings embody the world-making energies of the postwar period in the building, respectively, of nations (Festival of Britain and the Telekinema), and world cities (Expo 67 and *Labyrinth*).

Chapter 3 is devoted to the future visions presented at the Festival of Britain. The notion of the one and the many, or Jean-Luc Nancy's "singular plural," lies at the heart of the new approaches to urban planning on display at the Festival's "Live Architecture Exhibition," which town planner Jaqueline Tyrwhitt participated in designing and overseeing. This exhibition was a public demonstration of town planning and building techniques in the context of recovery—it included entire neighborhoods in the process of reconstruction, along with information about the choices that planners and architects were making and opportunities for public discussion. Elsewhere, the Festival's approach to cultural inclusiveness and public culture was also visible in the extraordinary Telekinema designed

by architect Wells Coates, which combined live television projection and 3D cinema. This combination of television and 3D film helped to frame the performative (the liveness) and future-oriented aspects of a national fair deeply engaged with processes of postwar globalization; these processes included an approach to planning that ran counter to the Athens Charter,[31] inspired instead by the ecological urban theories of the Scottish-born Patrick Geddes—a concern for people and nature rather than mere functionality. Furthermore, Mannheim's sociology and utopian energies had an important influence on British town planning as well as on the work of the Modern Architectural Research Group (MARS)—the British wing of the Congrès International d'Architecture Moderne (CIAM)—which Tyrwhitt was involved in developing as both a teacher and a planner.

Chapter 4 expands on many of the themes introduced by the Festival of Britain's emphasis on urban planning and media, developed further at Montreal's Expo 67. Jaqueline Tyrwhitt worked with Marshall McLuhan at the University of Toronto from 1952 through 1955 with the Explorations Group—an interdisciplinary think tank dedicated to understanding the spatiotemporal effects of media—and we can see the important influence of contemporary approaches to architecture and urban media on both the Festival of Britain and Expo 67's media city. This influence is only one of the numerous cultural resonances between the two expositions. Norman McLaren was the head of the animation department at the National Film Board (NFB) of Canada when he was invited to produce two 3D films for the Telekinema. McLaren hired Colin Low as an intern at the NFB in 1945 and served as his lifelong mentor. While Low did not work on the Festival of Britain films, he was deeply influenced by McLaren's love of 3D. I examine McLaren and Evelyn Lambart's two films produced for the festival, and I also look at the multiscreen immersive film *Labyrinth* produced by Low and Roman Kroitor for Expo 67. All of these films were aimed at creating ecstatic sensations in viewers who experienced the singular and collective haptic effects of 3D and multiscreen cinema.

Part III: Planet

The final section of the book focuses on two spaces, a microcinema and an archive, that exist within gift economies. CineCycle, an alternative microcinema and bicycle repair shop, and a vital venue for experimental film

and media since 1991 in the city of Toronto, is the subject of chapter 6. Here I trace the career of Martin Heath, the British projectionist, film collector, and CineCycle owner, who helped to design a film theater for the Russian Pavilion at Expo 67 while he worked for the radical film distributor Charles Cooper. Heath was part of a lively film community in London in the 1960s; then, in the late 1960s and early 1970s, he worked with pneumatic artist Graham Stevens to create new inflatable cinemas. CineCycle has helped to create a form of what I call "resistant obsolescence" in the context of perpetual technological change. Its commitment to low-end technologies and a variety of film and video formats has encouraged an alternative cultural economy of temporary events (festivals, dinners, exhibitions, performances), which can be traced through a multiplicity of cultural networks across North America, as well as parts of Europe and Asia. These types of gatherings are part of what Allan Stoekl has called the "postsustainable economy."[32] This economy appeared with the oil crisis of the 1970s and early 1980s and is situated within contexts of energy use and depletion.

In addition to CineCycle, chapter 6 discusses Agnès Varda's film *Les glaneurs et la glaneuse* (2000). Both CineCycle and Varda's film materialize acts of collecting, recycling, and circulating, as well as the concept of an ecology of images in the context of a capitalist technocratic economy. The themes of aging, waste, and recycling are framed here by Bataille's theory of expenditure as developed in *The Accursed Share*. Written under the influence of Vernadsky in the 1940s, Bataille called for a transformation of the ethics upon which capitalist economies have been built, and for a shift from a restrictive economy (i.e., an economy based on scarcity) to a general economy or one of exuberant gifting. Bataille reminds us that economic growth cannot be praised without considering the effects of production on the very surface of the earth. He encourages us to think "at the scale of the universe."[33] As Nigel Clark suggests, "We might have a better chance of prising the planet out of its downward ecological spiral, accidently, not as the goal of a grand visionary project but as the unintended consequence of more joyous and generous living right here and now."[34] CineCyle is a work of love, hospitality, and gifting. This is in line with Donna Haraway's joyous exhortation to think and create together, both humans and nonhumans, in "collaborative entanglements" across the new knowledge ecologies and materialities of the geologic.

The final chapter of part III examines the planetary ambitions of Buckminster Fuller to create a World Game—the geoscope—in which winning means making the planet work for everyone by rationalizing resources and distributing them so that everyone can live luxuriously. While never built, the geoscope represents one of the most utopian projections of the planet. The American collective Ant Farm, a group of architects deeply influenced by Fuller's ecological vision and McLuhan's approach to media ecology, devised a transspecies communication platform—the Dolphin Embassy. Their proposal for this research laboratory in the ocean that allows cetaceans and humans to study each other using video technology, helps to shift the planetary perspective away from a human-centered vision and toward a shared world. The chapter goes on to examine Finnish artist and scientist Erkki Kurenniemi's "Death of the Planet" project—a universal archive and planetary museum inspired by the transhumanism of Ray Kurzweil. Kurenniemi is constructing an archive of his entire life, which he intends to be (re)played by a future generation on Mars in 2048. He firmly believes that mathematics will provide a new universal language and that, in the not-too-distant future when humans have destroyed the earth, human consciousness will be stored in computers on another planet. This chapter explores the distinctions between humanism, posthumanism, and transhumanism in the context of intelligent machines. Critical of Kurzweil and transhuman discourse, I situate Kurenniemi's archival project alongside the postanthropocentric ecologies of Haraway and Rosi Braidotti. I also consider new formulations of the digital archive as generative and "transtemporal" within a gift economy.

Kurenniemi's archive and Ant Farm's Dolphin Embassy extend the experiments with media that I contemplate in *Ecstatic Worlds*: from Steichen's "Family of Man" to Cousteau's underwater films, from world's fairs to Heath's microcinema—each represents an engagement with a different conception of connectivity and collectivity through media that can be seen as belonging to the prehistory of the Internet. *Ecstatic Worlds* maintains the need to shift our foundational conceptualizations of worlds to include the physical planet we inhabit collectively despite being differently located. The book seeks to rethink through each project the potential relationship between environment and media, to consider a media ecology by way of Uexküll's notion of umwelts, Merleau-Ponty's theorization of flesh,

Whitehead's notion of the aesthetic, and Bataille's general economy. I argue that a new brand of humanism, global rather than universal, is needed to support the new forms of ecological consciousness that the Anthropocene calls for. Donna Haraway enjoins us to "think" in the face of the ecological crisis of the present world. The utopian architectures that *Ecstatic Worlds* brings together allow us to do just that, to reimagine a future way of being together going forward.

Part I Earth

1 Anonymous Reality and Redemption in "The Family of Man"

The remedy for the kind of abstractness which befalls minds under the impact of science is experience—the experience of things in their concreteness. Whitehead was the first to see our situation in this light and to comment on it accordingly. He blames contemporary society for favoring the tendency toward abstract thinking and insists that we want concretion—want it in the double sense of the word: "When you understand all about the sun and all about the atmosphere and all about the rotation of the earth, you still miss the radiance of the sunset. We want concrete fact with a high light thrown on what is relevant to its preciousness."

—Siegfried Kracauer, *Theory of Film: The Redemption of Physical Reality*

We begin with the representation of the human community as a family—that is, with Edward J. Steichen's now infamous 1955 photographic exhibition "The Family of Man." This exhibition belongs to the Cold War media of the mid-1950s. It circulated as an iconic statement of global unity at a pivotal moment in world history when the United States asserted its economic and political dominance through cinema and media. The exhibition's success is tied to the use of photography as a connective and flexible tissue that enables a communicative network. The photographic and curatorial work of Steichen—his earlier wartime exhibitions as well as his work as a commercial photographer—helps us to consider the questions central to this book: Do we live in one world or many? How does the planetary come to figure in our understanding of the plurality of human communities? What is the role of photography in fostering a sense of the common world? This chapter seeks to understand how Steichen articulated a response to these questions through photography, and why over the past decade there have been so many rereadings of the exhibition that have been more nuanced than earlier interpretations which dismissed it as both naïve and imperialist.[1]

Held at the Museum of Modern Art in New York in 1955, "The Family of Man" comprised 503 photographs from sixty-eight countries made by 273 photographers. The aim of the exhibition was to excavate the "essential oneness of mankind throughout the world."[2] "The Family of Man" is considered to have been the most popular photographic exhibition in the history of the twentieth century. It featured photographs taken by professionals and amateurs alike that were selected on the basis of their ability to show aspects of the everyday around the world. The exhibition catalog was immediately distributed as an inexpensive paperback book (the initial run was 135,000 copies, which quickly sold out, and it became the best-selling photography book of all time—five million copies sold by 2000). Supported by the US State Department, the exhibition was seen by nine million people in sixty-nine countries in eighty-five separate exhibitions.[3] Roland Barthes's 1957 critique of the exhibition in *Mythologies*, which challenged its "sentimental humanism," was thus decidedly against the popular grain. For Barthes, the photographs represented a "human essence" devoid of the weight of history, a humanism devoid of difference, "magically produced: man is born, works, laughs and dies everywhere in the same way." For Barthes, the exhibition's ahistoricism reinforces the old perils of classical humanism: "Any classic humanism postulates that in scratching the history of men a little, the relativity of the institutions or the superficial diversity of their skins (but why not ask the parents of Emmet Till, the young Negro assassinated by the Whites what they think of The Great Family of Man?), one very quickly reaches the solid rock of a universal human nature." Emmet Till, a young black teenager from Chicago, was brutally murdered in Mississippi by two white men for having whistled at a white woman in a grocery store in 1955. Till's mother insisted on an open casket and the photograph of the young man's mutilated body received international media coverage, and served to ignite the civil rights movement in the United States. Barthes does not dismiss humanism outright; instead, he suggests, "Progressive humanism … must always remember to reverse the terms of this very old imposture, constantly to scour nature, its 'laws' and its 'limits' in order to discover History there, and at last to establish Nature itself as historical."[4]

A similar response greeted the show when it opened in Moscow in 1959. *Pravda* published a review that ironically asked why the exhibition did not feature statistics on child mortality in Timbuktu and New York in order to

foreground differences.[5] Subsequent readings of the exhibition within the canons of photographic theory, by Susan Sontag and Allan Sekula, for example, framed its alleged sentimental humanism in terms of Cold War cultural imperialism and the US State Department's global cultural offensive started during World War II. Sekula, writing in the early 1980s, singled out Carl Sandburg's comments that "The Family of Man" featured a "multiplication table of living breathing human faces" as evidence of the way Steichen's project sought a unifying biological essence that would efface cultural difference under the banner of freedom and would identify diversity in terms of a diversity of markets to be unified by an image of oneness. The cliché of photography as a universal language has served, Sekula underlines, to bolster the expansionist colonial project of the capitalist *world order*.[6]

While such criticisms are absolutely vital to any analysis, I have always been intrigued by the closing passages of Siegfried Kracauer's *Theory of Film* which argue that "The Family of Man" foregrounds an emancipatory intercultural communication. According to Miriam Hansen, Kracauer's postwar writings on film and photography resist any kind of "fetishistic wholeness, perfection, distance and control," incorporating "the threat of annihilation, disintegration, and mortal fear into his film aesthetics— as a fundamental historical experience of modernity." Kracauer's cultural interpretations must be situated, Hansen submits, in terms of "life after the apocalypse." It is in this sense that we can understand Kracauer's reading of Steichen's exhibition, which for Hansen represents a troubling turn away from history.[7]

For Kracauer, "The Family of Man" offers a future direction for the photographic medium: to make visible "the elementary things which men in general have in common."[8] This perspective might well have been due to the experience of the war shared by both Kracauer and Steichen. We see a fear of catastrophe reflected in the central image of Steichen's exhibition— the eight-foot color transparency of an atomic mushroom explosion. It is the threat contained in this image, as well as its reality, that I would argue drove Steichen to conceive this exhibition of the human community as one family. Yet, of course, such an exhibition also reflected the new role of culture and of the United States in the world, and the selling of the American way of life as the explicit strategy of the United States Information Agency (USIA) during the Cold War. Thus, the exhibition must be interpreted in terms of this contradiction between Steichen's desire to foreground

commonality in the face of possible nuclear warfare that would end human life on the planet and the US government's new ideological war that was being waged with images.

Steichen's War and Fashion Photography

During World War II, Steichen served in the US Navy, where he oversaw all combat photography, directed toward recruiting and chronicling the war. When he returned from service, Steichen was appointed director of the Department of Photography at MoMA in 1947—a newly created position. He was sixty-seven and had already organized two war exhibitions for MoMA, "Road to Victory" (1942) and "Power in the Pacific" (1945), both in collaboration with the US Navy. Though he came to the position with a great deal of experience, his hiring provoked controversy and several resignations. Beaumont Newhall, who had been the curator of the Department of Photography, resigned in protest at the appointment, along with the thirty members of the department's advisory board. Steichen's brand of populism, his reputation as a commercial photographer, and his curatorial approach to photography did not bode well for the future of photography as a fine art. Steichen's first exhibition at MoMA, held in 1936 prior to his appointment, was the hugely popular display of hybrid delphiniums (these were the actual plants) from his collection; the results of his years as a horticulturalist and plant breeder were made public—such pure blue delphinium spires and new interspecies crosses had never been seen before. The audacity of this exhibition, which opened the museum to the materiality of the natural world and to audiences who did not go to museums, was a precursor of things to come.

Let me turn to Steichen's relationship to the photographer Alfred Stieglitz to more fully understand his populist approach as a curator at MoMA. The criticisms of "The Family of Man," especially Sekula's essay "The Traffic in Photographs" quoted above, have in the past skewed my engagement with Steichen's exhibition, or least prevented me from taking it seriously. Sekula's essay, like Barthes, situates the realism and the liberal humanism of the exhibition in the context of American Cold War propaganda efforts, and different versions of nineteenth-century positivism and physiognomic science. Yet here I want to argue that Steichen's desire to communicate with a broad spectrum of people was fueled by a politics of the popular

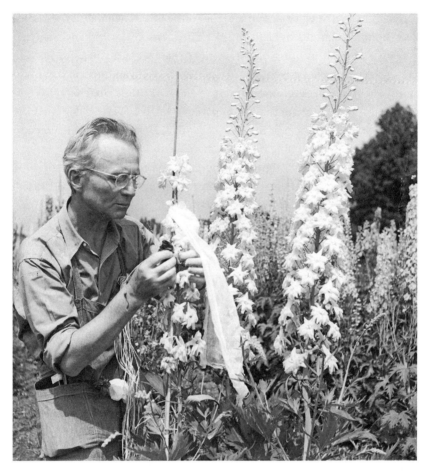

Figure 1.1
Edward Steichen with delphiniums. Umpawaug House, Redding, Connecticut, ca. 1938. The Museum of Modern Art Archives. Digital Image © The Museum of Modern Art / Licensed by SCALA / Art Resource, NY.

that photography was able to fulfill. His approach to photography, like Kracauer's, is based on a complex understanding of photographic realism that is historically grounded in the experience of the spectator.

Steichen had met Stieglitz in 1900 and had been part of his inner circle of early art photographers, the Photo-Secession, an invitation-only group Stieglitz founded in 1902, which included Robert Demachy, Will Cadby, Gertrude Käsebier, Frank Eugene, J. Craig Annan, Clarence H. White, William Dyer, Eva Watson, Frances Benjamin Johnston, and R. Child Baley.

Steichen helped Stieglitz design and found the Little Galleries of the Photo-Secession, also known as Gallery 291. A frequent visitor to Paris, Steichen was instrumental in bringing the work of Matisse, Cézanne, and Picasso, among others, from Paris to New York's 291, creating an important (mostly one-way) bridge between modern art in the two cities.[9] Steichen also participated in Stieglitz's journal *Camera Work* (1903–1917); he designed the cover logo and typeface for the journal, and an entire issue was devoted to his photographs, including his experiments with color printing.

Steichen later recollected that "the great photographic event of 1907 was the Lumière Brothers' introduction of color photography." Indeed, Steichen was one of the first photographers in the United States to use (and even perfect) the Lumière Brothers' autochrome plates.[10] The process involved breaking the photograph down into separate images using potato starch particles that were infused with red-orange, green, and blue-violet dyes. The exposed double-coated glass plate was processed in reverse to create a color transparency that could be held up to the light or projected (printing proved to be too unstable), revealing a full-color image "as a mist of pointillist color specks."[11] As early as 1900, Steichen had experimented with Robert Demachy's gum-bichromate, which gave him greater control over the development process by allowing him to coat the paper himself. The paper was coated with gum arabic and watercolor shades (brown, black, or almost any other shade); the light-sensitive agent was bichromate of potash, which was applied with a brush. This process attracted Steichen precisely because it broke down the divide between painting and photography. Such experiments with tone and color reinforced his commitment to pictorial experimentation in photography (and possibly fulfilled his early desire to be painter). Steichen expressed this formalist proclivity in the numerous experiments he carried out with color photography using selectively filtered, three-negative exposures, some of which were exhibited in 1906 at the Little Galleries of the Photo-Secession, in a show called "Photographs by Eduard J. Steichen." Steichen also hand-tinted each issue of the 1906 supplement of Stieglitz's journal *Camera Work*, which featured a photogravure of his photograph *Road into the Valley—Moonrise.*[12]

While the professional and personal friendship between Steichen and Stieglitz was fruitful for many years, the two parted ways over World War I. By Steichen's account, each took a different view of the German situation during the war. Although raised in Milwaukee, Steichen was born in

Luxembourg to a working-class family of committed socialists; as a result, he identified strongly with the French. For Steichen, "France had become another mother country to me, and I sided with her in all the arguments with Stieglitz."[13] Yet there were certainly also differences brewing between the two men over their interpretations of photography's essential characteristics. While the relation between painting and photography (especially color photography and photochemical processes) was an ongoing source of creative exploration for Steichen, Stieglitz increasingly separated the two media as sign systems working at cross-purposes.[14] Stieglitz dissolved both the Photo-Secession and the journal in 1917. The same year, Steichen joined the American Expeditionary Forces and helped to innovate aerial photography for the Army Signal Corps in northern France.

This encounter with the realities of war did not so much alter Steichen's view of photography as a dynamic creative process as it increased his sensitivity to the power of photography to alter the world. His interest in the technical capabilities of photography was expanded by the "exacting science" of aerial photography, which was, he wrote, "completely different from the pictorial interest I had had as a boy in Milwaukee and as a young man in the Photo-Secession days."[15] The photographs of enemy territory, movements, and weapons storage provided information that helped to pinpoint targets to be killed. Suddenly, for Steichen, photography was not simply documenting aspects of war; rather, it directly, and devastatingly, participated as a weapon of war: "A state of depression remained with me for days, but gradually there came a feeling that, perhaps, in the field of art, there might be some way of making an affirmative contribution to life."[16] We can see in this first encounter with war the seeds of Steichen's imagining of how photography and art could be directed toward ends different from simply gathering information. Later he would imagine that "if a real image of war could be photographed and presented to the world, it might make a contribution toward ending the spectre of war."[17]

Steichen's interest in photography's technical potential had been intensified during the First World War and in the following years. After the war he returned to the farm he rented in Voulangis, on the outskirts of Paris, and for several years he carried out rigorous photographic experiments using the plants and flowers from his own garden. This turning toward the outside, toward nature, was inspired by the wartime problem of taking photographs "from a vibrating, speeding airplane ten to twenty thousand

feet in the air." It was also driven by a desire to find meaning in the external forms of the world, connections between plant life, humans, and built forms. Steichen was elated to find Theodore Andrea Cooke's 1914 book *The Curves of Life, Being an Account of Spiral Formations and Their Application to Growth in Nature*. Cooke was trained as an art historian, yet his book represents an early example of interdisciplinary studies in visual culture, crossing zoology, botany, art history, and architecture to trace the existence and persistence of spirals in all parts of the physical (natural and cultural) world. Cooke was interested not in reducing the world to a law of spirals, but in the interconnectivities across worlds (natural and built); in the relation between art, science, and nature across many historical periods.

Between the First and Second World Wars, this extended study of nature and the built environment was interrupted by Steichen's unprecedented financial and critical success as a commercial photographer in the United States. In 1923 he returned to the United States, opening a commercial studio in New York City. For the next fifteen years he shifted his focus from his earlier pictorialist and experimental work, concentrating his efforts on mainstream fashion and commercial photography. He created photographs for well-known American fashion magazines such as *Vanity Fair* and *Vogue* (both Condé Nast publications) as well as for advertising agencies such as the J. Walter Thompson Advertising Company.

Steichen had a great deal of previous experience working in advertising design. He had apprenticed as a lithographer and, drawing upon an entire aesthetic idiom from the Beaux Arts, he had designed ads for magazines as early as 1899. Now he introduced a new aesthetic standard to fashion photography and celebrity portraiture, creating a distinctly modern style that would merge the two. He produced photographs of anonymous models in a manner that celebrated their individuality and distinct appearance— making stars out of unknowns and laying the foundation for some of the first "super models."[18] He also produced well-known portraits of celebrities like Charlie Chaplin, Greta Garbo, and Gloria Swanson. Yet what is distinctive in his photographs is not so much the faces (though these faces, whether famous or anonymous, were always glamorous) but the materiality of the photographs themselves—the sharpness of focus and lighting, the "objectness" of the objects and the sensuality of the settings.

Steichen came into the photo industry alongside the development of marketing as a science. Like most agencies of the period, the J. Walter

Thompson Company employed a psychologist to head up the research department—in this instance, the behavioral psychologist John B. Watson. Trained at the University of Chicago, Watson drew on the simple stimulus-response model, believing that consumers were no different from rats.[19] His basic premise was that three innate emotions—fear, rage, and love—drive all human behavior. Advertising could manipulate these emotions to set up conditioned responses by constructing images to stimulate and trigger people to buy products.[20] While Steichen used two of these emotions—love and fear—extensively, his advertising work was far more nuanced than Watson's functionalism allowed, no doubt owing to the influence of the European avant-garde art practices that he brought to his photography.

Magazines such as *Life*, *Look*, and *National Geographic* played a particularly important role in giving photography a more conspicuous function in information reporting, moving it from the background (that is, ads or simple illustrations) into the foreground of print media. Especially during World War II, photo essays and photojournalism was the mainstay of these magazines, made possible by advances in lightweight cameras such as the Leica, which could accommodate thirty-six exposures of 35mm film in each roll. In the November 23, 1936, issue of *Life*, the introduction "Life Begins," which featured a photograph of a baby in motion by Margaret Bourke-White, stated the magazine's mandate in purely visual terms: "to see life, to see the world, to eyewitness great events; to watch the faces of the poor and the gestures of the proud ..." This type of visual emphasis proved successful, and the circulation for all three of these magazines increased significantly.[21]

The Depression opened up a whole new dimension and role for social realist photography with the James Agee / Walker Evans project *Let Us Now Praise Famous Men*, which documented the lives of three southern families of sharecroppers, as well as the general photography project for the Farm Security Administration and the landmark exhibition of photographs at the New York train station. This exhibition tremendously impressed Steichen, who reviewed the show and in 1938 left advertising and his New York studio entirely, trading in his 8-by-10 studio camera for a small 35mm Contax, a "round the corner finder" which permitted taking pictures more discretely, and the newly available Kodachrome color film.

Most historians agree that it was not until World War II that photographers got into the business of actively and aggressively "covering" the war.[22]

While Steichen had produced aerial photographs for the military during the First World War, the Second World War brought him to the ground—more specifically, to water and air—as he had volunteered to create a photographic record of the war. He was assigned to cover naval aviation in the Pacific. Although he began working with a team of ten photographers, by 1945 he was director of the Navy Photographic Institute where he oversaw a stable of more than four thousand photographers. The institute's goal was to create a photographic chronicle of the war and to provide a steady stream of information to be disseminated to the public. That remarkable expansion also represented a shift in the United States government's budget toward producing the image of war and manufacturing propaganda. To be sure, many of the scenes of war photographed by Steichen and his team were staged, and they unquestionably portrayed a particular view of war. Yet for Steichen, the images of smaller gestures and the details of everyday life in the war zone were what would create an unprecedented archive of the war, and as he later recalled, emotional impact was the criterion by which images were judged. Steichen felt that such images would, paradoxically, lead to peace. While many of the institute's images were broadly distributed, most were unauthored, and thus belonged to the American Navy. "Road to Victory" and "Power in the Pacific" were exhibitions of some of these photographs, whose objective was not only to express or instill patriotism but to create a true understanding of war. In the case of "Faces of Korea," also known as "The Impact of War," this understanding of war included some of the most graphic photographs from the Korean War. This last exhibition featured the work of David Douglas Duncan, whose book *This Is War: A Photo-Narrative of the Korean War* (1951) was, Steichen argued, "the most forceful indictment of war" and represented "the most realistic photographic interpretation of war ever put forward."[23]

"The Family of Man"

Steichen believed that his war-related exhibitions (particularly "Faces of Korea") failed because they simply made people sad rather than moving them to action. The affective framework for "The Family of Man" was to incite united action against war by creating an image of interrelatedness. Steichen found the inspiration for this idea in a biography on Abraham

Lincoln written by Steichen's brother-in-law and longtime collaborator, the socialist poet Carl Sandburg. The title for the exhibition was taken from a speech by Lincoln quoted in Sandburg's four-volume set on the Civil War, called *The War Years*.[24] As the introduction to the *Family of Man* catalog tells it, the exhibition was conceived as "a mirror of the universal elements and emotions in the everydayness of life—as a mirror of the essential oneness of mankind throughout the world."[25]

One definite precursor to the quotidian interests of "The Family of Man" was a series of photographic stories entitled "People Are People the World Over" that ran in the *Ladies' Home Journal* from 1948 to 1949. The photographic series was pitched to the magazine by the Magnum group, a Paris-based collective that retained the rights to their own photographs and included photographers Robert Capa, David Seymour, Henri Cartier-Bresson, George Rodger, and Bill Vandivert. "People Are People the World Over" was a series of twelve two-page spreads about family life all over the world; many of the photographs were later included in "The Family of Man."[26] This project reflected an interest in cultures of the world and a conscious postwar and Cold War strategy to carefully educate the US population about the larger world, and the larger world about the United States. US high school curricula were redesigned to include anthropology, for example, and the *Ladies' Home Journal* stories were marketed to schools for their educational value.[27]

"The Family of Man" took three years to produce, with Steichen and his assistant, photographer Wayne Miller, searching through more than two million photographs from individuals, artist's collections, and archival files from magazines like *Life* and the *Ladies' Home Journal*. Swiss photographer Robert Frank assisted Steichen with the research for the exhibition, and the two of them visited twenty-nine cities in eleven countries. They also solicited photographs from film societies, photo clubs, and magazines around the world. The final images selected for the exhibition were taken by 273 men and women, amateurs and professionals, famed and unknown alike. As the catalog recounts, the photographs were "made in all parts of the world, of the gamut of life from birth to death with emphasis on the daily relationships. … Photographs of lovers and marriage and child bearing, of the family unit with its joys, trials and tribulations."[28] Despite this claim to diversity, there is nevertheless a strong representation of photographs that were previously published in *Life*, *Ladies' Home Journal*, and *Fortune*,

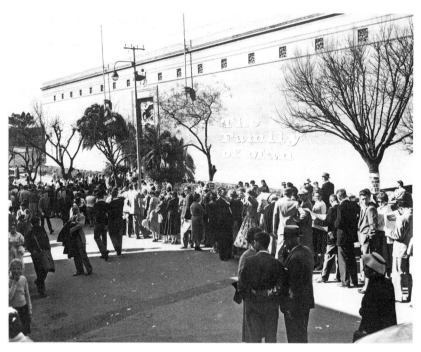

Figure 1.2
Visitors in Johannesburg awaiting entry into the exhibition "The Family of Man,"
organized by the Museum of Modern Art, New York, installation at Government
Pavilion, Johannesburg, Union of South Africa, August 30 through September 13,
1958. International Council / International Program Records. The Museum of Mod-
ern Art Archives. Digital Image © The Museum of Modern Art / Licensed by SCALA
/ Art Resource, NY.

and many of the contributors were from the Magnum group or were other
well-established photographers (among them Ansel Adams, Margaret
Bourke-White, Bill Brandt, Dorothea Lange, Helen Levitt). This is why the
exhibition can, in some ways, be seen as a record of the documentary social
realist trend in American photography that had started with the Depres-
sion.[29] Though it claimed to be open to amateurs, the exhibition featured
mostly professional photographers. Yet the idea the exhibition wanted to
put forward was the accessibility of photography as a technology and the
accessibility of the world through photographs. While no snapshots were
included, Steichen wanted to convey the freedom and spontaneity of the
snapshot in the unframed and floating photos.

Despite its informal feel, the exhibition design was rigorously implemented by the young architect Paul Rudolph (who had studied with Walter Gropius at Harvard) and was heavily informed by the Bauhaus designer Herbert Bayer. Bayer had been a student of Wassily Kandinsky and László Moholy-Nagy at the Weimar Bauhaus, and had been appointed to teach in the newly created typography workshop. He designed his own unique typography, the Universal alphabet, a font that included only lowercase letters that would come to be strongly identified with the Bauhaus. During his time at the Bauhaus and after, Bayer was involved in developing a distinctive approach to exhibition design, which he treated as a metamedium.[30] He would publish his ideas in 1939 in the essay "Fundamentals of Exhibition Design," where he explained (using all lowercase type): "in exhibition design, we have a new and complex means of communication of the idea, in which elements, such as painting, photography, etc., fill only part of the field. the great possibilities of the exhibition design rest on the *universal* application of all known means of design: diagram, lettering, the word, photography, architecture, painting, sculpture, tone, light, film." The exhibition, Bayer continues, is the culmination of "all powers of design." The theme should be clearly expressed and should not "retain its distance from the spectator … it should be brought close to him, penetrate and leave an impression on him." Exhibition design should "explain, demonstrate and even persuade and lead"; its influence "runs parallel with the psychology of advertising."[31] This psychology is not the behaviorism of John B. Watson that Steichen came to know in the United States but rather, as several scholars have speculated, the Gestalt psychology and pyschophysics that influenced faculty and students at the Weimar and Dessau Bauhaus.[32] As is obvious from his essay and his approach to typeface, Bayer supported a universal theory of perception in which human physiology brings all of the different perceptual modalities together onto one plane.

Bayer's essay encouraged designers to explore sensory experience: "by means of movement of the eye, of the head, or of the body, the field of vision is extended. it also becomes larger with increasing distance between the eye and the object. normal sight is horizontal. since, however, the perspective may be so greatly enlarged, there lies here an elementary motif of design" which is often not explored to its full potential. Bayer maintains that it is important to consider material in the exhibition design; new synthetic materials which have "enriched the store of media" serve as

"structure and texture to the eye." Other sensory experiences besides sight are suggested: "the sense of touch or smell are elements of the psychology of the effect. development and discipline of the feeling for the material were especially fostered at the Bauhaus," he recalls.[33] The exhibition design extends the visitor's field of vision as well as other senses in a dynamic and stimulating environment. The final illustration in the article is an eye-ball poised on top of a headless gentleman surrounded by a multiplicity of frames—site lines moving off in all directions.

In 1938, Bayer immigrated from Nazi Germany to the United States, the last of the Bauhaus designers to leave. He was invited to design the

Figure 1.3
The visitor's extended vision illustrated in Herbert Bayer, "Fundamentals of Exhibition Design," 1939. © Estate of Herbert Bayer / SODRAC (2017).

exhibition "Bauhaus: 1919–28" for MoMA along with its catalogue. He also designed two other exhibitions, "Arts in Therapy" (1941) with Monroe Wheeler and, through a close collaboration with Steichen, the unique war exhibition "Road to Victory" (1942), which would help to define Steichen's distinctive approach to exhibiting photography. The design innovations that Bayer initiated, and that Steichen used to great effect, were a three-dimensional understanding of space and perception that constructed sculpted views out of overlapping photographs, as well as the use of transparent plastics, curved murals and walls, and other architectural features like railings and curtains to divide space in expressionist ways. Such techniques had been seen in Europe for nearly a decade, but had never been seen in a North American context before 1938.[34] MoMA's remarkable architectural features included its movable walls, which easily accommodated the large murals that Steichen had started to experiment with in his war exhibitions.

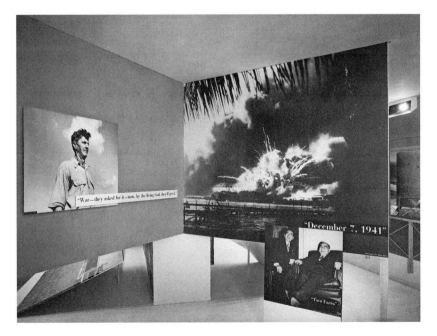

Figure 1.4
Installation view of the exhibition "Road to Victory," Museum of Modern Art, New York, May 21 through October 4, 1942. Photo credit: The Museum of the City of New York / Art Resource, NY.

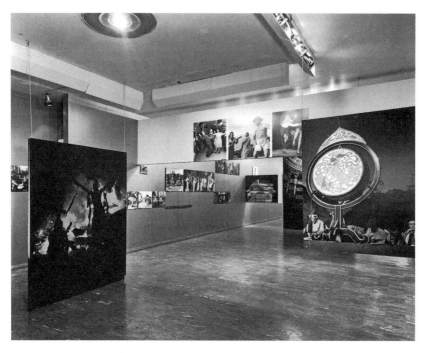

Figure 1.5
Installation view of the exhibition "The Family of Man" at the Museum of Modern Art, New York, January 24 through May 8, 1955. The Museum of Modern Art Archives, New York. Photographer: Rolf Petersen. Digital Image © The Museum of Modern Art / Licensed by SCALA / Art Resource, NY.

As with the war exhibitions, the photographs in "The Family of Man" were not framed but rather suspended from the ceiling; some were blown up into large murals and others were set in smaller clusters that were cinematic.[35] Visual montage guided viewers through the exhibition and orchestrated their lines of vision. One of the key components in making such innovative exhibition spaces was the breaking up of symmetries and varying of image scales. (Recalling his work at MoMA, Bayer cites his teacher El Lissitzky as revolutionizing exhibition design by using montage techniques with photo enlargements.)[36] With the help of his assistant Dorothy Norman, Steichen designed narrative chains that were connected to fragments of poetry and aphorisms from texts as diverse as the Bible, the *Bhagavad Gita*, poetic reflections from the Sioux and Navajo communities, and African, Russian, and Maori folk tales, as well as from writers including

Sophocles, Homer, Euripides, George Sand, Lao Tzu, Montaigne, Shakespeare, Saint-John Perse, Thomas Jefferson, Kakuzō Okakura, the US Atomic Energy Commission, Lillian Smith, John Masefield, Thomas Paine, Albert Einstein, James Joyce, and Bertrand Russell.

Steichen had imagined for the "Family of Man" exhibition a choreographed walk-through of a modernist space of overlapping, multiple views of black-and-white photographs. The walk was divided into simple "universal" themes: romantic love, marriage, childbirth, parenting, work, music making and joy, child's play, education, sadness, hunger, old age, and worship that would lead toward one dramatic image. As the visitors glimpsed an image of a dead soldier, the theme and the quotations became more focused on war: "Who is the slayer, who is the victim? Speak" (Sophocles). Or "the best authorities are unanimous in saying that a war with

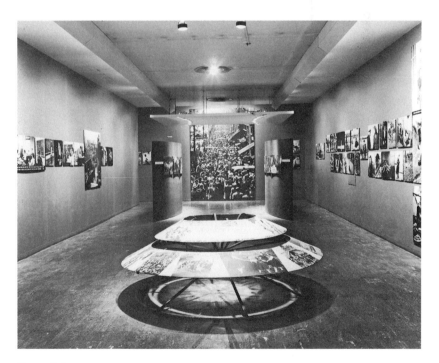

Figure 1.6
Installation view of the exhibition "The Family of Man" at the Museum of Modern Art, New York, January 24 through May 8, 1955. The Museum of Modern Art Archives, New York. Photographer: Rolf Petersen. Digital Image © The Museum of Modern Art / Licensed by SCALA / Art Resource, NY.

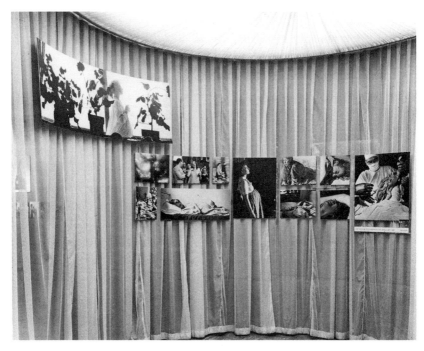

Figure 1.7
Installation view of the exhibition "The Family of Man" at the Museum of Modern Art, New York, January 24 through May 8, 1955. The Museum of Modern Art Archives, New York. Photographer: Rolf Petersen. Digital Image © The Museum of Modern Art / Licensed by SCALA / Art Resource, NY.

hydrogen bombs is quite likely to put an end to the human race … there will be universal death" (Russell). This focus on war culminated in a dramatic climax—a darkened room that housed one six-by-eight-foot glowing backlit color Milar transparency of a thermonuclear explosion. The image of the 1952 hydrogen explosion of test Mike, from Operation Ivy at Enewetak Atoll, was first published in *Life* magazine on May 3, 1954.[37] After encountering this image in a darkened room, audiences would exit to find an image of the United Nations in session, a quotation from the 1948 Charter of the United Nations, and nearby a cluster of nine photographs of distressed faces.

While the exhibition was a popular success, criticisms of it were many. As noted earlier, many centered on the decontextualization of the photographs. Historian Christopher Phillips, for example, criticized Steichen's

thematic exhibitions for the decontextualization that comes with collage techniques, which he argued, had become the benchmark of Steichen's ahistorical populist practices: "To prise photographs from their original contexts, to discard or alter their captions, to recrop their borders in the enforcement of a unitary meaning, to reprint them for dramatic impact, to redistribute them in a new narrative chain consistent with a predetermined thesis."[38] More recently, Mary Warner Marien's *Photography: A Cultural History* (2002) points out that the exhibition attempted to create unity at a time when artists and activists around the world were using photography to express their differences. Describing the juxtaposition of Dorothea Lange's iconic photograph *Migrant Mother*, which was produced as part of the Farm Security Administration photography program, with other images of unspecified calamities, she writes: "Images of workers from the Belgian Congo, Bolivia, Denmark, Germany, and the United States were thematically linked without regard for the drastically unequal circumstances of labor in those countries. Nathan Farbman's photograph of an African Storyteller in Bechuanaland (now Botswana) becomes part of a cluster of images on education, twisting its meaning to relate it to Western educational practices."[39] Not only was this erasure of context an inherent part of the exhibition's aesthetic, but it marshaled the different photographs to a Western (United Nations and United States) view of the world. In essence, she maintains, the exhibition could be read as an extension of American cultural imperialism.

In his essay "The Nuclear Family of Man" (2007), John O'Brian examines the way in which historically specific photographs, such as that of the lynching of a black man in Mississippi in 1937 or the devastating effects of the atomic bombs in Hiroshima and Nagasaki, were either excised from the exhibition or never included. As Eric Sandeen reports, "Death Slump at Mississippi Lynching" (1937) was first included in the "Family of Man" but removed after the New York opening. According to Steichen's assistant Wayne Miller, Steichen felt that the image was so violent that it became a "focal point" and stood out from the other photographs.[40] Reflecting upon the different and productive subject positions that such a photograph could elicit, O'Brian also wonders why the extraordinary photographs of Matsushige Yoshito (the only photographs made the day the bomb fell on Hiroshima) were not included, or why Miller's family photos were preferred over his series shot in Hiroshima in 1945, given the exhibition's antinuclear

message. While Steichen did include one photograph from Yosuke Yamahata's 1952 book *Atomized Nagasaki*, of an injured child holding a rice ball with the identification simply "Nagasaki," it floated in the cluster of nine portraits near the color transparency of the bomb, juxtaposed with anguished and concerned faces of other children, women, and men from Mexico, Africa, Poland, the United States, Indochina, Italy, Korea, and Austria. Arguably the historical specificity of the photograph is lost. Like Marien, O'Brian argues that

the overwhelmingly affirmative thrust of the exhibition smothered whatever potential may have existed for the representation of nuclear tragedy. His decision to represent the destructive power of the bomb in the form of a mushroom cloud and a single photograph by Yamahata, while rejecting other images of the destruction of human life and cities that occurred beneath the mushroom cloud ... corresponded to the propaganda policies of the United States following August 6, 1945. The effects of radiation were consistently denied by official US sources.[41]

All of these criticisms remain a vital part of any consideration of Steichen's efforts. But I would like to argue that the process of decontextualization was invigorated by juxtapositions and comparisons enabled by the exhibition design at MoMA, and by the selection of photographs which did depict, as Sandeen has recently pointed out, "unrest, mass turmoil and social injustice. Details of suffering, death and atrocity could be supplied by those able to place a grainy photograph into the context of the destruction of the Warsaw Ghetto or a little girl into the atomic landscape of Nagasaki."[42] While not a "world wide" exhibition expressing the "determining weight of history," as Barthes surmised, it does produce, I would submit, a deeply historical version of humanism—a "progressive humanism" whose central articulation rests on one image of destruction through war and technology. Steichen's exhibition at MoMA was not an empirical realist survey replete with rigorous sociological analysis—it was an activist exhibition staged at the very center of empire. As Sandeen puts it, Steichen's "goal was to draw people into his world of photographs that asserted a common humanity, his antidote for the East–West militarism of the Cold War. He fought against the ambitions of empire through his one-world statement."[43] Indeed, as I explore below, this is expressly how Kracauer read the exhibition.

It is important to underscore that "The Family of Man" exhibition differed from the book in that the exhibition was based on fragments unified through the threat of global destruction, as represented by the photograph

of the atomic explosion. The book did not contain this central image of the bomb. The exhibition had been designed with clusters of images that were intended to be read by a mobile spectator according to Bayer's extended-field-of-vision methodology, bringing together different vistas, views, and associations. While Warhol's silkscreens a decade later produced a most commodified and iconic version of the mushroom image of the bomb (*Red Explosion*, 1963), Steichen drew on the image before it had become cliché in order to produce the emotional culmination of the narrative—one that, like Warhol's, commented on spectacularization, consumer culture, and even the banal beauty of such destruction. Unity is created paradoxically through the technology that slices through history and unites absolutely. Unity, here, is not simply essential and a priori but a deeply historical matter of necessity—the view of a shared planet produced precisely by a world that is not shared. Planetary thinking in the twenty-first-century context of climate change, as I explore in the final chapter, necessitates thinking about what globalized humanism looks like, about ecological interdependence and interconnectedness, just as antinuclear and a nascent environmental activism did in the postwar period.[44]

As noted, the color image of the atomic explosion is not reproduced in the book, which included only the black-and-white photographs. Moreover, it was not included in any of the traveling iterations of the exhibition, which included a black-and-white image of an atomic explosion (though in Japan this image was not included).[45] The color image of the explosion seems to have disappeared and is not in the MoMA archives. Even the permanent home for the exhibition at Clervaux Castle in Luxembourg (Steichen's birthplace) does not include the original color image of the bomb—though there is a black-and-white photograph of an H-bomb in its place. One can see the original image, however, in a documentary photograph shot by Miller of his family looking at it, which was included in the deluxe version of the book.

The question of the bomb photograph is not the only reason that I want to suggest another way of seeing the exhibition. Clearly, the exhibition, in its multiplicity of emotional registers, used the techniques of manipulation that Steichen had always used—joy and sorrow placed within familiar narratives of necessity and social ritual in order to be widely accessible. Most of the photographs of everyday life featured the human face as an affective register. Yet I would argue, with Kracauer, that we can read "The Family

Figure 1.8
Wayne Miller's wife and children in front of a picture of the H-Bomb at the "Family of Man" exhibition, Museum of Modern Art, New York, February 1955. The H-bomb photograph was provided by the US government and was the only color photograph in the exhibition. Photo credit: Wayne Miller / Magnum Photos.

of Man" as a collage that does not simply constitute a seamless whole or a reactionary decontextualization. Let me now turn to the "photographic approach" that underlies "The Family of Man" and its representation of the whole—as Sandburg put it: "one big family hugging close to the ball of Earth for its life and being."[46]

Kracauer, Anonymous People

At the end of his classic history of nineteenth-century material culture, *Mechanization Takes Command* (1948), the Swiss architectural historian Sigfried Giedion would state: "We have tried to assemble fragments of the anonymous history of our period. The searchlight has fallen on scattered facts and facets, leaving vast stretches of darkness between. The complexes of meaning thus arising have not been explicitly linked. In the mind of

the active reader new interrelations and new complexes of meaning will be found."[47] Giedion developed the idea of "anonymous history" from the 1920s through the 1940s. In his first book, *Bauen in Frankreich, Eisen, Eisenbeton* (1928), which influenced both Walter Benjamin and Kracauer, he described architectural form as "anonym" and "kollektiv."[48] Accordingly, this history of industrial architecture rests with the unnamed engineers and builders who shaped the nineteenth century.[49]

Building on the formalism of his teacher, the art historian Heinrich Wölfflin, Giedion sees that various trends of historical periods are connected. A history of patents and inventions is a history of creativity, which binds all disciplines together and ultimately influences even the most isolated elements of everyday life. Giedion's insights had sources in the practices of the surrealists and of the Bauhaus designers for whom objects and things were embedded in and with the energies of historical forces. Through these objects, and through the networks that enabled an object to appear (there are hundreds of networks stored in the object—from the extraction of natural resources to the labor that produced the object; from ways of storing things to ways of moving them), Giedion maintains that one has access to life itself. He tells us: "the meaning of history arises in the uncovering of relationships. These relations will vary with the shifting point of view, for like constellations of stars, they are ceaselessly in change. … History regarded as insight into the moving process of life, draws closer to biological phenomenon."[50] The concept of anonymous history is conceived as a dynamic nonanthropocentric, nonlinear cultural ecology. Giedion's proposal for tracing the anonymous histories of inventions and ideas presents us with one of the first interdisciplinary methodologies for studying everyday material culture. He was committed to bridging the disciplinary boundaries between science, technology, and art as a means to engage with fragments of history as a living process of "new and manifold relations."

This notion of anonymous history as a presentation of "manifold relations" (indeed, Giedion's books are like world's fairs or expositions in terms of their juxtapositions and comparisons) underpins both Kracauer's film theory and Steichen's curatorial approach. The introduction of photography into advertisements and the advent of color photography in the mid-1930s helped to consolidate what the young Weimar writer had called a "blizzard [*Schneegestöber*] of photographs." In his 1927 essay "Photography,"

Kracauer expressed his fear that this "mass of images" created by American magazines and emulated in other countries functioned to reduce the world, which had taken on a "photographic face," to "the quintessence of the photographs." The world "can be photographed because it strives to be absorbed into the spatial continuum which yields to snapshots."[51] This snapshot continuum works against the memory image (the instance recollected through human cognition); and this world of disconnected fragments, this jumbled photographic archive, constitutes the aesthetic of modernity.

In *Theory of Film*, Kracauer significantly revises his earlier view that the industrialization of photography is a threat to human memory. Breaking down the opposition between human consciousness and the image, he reads photography as an antidote to the alienated life. Kracauer puts forward the notion that photography and cinema are able to communicate across cultures not by representing differences but by excavating similarities, commonness, and shared material reality. In the now infamous epilogue to this book, which he completed in exile in the United States during the postwar/Cold War period, Kracauer delineates the aesthetic vocation of film (whether depicted via photography or shown in the cinema) in terms of a new cross-cultural language of fragmentary moments. Trained as an architect, Kracauer is sensitive to the built environment and to the city's relation to mechanical reproduction. This "photogenic" theme was an essential component of the early photography of Charles Marville, Stieglitz, and Eugène Atget. In his earlier writings on city culture and in *Theory of Film* especially, Kracauer frequently returns to "the street," because the essential equation that underpins his photographic aesthetics is: film strip = the street = flow of life.[52] As Miriam Hansen has observed, Kracauer creates a theory of film that eschews a "fetishistic wholeness, perfection, distance and control."[53] In his emphatic delineation of cinema's capacity to capture the street with its "ever moving anonymous crowds," its "indeterminate" shapes and patterns which "cancel each other out," its infinite possibilities "eternally dissolving," Kracauer has incorporated "the threat of annihilation, disintegration, and mortal fear into his film aesthetics—as a fundamental historical experience of modernity."[54] Kracauer's interpretation of photographic ontology was developed during the war and in exile from his home in Germany and must be situated in terms of "film after Auschwitz." In this way, the

photographic medium provides a means to understand both the past and the present moment. As time passes, photographs lose their connection to individual memories and take on documentary and archival functions, revealing hidden aspects of the world; they become artifacts. Not only does the photograph reveal the details of physical reality, but over time, it is a document of worldly things: "things emerge [that viewers] would not have suspected in the original print—nor in reality itself, for that matter."[55] The photograph becomes a collective object of "discovery" and "exploration" that is imbued with the energies of the physical world, opening the world to a reading public.

Despite Kracauer's belief in the "photographic approach," he has no theory of verisimilitude. To Proust's description of the photographer as "alienated consciousness," "camera eye," and "stranger" who stands opposed to the "unseeing lover" caught in the "vortex" of "incessant love" which is always a "mirror of the past," Kracauer replies: "Actually, there is no mirror at all."[56] The photographer's consciousness carries a carnal density, a storehouse of memories that like the "unseeing lover" structures reality similar to the way an empathetic reader studies and deciphers an elusive text. This "inner disposition" can be described in terms of "melancholy" and "self-estrangement," whereby the dejected individual comes to identify with objects, losing herself in the configurations of environments. Kracauer's materialist aesthetics will look to the photograph—the single shot—as the basis for the cinema's ontology. The photographic medium has an inherent "affinity" for the ephemeral and "unstaged reality" which exists "independently from us."[57] As such, photographs have the ability to render "the fortuitous," those "chance meetings, strange overlappings and fabulous coincidences." Photography and cinema, according to Kracauer, offset the temporal and material abstraction imposed by the modern world of industrial capitalism. His lifetime preoccupation, as stated in his early Marseille notebooks, was the photograph's capacity to convey "the process of materialization."[58] To Simmel's famous formulation of the city as a lonely place, Kracauer adds the proposal that photography and film function to reestablish a sensuous contact between citizens and the world of things and surfaces. Like Benjamin, Kracauer sees the consumption of forms of mechanical reproduction as a way of responding to modernization rather than as an effect or even expression of it. This is why we can read *Theory of Film* as a theory of spectatorship in the twentieth century. Photography

and cinema are the art of the urban: they reproduce the "susceptibility to the transient real-life phenomena," and provide spectators with "the stuff of dreaming," with a reality that "eludes measurement," that is open and full of possibility. It is the anonymity of the setting rather than the staged story that is most important for the dreamer: "taxi cabs, buildings, passers-by, inanimate objects, faces … bar interiors; improvised gatherings" all hold "the opportunity of drama."[59] Thus, photography also has an affinity for the "endlessness" of the world, as the photograph invites us to "probe" and "explore" reality through it, which brings it close to science. This "endless-ness" is unending precisely because photography and film will always be indeterminate, replete with a multiplicity of meanings and readings. This is different from a painting, whose meanings may well be multiple but can, to some extent, be ascertained through human intentions and circumstances. By contrast, a photograph "is bound to convey unshaped nature itself, nature in its inscrutability."[60] Kracauer's approach to photography as a materialization which includes the human and the nonhuman, objects and environments, echoes Giedion's idea of anonymous history, with which he was certainly familiar. His appreciation of the medium (which is no doubt prescriptive) is imbued with the plurality of the world in a way that seeks to shatter an anthropocentric worldview. According to Kracauer, film renders the world visible, it enables us to discover the material world and to appre-hend the "psychophysical correspondences" materialized through film: "We literally redeem the world from its dormant state, its state of virtual nonexistence, by endeavoring to experience it through the camera. And we are free to experience it because we are fragmentized."[61] The purely subjec-tive image is, however, problematic: "the intrusion of Art into film thwarts the cinema's intrinsic possibilities," which are tied to its affinities to "actual physical reality."[62]

This notion of anonymity was central to Steichen's exhibitions "Road to Victory," "Power in the Pacific," "Faces of Korea," and "The Family of Man." The photographers he worked with in the Army and that he curated were largely uncredited; they were soldiers serving the country. So too those photographed who were part of the situations of war were left nameless. Steichen eschewed the high art of modernism and the low art of commercial photography in favor of what he thought photographers could do so well, which was to interpret the fleeting and minute aspects of everyday life. Although there were some extremely beautiful and now

classic photographs in "The Family of Man," no single photograph stands out from this collective work of art. The Lange photograph of the migrant mother was relegated to a corner in the exhibition precisely because Steichen knew that it would stand out from the other photographs. The exhibition concerns the collective and democratic nature of photography, and the aim of the exhibition was to create a space whereby beauty and masterpieces were secondary to the interpretations presented in the photographs and enabled by their juxtapositions.

Several aspects of this exhibition can be read as precursors to contemporary image culture and the globalization of images that Kracauer foresaw—a sense of the impermanence of the world, of radical incongruities that come with globalization: fragmentary narratives. While Steichen sought to find universal patterns in the photographs, they are not simply timeless. The exhibition "had an existence of its own" as any work of art would.[63] It was specifically created to engage with a moment in time, after Steichen had experienced the atrocities and horrors of two wars. Yet this moment in time was not static but included mobility and movement in two respects: the mobility of the photographer and, as Bayer had described, the extended field of vision of the museum visitor.

As noted above, the Swiss photographer Robert Frank acted as Steichen's curatorial assistant and accompanied him to Europe; he also contributed several photographs to the final exhibition. Like Steichen, Frank began his career as a commercial photographer for *Harper's Bazaar*, and was interested in precisely those aspects of daily living that would never make it into the museum or the glossy magazine. Against the spectacular image of fashion photography or photojournalism, he was drawn to the unfinished moment. Steichen had supported Frank in his application for a Guggenheim grant which he received in 1954, giving him time to drive his automobile across the United States taking photographs of Americans. The images Frank made on the road are filled with anonymous faces. Documentary photography on the road paradoxically singles out anonymous things from the flow of life to create identities through connected particularities.[64] We can see here the development of strategies (those affinities described by Kracauer) based on coincidence, accident, indeterminacy, endlessness, and contingency; strategies taken up in experimental art and writing of the postwar period of *a world in movement*. These were expressly the aesthetic

strategies that went into the exhibition design for "The Family of Man" created for the mobile spectator.

This was something that Steichen explored in 1952 in a series of group shows that juxtaposed five or six photographers under the rubric "Diogenes with a camera." His objective was to present "a rich diversity of interpretation." These exhibitions were based "in the desire to have photography collectively communicate a significant human experience." As Steichen's career as curator developed at MoMA, he began to understand how the exhibition gallery itself could bring another dimension to the mass media of photography, cinema, television, and print:

In the cinema and television, the image is revealed at a pace set by the director. In the exhibition gallery, the visitor sets his own pace. He can go forward and then retreat or hurry along according to his own impulse and mood as these are stimulated by the exhibition. In the creation of such an exhibition, resources are brought into play that are not available elsewhere. The contrast in scale of images, the shifting of focal points, the intriguing perspective of long- and short-range visibility with the images to come being glimpsed beyond the images at hand—all these permit the spectator an active participation that no other form of visual communication can give.[65]

We see here how Steichen's curatorial insights were inspired by Bayer's "fundamentals." Thus the exhibition at MoMA, its performance, cannot be read separately from the event as staged. The performance itself included the spectator and was based on radical juxtapositions of images.

The anthropologist David MacDougall points out that it is not singularities but interconnectivities and flows between particular cultures that lead to deeply phenomenological and pedagogical gestures.[66] "The Family of Man" gives us the interval or interface between places where identities and experiences acquire their meanings. Yet, as Kracauer theorizes, the exhibition is also characteristic of the "found story" in that it remains open and fragmented, burning through myths and clichés. It must resist the "self-contained whole" that would betray its force by casting a tight structure with a beginning, middle, and end around its anonymous core. The "found story," Kracauer explains, arises out of and dissolves into the material environment, often in "embryonic" forms that reveal patterns of collectivity.[67] It comes from the process aesthetic of the street, and it holds infinite possibilities for the psychic investment in the whole—in Steichen's case, this is the whole family and the whole planet—even as it takes that whole apart.

Fundamentally, Kracauer's theory of film and Steichen's MoMA exhibitions highlight spectatorship as an active process of apprehension.

While Kracauer is critical of the art film just as Steichen would be critical of the overly artful photograph, he nevertheless concurs with Alfred North Whitehead's evaluation of the critical role played by "aesthetic apprehension," emphasizing the "aesthetic character of experience." As Whitehead explains: "When you understand all about the sun and all about the atmosphere and all about the rotation of the earth, you still miss the radiance of the sunset. We want concrete fact with a high light thrown on what is relevant to its preciousness." Whitehead is interested in art as pedagogy, art as a training ground for sensory perception: "Art is a special example, what we want is to draw out habits of aesthetic apprehension."[68] The notion of radiance is important for Kracauer as it points not only to the outside, beyond human experience, but also to the processes of making visible—to photography and film, which are central to his thinking about redemption. Further, giving the example of a factory, Whitehead tells us that we need to understand the factory in all its complexity—"its machinery, its community of operatives, its social service to the general population, etc."—in order to apprehend "such an organism in its completeness." For Kracauer, this last term is not adequate: "In experiencing an object, we not only broaden our knowledge of its diverse qualities, but in a manner of speaking, incorporate it into us so that we grasp its being and its dynamics from within—a sort of blood transfusion, as it were." As we will see in the next chapter, Maurice Merleau-Ponty was developing similar phenomenological ideas around the interpenetration of the "flesh of the world," and Kracauer, as we know from his bibliography (Cohen-Séat, Sève, Laffay, Morin, Callois, etc.), was reading French film theory and was involved with the *Revue internationale de filmologie*. Kracauer commented: "What we want, then, is to touch reality not only with the fingertips but to seize it and shake hands with it."[69]

Redemption

If Kracauer's film theory incorporates "a fundamental historical experience of modernity" into its central ontological claims, it also seeks to find redemption in this experience in and through film itself.[70] For the cinema is not only an "eternally dissolving world"; it also offers a possible way forward

out of that experience through the creation of a shared world. What these fragments of photographed moments portend is nothing more and nothing less than the "redemption of physical reality."[71] What does Kracauer mean by "redemption" in *Theory of Film*? He looks to his friend Erich Auerbach and his work *Mimesis* for illumination on this question. Auerbach's work on literature locates redemption in "the moment" as something that is both historical and phenomenological: these moments concern not only the individuals depicted in them, but also "the elementary things which men in general have in common. It is precisely the random moment which is comparatively independent of the controversial and unstable orders over which men fight and despair; it passes unaffected by them, as daily life."[72] For Auerbach, who wrote *Mimesis* in Istanbul between May 1942 and April 1945 in response to a profound pessimism and relativism among German Jewish intellectuals, this commonality was a way of thinking about ethics and enabling judgment. He defines judgment as making oneself at home in a world without fixed points of reference, without universals, "in keeping with the constantly changing and expanding reality of modern life."[73] Kracauer contends, however, that Auerbach's study of Western literature and realism fails to note that the task of rendering visible the "texture of everyday life" is most powerful in the photographic medium. It is not by accident, Kracauer writes, that the idea of "*The Family of Man* was conceived by a born photographer."[74] Until the twentieth century, no other period in history had had access to such a vast photographic archive of its past, Kracauer points out. These photographic cultures "virtually make the world our home."[75] Despite the accusations of naïve realism that greeted Kracauer's book, he is not advocating the end of ideology or celebrating the end of history.[76] Rather, like his friend Auerbach, he discerns in the "exploratory type of representation … that beneath the conflicts and also through them, an economic and cultural leveling process is taking place. … It is still a long way to a common life of mankind on earth, but the goal begins to be visible."[77]

Kracauer gives special mention to Paul Rotha and Basil Wright's film *World without End* (1953), a documentary sponsored by UNESCO that explores the similarities and differences between the people of Mexico and Thailand without conflating their different economic and social situations. *World without End* was presented at the Edinburgh Film Festival in 1953 and was subsequently broadcast on British television to seven million

viewers—a strategy to reach as many spectators in Britain as possible.[78] To be sure, *World without End* can be read as a promotional film for UNESCO that reinforced rather than questioned the British Colonial Office; a film that clearly demarcated the victims from the caregivers (who worked for UN agencies).[79] Yet Kracauer was interested in the utopian universality of cinema, its capacity to transcend linguistic differences.

At the end of *Theory of Film*, he turns to Satyajit Ray's film *Aparajito* (1956) which perhaps best illustrates his point, a film that makes the everyday in Calcutta intelligible to viewers in "Manhattan or Brooklyn or the Bronx." Kracauer describes one scene from Ray's film:

the camera focuses on the ornamental bark of an old tree and then slowly tilts down to the face of Apu's sick mother who yearns for her son in the big city. In the distance a train is passing by. The mother walks heavily back to the house where she imagines she hears Apu shout "MA." Is he returning to her? She gets up and looks into the empty night aglow with water reflections and dancing will-o'-the-wisps. India is in this episode but not only India.[80]

The final images are layered with realities that include emotion, dwelling, nature, and a tapestry of relations contained in the material circumstances of everyday life.

In the end, what is the substance of the redemption and indeed the kind of humanism that Kracauer locates in the documentary trend, which he predicted as cinema's future? It is quite simply that photographic images open up their "anonymous state of reality," an idea he credits to the young French film critic Lucien Sève. Kracauer cites Sève's essay "Cinéma et méthode" which argues that the shot, as the fundamental element of film, reflects "the indeterminacy of natural objects."[81] Redemption is not only a space connected to the past; it is also potentiality. This is why Kracauer ends *Theory of Film* by looking to the relations *between* cultures, to film's communicative capacity to connect things both human and nonhuman, and to open up new understandings. While Kracauer was unable to fulfill his impossible ambition—to explain the material complexity of film through one comprehensive theory—he had the great acuity to understand cinema in terms of communication and the creation of a public sphere of images, a common space that does not belong to any one subject. What he could not predict was the extent to which "the blizzard" of images that defined the visual culture of the 1940s and 1950s would implode into an entirely new apparatus of global interconnectivity and history—a multifaceted mass

medium that would dematerialize, dissolve, and disintegrate audiovisual images beyond the frame, making their production and circulation more flexible, and at once more anonymous and more personal, while being subject to greater controls and surveillance.

"The Family of Man" emerged at precisely that point in the twentieth century where technological and economic globalization began to be visible. The critical scholarship about the exhibition reveals that Steichen was under pressure from both the government and from MoMA board president Nelson Rockefeller to be more accessible to amateur photographers, to the photo industry, and indeed to the world in order to create an image of the United States that was easily exportable.[82] Certainly, as Sandeen has demonstrated, the exhibition was appropriated by the United States Information Agency (USIA), which was charged with "projecting American values abroad." Steichen essentially lost control of the exhibition once it began to travel—more than 9,000,000 people visited it in over 100 locations around the world.[83] "The Family of Man" is not one exhibition but many different exhibitions and iterations around the world, with very different exhibition contexts and related geopolitical negotiations. In his most recent study of it, Sandeen looks at the Cold War terrain that greeted the exhibition in postrevolutionary Guatemala in 1955 under the control of US imperial interests.[84] Indeed, away from its original location at MoMA, the organic aspects of the exhibition were transformed by the different temporal, geographical, political, and cultural registers defined by US foreign policy, of which Steichen had very little understanding. Such contexts often challenged what he assumed to be "the universally understood meanings" of the photographs and the "immutable message" of the exhibiton.[85] Herein lies the difference between Steichen and Kracauer. There is little doubt that Kracauer's theory of spectatorship and phenomenological understanding of images would have recognized the difficulties inherent in such a massive undertaking.

2 Invisible Ecologies: Cousteau's Cameras and Ocean Wonders

Like Edward Steichen, Jacques-Yves Cousteau was a naval officer in World War II. Both were "captains" who insisted on this identity throughout their long careers. They were also both involved in developing photographic and sensory technologies that supported militaristic surveillance in the air (Steichen) and underwater (Cousteau). Yet unlike Steichen, who went on to use photography with the intention of uniting the peoples of the world in a single human community, Cousteau was intent on expanding our experience of the planet by opening up a new world, a hidden world beneath the oceans that he would explore in more than 120 films and television programs, as well as 50 popular books throughout his long career.

Lorraine Daston has emphasized that wonder is historically opposed to reason; it is "the barometer of ignorance. ... The more we know, the less we wonder."[1] Yet for Daston, contemporary forms of wonder have been reduced to childlike fascination, paling in comparison with that of previous centuries.[2] I would argue that the ocean continues to carry a deep sense of wonder precisely because it is an essential and ever-growing mystery. If we learned anything from the tragic disappearance of Malaysia Airlines Flight 370 in 2014, it was that the earth's oceans are largely unknown and inaccessible to us. The knowledge that is produced about them, whether it involves our pollution of the oceans or the attempt to map their depths, reveals how little we know. I want to understand how this sense of vast unknowing, this wonder, was produced and marketed through Cousteau's documentaries.

Cousteau's lifelong inspiration for this popular enterprise was the nineteenth-century science fiction writer Jules Verne, whose stories were published under the rubric *Voyages extraordinaires*. The most successful of these include *Voyage au centre de la Terre* (*Journey to the Center of the Earth*,

1864); *De la terre à la lune* (*From the Earth to the Moon*, 1865); *Vingt mille lieues sous les mers* (*Twenty Thousand Leagues under the Sea*, 1869); and *Le tour du monde en quatre-vingts jours* (*Around the World in Eighty Days*, 1872). Verne's influence extends far and wide, and authors as diverse as Rimbaud and Antoine de Saint-Exupéry found inspiration in his imaginative tales of adventure. For Roland Barthes, however, Verne's works constitute bourgeois narratives of appropriation. He maintains that Verne "in no way sought to enlarge the world by romantic ways of escape or mystical plans to reach the infinite: he constantly sought to shrink it, to populate it, to reduce it to a known and enclosed space, where man could subsequently live in comfort." Barthes argues that the image of the ship—central to all of Verne's utopian science fictions—underpins this "appropriation" and imperialist thrust. Verne's ship is the "emblem of closure," which always signifies "having at one's disposal an absolute finite space." Evoking Rimbaud's "drunken boat," Barthes maintains that the only way Verne could have created a "genuine poetics of exploration" would have been to "leave the ship on its own," thereby transforming it into "a traveling eye, which [would come] close to the infinite, … constantly beget[ting] departures."[3]

In what follows, I consider Jacques Cousteau and Louis Malle's film *Le monde du silence* (*The Silent World*, 1956), released one year after Steichen's "Family of Man" exhibition, and situate it, and the expeditions it represents, alongside Barthes's reflections on Verne. Having characterized "The Family of Man" as "sentimental humanism," Barthes was likewise critical of Verne's construction of the natural world, accusing him of an appropriation of space that collapses the outside world into the commodified space of a conventional, bourgeois imagining. Using Barthes's juxtaposition of spatial appropriation with the utopian possibilities of Rimbaud's "drunken boat"—a boat literally filled with water and thus at one with the sea—I intend to read Cousteau's environmental films of the 1950s dialectically. In this chapter, I argue that after World War II, the oceans, made newly visible through popular media, underwent a process of territorialization that transformed and parsed them out as never before. Such changes, as we shall see, were in part facilitated by changes to the long-standing laws pertaining to the seas as well as by advances in media and recording technologies. I am particularly interested in locating *The Silent World* in the context of a new experience of *mediatic* space in the postwar period of the 1950s. This new sense of space as open and infinite—wondrous and ecstatic—and at the

same time enveloping and immersive, comes about in the context created by World War II (which is not to discount the impact of World War I).[4] This situation was defined by the destructive capabilities of the atomic bomb, extensively viewed on American television, as well as by the geographical reach of communications technologies like television and computers and, in particular, radar and sonar. *The Silent World* celebrated Cousteau's boat, *Calypso*, which was equipped with both radar and sonar, as a technologically advanced research laboratory and film studio.[5] The film thus helped to introduce a technological humanism and an environmental ethos that, while pointing toward the future of the planet, revealed the earth's previously undisturbed and unseen depths in ways both utopian and imperial.

Cousteau's explorations led to many technological innovations in cinema, especially in underwater photography, to which Cousteau devoted his life. Yet his early "research" was not disinterested; it was supported by the ideological and capitalist agendas of companies such as British Petroleum (BP) and the National Geographic Society, whose magazine also documented and publicized his expeditions. Moreover, as we shall see, Cousteau's discovery and filming of the underwater world cannot be considered apart from the Nazi occupation of France during World War II, nor from France's long-standing colonial and capitalist ventures in the Mediterranean.

If Steichen's photographic archive of the "human family" sought to visualize the people of the earth in order to establish a common bond between them—a bond rooted in the survival of humankind living together on the planet—Cousteau's project was oriented toward the future. Referring to his divers as "oceanauts," he wished to uncover a new world through "space exploration," to link inner and outer space. His environmental ethos concerned not so much humankind as it did planet earth—particularly the oceans. Before discussing Cousteau's world, I want to highlight another architect of utopian spaces, a lifelong rival who represented for Cousteau an antithetical cultural sensibility—Walter Elias Disney.

Disney's Anthropocentrism

On a 160-acre site near Anaheim, California, Walt Disney inaugurated Disneyland Park in 1955. He also personally produced a film adaptation of Verne's *20,000 Leagues under the Sea* (1954, directed by Richard Fleischer),

which was released two years before Cousteau and Malle's *Silent World*. For *20,000 Leagues*, Disney used the new CinemaScope process for the first time in one of his films. Marketed as a "new form of entertainment" and "the modern miracle you [can] see without glasses," CinemaScope was the hallmark of 20th Century Fox's challenge to television and Cinerama.[6] The expansive spatial quality produced by the anamorphic wide-screen process was perfectly suited to the new world that Disney wished to present and naturalize. In the marketing for this new technology, CinemaScope itself was equated with the sublime beauty of nature:

From the Depths of the Never Ending Ocean

From that Fathomless

World of Infinite

Mystery & Unearthly

Beauty Which Man has yet

to Discover

Comes the

MIGHTIEST

Motion Picture

Of Them ALL!

Walt Disney Presents

Jules Verne's

20,000 Leagues Under the Sea

In CinemaScope Color by Technicolor[7]

Although most of the film's underwater scenes were shot in a large water tank in Stage 3 of the Disney Studios, *20,000 Leagues under the Sea* was heralded as a breakthrough in underwater photography.[8] Till Gabbani was chief technical director for the underwater photography done in the tanks and a small portion off the coast of Nassau in the Bahamas. In February 1954, ten months before the film's release, *Life* magazine featured a photo essay illustrating the film's technical feats in underwater VistaVision photography and its ingenuous costume design of nineteenth-century diving suits.[9]

James Maertens has argued that the Verne novels were popular during the Cold War because they evoked nostalgia for the Victorian world, with its clearly established class distinctions and colonial wealth.[10] In the film version of *20,000 Leagues*, the Industrial Revolution is taken up as a metaphor for the cybernetic and atomic revolutions that followed World War II—providing a simple historical lineage and moral tale for the atomic age. The Disney film abandons the pedagogical aspects of Verne's novels, whose scientific fiction Foucault appreciated,[11] offering instead a science fiction that celebrates technology as a nostalgic space and an idealized past. Unlike Verne's novel, in which Dr. Nemo's fate remains uncertain, in Disney's rendition he dies.

Eisenstein and Bazin on Disney

Both Sergei Eisenstein and André Bazin found much to admire in Disney's animation and nature films. Eisenstein's esteem was based largely on his aesthetic appreciation of the malleability of the image in Disney animation—an experience he related to Lewis Carroll's *Alice in Wonderland*: "Now I am opening out like the largest telescope that ever was!" He was fascinated by the "scattering of extremities" in Disney's drawings—a phenomenological "attractiveness," a "plasmaticness" that emerges, Eisenstein wrote, from a "fictitious freedom. For an instant. A momentary, imaginary, comical liberation from the time lock mechanism of American life."[12] It is almost as if Eisenstein in his emphasis on "plasmaticness" discerned that his theory of montage would one day be superseded by another medium and methodology that would redefine the connection between shots in terms of "a rejection of once-and-forever allotted form, freedom from ossification, [and] the ability to dynamically assume" any form. For Eisenstein, Disney's animations come close to producing the primordial sensation of the ecstatic which is tied to the "unstable image": "these seemingly strange traits which permeate folktales, cartoons, the spineless circus performer and the seemingly groundless scattering of extremities in Disney's drawings."[13] Disney's animations are ecstatic in themselves. Disney's animation (*anima* [soul] + motion) heralds a return to totemism by offering up a participatory animism, an interface between human and nonhuman animals, "a condition of undifferentiated consciousness."[14] Eisenstein defines ecstasy as "the sense and experience of the primary 'all possible'—of the element

of 'formation'—of the 'plasmaticity' of existence from which all can arise." Ecstasy occurs "*beyond* image, *without* image, just as pure sensation." In order to strengthen this feeling, humans seek out certain images that "due to certain features can resemble this state and this sensation."[15] Such "multiform possibilities" are found in the "eternal shape-shifting" phenomena like fire, plasmatic forms, water, clouds, and music. The union with animals is seen in the earliest caricatures. For Eisenstein, it is indicative of a threshold, a shift in human consciousness that expresses "a *unity* with animals" but at the same time, and critically, a "non-identification with them." It is based on the principle that Marx explicated, "'laughing, we part with our past,' with an overcoming."[16] Disney's animations represented a shift toward a different mode of apprehending the world, the "plasmatic" promethean quality of his animations enabling a return to childlike and liquid connection to potentiality.

Even though most of *20 Leagues* was shot in the studio, Disney was committed to location shooting for his live-action films. He began to develop the most realistic means to depict nature, promoting advances in cinematic technology as a kind of second nature. Yet this is not what interested the realist film critic André Bazin about Disney. Disney produced the most realistic animations, to be sure. But his nature films, featured in the *True-Life Adventures* series (1948–1960), though similarly realistic, demonstrated a fantastical and anthropomorphic approach to nature that Bazin found intriguing. For Bazin, anthropomorphism is "not a priori condemnable."[17] Rather, he argues, anthropomorphism could be more or less justified and effective depending upon its context and application. For example, the ethnologist Karl Von Frisch, beginning from anthropomorphic assumptions, discovered the complex communication patterns of bees in the 1920s. In fact, preferring Buffon's half-human animals to Descartes's animal machines, Bazin believed that anthropomorphism caused harm only in the realm of science. He grasped that anthropomorphism is an ancient form of analogical knowledge whose domain extends from moral philosophy to the highest forms of religious symbolism by way of magic and poetry. The justification and effectiveness of anthropomorphism in cinema must be understood, he argues, in terms of different "levels." Bazin distinguishes good from bad uses of anthropomorphism, famously comparing Jean Tourane's *Une fée pas comme les autres* (1956) with Albert Lamorrisse's *Le ballon rouge* (1956) in *Cahiers du Cinéma* under the title "Montage interdit."[18] By trapping

the animals in a montage that Bazin describes as "bad literature," Tourane failed to provide a credible image of animals; his cinema thus belongs to the lowest level. Contrariwise, Bazin maintains that, whether animals are represented anthropomorphically, zoomorphically, or objectively, it is the spatial integrity of the situation that matters. The action must be real or must speak to an underlying power in nature; it makes no sense to fragment films about animals because, like films about conjuring and magic tricks, in order to represent the trick as a trick, the film must preserve the spatial and temporal integrity of the action. Tourane's animals do not need to behave like animals; indeed, they need to do nothing at all because the voice-over and montage do all the work. For Bazin, montage preserves the state of unreality demanded by the spectacularization of animals. His prescribed unity of action takes us beyond spectacle and fiction, and allows us to appreciate animals themselves. Here, Bazin highlights the difference between montage, which creates action internally, and *découpage*, which is external and continuous.

In an extraordinary follow-up to this essay, Bazin expanded his discussion of montage to include Disney's fifth live-action feature film, *A True-Life Fantasy: Perri* (Paul Kenworthy and Ralph Wright, 1957), part of the *True-Life Adventures* series. In "Les périls de Perri," Bazin observes that nature appears to imitate Disney in this film. Though he acknowledges the speciousness of this comment, Bazin was responding to something real in Disney's films; Disney and his animators had long imitated nature, seeking out analogical symmetries between the human and animal worlds.[19] Bazin maintains that Disney had discovered his unique animation aesthetic in nature itself.[20] Furthermore, one can detect in the evolution of Disney's aesthetic—from the sentimental realism of *Snow White* (1937) to the burlesque synchronism of *Water Birds* (1952) and *The Living Desert* (1953)—the shift from montage to *découpage*. Though highly fantastical and unrealistic (*Perri* follows a squirrel from birth to marriage), *A True-Life Fantasy* presents us with scenes that "are exposed with the same topographic clarity, the same spatial realism, the same dramatic progression as any scripted film."[21] The scene in which, for example, a beaver gnaws at a tree, knocking the young squirrel out of its nest, is conveyed in one continuous shot, without the help of montage. Moreover, the complexities of the scene were revealed through the use of not only *découpage* but also deep focus.[22]

Bazin was interested in the way cinematic reality and fantasy commingle in *Perri*; the nature that served as a model for Disney was integrated into the images it inspired to the extent that a film's commentary could, with a "natural" ease, conflate a real animal (a deer) with the animated Disney version. Thus, the voice-over in *Bambi* boldly proclaims: "Here is Bambi, the king of the forest." As Bazin wryly notes, if the wild cat or the marmot continued to be referred to by their common names, it was only because they had not yet received the Disney treatment. Many animals in Disney films, however, were simply anonymous—*Snow White* and *Cinderella* (1950) were populated with many such creatures. In *Perri*, this assimilation of first reality to second reality by means of fiction culminated in the most astonishing experience: the viewer inhabits the squirrel's dream, in which photographic images are mixed with animated snowflakes. Although this was not the first time that photographic and animated images had been combined, the effect, for Bazin, was the creation of a delicate interaction in which animals could move between the two spheres. This hybrid live-action film, shifting between the photographic and the animated worlds, between realism and the imagined dream world of the animal, emphasized a certain reciprocity between and layering of documentary and fiction, which produced an "ambiguity integral to this universe."[23] Bazin was most impressed with Disney's representation of these overlapping and interpenetrating spheres—liminal spaces, like Perri's dream, between inside and outside worlds.

Animal Environments: Umwelt

Both Eisenstein and Bazin must have been familiar with the work of Estonian biophilosopher Jakob von Uexküll (1864–1944), whose research provides us with a scientific theory of the animal world and its representation.[24] Uexküll had worked with the physiologist Étienne-Jules Marey (1830–1904) and had directly influenced many philosophers including Martin Heidegger and Maurice Merleau-Ponty. Proposing a new definition of the environment in his book *A Foray into the Worlds of Animals and Humans: Picture Book of Invisible Worlds*, Uexküll explored the idea that the universe is made up of unique and multiple subjective environments. Working with biologists at the Institute for Environmental Research in Hamburg, Uexküll proposed not a new science, but a "walk into unknown worlds … [that were] not only unknown, [but] invisible."[25] Building

upon Kant's philosophy, Uexküll maintained that the world of every liv-
ing organism on the earth is different from that of every other organism
because of the uniqueness of its sensory organs and its environment; each
creature inhabits a unique environment that is uniquely experienced.
The world is thus made up of multiple, overlapping environments.[26] For
Uexküll, each animal's environment constitutes a bubble "contain[ing] all
the features accessible to the subject. As soon as we enter into one such
bubble, the previous surroundings of the subject are completely reconfig-
ured. ... A new world arises in each bubble."[27] Recognizing that each living
entity on the planet communicates in its own singular fashion, Uexküll's
mission was to redefine the field of biology by bringing communication to
bear on the study of the lifeworld. Through his work on invertebrate sea
animals (sea urchins, brittle stars, octopuses, etc.), Uexküll developed the
decidedly liquid and fluid concept of umwelt to refer to these subjective
environments in 1909. What interests me here is the "aesthetic dimen-
sion" of the umwelt, which Geoffrey Winthrop-Young likens to Edgar Allan
Poe's "gyrating maelstrom" in which the shipwreck survivor finds himself
immersed in a kaleidoscopic waterscape.[28] The environment described by
Uexküll is defined by a multiplicity of overlapping subjective experiences
of time. This conception is highly experimental in the way it completely
decentralizes a singular scientific gaze and posits the existence of simulta-
neous sensory worlds distributed across space.

In 1899, Uexküll traveled to Paris in order to study with Marey, the pro-
genitor of chronophotography, an experimental method in the growing
field of physiology in the late nineteenth century. Buying a camera and
emulating this method, Uexküll incorporated Marey's studies of motion
into biology. Using the chronophotographic method to analyze the flight
of dragonflies and the movements of starfish as well as other small animals,
over the next twenty years he further developed the idea, first suggested
by Estonian entomologist Karl Ernst von Baer, that time is relative to each
species. The complex environments formed by these perceptions required
new forms of observation, which Uexküll exhorted biologists to undertake:
"Our anthropocentric way of looking at things must retreat further and
further, and the standpoint of the animal alone must remain. When this
occurs, everything that we hold as self-evident disappears: all of nature,
earth, heaven, stars, indeed, all the objects that surround us. ... A new
world takes shape around every animal, completely different from our own:

its Umwelt."[29] As Janelle Blankenship explains, Uexküll and the historical avant-garde recommended the use of stop-motion photography and other forms of cinematic recording as a means to better observe the rhythms of plant and animal worlds. Certainly, this approach was commensurate with Marey's graphic method, which sought to supersede the limits of the observing body through technologies that "perform[ed] like a new sense"—what he would call "l'écriture de la nature" (nature's writing).[30] Yet Uexküll, interested in the perceptual environments of diverse animals, went further than Marey, who wanted to study human and animal movement to better harness their energies. To be able to access these environments, Uexküll argued, the invisible animal umwelt had to be made visible. In Uexküll's work, the observer, though necessarily outside, is simultaneously interconnected with and interpenetrated by each of the umwelt spheres. As we shall see, this duality of visible and invisible worlds would influence Merleau-Ponty's concept of the intertwining and the chiasm in his final unfinished opus, *The Visible and the Invisible*.

The importance of Uexküll's thought and the increasing popularity of his work—as well as the adoption of the term "umwelt" in the field of animal studies and beyond—lies in his recognition of the need to expand our understanding of the world beyond mere human perception.[31] His conception of the world as made up of a multiplicity of perceptions also opens up new worlds, both human and nonhuman. Peter Sloterdijk has warned against the "confusing career that sometimes befalls terms that have the appearance of self-evidence." Affirming the value of Uexküll's work on the existence of multiple environments, Sloterdijk remarks that the "observation that life is always life-in-an-environment—and hence also against other environments—triggers a perpetual crisis of holism: humanity's old-fashioned propensity to submit to local totalities as if to benevolent local gods is divested of all orientational value, since the surroundings have themselves become constructs, or are recognized as such."[32] Sloterdijk underscores the way in which the umwelt brings in a process-oriented and open view of the environment.

Cousteau: Commandant or *Man-Fish*?

Like Uexküll, Bazin valued the importance of recognizing different environments and, correspondingly, cinema's capacity to reveal

non-human-centered views of our natural environments. It was this focus and capacity that underlies his admiration for Disney *as well as* for Cousteau and Malle's *The Silent World*. Despite Cousteau's desire to differentiate *The Silent World* from Disney's nature documentaries,[33] Bazin reminds us that they both creatively and effectively negotiated the porous boundaries between documentary and fiction, as well as between human and nonhuman spaces.

While Cousteau's approach to nature did share certain elements with Disney's, it differed significantly in terms of the understanding of the natural world as precisely a *silent* world—a world that is autonomous and separate from humans. As we shall see, even though many aspects of Cousteau and Malle's film involved staging and reenactments, it was deeply connected to the contingency of the natural world. Disney's live-action films sought to overcome this reality. The filming of Perri the squirrel's adventures, for example, were captured through a 25:1 shooting ratio that essentially veiled the contingency of nature.

Throughout his fifty-year career, Cousteau developed two public personas that were seemingly at odds with one another. On the one hand, he was Commandant Cousteau, the captain. This figure was first reported on the pages of *Life* magazine in November 1950, in a photographic essay that featured "underwater wonders." Here, a forty-year-old French naval commandant was introduced to the American public as a free diver and filmmaker whose seven films would soon be released. Cousteau, according to the accompanying commentary, intended to make "oceanographic studies around the world." The text went on to explain, "He does not expect to encounter any difficulties … because like any well-bred visitor, he usually respects the inhabitants of the watery world he invades and in turn is usually unmolested."[34]

While this might well have been Cousteau's general approach, his films of the wonders of the sea occasionally featured dramatic and violent interactions with fish. In one filmed encounter with an octopus, Cousteau's close collaborator Frédéric Dumas was sprayed in the face with ink. In another film, Cousteau and his team encountered a "deadly" shark, pictured head-on through Cousteau's lens in "a nose-to-nose close-up." The caption to this image, in which the shark eerily resembles a submarine, reads: "'It was not until this moment,' says Cousteau solemnly, 'that I realized the seriousness of the situation.'"[35] In contrast, one year later, in 1951,

Paris-Match magazine would introduce a decidedly different Cousteau to the French public, describing the retired naval officer as *l'homme-poisson*— "the man-fish"—who, in his efforts to connect with the ocean's inhabitants, was learning to imitate and swim like a fish. *Paris-Match* published Cousteau's first color photographs of the ocean floor—indeed, the first such photographs in the world, according to the article. Cousteau would play up this anthropomorphic identity in his 1952 article for *National Geographic*, "Fish Men Explore a New World Undersea."[36]

Arguably, one of the reasons for Cousteau's success lies in the movement between these two figures, one of knowledge (the commandant) and the other, *l'homme-poisson*, as a kind of composite being. These two figures provide a mediation between ground and water, stable and unstable worlds. As Lorraine Daston and Katharine Park explain, hybrid beings are "exotic races"; they are not singular aberrations, which would make them monsters: "They hold fascination because of their meaning rather than their form."[37] In Cousteau's case, these beings represented the future of the planet. Indeed, in their lightweight costumes and their high-tech gear—featuring underwater scooters and diving saucers, specially designed cameras, and sonar—Cousteau's advanced technology was a signature of his enterprise.

According to Cousteau's biographers, he was, like Disney, inspired by Verne's *Twenty Thousand Leagues under the Sea* to create underwater explorations for film. Though neither a scientist nor an engineer, Cousteau was devoted to both science and engineering, which came together in cinema. He began experimenting with diving gear and underwater cameras during the war and, in 1943, he co-invented, with Émile Gagnan, the Aqualung— the first successful self-contained underwater breathing apparatus (scuba), which revolutionized both diving and deep-sea photography by creating compressed and regulated portable air. Cousteau's innovations in diving equipment were motivated by his desire to film underwater, which required an ability to descend to great depths and to remain underwater for long periods of time. His innovations in both diving and cinema also enabled him to provide valuable information to the French Underground and the military during World War II.[38]

This combination of engineering, science, and filmmaking would define the *commandant* in the red knit cap, a persona that Cousteau would present consistently in the following decades. From the beginning of his early

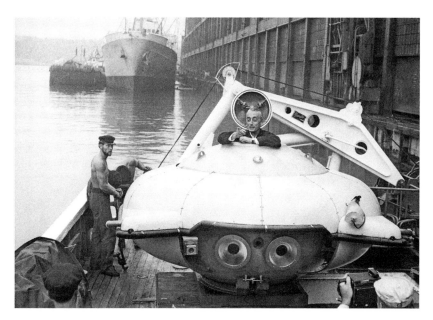

Figure 2.1
Jacques Cousteau climbing into his Diving Saucer on board the *Calypso* docked in New York Harbor in August 1959. Credit: Granger Historical Picture Archive/Alamy.

documentaries, Cousteau had worked with Philippe Tailliez and Frédéric Dumas; they called themselves "Les Musquemers." Underwater films had always been plagued by lighting problems, and they struggled with light from early on, in *Par 18mm de fond* (1942) as well as in the award-winning *Épaves* (1943), which, with its sunken ships, shark fishing, and underwater choreography, was in so many ways a rough draft of *The Silent World*. Cousteau took inspiration from the underwater photographs of Louis Boutan (1859–1934), which had been published in 1893, and from the underwater photographs and films created by the English journalist John Ernest Williamson (1881–1966), whose images were created through a deep-sea tube. He was equally admiring of the beautiful surrealist documentaries of his contemporary Jean Painlevé, who recorded anthropocentric animal movement, which he created in water tanks, in a manner that resembled Uexküll's umwelt bubbles. Yet Cousteau was single-minded in his desire to film life underwater, and his team recorded at greater depths than any of his predecessors.

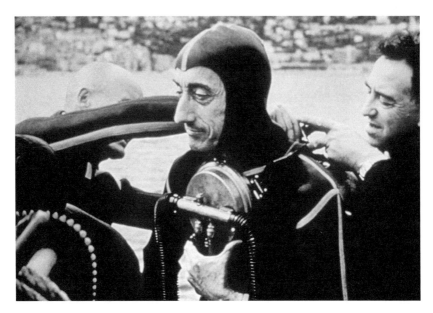

Figure 2.2
Jacques Cousteau receives assistance from his crew in adjusting his "Self-Contained Underwater Breathing Apparatus," or as it was originally called, the "Aqualung." Paris, France, 1965. Photo credit: MARKA/Alamy.

In 1946, Cousteau and Tailliez, with the approval of the French Navy in Toulon, established the Groupement de recherches sous-marines (GRS) (Underwater Research Group).[39] The group carried out mine-clearing missions as well as technological and physiological tests. Although Cousteau's wife, Simone Melchior, was very much a part of all of his expeditions from 1937 onward, and though she often organized, managed, and raised funds for the expeditions, she did not wish to appear in his films or television programs.[40] In 1948, on board the *Élie Monnier*, the group, along with Frédéric Dumas, Jean Alinat, and scriptwriter Marcel Ichac, undertook their first exploration of the Mediterranean, in which they "excavated," as it were, a Roman wreck off the coast of Tunisia.[41] While Cousteau had previously explored other sunken ships, this expedition represented one of the first international underwater archaeology operations, and helped to establish scientific oceanic archaeology. Not long after, Cousteau left the French Navy in order to pursue his own research interests. The archaeological aspects of his work lent legitimacy to his undertakings and likely

allowed him to bypass some of the restrictions to navigation that were curtailing the long-standing policy of the freedom of the seas, especially during the Algerian War and the complex geopolitics of the Middle East in the 1950s and 1960s.

To solve the lighting problems that prevented him from filming at greater depths, Cousteau visited the Massachusetts Institute of Technology (MIT) in 1953. There he began a collaboration with Harold Edgerton, the pioneer in high-speed photography and inventor of the strobe light and other photographic devices. Edgerton spent several summers aboard the *Calypso*, outfitting the ship with a sonar camera that skimmed along the ocean floor on a sled (creating 800 exposures per hour) and produced low-resolution, ghostlike photographs of deep-sea creatures. While Edgerton's innovations in lighting technology helped Cousteau conceptualize his forms of lighting and synchronize them with the camera, he was less interested in remote sensing (though this is represented in the film *Silent World*) than in direct contact with life in the sea.

To better record the rapid movements of fish and water, and to explore the depths of the ocean floor, Cousteau and Edgerton experimented with stop-motion photography. Cousteau's awareness of the density and changeability of the ocean as a living, interactive world drove him to continuously revise the design of his camera from the 1940s through the early 1960s. Like Uexküll's use of chronophotography to photograph small sea animals in context (i.e., in their umwelts), Cousteau's experimental methodology allowed him to constantly adapt his techniques and technology as he learned more about cameras, as well as about the ocean and its inhabitants. Cousteau oversaw the design of a special camera that could handle sixty meters of film—enough to last for the duration of a single dive. He experimented with film stock, choosing Eastman Color over Kodachrome because it was more sensitive to light. A Hublot prototype of an ultra-wide-angle lens of 18mm focal length with a diaphragm opening of f.7 was devised in order to correct underwater distortion. Some parts of *The Silent World* were shot at forty-eight frames per second in order to capture the movement of fish.[42] Eventually, Cousteau created new forms of lighting that were able to illuminate depths of more than 100 meters. All of these techniques helped to reproduce the experience of being under the sea and allowed him to photograph animals in their natural environments. These innovations

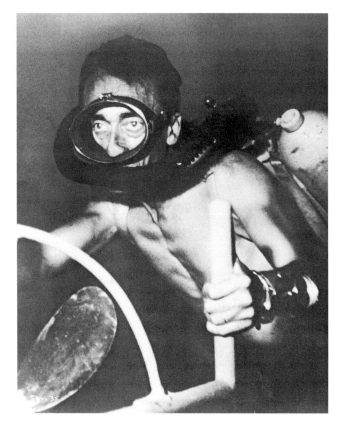

Figure 2.3
Jacques Cousteau driving his underwater electric scooter in a scene from his film *The Silent World*, filmed in 1954–1955 and released in 1956. Credit: Granger Historical Picture Archive/Alamy.

inaugurated a radical era in expedition films, with, as Bazin pointed out, the advent of *le documentaire sous marin*.

The Silent World

Noted as one of the first films to use underwater cinematography to show the ocean world in color, *The Silent World* garnered a Palme d'Or, an Academy Award, and worldwide attention when it was released in 1956. Cousteau had brought together a team of people who were both skilled cinematographers and scuba divers. This included a young Louis Malle, who,

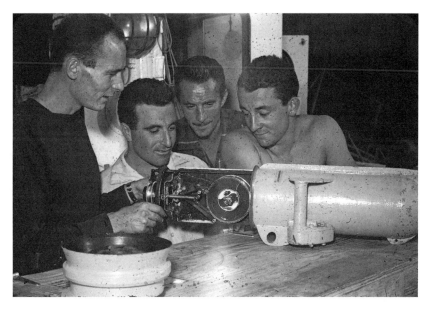

Figure 2.4
Louis Malle (right) and three crew members examine an underwater camera partly pulled out of its housing, aboard the *Calypso* in 1955. Credit: © 2010 MIT. Courtesy of MIT Museum.

at twenty-two, had recently graduated from the Institut des Hautes Études Cinématographiques and, fortuitously, knew how to scuba dive. Given the role of codirector, Malle worked with Cousteau to create the script for *The Silent World*, and the two worked on other shorter documentaries that preceded the feature film as well.

The Silent World opens with an explosion—a phosphorous torch lights up the dark depths of the ocean below. Half a dozen divers, their torches guiding them, make their way down to the ocean floor, 115 feet below the surface. There is something timeless and undeniably otherworldly about these opening images; as the male narrator describes it, we are "in a mysterious realm, the silent world." According to the shooting script, these images, glowing gold in deep blue water, were to be reserved for the film's final scenes, but Cousteau and Malle apparently changed their minds. Clearly, they recognized the power of leading with an image of the ocean being cracked open by light and human divers, accompanied by the sound of breathing and images of bubbles and foam. Not only do the film's images

reveal an ephemeral beauty, but, more significantly and as Bazin empha-
sizes, the film gives us—liberates us into—water not as metaphor, "superfi-
cial, mobile, rustling, lustrous," but instead, "the Ocean, water considered
as the other half of the universe, as three-dimensional milieu, more stable
and homogenous than air and whose envelopment frees us from gravity."
It offers us "a science ... stronger than our imagination." In contrast to
the cosmos, the film presents the space beneath us, a lifeworld reflected
through radar. From this perspective, we are but one grain of sand among
others on the ocean's beach.[43]

Indeed, from *The Silent World*'s opening images, it is impossible to orient
ourselves in this space of darkness in which the near and the far cannot
be fathomed—a space at first seemingly devoid of animals, a safe space for
humans outfitted as fish, a space that is completely foreign. The central
theme of the film is the human exploration of the ocean environment,
which includes nonhuman animals and plants. Penetrated by the phos-
phorous torches of the divers, this silent and liquid world envelops and
overwhelms them. Though we have no sense of where we are, we are inside
something that appears to be beyond the confines of culture and society—it
is a space that exceeds the humans who study it. As Bazin declared, the film
materializes a mythology of water and sets up a deep and secret encounter
between the sea and humankind: "Humans, say biologists, are sea animals
who wear the sea on the inside." The film thus creates the sense of a return
to origins.[44]

In his final, posthumously published book, *The Visible and the Invisible*,
Maurice Merleau-Ponty describes a space that is created from the experi-
ence of the interiority of the external world of nature. This space, between
inside and outside, he calls a "chiasm," which is an "intertwining" of inte-
rior and exterior, a space between one's flesh and the flesh of the world.
He describes an experience of spatial depth, which envelops one's flesh,
as part of the process of perception and visibility: "Between the massive
sentiment I have of the sack in which I am enclosed, and the control from
without that my hand exercises over my hand, there is as much difference
as between the movements of my eyes and the changes they produce in the
visible." He continues: "[H]e who sees cannot possess the visible unless he
is possessed by it, unless he *is of it*, unless ... he is one of the visibles, capable
by a singular reversal, of seeing them—he who is one of them."[45] His own
body is "*surrounded* by the visible. This does not place it on a plane of which

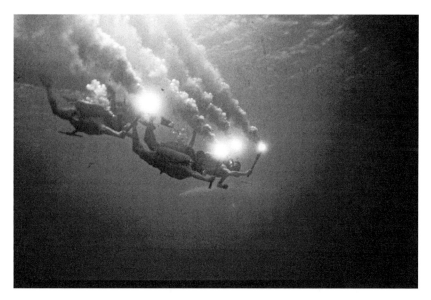

Figure 2.5
Film still of divers in Jacques Cousteau and Louis Malle's 1956 documentary *The Silent World*. Credit: Jacques-Yves Cousteau and Louis Malle, *Le monde du silence* (1956); FSJYC Production, Requins Associés, Société Filmad, Titanus.

it would be an inlay, it is really surrounded, circumvented. ... Thus the body stands before the world and the world upright before it, and between them there is a relation that is one of embrace."[46]

Brett Buchanan has shown that Uexküll's notion of the umwelt provided an important model for Merleau-Ponty, as is especially evident in his later lectures on nature and his working notes for *The Visible and the Invisible*.[47] It helped Merleau-Ponty to formulate a new ontology of nature through the localized milieu of animals, to conceive their interrelations within the world as flesh. He drew upon the concept to further refine his idea of nature as an active, dynamic interrelation "enveloping" and "surrounding" the body in the world. He understood the umwelt in terms of "openness" and an unfolding of relationships, which he opposed to finitude: "I am against finitude in the empirical sense."[48] Buchanan points out that "Uexküll's *umwelt* aids Merleau-Ponty in considering the structural relation between organism and environment in such a way that he surpasses the subject-object distinction and instead posits a sensible layer uniting all life in the flesh of the world."[49] Further, David Abram argues that the shift in

Merleau-Ponty's later writings toward a conceptualization of "the world as flesh" signaled a new sense of the environment as consisting of reciprocal but differentiated relationships between one's own flesh and the world, between touching and being touched, the visible and invisible, the sensate and the sensible—a conception that, as we shall see, also resembled Russian geochemist and mineralogist Vladimir I. Vernadsky's concept of the biosphere.[50]

While Merleau-Ponty did not write about Cousteau's film, he did write a short essay called "La nature et le monde du silence" (Nature and the silent world) around the time of the film's release. Silence plays an important role in Merleau-Ponty's phenomenology, and it can be understood as a mediating passage between nature, which we can only know through human experience, and language. As he writes in *The Visible and the Invisible*: "Philosophy is the reconversion of silence and speech into one another."[51] Or put differently, silence is a liminal and active space of reflection.

Cousteau was not influenced by Merleau-Ponty in his use of the phrase "the silent world" in either his popular 1953 book (which I discuss below) or his subsequent film, which was referencing the absolute otherness of life beneath the sea using a popular lexicon. Yet the fact that Cousteau conceived of the ocean environment in biospheric terms is especially evident in the overt environmental politics of his films and television programs from the late 1960s onward.[52] This focus was made explicit by the creation of the Cousteau Society in 1973, an environmental organization "dedicated to the protection and improvement of the quality of life" that supported ocean research not funded by governments or industry. In *The Ocean World of Jacques Cousteau* (1973–1975), his popular series of educational books, Cousteau often refers to the ocean as a living entity, changing and evolving within a universe "radiating" and "vibrating" with invisible messages.[53] The concept of the biosphere became central to the environmental movement during the postwar period.

Vernadsky and the Biosphere

No doubt one of the most important ideas of the twentieth century, the notion of the biosphere has had a significant impact beyond the biological and earth sciences.[54] The desire to unite geophysics and biology began with

the term "biosphere," which was coined by the Austrian geologist Eduard Suess in 1875. He defined it simply as "the place on Earth's surface where life dwells." Vernadsky transformed this initial idea of "the concentric, life-supporting layer of the primordial Earth" from a static understanding of the earth's geology into a dynamic and holistic concept in modern scientific thought. He argued that the biosphere encompassed the history of the earth as a changing and evolving system: "[T]he domain of life on Earth is a biogeochemical evolving system with a cosmic significance."[55] He thus understood ecology to be the science of the biosphere, which is "living matter."[56]

Henri Bergson's *L'évolution créatrice* (1907) served as a pivotal and life-long influence on Vernadsky, and Bergson hosted him at the Sorbonne. Invited to the Sorbonne by the rector, Paul Appel, Vernadsky remained there for four years, from 1922 to 1926. In a series of lectures he gave there, Vernadsky presented the idea of the biosphere as evolving living matter that is influenced by cosmic energy. Solar radiation lies at the center of his concept of the biosphere; the "carrier of cosmic energy," solar radiation not only "initiates its own transformation into terrestrial chemical energy, but also actually creates the transformers themselves. Taken together, these make up living nature, which assumes different aspects on land and in the water."[57] Vernadsky's theory of the earth's evolution proposed, first, the geosphere (inanimate life); second, the biosphere (biological life); and, finally, the ultimate stage in the evolutionary process, the noosphere (cognitive life). He understood each successive sphere as contributing to the shaping of the previous one. Édouard Le Roy, who attended Vernadsky's lectures along with Teilhard de Chardin, coined the term "noosphere" to denote the sphere of human thought. Indeed, as Cédric Mong-Hy has pointed out, Vernadsky essentially authored *The Biosphere* while in Paris, and it is not surprising that the book, and the idea of ecology it proposed, have had a greater impact in France than elsewhere.[58]

Vernadsky's Paris lectures were published in France under the title *Géochimie* in 1924, and *Biosphera* was published in Russian in 1926. The French-language edition followed in 1929, but a full English translation did not appear until 1998. His radical account of the biosphere as a planetary phenomenon of interconnection was not available in the Anglo-American world until it was published as an article in 1945—the year of his death—in *Scientific American*. Here, he argued that

humankind taken as a whole is becoming a mighty geological force. There arises the problem of the reconstruction of the biosphere in the interests of freely thinking humanity as a single totality. This new state of the biosphere, which we approach without our noticing, is the noosphere. ... This new elemental geological process is taking place at a stormy time in the epoch of a destructive world war. But the important fact is that our democratic ideals are in tune with the elemental geological processes, with the law of nature.[59]

Vernadsky believed that the evolution of living matter had created a new, shared consciousness that would increasingly recognize the interdependence of human and nonhuman forms of life on the planet and lead to new possibilities for world peace.

That same year, Merleau-Ponty delivered a lecture entitled "Film and the New Psychology" at the Institut des Hautes Études Cinématographiques. Film, he argued, can make us "see the bond between subject and world, between subject and others."[60] He posited a new ontology for cinema that corresponded to developments in psychology (gestalt) and philosophy (phenomenology). Cinematic images cannot be understood as simply derivative or secondary experience, as Gilles Deleuze's critique of phenomenology suggests,[61] precisely because, as Merleau-Ponty pointed out, film is not concerned merely with showing. Rather, it creates an experience of space: film can reveal being to us "not as an understanding which constructs the world but as a being-thrown into the world and [being] attached to it by a natural bond."[62] For Merleau-Ponty, the connection between film and the "new psychology" lies in film's ability to visualize and enact the "mingling of consciousness with the world ... and its coexistence with others," which includes nonhuman others. Thus, he concluded: "[I]f philosophy is in harmony with the cinema, if thought and technical effort are heading in the same direction, it is because the philosopher and the moviemaker share a certain way of being, a certain view of the world which belongs to a generation. It offers us yet another chance to confirm that modes of thought correspond to technical methods and that, to use Goethe's phrase, 'what is inside is also outside.'"[63] Merleau-Ponty's essay is useful for thinking about our present mediatized experience of the planet because the only means by which we will be able to experience the 80 percent of the earth that we cannot directly access is through virtual renderings.

While the golden age of 3D had passed by 1956, Cousteau and Malle's *The Silent World* demonstrated a strong multidimensional sensibility.[64] Rudolf Arnheim reviewed *World without Sun*, Cousteau's 1964 follow-up

to *The Silent World*, which documents the Continental Shelf Station Two, the first ambitious experiment to create a habitat in which oceanauts lived and worked on the sea floor for a number of weeks, 10 meters under the ocean. Arnheim argued that "the film reveals a world of profound mystery, a darkness momentarily lifted by flashes of unnatural light, a complete suspension of the familiar vertical and horizontal coordinates of space."[65] For Arnheim, Cousteau's underwater film both disorients and imparts a sense of weightlessness to the viewer; with no setup to orient the audience for an encounter with such a bewildering space, the film presents "the ghostliness of the physical world by means of authentic appearances drawn directly from that world." It was precisely this kind of "bewildering space" that Merleau-Ponty had posited in both "Film and the New Psychology" and *The Visible and the Invisible* as the existence of the chiasm, the intertwining of inside and outside, of interior and exterior which film enables us to visualize and experience more fully.

The Ocean as a Resource

The oceans had a new visibility and increasing presence in the popular culture of North America and Europe in the 1950s and 1960s. This visibility was tied, on the one hand, to changes in the law of the seas that followed World War II and, on the other, to new modes of representation which Cousteau and his team were instrumental in helping to launch. American President Harry Truman's Proclamation of 1945 challenged the long-standing freedom of the seas by declaring that national sovereignty extended to the resources of the continental shelf. Other nations soon followed, claiming jurisdiction over as much of the sea as two hundred miles from shore. As R. P. Anand has pointed out, new marine technologies had revealed a new world under the sea; oceanographers had uncovered underwater vegetation that could benefit humankind and, more importantly, had discovered that the sea floor was an abundant source of natural resources and minerals. Technology made accessible oil and gas resources that lay buried under the seabed off the shores of various countries.[66] Furthermore, technology was transforming the fishing industry, and the maritime and military great powers (the United States, the Soviet Union, France, and the United Kingdom) were claiming the seas in order to test modern weapons. Not long after World War II, Egypt, Ethiopia, Saudi Arabia, Libya, Venezuela, and

some Eastern European countries, departing from the traditional three-mile limit, laid territorial claim to twelve miles of the sea off their respective coasts.

It is in this closer linking of the oceans to the terrestrial world, in the territorializing of the oceans following World War II, that the oceans were reconfigured in utilitarian terms. As Martin Heidegger expressed it, the earth had come to be seen as a "standing reserve." Heidegger, like Merleau-Ponty, was influenced by the concept of the umwelt, yet in "The Question Concerning Technology" and "The Age of the World Picture," he was less concerned with animal environments than with the world generally, as an environment that was being reduced to an exploitable resource. Heidegger provides a framework with which to understand that the earth, as mediated through technology, can be grasped only as a "standing reserve"; "ripe for quantification, stockpiling, use and disposal, [its] only aspect is that it can be brought forth by man violently in techne." This picturing "puts to nature the unreasonable demand that it supply energy that can be extracted and stored as such."[67]

Conceiving of the sea as a resource and as territory served military interests as well. Cousteau's exploration of the sea in the 1940s and '50s was supported by the National Geographic Society, which sent their star photographer, Luis Marden, to photograph the shooting of *The Silent World*.[68] Cousteau also received funds from the French government and the navy, both during the Vichy regime and after its fall. The French Ministry of National Education approved a major research grant that enabled him to produce the film. British Petroleum, via its subsidiary the D'Arcy Exploration Company with interests in Abu Dhabi, also contributed to his explorations, giving him a major contract for a geological survey in the Persian Gulf that allowed him to outfit the *Calypso* with state-of-the-art cameras and diving equipment.[69] The black-and-white film *Station 307* (1955), written, shot, edited, and directed by Louis Malle with Cousteau as narrator, provided a kind of prequel and a bank of images and camera angles for *The Silent World*. *Station 307* featured Cousteau the Captain, and the *Calypso*. Whereas previous films had always equally featured Dumas and Tailliez, this singling out of Cousteau as a central character in the film was ostensibly at the inclination of Malle, whose film training was in fiction.[70] This film (running eighteen minutes long) concerned the use of divers to carry out geological surveys for oil. Cousteau's words at the end of the film

would directly contradict his later environmentalist position: "These operations have inaugurated a new technique in the history of oil prospecting. The day is near when everywhere in the world, oil will gush from the oceans."[71]

As part of his fundraising strategy for *The Silent World*, Cousteau, along with Dumas, co-wrote the popular book *The Silent World: A Story of Undersea Discovery and Adventure, by the First Men to Swim at Record Depths with the Freedom of Fish*, published by Harper and Brothers in 1953. The book was based on their daily logs, and Cousteau commissioned American journalist James Dugan, who later wrote the English voice-over for the film, to ghost-write the book. In its first year, the book sold half a million copies and was translated into more than twenty languages.[72] American marine biologist Rachel Carson had published a poetic and very popular scientific study in 1951, *The Sea around Us*, innovating a new genre in science and nature writing. Having won the National Book Award in 1952 for *The Sea around Us*—an ode to the sea masterfully interwoven with science and poetry—Carson was well regarded both as a writer and as a scientist.[73] Its success, along with the publishing of many other books on the ocean, evidenced the American market's hunger for books, photographs, and films about the sea in the postwar period. As Cousteau and Duggan would comment: "the recent rash of books on … the sea are a result of the fact that man has found that there are fields of activity in which he never will emerge as the conqueror. Science has led him to the brink of disaster, and nature offers him a new vehicle for his irrepressible energies."[74] These "irrepressible energies" will be expressed, as I discuss below, in the excessive and unjustified violence at the heart of *The Silent World*.

Carson's favorable review of Cousteau and Malle's film in 1956 made an ally of Cousteau, and she confidently confirmed his agenda: "As Captain Cousteau points out, in the future, we must look to the sea, more and more, for foods, minerals, petroleum." She recognized that the aqualung constituted a "vital step in the development of means to explore and utilize the sea's resources."[75] In retrospect, of course, Carson might have been less keen to endorse the agenda of resource extraction. But in the mid-1950s, as the oceans were being increasingly defined as national resources rather than as territories vaguely delimited by the long-standing convention of "freedom of the seas," it was, perhaps, strategic of Carson to characterize them in this way. It was no doubt a useful formulation with which to entice governments

to take an interest in the well-being of the oceans.[76] Such interest enabled Cousteau to acquire funding and support for his expeditions.

In *Silent World* (the book), and in interviews as well, Cousteau described the sea in terms of silence, not the silence of death but a silence that contributed to the image of the sea as an "enigma," completely mysterious and foreign, "a jungle never seen by those who [float] on [its] opaque roof."[77] But in the first instance, in the early 1940s, the ocean represented for Cousteau escape from the German and Italian occupation of France. In profoundly masculinist terms, he wrote that he and his wife Simone would "never forget the Italian torches emasculating the gun barrels of the battleships. Sunken ships preyed on our minds."[78] The image of destruction fueled Dumas and Cousteau's second film, *Épaves*, which Cousteau claims was meant to impart a sense of freedom—literally, escape from the realities of the Occupation and the Vichy regime—to French audiences.[79] Under the Vichy regime, the Comité d'Organization des Industries Cinématographiques funded three filmmakers whom it deemed to be nonideological in the early 1940s: Jean Rouch, Jacques Becker, and Jacques Cousteau. Rouch filmed *Les maîtres fous* the same year that Cousteau made *The Silent World*. Both Rouch and Cousteau were working with innovations in camera equipment that expanded cinema's capacity to record the physical world, thereby expanding the limits of recorded reality.[80]

In *Fast Cars, Clean Bodies: Decolonization and the Reordering of French Culture*, Kristin Ross reminds us that France exhibited particular contradictions in the postwar period: it was an "exploiter / exploited country, dominator / dominated country, exploiting colonial populations at the same time that it was dominated by, or more precisely, entering more and more into collaboration or fusion with, American Capitalism."[81] Certainly, we must understand both Cousteau's book and film versions of *The Silent World* in these terms, as well as in terms of the new visual culture of the Cold War, which embraced the figure of Cousteau. His image of the ocean as escape and adventure complemented the burgeoning images of exotic locales that, thanks to innovations in commercial aviation—especially the introduction of the Boeing 707 jet in 1958, which enabled mass travel—were bolstering the explosion of the tourism industry in the 1950s and 1960s. As I discussed in the previous chapter, publications such as *Life, Look*, and *National Geographic* contributed to the growth of a new visual culture of travel beyond the United States.

In *Silent World* (the book), we can detect the way in which Cousteau was developing a specific relation with the ocean's underwater life. He noted that fish, far from being monsters, demonstrated either indifference or fear toward humans. In a description of his early experiments with oxygen, he recollected: "I was accepted in the sea jungle and would pay it the compliment of putting aside my anthropoid ways, clamp my legs together and swim down with the spinal undulations of a porpoise."[82] As was mentioned earlier, this desire to swim among the fish—to swim *like* fish—earned Cousteau the moniker *l'homme-poisson.* In a chapter entitled "Monsters We Have Met," Cousteau identifies with a shoal of tuna that had been caught in a net in Tunisia:

Life took on a new perspective, when considered from the viewpoint of the creatures imprisoned in the *corpo*. We pondered how it would feel to be trapped with the other animals and have to live their tragedy. Dumas and I were the only ones in the creeping, constricting prison who knew the outcome. ... The herd swam restlessly, faster but still in formation. Their eyes passed us with almost human expressions of fright. Never have I beheld the sight like the death cell in the last moments. ... It took all my willpower to stay down and hold the camera.[83]

Cousteau reported that the captors of these terrified creatures let out a "barbarian roar" at the sight of their catch, lending ambiguity to the chapter's title—"Monsters We Have Met." Cousteau would have been thinking not only about World War II, but also about the tensions produced by the forces of decolonization and the growing independence movements in Algeria and the Middle East, which were gathering strength by the early 1950s. The ambiguity of this passage and Cousteau's identification with the world of fish rather than with the Arab fishermen demonstrate his capacity to simultaneously occupy the positions of French commandant and *l'homme-poisson.*

I would like to conclude this chapter with two scenes from *The Silent World* that, unfolding in the middle of the film, bring together the elements and themes of the dialectical framework I have been developing: the phenomenological aspects of the hybrid "Man Fish"; the concept of the umwelt as a chiasm of intertwined experiences both subjective and objective—Rimbaud's drunken boat, if you will; and the militaristic and capitalistic aspects of Cousteau's early enterprise, which conceived of the oceans as an adventure and as a resource to be exploited.

One of the most poetic scenes in the film is a long sequence in which Dumas explores the *Thistlegorm*, a Scottish merchant ship sunk by German bombers in 1941, lying at the bottom of the Red Sea. While on their way to the Indian Ocean in 1955, Cousteau's crew discovered it and decided to incorporate it into their film. Shot by Cousteau over several days and carefully timed to include certain schools of fish, the scene depicts a solitary diver swimming through the nooks and crannies of the sunken ship. This meticulously choreographed scene displays a multiplicity of overlapping worlds and temporalities. The ship "at one with the sea" is also the ship as coffin in which nine of its crew perished. As the camera reveals the ship's cargo—much of it intact—and its contents (shoes, cups, doors, as well as the bell—the only identifying feature of the ship), the sound of a ringing bell and a woman's Scottish brogue whispering "Thistlegorm" pierces the film's silence. Accompanied by Yves Baudrier's eerie score, these sounds bring a surrealist sensibility to the scene. The meditative quality of these interconnected umwelts—scores of fish and plant life, all moving in different directions and at different levels of the frame—presented on a screen with no horizon stands in stark contrast to the horror that will soon follow.

Almost directly following the exploration of the *Thistlegorm* are several scenes in which the violence enacted against animals is shocking, even by today's standards. Cousteau's voice-over frames what he describes as the most tragic scene in the film: drifting away from its herd, which was following the *Calypso*, a whale calf is badly wounded by the ship's propellers. After Cousteau's crew put the animal out of its misery by shooting it, a number of sharks arrive in order to feed on the carcass. Cousteau's men then "defend" the dead calf against the sharks encircling it. An exceptionally bloody and protracted massacre of sharks ensues.

Both scenes use reconstructed footage. As noted earlier, Cousteau and Malle had shot an earlier 16mm film (*Calypso, cap au sud, Requins bleus et corail noir* (1954) that had been funded through a contract with British Petroleum, and they incorporated footage from this film—which had been blown up to 35mm—in *The Silent World*. For Bazin, the reconstruction of this footage was perfectly defensible because the scenes adhered to his two rules: (1) not to trick the spectator, and (2) to be true to actual events. The filmmakers did not attempt to hide the filmmaking process; on the contrary, in many scenes they explain and demonstrate how the filming was

done. Bazin argues that the incorporation of footage from another film, along with the use of reenactments in order to produce a clear and logical sequence of events, do not detract from the film's authenticity.[84]

The film includes other scenes of violence: turtles are straddled and ridden, and a dynamite blast destroys a remote coral reef. While the use of dynamite as a method of fishing is illegal, Cousteau tells us that he and Malle employ it in the name of science, leaving hundreds of fish to die on the shore in order to take a census of marine life. James Cahill has suggested that the film's violence can be read as a profound sublimation of the history of colonial violence in Algeria and of the war of independence that was at its height during the filming of *The Silent World*, which unfolded in the Red Sea and the Indian Ocean.[85] Indeed, we can well wonder, given the war in Algeria and the changes in the Law of the Sea in the Middle East at that time, how Cousteau and his team were able to move through and film in those waters. His free movements may have been enabled through the BP contract and Cousteau's scientific credentials with respect to archaeological excavations, as well as through some of the ties he had made with Red Sea fishermen and sheikhs in the Persian Gulf.[86]

For Bazin, the *Thistlegorm* scene was excessively poetic and obvious.[87] Yet it was the shark scene—which clearly overwhelmed the directors, who were not quite in control of the spectacle—that struck him as most profound. The poetic force of these images represented "a big moment" in the film precisely because the richness of interpretation they afforded exceeded any meaning the *cineastes* might have intended.[88] Bazin foregrounds the absurdity of the relations between the crew, the whale, and the sharks; in a spontaneous scenario, the men, after unintentionally but cruelly provoking the whale calf's accident by seeking contact with the pod, try to avenge the death *for which they are responsible* by protecting the dead calf from the sharks—a situation in which the men feel "solidarity [with] the suffering of the injured mammals" and disgust for the sharks, which are, "after all, only ... fish." But for Bazin, the irrationality of violence and the horrific theater of anthropocentric brutality exposed by the slaughter of the sharks were not especially troubling. The primary moral question, for him, was the technical question of the documentary—that is, the cinematic truth of the rendering: "Il s'agit en effet tout à la fois de tricher pour mieux voir" (It is, in effect, a matter of cheating in order to better see).[89] Comparing Cousteau's *Calypso* to Jules Verne's fictitious submarine,

the *Nautilus*, Bazin observes that Cousteau had created an almost ideal observation deck with its underwater window that did not modify the aspect or significance of the object observed. This, according to Bazin, was the film's great success.

The Cousteau of *The Silent World* was the militaristic Cousteau, the explorer, the conqueror, and more rarely, the "Man Fish." This is not the Cousteau we have come to know through the television programs of the 1970s, especially ABC's award-winning series *The Undersea World of Jacques Cousteau* (1968–1976). The latter featured "Captain Cousteau" with his familiar red cap, whose reassuring accented voice-over became increasingly concerned with environmental issues over the course of the series, especially from 1969 onward. Instead of a sophisticated technoscientific film studio, the *Calypso* became a medical clinic for measuring and assessing the pulse of the oceans.[90]

Interestingly, as the Cousteau Society was preparing to remaster *The Silent World* in the late 1980s, some members suggested that the shark scene be excised from the film. Cousteau is said to have refused to do so on the grounds that the events depicted were "true, and [the film] shows how far we've come and how dreadful humans can be if we don't curtail ourselves."[91] Certainly, from the late 1960s onward, Cousteau advocated for the protection of the oceans. His television programs and books of the 1970s and '80s were highly pedagogical, directed toward raising consciousness about the ecology of the oceans and introducing a new generation to the wonders of the sea, but with an eye on sustainability and the history of destruction that has defined the relation between humans and oceans. His popular book series *The Ocean World of Jacques Cousteau*, mostly directed toward youth, concluded in 1973 with a heartfelt section on the common human heritage of the oceans. Here, Cousteau recounts that in 1970 the General Assembly of the United Nations adopted a "Declaration of Principles Governing the Seabed and the Ocean Floor, and the Subsoil Thereof, Beyond the Limits of National Jurisdiction." The Cousteau Society endorsed the idea of the oceans as a common responsibility for all nations, lobbying for an independent UN-sanctioned advisory board that would manage and oversee the interests of "the common human heritage." The Cousteau Society was critical of the proposal put forward at the 1974 UN Conference on the Law of the Sea to support exclusive economic zones that would lead to the sea becoming "recklessly parceled and dredged for profit."[92] Cousteau predicted

that the uncertainty of this law would make the ocean more vulnerable to chaotic land grabs and harmful resource extraction. This is, indeed, precisely what is going on in the twenty-first century with offshore drilling (deep ocean drilling that was responsible for the BP Deepwater Horizon oil spill); the melting Arctic is becoming the new frontier, believed to contain as much as one-quarter of the world's undiscovered energy resources.[93] We see countries (China, Canada, Russia, and the United States) vying for the rights to polar sea-floor assets. Cousteau's films and television programs, so filled with wonder and horror, foreshadowed the increasing militarization of the Arctic environment, from symbolic Cold War battles to those of resource extraction today. His work is also the urtext for so many of the Arctic and Antarctic environmental films of today, from the films of Werner Herzog to the documentary *Chasing Ice* (2012), with the intrepid explorer conflated with the dazzling reaches of the camera, both battling harsh environments in order to bring them to light.

Part II Worlds

"The Family of Man" has been read both as an expression of the United States' new power and position in the world, and as an attempt to combat the threat of communism by promoting a vision of American openness and of consumer culture as embracing the cultural diversity of the world. As I argued in part I, when it is read as the foregrounding of human solidarity in the face of a common danger (the atom bomb), "The Family of Man" can be understood more broadly in terms of a postwar brand of humanism and more specifically in relation to Steichen's pacifist desires. Cousteau's underwater films presented an entirely different response to the war and its aftermath. On the one hand, they can be read as a naïve yearning to escape the horrors of war and military occupation, and as a humanistic and phenomenological commitment to the planet's oceans through the popular culture of cinema. On the other hand, they can be seen as expressions of France's imperialistic ventures into unexplored territory, and as a quest to control untapped resources in a decolonizing world.

Steichen and Cousteau shared a common view of the ways in which media (photography, film, and later television) could enable a popular type of environmental pedagogy and facilitate forms of global community and solidarity by representing previously hidden relationships and bonds. In this sense, and despite the differences between their projects, both Steichen and Cousteau augment our perceptions of the planet through their respective emphases on limits (Steichen's apocalyptic vision of the end of the world) and expansion (Cousteau's representation of ocean wonders). Each created specific kinds of mobile interfaces (the exhibitions and the films) that traveled around the world and consolidated a global audience.

Part II, "Worlds," focuses on smaller utopian projects found in spatial events such as a national festival and a world's fair that occupy cities to

create experiences articulating a particular view of futurity which grows out of the concept of worlds. Chapter 3 is devoted to future visions, to the discourse of the global and an emerging globalization politics presented at the Festival of Britain in 1951—an important moment of reconstruction in Europe. A global vision of the nation lay at the heart of the new approaches to urban planning, along with the films and media on display at the Festival. Indeed, a critical relationship existed between the utopianism of town planning in the United Kingdom in the late 1940s and 1950s and the new forms of cinema and spectatorship on display at the Festival, including the Telekinema, which combined stereoscopic 3D film and large-screen television, as well as many other film events throughout. Media (3D, television, films, festivals) enabled a utopian vision. Chapter 4 extends considerations of these utopian experiments with urban planning and media through Montreal's Expo 67. At both the 1951 Festival of Britain and the 1967 World Exposition (Expo 67), a planetary sensibility emerged out of a newly globalizing media culture—in television, film, and intermedia networks such as photography and print journalism. An architecture of futurity framed each event, which embodied the world-making energies of the postwar period in the building of nations (the Festival) and media cities (Expo).

In their very design, both of these events can be seen as forms of what Jakob von Uexküll calls umwelt—in these cases, human spheres in which distinct and particular worlds are defined by how living organisms subjectively perceive their own environments. As we saw in the preceding chapter, a central premise of Uexküll's umwelt theory maintains that all beings, human and nonhuman alike, inhabit unique worlds. World expositions are literally utopian world-making events in which nations are made to articulate, on the one hand, unique forms of sociality, governmentality, cultures, and inventions, and, on the other, a supposed common humanity that the form of the world's fair demands in its very structure as an encounter between people, places, and things.

3 T Is for Telekinema: Projecting Future Worlds at the Festival of Britain

This chapter analyzes the postwar status and self-image of Great Britain and its "wishful" efforts toward reconstruction after the Second World War, with a focus on the Festival of Britain. The Festival was a national exhibition of artistic, architectural, scientific, technological, and industrial displays intended to inspire war-weary Britons in 1951. A unique and remarkable technological feature of the Festival was the Telekinema—the only cinema of its kind—that combined 3D cinema with projected live television and a television studio. Before discussing this theater in more detail, I want to examine several of the Festival's general themes and, in particular, its emphasis on urban planning and architecture. I am especially interested in the new sense of space that emerged in the urban planning exhibits and the new media of cinema and television that were presented at the Festival. Of concern is the relationship between the utopianism of town planning in the United Kingdom just after World War II and new forms of cinema and spectatorship on display at the Festival of Britain, including the Telekinema. My argument is that the utopianism of urban planning, which I explore through Karl Mannheim's theory of utopias, was manifested in the most embodied way as a future projection and wish fulfillment, creating a new sense of wonder and possibility after the horrors of the war.

Alison Ravetz has observed that the 1940s marked the "ultimate episode of utopianism in British council housing," because many of England's cities had been reduced to rubble by the Blitz.[1] Moreover, as Matthew Hollow has argued, exhibitions such as the Festival of Britain invited visitors to "escape from the mundane reality of everyday life … [to] experience alternative worlds filled with the possibilities of new and exciting experiences," manifesting an explicitly utopian energy.[2] Because cities and villages needed to be reconstructed, architects and planners were given new opportunities

"to sweep away the past," to update outmoded infrastructures and incorporate modern thinking into city plans.[3] British audiences were already accustomed to seeing new housing and planning ideas displayed in public events such as the *Daily Mail*'s Ideal Home Exhibitions, held annually at the Olympia Exhibition Centre in London from 1908 onward. By the 1930s, these exhibitions attracted more than a million visitors each year, providing them not only with advice about beautifying their homes but also a glimpse into the future of design and architecture.[4]

It was in response to England's deep sense of futility following the end of the Second World War that Gerald Barry, then editor of the liberal broadsheet *News Chronicle* and a founding member of the Political and Economic Planning group (a nongovernmental think tank), conceived the Festival of Britain. Though an earlier proposal for a world exposition to be held in Britain had to be shelved due to a lack of funds, Barry's much more modest plan was approved by the Labour government. At a time of great and prolonged economic hardship in Britain, the government regarded the Festival as an opportunity to celebrate the nation's contributions to "common human heritage." Barry was appointed the Festival's director-general in 1947, and his vision of postwar Britain gave preeminence to the architects and designers who would rebuild the country. Indeed, as Harriet Atkinson has emphasized, the Festival would marry the concept of national celebration with the process of rebuilding Britain after the war. Architects involved in designing the Festival included members of the MARS group: Misha Black, H. T. Cadbury-Brown, Ralph Tubbs, Frederick Gibberd, Hugh Casson, Maxwell Fry, Jane Drew, and Wells Coates. Many festival designers, including Black and James Holland, were members of the Artists' International Association cofounded in 1933, which promoted the "Unity of Artists for Peace, Democracy, and Cultural Development."[5] Atkinson underlines that hundreds of architects, landscape architects, designers, and artists were involved in heated discussions and debates about how best to create the different buildings and exhibitions for the Festival, a question that was also tied to the processes of postwar reconstruction. Architects such as Ralph Tubbs, who designed the very popular aluminum saucer dome—the Dome of Discovery[6]—had earlier staged a series of exhibitions and books devoted to rebuilding Britain's towns and cities.

The Festival of Britain ("Britain" here denoting England, Scotland, Northern Ireland, and Wales) featured eight official, government-funded

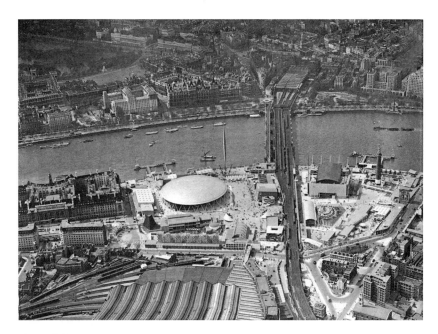

Figure 3.1
An aerial view of the South Bank exhibition site near the River Thames in London
during the Festival of Britain in 1951. Credit: Trinity Mirror, Mirrorpix / Alamy.

exhibitions held in each of the four nations, as well as twenty-four arts
festivals: the South Bank Exhibition in London; the Exhibition of Science
at South Kensington, London; the Exhibition of Architecture at Lansbury,
in the Poplar District of London; the Exhibition of Industrial Power in
Glasgow; the Ulster Farm and Factory Exhibition in Belfast; a Land Trav-
eling Exhibition; the Festival Ship *Campania*, a traveling exhibition that
toured the coast of Britain; and the Festival Pleasure Gardens in Battersea,
London.[7] Eight and a half million people visited the South Bank Exhibi-
tion, and the BBC aired 2,700 Festival-related broadcasts. As Becky Conekin
reports, "On the local level, close to two thousand cities, towns and vil-
lages across the United Kingdom organized and funded a Festival event of
some kind."[8] The Festival differed from others of its kind in its decentral-
ized approach of involving regional as well as national interests.

The Festival was also widely publicized throughout Europe and North
America. Two million promotional pamphlets were produced in eight
languages, and press advertisements appeared in thirty-four countries.[9]

Representing Britain's response to the early days of the Cold War as one of openness and transparency, the Festival advertised that the nation was opening its doors to the world. A huge, four-page color spread in the January 22, 1951, issue of *Life* magazine highlighted Glasgow's "Hall of the Future," which featured a scientific display that championed atomic energy as the energy of the future—modern technology par excellence, with the power to unite the world—rather than as a divisive, destructive wartime technology.[10]

Jennings's *Family Portrait*: Urban Planning and Ecology

A well-known British documentary filmmaker, Humphrey Jennings, was invited to make the official film for the Festival, which he completed shortly before his untimely death in 1950. The film, titled *Family Portrait*, along with sample displays from the various exhibitions, toured Europe throughout 1950 in order to advertise the Festival. Though many critics consider it a minor film in the Jennings oeuvre, and several historians have condemned the film for its alleged nostalgia, conservatism, and patriotism,[11] I would argue that *Family Portrait* stands as a deeply humanistic and utopian rumination that dovetailed with the overall spirit of the Festival. Based on a 1948 treatment for an unrealized film project—*The Decline and Fall of the British Empire*—the film not only celebrated British accomplishments in art, philosophy, and science (from the Normans to Shakespeare to the steam engine), but also subtly articulated the scientific and industrial pragmatism of the postwar era, which the Festival of Britain was intended to highlight.

Jennings was, among other things, a surrealist painter, a Cambridge-educated literary scholar, and a theater designer. He was a student at the Perse School in Cambridge, which supported an experiential curriculum inspired by John Ruskin and William Morris as well as by biologist, sociologist, and civics planner Patrick Geddes, whose work I explore in greater detail below.[12] As Kenneth Robson has pointed out, "Jennings and his contemporaries were acutely conscious of inhabiting a world of shattered ideals and shabby compromises. ... Raised and educated in the turbulent period between two wars, they faced an awesome task. ... Under increasing threat of another world war, they found their society and their choices polarized into clear oppositions between art and action, aesthetics and propaganda,

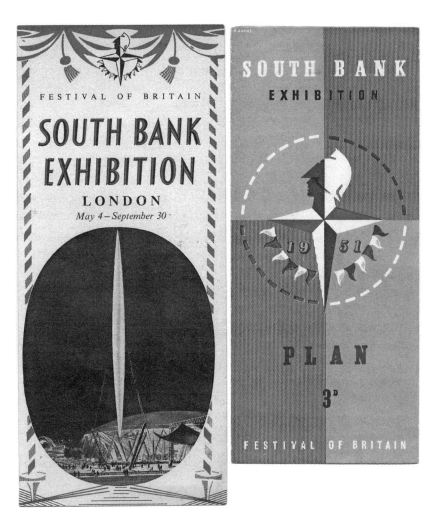

Figure 3.2
Festival of Britain 1951 leaflets featuring logos by British graphic designer Abram Games (1914–1996). Credit: Amoret Tanner / Alamy.

individualism and collectivism, freedom and tyranny, tradition and revolution."[13] In 1937, Jennings, along with journalist Charles Madge (another Cambridge graduate), and later joined by anthropologist Tom Harrison, cofounded the Mass Observation research project, an undertaking to get citizens to voluntarily record and keep track of aspects of their daily lives through diaries or other means of recording like photography and film. The group was inspired by André Breton's Parisian surrealism and the Bureau

of Surrealist Research. Their surveys often featured a collage of individual and collective experience impacted by the common situation. They did not privilege any single point of view but sought to highlight individuals, coincidences, relations between them, and commonly shared events.

In one of the first Mass Observation publications, readers are asked to contemplate how scientific developments have affected their mental and physical behavior: "Take the example of the railway. … We know how to use the railway in our daily life; but what we do not realize is the power of the railway to modify our lives when we are not using it. It has given us a different conception of space, of speed and of power. It has rendered possible mass activities—the Cup Final, the monster rally, the seaside holiday, the hiking excursion—whose ramifying effect on our behavior and mentality extend almost beyond imagination."[14] The integration of individual and collective experience impacted by the common situation is clearly evident in the publication "May the Twelfth: Mass Observation Day Surveys 1937," a pamphlet produced from the Mass Observation Day survey held on the day of George VI's coronation. Madge and Jennings edited hundreds of individual reports to produce a portrait of British life on a single day of national occasion, which conveyed through a documentary account the "feeling" of the country—an atmosphere of shared excitement that included a response to the abdication crisis of 1936. This collage of voices, observations, and emotions created an overall sense of the national experience—a collective and plural account that did not privilege any one voice but sought to highlight individuals, relations between them, and commonly shared events.

Harrison later recounted that the early days of the Mass Observation project involved many filmmakers, such as Jack Holmes, Stuart Legg, Basil Wright, and Arthur Elton, as well as painters in the development of a new realist aesthetic: "All these people had a kind of visionary concept, not only [about] film but about everything, an approach which was unscientific-literary or poetic-literary. It wasn't a question of 'social-realism' … in fact, just the opposite: a kind of super-realism. That's where the 'Mass' came in. You see … [p]eople were just going to document themselves."[15] Jennings left the group by May 1938, having fallen out with Harrison, whose anthropological framework he accused of flattening the more poetic aspects of the observations that he and Madge had been most interested in at the start of the project. Jennings's contributions lay in editing

Figure 3.3
The First Year's Work, Mass Observation, 1937–1938. Edited by Charles Madge and Tom Harrisson. Cover design by Humphrey Jennings. London: Lindsay Drummond, 1938. Courtesy of the Trustees of the Mass Observation Archive, University of Sussex.

the different accounts and diaries, finding patterns and coincidences, as well as ambiguities, in the collage of different perspectives. After leaving, he would extend the montage aesthetic he had developed with the Mass Observation movement to his extraordinary documentary portraits such as *Spare Time* (1939) and his wartime films like *Listen to Britain* (1942), *Fires Were Started* (1943), and *The Silent Village* (1943)—all portrayals of the British people coping with the Blitz.[16] Jennings blended together voices and songs, cross-cutting between groups of people and guided by a very sparse voice-over, to create an acoustic space made up of a plurality of simultaneous experiences located differently in space. These films were instant milestones in the history of documentary film and continue to be of interest, along with the work of the Mass Observation movement. In the context of twenty-first-century social media and cultures of the Internet, which are characterized by both an aesthetics and a politics of simultaneity and networks, Jennings and Madge's desire to have "people document themselves" stands as an important aesthetic precursor. Harrison maintains that

Jennings had wanted to find coincidences in the mass amount of materials he received: "It's … very difficult to look for coincidence in 5000 sheets of paper from people all over England." Of course, computers would have helped, according to Hodgkinson; Harrison's approach was much more objective and scientific—a practice which we now recognize in the fields of market research and opinion polls.[17]

For *Family Portrait*, Jennings drew upon the insights of his then incomplete, and posthumously published, book *Pandaemonium: The Coming of the Machine as Seen by Contemporary Observers 1660–1885* (1985), a collection of more than one thousand pages of newspaper accounts, diaries, excerpts of fiction, drawings, patent applications, and other visual materials created "by contemporary observers." Through a radical collage of found images, this "imaginative history of the Industrial Revolution"—started in 1937, the same year he founded the Mass Observation project—juxtaposes the empirical traces of British social history between the seventeenth and nineteenth centuries. Like Walter Benjamin's *Arcades Project* or Sigfried Giedion's *Mechanization Takes Command*, *Pandaemonium*, which was never completed, reads the inventions of the machine age in terms of the environments, visual modalities, and cognitive experiences that were emerging through and alongside them. Indeed, the book took its name from John Milton's epic poem *Paradise Lost* (1667, 1674). "Pandaemonium" was the name Milton gave to the capital of hell at the end of Book I, a city created by and for fallen angels. Jennings drew upon this poetic form to produce a radical history of capitalist modernity as experienced in Britain.

In their incisive comparison of *Pandaemonium* and *Family Portrait*, Ben Jones and Rebecca Searle argue that the sheer volume of *Pandaemonium*'s analysis of modernity (a collection of some 370 texts ranging from the 1660s to the 1880s) and its political radicalism make any comparison between the book and the twenty-minute short film difficult. The book's experimental constellation of subjective images, each belonging to a particular experience of modernity, enabled Jennings to "construct a dialectical, polyvocal account," a montage of viewpoints that could not be reduced to one overarching narrative, and yet was grounded within the empirical traces of the experience of modernity.[18] *Pandaemonium*, they maintain, "presented the advent of modernity as occasioning a shift in the 'means of vision,' commensurate with changes in the 'means of production.'"[19] It is just such a historical methodology that we see in Benjamin's *Arcades*

Project, influenced—like Jennings—by the French surrealists. This montage approach, which mimics the shocks of the modern industrial landscape on the human sensorium, is nowhere present in the form of *Family Portrait*. While clearly building on his earlier experiments and research, *Family Portrait* appears restricted to a more conventional aesthetic due in part to the financial constraints that affected all films produced for the Festival of Britain.[20] As is evident from the draft treatment of the film, Jennings had planned a far more ambitious project that experimented with layers of voice-over. It was to have featured three different voices: (1) the official "voice of the Festival"; (2) a voice representing the "average man"; and finally (3) a collage of archival and reenacted recordings of historical characters, from Constable to Churchill.[21] This evocative technique of sound collage was replaced in the final version by an official narration spoken by the British actor Michael Goodliffe. Certainly, this voice-over gives the film the paternalistic and traditional sensibility that led Lindsay Anderson to harshly dismiss it as conservative and nostalgic. Moreover, while representing past British scientific and artistic achievements, half of which are Victorian, the film merely alludes to the history of British imperialism and the world wars as "our common history."[22]

Yet, despite this gloss on family history, a strong ecological sensibility drives the film, one that goes beyond mere boosterism for the Festival. The film opens and closes with the pages of a scrapbook containing photographs of groups of people and families on a beach. One image of women amid the rubble of a bombed-out neighborhood stands out from the rest. The narrator tells us the film is a place to "let the young and the old, the past and the future meet and discuss ... to voice our hopes and fears, our faith for our children."[23] He goes on: "Where to begin? Here, this is Beachy Head in Southern England, in the county of East Sussex." We see "the remains of a radar station," wartime technology invented by British scientists woven into the presentation of history (the Romans, the Saxons) and landscapes: "the extraordinary diversity of nature in this small space, the variety of land structure, the local variations of soil and climate; the rapid exchanges of the weather above; the jumble of coal and rock underground—all somehow match the diversity of the people." Diverging from the incongruity and schism that characterizes technological modernity in *Pandaemonium*, *Family Portrait* historicizes modernity "within a continuous narrative of humanity's interactions with the landscape."[24]

Figure 3.4
Humphrey Jennings (center) on the set during the shooting of *Family Portrait*, London, 1950. Courtesy of BFI National Archive.

The film's narration then encourages urban planning: "We must plan the use of the small space we have. Where to live, where to work, where to draw power from water as well as coal, where and how to plant new forests, what to preserve and what to exploit." This narration reflects the new approaches to urban planning and energy use that were developing in England. These ideas were very much a part of the mandate of the Festival and the leftist politics of Britain in the 1940s. We can situate Jennings in the context of what E. P. Thompson characterized as the "populist radicalism" of leftist activism after the war.[25]

Jennings's *Family Portrait* called for change. Jennings did more than simply celebrate the national past; he pointed to the future in terms that express a need to connect to the world situated within the cosmos. The interconnected and diverse landscapes and references to the "outside world" (allusion to the "outside" and to the stars is also prominent in the film treatment) define a sustainable future, a future that depends upon new relations with other parts of the world—"Cairo, India and the Continent, as well as America" and nature. Images of transportation—ships, ports, as well as turbo jets—underline the new globalism: "we belong to a communion across the Atlantic and the South seas, we are too small ... to stand alone." Survival also depends on "the two sides of the family"—the farmer and the scientist: the farmer reconciled with "local wisdom" and the "sense of the living thing," and the scientist with "learning to accept ... the richness and subtlety of nature not as errors to be corrected, but as part of a truth to be understood."

The cosmic has a ubiquitous presence throughout the film, with the reoccurring image of a massive radio telescope "picking up radio waves coming from the blank spaces of the Milky Way ... the fantastic antennae of modern science reaching out to the unknown." Toward the end of *Family Portrait*, a scientist—a woman—peers at strips of 35mm film to examine the electromagnetic waves registered on the emulsion as the dramatic music of John Greenwood swells to punctuate a utopian affirmation of the "human spirit" searching to understand the blank unknown spaces of the cosmos. The last shot of the film confirms the accomplishments of British parliamentary democracy and the need to protect democratic freedom and the pursuit of knowledge. Altogether, *Family Portrait* suggests that the future of the nation and of the world is assured through new technologies, coordinated efforts around the globe to share knowledge and resources, and the freedom of movement and thought necessary to do so. Media of communications and architecture are perceived as absolutely central components of the new citizenship that the film promotes. This emphasis on media and citizenship was not anathema to the forms of collectivity and connectivity that Jennings had been developing from his days with the Mass Observation movement. Rather than seeing this film as a compromise, we can see how it represents an extension of many of the socialist ideals and humanist aesthetics that have come to define Jennings's works.

Family Portrait is a particular expression of what Mary Louise Pratt characterizes as the "Eurocentric planetary consciousness" evident in European cultural discourses after the Second World War.[26] The conclusion with the farmer and the scientist helps to illustrate the utopianism and Eurocentrism of planetary consciousness during this period. Yet it would not be a stretch to align this planetary consciousness—the balance between ecology and science—with the ecological thinking of the Scottish biologist, geographer, and pioneering town planner Patrick Geddes. Geddesian urban theory was very much present in British planning of the 1940s and 1950s. Even though he died in 1932, Geddes's major works were taught to over two thousand members of the armed and Allied forces at the new planning schools and in correspondence courses in England. The archivist Volker M. Welter has shown how Geddes's thought permeated British planning circles and shaped the utopianism of postwar reconstruction, most especially through the Modern Architectural Research Group (MARS)—the British wing of the Congrès International d'Architecture Moderne (CIAM). Several members of MARS were involved in planning the architectural components of the Festival of Britain, including horticulturalist and city planner Jaqueline Tyrwhitt (a Geddes specialist) and the Canadian architect Wells Coates, who designed the Telekinema, which I will discuss shortly. First, however, I want to turn to Geddes's environmental thought. He has without doubt been an overlooked thinker, far ahead of his time, whose ideas and projects may give us insight into the utopian strands of ecological thinking in the 1950s.

Geddes's Outlook

As noted earlier, Jennings would have encountered Geddes's ideas on ecology at a young age at the Perse School in Cambridge, which adopted the arts and crafts ideas of Ruskin and Morris as well as many new ecological approaches.[27] Jennings's teacher, Caldwell Cook, who undoubtedly would have introduced Geddes's ideas into the interdisciplinary curriculum, went on to write a book on education methods called *The Play Way*, which concludes with a plan for PlayTown (not a playground but a town with all the machinations of towns) that emphasizes the role of the environment in civic-oriented education.

A student of Thomas Huxley, Geddes was among the first people to bring the notion of ecology into architecture and urban planning at the end of the nineteenth century.[28] A self-taught planner and educator, his utopian vision of the city drew heavily from biology; in its interdisciplinary blending of geography, history, and sociology, it constituted one of the first radical ecological visions of urban living. Geddes was very much inspired by anarchist geographers like Peter Kropotkin in Russia and Elysée Reclus in France, who theorized the human-nature relationship as one of mutual aid and cooperation, and proposed the new idea of bioregionalism that he drew upon.[29] He was deeply connected to India and Eastern religions early on. As Lewis Mumford, a longtime disciple of Geddes wrote, "The test of Geddes's essential life-feeling came in India, where he mingled his own dynamic Western approach with a new appreciation of that wise passiveness, that disciplined contemplation which marks Hindu culture. In his biography of the great Indian physicist, Sir Jagadis Chandra Bose, Geddes paid tribute to the Hindu's mystical sense of the unity of all life as a key to Bose's essential discoveries in the sensitivity of plants and metals."[30] Indeed, throughout his adult life, Geddes was concerned with a synthesis of all knowledge, Eastern and Western (he spent significant amounts of time in India between 1914 and 1924 on four separate trips).[31] Describing Geddes's unique contribution to urban planning, Sigfried Giedion remarked, "[T]he city is inseparable from the landscape in which it is set and can only be understood in terms of its geographic situation, its climactic and meteorological acts, its economic bases, and its historic heritage."[32] Geddes was concerned that planning take on a larger view of places, and advocated for approaches to planning that utilized what he would call "conservative surgery," as opposed to the tradition of the "gridiron plan" characteristic of colonial town design in the nineteenth century.[33] His unique approach was grounded in a holistic understanding of place that took into account existing physical and cultural landscapes in order to plan for development, emphasizing the home rather than housing.[34] He also recognized the central role played by urban centers, public spaces, and gardens in the creation and sustenance of community utopias, or as he put it, eutopias—good places.[35]

As Ruth Levitas describes, Geddes and his long-time collaborator the sociologist Victor Branford (and Mumford after them) "distinguish between 'good' and 'bad' utopia, between the real possible future and

Figure 3.5
Portrait of Patrick Geddes in Bombay, India, December 1922. Photographer: Gopal Advami. Courtesy of the University of Strathclyde, Department of Archives and Special Collections.

Figure 3.6
Notes by Patrick Geddes on the classification of the sciences and arts. Courtesy of the University of Strathclyde, Department of Archives and Special Collections.

wishful thinking, between reconstruction based on science and irrational dreaming."[36] Like Giedion, Mumford appreciated how Geddes's approach to urban planning broke down the apparent opposition between the parochial and the cosmopolitan. Although he developed his "rich and subtle practice of city planning" in India, Geddes's community-building efforts were grounded in his home city of Edinburgh. But as Giedion succinctly commented, "Geddes's Scotland encompassed Europe and his Europe encompassed the World."[37] Geddes viewed the world in biospheric terms—he was interested in the interconnectedness of things on a local, regional, and cosmic level. To foster this view of interconnection, he advocated approaches to education that expanded perception by incorporating media (camera obscura, episcope, periscope, prisms, panoramas, georama, globes, and more) into new interdisciplinary public education programs, which he sought to locate in plans for museums and exhibitions.[38] One of his earliest

and most innovative "thinking machines" (as he called museums) was the Outlook Tower, an experimental laboratory and model for a municipal museum. In 1890, Geddes purchased an observatory previously owned by Maria Theresa Short in the center of Edinburgh. Geddes renamed the tourist attraction the Outlook Tower and invited the public to view the city from its different levels and wide array of "outlooks." The tour began at the top of the domed tower with a panoramic outdoor view of colored images projected on a white surface inside the dome. The spatial introversion of the camera obscura offered a threshold into Geddes's "In-World," enabling visitors to see the connection between the city and hinterland. From here, visitors went outside to the "Out-World" terrace or prospect from which they could view the city from all sides. Back inside the octagonal room they were introduced to all the different ways and scientific means used for measuring and making sense of the city, drawn from botany, zoology, geology, geography, meteorology, and so on. According to Anthony Vidler's detailed description,

On this level in the octagonal room that supported the observatory turret were astronomical charts demonstrating the orbit of the earth, together with a hollow celestial globe or miniature planetarium, within which might be seen the pattern of the stars. Later Geddes installed an "episcope" designed by the French geographer Paul Reclus that enabled viewers to "see" through the earth along any selected path to its opposite point. Then followed the exhibition rooms in sequence, starting with Edinburgh with a relief map of the city painted on the floor. Below this was a Scottish room, and this in turn led to an exhibition devoted to the countries where English was spoken—the Empire—thence to Europe, and finally, on the ground floor, to the world.[39]

The mobile visitors would eventually emerge into the city itself in a sequence that led the visitor from the local to the regional to the national and the global in a vertical architecture. Geddes saw the Outlook Tower as a prototype for future museums. The whole museum was unified through geography. As Helen Meller points out, equally important was Geddes's use of symbolism as a tool to communicate the vast details of his museum.[40]

Geddes, however, was always aware of the limitations of the tower architecture, which insinuated hierarchies of knowledge and could not convey its simultaneous universal aspects. He sought to develop a parallel and complementary structure with a georama as an alternative "knowledge organizing form,"[41] as Pierre Chabard has shown:

FIG 50.—Outlook Tower in diagrammatic elevation, with indications of uses of its storeys—as Observatory, Summer School, etc., of Regional and Civic Surveys ; with their widening relations, and with corresponding practical initiatives.

Figure 3.7
Diagram of the Outlook Tower in *Cities in Evolution* (1915) by Patrick Geddes. Courtesy of the University of Strathclyde, Department of Archives and Special Collections.

In the second half of the 1890s, Geddes was very involved in this project for a huge *géorama* that was to represent the universality of the world in both its human and its geographical dimensions, with a pacifist and internationalist aim. Designed by Louis Bonnier, the final version of the project consisted of a huge, egg-like building 60 meters high, containing a 1/500,000 relief globe of 26 meters in diameter, around which the visitor would "travel" on a helicoidal catwalk. The sphere contained within itself a *planetarium* and a chronophotographical *panorama* of the evolution of humanity conceived by Etienne-Jules Marey.[42]

The "Great Globe," though never built, was always an important touchstone for Geddes to imagine a possible architectural synthesis between the two structures. Chabard points out that the project that interested Geddes at the Paris Exposition was "the Cosmorama" at the foot of the Eiffel Tower: "Forty-six meters in diameter, this Celestial Sphere was a spherical panorama of the vault of the heavens, conceived by the French architect and astronomer Paul Louis Albert Galeron. Geddes was fascinated by both the didactic and scientific as well as the ludic and spectacular aspects of the building; in these aspects of this project he saw a particular realization of his ideals for the Outlook Tower."[43] In Geddes's conceptualization, the Outlook Tower would support a variety of interdependent and interconnected activities, including a summer school, a press, and the Old Edinburgh School of Art. The idea was to create a space for the production of art that was not subject to the whims of the art market but would infuse the museum with creative ideas. The role of the artist was central to Geddes's evolutionary vision. As Meller explains: "His whole range of activities were thus synthesized into one operation. The exhibitions and maps of Edinburgh provided a survey or description of the area; the building operations of the Old Town were the field of action; the Summer Meetings provided a new kind of evolutionary education; the publishing ventures, a new cultural identity; and the Art School provided the ideals."[44] Throughout his life, Geddes developed a theory of museums (he was working on a book about museums, although it was never published),[45] the cornerstone of which Professor Browngoode, director of the United States National Museum, summed up this way: "a finished museum is a dead museum, and a dead museum is a useless museum."[46] The museum was to serve the civic function of connecting citizens to their city through both history and geography. Ultimately, Geddes's aim was worldly—"know your region and you can understand the world"[47]—just what, in many ways, Jaqueline Tyrwhitt and Wells Coates sought to do at the Festival of Britain.

Jaqueline Tyrwhitt and Live Architecture

In 1950, Coates brought British horticulturalist and town planner Jaqueline Tyrwhitt on board for the Festival of Britain's town planning projects. A member of CIAM since 1941, Tyrwhitt had become the assistant director of MARS in 1949. She and Coates were involved in many of the architectural exhibitions for the Festival. Tyrwhitt's urban planning vision was very much inspired by Geddes. She had restaged his acclaimed "Cities and Town Planning" exhibition, which he first mounted in London in 1910, and edited the revised edition of his major works under the title *Patrick Geddes in India* (1947). Tyrwhitt was also influenced by Sigfried Giedion, especially his works *Space, Time and Architecture* (1941) and *Mechanization Takes Command* (1948). A lifelong friendship between the two began when they met at CIAM 6, organized by MARS in 1947 in Bridgewater, England. For many years, Tyrwhitt worked as Giedion's translator and editor, assisting him with *Mechanization Takes Command* as well as several other publications.

To the discussion of architecture and urban planning, Giedion brought the dynamic concept of space-time, largely inspired by the discoveries of modern physics and their impact in the visual arts (evident in the artworks of Picasso and Moholy-Nagy, for example). He proposed a conception of the city as an integrated, multiple, and simultaneous experience, arguing that such a new direction in urban planning had been noticeable "since about 1925."[48] "The future of architecture is inseparably bound up with town planning," he explained. "Everything depends on the unified organization of life." It is precisely this interdisciplinary mentality that served to create a link between architects, urban planners, and artists involved in media of all forms. This conception, of course, echoes the principles of the program of art education formulated by the Bauhaus under Gropius, a program that had "developed out of a new sense of space" and in which "the effort was made to unite art and daily life, using architecture as the intermediary."[49] For Giedion, the task of urban planners and architects was to restore feeling to a project that thinking had come to dominate. The individual, he argued, must be "integrated in his inner nature, without being brutalized, so that his emotional and intellectual outlets will no longer be kept apart." Giedion continues, "the outstanding task of our period: to humanize—that is, to reabsorb emotionally—what has been created by the

spirit. All talk around reorganizing and planning is in vain unless we first create again the whole man, unfractured in his methods of thinking and feeling."[50] Following Geddes's interdisciplinary approach, and echoing the comparative methodology advocated by his teacher, the art historian Heinrich Wölfflin, Giedion advocated the comparative study of methods in different realms, whatever they may be, from biology to music. A comparative approach would ultimately produce "objective insight" into commonalities between the disciplines, Giedion believed—"an identity of methods."[51] He advanced this interdisciplinary and broad-based approach to knowledge as "a cure" to this century's "fatal disease," the fragmentation and specialism that worked against the holistic view.

Giedion's integrative approach to urban planning was a response to the aftermath of the Second World War as well as to CIAM 6, which, originally scheduled for 1938, had been delayed by the war by ten years. In the intervening years, several members of CIAM, including Giedion, Knud Lönberg-Holm, Walter Gropius, Josep Sert, Richard Neutra, and Stamo Papadaki, among others, had formed the CIAM Chapter for Relief and Post-War Planning, which sought ways of overcoming wartime fragmentation and disruption in order to prepare for postwar rebuilding.[52]

The integrated approach to planning and architecture for which the members of CIAM so passionately advocated, the Festival of Britain made manifest. As the acting secretary and principal organizer for CIAM 8 in 1951, Tyrwhitt brought the congress to Huddleston, England, about twenty miles north of London, thus enabling participants to visit the Festival. The theme of the congress that year, "The Heart of the City: Towards the Humanization of Urban Life," reflected the intersection of concerns and interests between the Festival and CIAM 8. In the proceedings edited by Tyrwhitt, Sert, and E. N. Rogers under the title *The Heart of the City*, Giedion summarized the problematic central to postwar urban planning in terms of the need to create a new kind of "spectator-citizen": "The thing that is needed today to turn people back from passive spectators to active participants is an emotional experience which can reawaken their apparently lost powers of spontaneity."[53] The city should be planned and designed with a view to making affective spaces for citizens, engaging them in their everyday environments.

The Festival of Britain's South Bank Exhibition presented architecture in process and a "live architecture" exhibition in the Lansbury neighborhood

of the Stepney-Poplar District in London's East End, which "demonstrate[d] the possibilities inherent in good town planning, architecture and building by … show[ing] part of a re-planned, living community in the process of going about its daily life."[54] The London County Council, a planning authority empowered by the Town and Country Planning Act of 1947, proposed a plan prepared by J. H. Forshaw and Patrick Abercrombie for rebuilding those sections of London that had suffered the most extensive damage during the war. The Stepney-Poplar area, which covered 1,945 acres, was one of the zones proposed for reconstruction. After lengthy and prolonged consultations, Lansbury, one of three neighborhoods in the community, was chosen as "the scene" for the live architecture exhibition, which extended over 30 acres and encompassed 1,000 separate properties housing 9,500 people. The exhibition and rebuilding required a host of negotiations with approximately 370 property owners, which took place with the help of the Stepney-Poplar Planning Committee.[55] The total cost of the permanent development, estimated at approximately £1,600,000, was borne primarily by the London County Council. The Festival contributed £240,000 for the exhibition.[56]

The exhibition presented the cross-section of a residential neighborhood containing houses, flats, shops, street furniture and open spaces, light industry, a church, several pubs, and primary, secondary, and nursery schools, alongside a Building-Science Pavilion and a Town-Planning Pavilion. It was intended to illustrate the visual and practical advantages of post-war town planning and to make intelligible the latest advances in building techniques. Some of the structures were therefore left in various stages of completion, exposing innards in order to illustrate structural techniques. After the Festival, these structures were completed and the entire neighborhood was "delivered" to the city. Throughout the process, the town planning exhibition's predominant concern was the relationship of individuals to the community. According to the *Guide to the Exhibition of Architecture, Town-Planning and Building Research*: "The many and sometimes conflicting needs of people of different callings have to be provided for. … The lives of a baby, a schoolchild, a teenager, a single worker, a married woman with a job, a mother and an elderly person are very different, but all have to live together as one community."[57] Tyrwhitt's overarching concern with the wellbeing of the community's members reflected CIAM 8's focus on the "heart of the city." In Tyrwhitt and CIAM's vision of the city, the

"spectator-citizen" was invited to participate directly in the city's planning, which would address the needs of all. Describing the scene that the Neighborhood Unit should project, Tyrwhitt suggested, "representative buildings of entertainment, evening education and civil administration should be visible. A major stream of traffic should also be seen skirting the area. Trees and sculptures should be in evidence—possibly also water and perhaps grass. Visitors should receive an impression of freedom of movement; ease of choice of activity; of places where informal crowds can gather, places where one can 'promenade,' and places where one can rest."[58]

Noting the influence of CIAM on Tyrwhitt's design of the exhibition, Atkinson observed, "it is no coincidence that the Lansbury 'Live Architecture' Exhibition included 'The Heart of the Town' as one of its six sections. … [N]o doubt Tyrwhitt had been discussing [issues of planning and rebuilding] with CIAM and Festival colleagues."[59] But Tyrwhitt did more than simply import ideas from CIAM into the Festival of Britain. Ellen Shoshkes points out that she used the congress to conduct a comparative study of urban cores in different national contexts:

> To facilitate comparison Tyrwhitt asked participants to present examples of the core from their various countries and projects, which were displayed in a grid. This framework captured the competing landscapes of modernism and visions of modernity being produced in distant regions, under extremely different local circumstances. The format also highlighted the new notion of "humanistic regionalism"—in which the structure of the old town could guide the design of the new "Cores" needed within the polycentric "urban constellation."[60]

This grid is noteworthy precisely because it demonstrated a Geddesian sensitivity to local geography. It also facilitated the emergence of a comparative methodology in Britain that reflected the particularities of specific localities as well as more regional trends, while also displaying the new global mentality that was taking shape in the developing field of urban planning. Tyrwhitt treated the city as a continuously mediated sphere of cultural life. For her, cities had to be studied phenomenologically, because urban space is active, constantly shifting and changing. She proposed to study the *experience of living in cities*, not simply "the city" as an object. She regarded town planning as a means of developing new forms of urban design that, rather than being devoid of bodies and subjectivities, accounted for moments of attention, delight, and distraction. The 1951 "Live Architecture" exhibition exemplified this perspective, and Tyrwhitt's desire to design communities

that accommodated a plurality of needs brought together both the pragmatic and utopian aspects of planning. Indeed, Tyrwhitt served as both the director of research and the director of studies at the School of Planning and Research for Regional Development in Britain for seven years beginning in 1941. This school was the sister organization of the Association for Planning and Regional Reconstruction (APRR) established by E. A. A. Rowse. Tyrwhitt took over after Rowse enlisted in the war, and was asked by him to design the new correspondence courses in town planning for architects and others serving with the Allied forces. She was responsible for the training of hundreds of students who would form the next generation of planners, which included both men and women.

Along with Patrick Geddes, Karl Mannheim had a significant influence on some of the utopian aspects of Rowse's and Tyrwhitt's vision of urban planning. In particular, Mannheim and Geddes infused the curriculum with a utopian, civic-minded sensibility that was ecologically and historically grounded. Geddes's approach differed significantly from that proposed by Le Corbusier under the Athens Charter in 1943. The charter was based upon Le Corbusier's book *La ville radieuse* (Radiant City) of 1935 and on urban studies undertaken in thirty-three cities by members of CIAM in the early 1930s. The Athens Charter (so named because it was conceived at the fourth CIAM conference of 1933, which took place on shipboard during a cruise to Athens) was based on the idea of a functional city divided according to specific categories of living, working, recreating, and circulating.[61] This approach is often contrasted with Geddes's because, in contrast, he engaged with the specifics of each place, believing that urban planning could not be generalized.

Mannheim developed his theory of utopias in the Weimar Republic in the 1920s, and defined "utopia" as a process of "wishful thinking." The imagination, Mannheim articulates, "find[ing] no satisfaction in existing reality ... seeks refuge in wishfully constructed places and periods."[62] Since Thomas More's 1516 book of that name, a utopia has generally been defined as a space apart, a "nowhere" place, dislocated from the present situation. Recent approaches to utopian studies have sought to redirect our attention away from the concrete elements of imagined spaces toward utopias as aspirations, as problem-solving proposals, as expressions of the desire for a better world.[63] Similarly, Mannheim's *Ideology and Utopia* (1929; expanded English translation, 1936) distinguishes ideologies from

utopias by designating the latter as wish fulfillments that he regarded as imaginative projections into space.[64] Yet we should also note Mannheim's view that it is difficult to differentiate utopias from ideology—the distinction is sometimes only apparent in retrospect. More fully, he defines the utopian mentality as "all situationally transcendent ideas (not only wish-projections) which in any way have a transforming effect upon the existing historical-social order." Utopias are not opposed to realism, as many who dismiss utopian thought often suppose. For Mannheim they grow out of real situations as responses to or critiques of the status quo; they are historically and geographically specific and in a constant state of change.[65] Mannheim also differentiates the "utopian construct," which is a closed and static form, from "utopian consciousness," which he describes as an experimental, interactive, process-oriented action; these are above all "concrete discoverable structures of mentality" found in "living" individuals and collectives.[66]

Mannheim spent the last years of his life (1933–1947) in England where he contributed to the construction of a new sociology of knowledge rooted in a commitment to democratic education. In both *Man and Society in an Age of Reconstruction* (1935) and *Diagnosis of Our Time* (1943), he argues for a new pragmatism of social and educational planning in England and the United States, and his work touches upon many of the debates about planning in the 1940s. For Mannheim, the ideal society would combine high levels of centralization with high levels of popular democratic participation. In this formulation, and in a manner resembling Geddes's views, education would form the cornerstone of a strong and just society.[67] Because Mannheim died in London in 1947, just two years after the end of the war and just as the Festival of Britain was beginning to take shape, we can only surmise that he would have appreciated the Festival as a utopian, pedagogical, and participatory event.

Tyrwhitt had heard Mannheim lecture at the Winter School of Sociology and Civics organized by the School of Sociology (Le Play House) in January 1943, where he argued that any educational curriculum must be collaborative, like an orchestra where different minds work together toward the creation of a common goal.[68] That same year, Tyrwhitt drafted a definition of planning: "By 'Planning' is implied the intelligent use by a free community of its environment, for the common good of its neighbors, its successors and itself. Such planning must grow freely and calls for careful, balanced

thinking ahead and not for the rigid discipline of the blueprint; once this balanced thought has been achieved, a delicate but constant adjustment to the needs of the environment can take place."[69] Thus, Tyrwhitt came to conceive of education and urban planning as one and the same—urban planning as an interdisciplinary activity that must take place collectively and collaboratively, involving designers and architects, but also geographers and lawyers, doctors and social workers, with those citizens who must live with what is planned. Tyrwhitt built relationships between the APRR and other progressive educational organizations. She held an executive position with the Women's Farm and Garden Association and, with Brenda Colvin, trained women gardeners during the Second World War to specialize in growing food. Indeed, during the war, she developed an extensive and diverse network of women involved in urban planning and mapping projects.[70]

In addition to urban planning, Tyrwhitt wrote about media; she participated in the Culture and Communications graduate seminar at the University of Toronto, an interdisciplinary think tank codirected by Marshall McLuhan and cultural anthropologist Edmund Carpenter from 1953 to 1955. She went on to work with Josep Sert to establish a new professional field of urban design at Harvard University (1956–1969), directly inspired by Giedion's call for a new interdisciplinary approach to modern communications and planning. To be sure, Tyrwhitt had begun to think about media, and television in particular, several years earlier. In a lecture she gave at Vassar College in 1949 entitled "The Size and Spacing of Urban Communities," Tyrwhitt had reflected on what the then-new medium of television could offer urban planners. She exhorted planners to relinquish their attachment to the notion of a perfect city and their desire to impose it "upon a reluctant world."[71] She insisted on the need to understand current trends, arguing that the appropriate response to the social fact that television had "altered the function of many living-rooms" was not to condemn the technology as "the disrupter of family intercourse, nor to subordinate family liveliness to the television set," but, rather, to redesign the living room for the multiple purposes of social discourse *and* television viewing. Tyrwhitt's approach to planning was fundamentally and profoundly democratic, taking into account the social, educational, and physical needs of citizens. Media were not set apart but an inherent aspect of the environment. Moreover, they could be applied equally to neighborhood living rooms and metropolitan

centers. In the end, she argued that Ebenezer Howard's "Garden City" movement[72] and Clarence Perry's Neighborhood Unit[73]—two concepts that had had a substantial impact on British town planning—had to be interpreted in terms of "human needs and the technical trends" of the twentieth century.[74] This is precisely what the Festival of Britain, with its focus on newly designed neighborhoods and cinema, set out to do.

T Is for Telekinema

While the Festival of Britain, which included a centenary celebration of the first world's fair of 1851, was conceived as a celebration of "common human heritage," its focus was neither other nations nor simply the past, but a new vision of the nation's future. Just as the stereogram had been central to the Great Exhibition, film and the cinema-going experience were an essential component of the Festival of Britain. The British Film Institute (BFI), which had been established in 1933 to promote the art of the moving image, was asked to manage the commissioning and programming of films for the Festival. A new cinema was built in the depressed, war-torn area of the South Bank of London, the Festival's central site. Designed by the architect Wells Coates, this new, functionalist cinema was created specifically for 35mm, stereoscopic film and stereophonic sound, as well as for a large-screen, closed-circuit television. Known as the Telekinema, it was the most advanced media facility in the world, with a total seating capacity of 410 people. This remarkable structure is an all too often overlooked landmark in cinema and television history.

Part of the Bauhaus circle in London and chair of the Modern Architectural Research Group (MARS), Wells Coates had an established industrial design and architecture practice in England from 1928.[75] The Festival of Britain's emphasis on architecture and town planning, as well as film and television, was aimed toward producing a common cultural experience. This idea was captured in Coates's design of the Telekinema, an inimitable futuristic theater specifically imagined for the projection of 3D film and television. The BFI producers who worked on the Festival wanted the most futuristic and modern in audiovisual presentation. As I have discussed above, the urban planning on display during the Festival resembled in many of its aesthetic facets and characteristics, the innovative experiences offered up by the Telekinema. This congruence was no accident, since

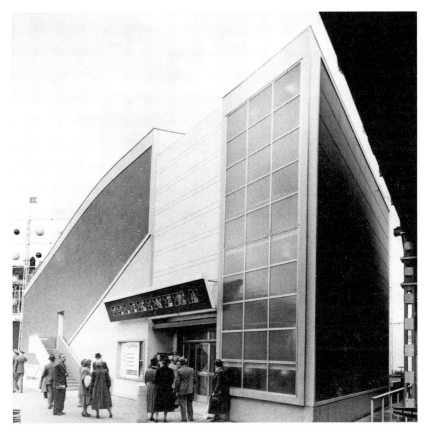

Figure 3.8
Exterior view of the main entrance to the Telekinema, a state-of-the-art cinema de-
signed for the Festival of Britain's South Bank Exhibition, London, 1951. Courtesy of
the BFI National Archive.

urban planning itself was being conceived in terms of a new kind of par-
ticipatory and active spectatorship; precisely a freeing of vision and a new
freedom of movement.

The design of the Telekinema can be read as an expression of, and a
means of strengthening, the British sense of collectivity in the postwar
period. In many ways, the Telekinema corresponded to the polyvalent
acoustic spaces that Geddes sought to create in his Outlook Museum. It
also complemented Humphrey Jennings's commitment to social inclusion
through documentary film, which allowed him to recognize—and use—the

Figure 3.9
Interior view of the Telekinema foyer, London, 1951. Courtesy of the BFI National Archive.

capacity of film to record the plurality of experiences that make up a people, and to appreciate cinema-going as a collective occasion with the power to create a common culture. Such a culture, in Mannheim's sense of the term, would be collectively made, democratically open, and inclusive.

The BFI Festival of Britain panel, made up of an experienced group of British film producers and directors, including Anthony Asquith, Michael Balcon, Arthur Elton, John Grierson, Howard Thomas, and Harry Watt, had the task of overseeing the selection of topics and themes for commissioned films. The stereoscopic 3D program comprised four commissioned films: two documentaries, *A Solid Explanation* (directed by Peter Bradford) and *Royal River / The Distant Thames* (directed by Brian Smith), and two animated experimental films, *Now Is the Time* and *Around Is Around*, both by Norman McLaren and Evelyn Lambart. A decentered celebration in which events took place throughout England, the Festival also featured a traveling program of 16mm films that crisscrossed the country, from Manchester to Leeds, Birmingham to Nottingham. In addition to commissioning original films, the BFI encouraged local communities to produce

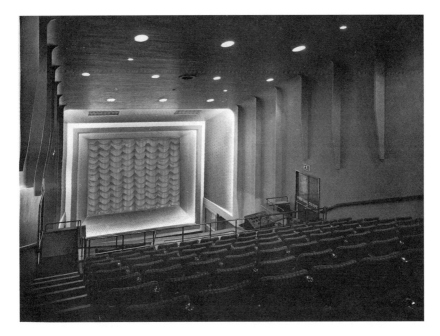

Figure 3.10
Interior view of the Telekinema's auditorium, London, 1951. Courtesy of the BFI National Archive.

their own events in makeshift cinemas. In an instructional pamphlet titled "How to Organise Film Shows during the Festival of Britain," the BFI declared:

One of the most effective means of dramatizing the achievements of our people is through the medium of film. We would urge every city and town to consider the possibility of providing facilities such as a special or temporary cinema for the showing of short informational films during the period of the Festival, preferably in connexion with any local celebrations that may have been organized. Encouragement should be given to manufacturers in the area to submit their own films for showing at the cinema so that visitors from abroad and other parts of the country can have a glimpse of products and activities of the district.[76]

It is important to keep in mind that the Festival was intended not as a trade fair but as a display and celebration of Britain's achievements in the arts, sciences, and industrial design. Film and television were regarded as important forms for the presentation of regional distinctions as well as national accomplishments. As a BFI press release put it:

In the South Bank exhibition a specially designed building takes its place among the other Festival pavilions for demonstrating new and experimental techniques as well as realist production. Also for the first time, big-screen television will be included in the regular cinema program, bringing to movie audiences at each performance a sense of up-to-the-moment actuality: what is going on in the other art sites of the Festival, along with interviews in the cinema itself, as well as demonstrations of the equipment.[77]

Along with the traveling film program, live television would unite the country, with 3D films bringing a new dimension of integration to viewers' experience of the world. The Telekinema perfectly encapsulated this new spectator. Designed to incorporate all that was new in film and its sister art, television, the Telekinema was to be the first theater in the world in which large-screen television, three-dimensional pictures, and stereophonic sound would occupy equal footing with the by then well-established sound film. Immersion was the ultimate goal:

Inside the auditorium the screen surround catches the eye at once. Wells Coates had abandoned the orthodox proscenium design inherited from the stage and set in its place a perforated frame, not unlike a picture frame, which splayed outwards from the screen and formed the sole link between the screen and the walls and ceiling. ... Then reaching out into the future the "TC" will present to its audiences a new kind of film sound track using the latest magnetic medium and causing the sound to issue at will from part of the screen or from the back or ceiling of the auditorium. Coupled with this "sound in space" will be a "picture in space," a three-dimensional movie which will appear to the spectator to reach out from the screen over the heads of the audience in front and also stretch back behind the place of the screen into the far distance. ... The method of achieving this effect involved projection, through polarizing filters, of two complementary images on the screen representing the left and right eye views.[78]

The effect of the Telekinema reverberated around the world. As R. M. Hayes has pointed out, it had a significant impact on Hollywood, which saw a boom in 3D films from 1953 to 1955. But it was in Britain in May 1951 that "dual projection 3D in full color with interlock stereophonic sound was [first] realized."[79] Although the Hollywood trade paper *Variety* claimed that it had invented the term "3D," it was film theorist Raymond Spottiswoode, the Telekinema's technical director, who coined the term.[80] The British Film Institute had designated Spottiswoode as technical director responsible for the Festival's stereoscopic presentations. To realize his ideas, he called upon his brother Nigel's engineering expertise and Lesley P. Dudley's skill as a camera technician.[81]

After the Festival's documentary film budget was severely cut, John Grierson, the former director-in-chief of the National Film Board of Canada (NFB) and a member of the BFI Festival programming committee, brought in the NFB's most talented artist, Scottish-born Norman McLaren. McLaren had established the NFB's animation department in 1942, and for the Telekinema, he and Canadian animator Evelyn Lambart produced two stereoscopic 3D Technicolor animated films.[82] For these works, McLaren and Lambart used a technique that McLaren had first explored in 1937's *Love on a Wing*, a short film produced for the British General Post Office film unit. Borrowed from Len Lye's *Color Box* (1935), the technique consisted of drawing directly on the filmstrip. McLaren recalled seeing Lye's film in 1936: "I was electrified and ecstatic. I wanted to see it over and over again. Here was the pioneer of the hand-painted film. … I had dabbled with drawing and painting on film … and had turned out a small amount of footage but I had never succeeded in making a film. Len Lye had shown the way, and shown it in a masterly and brilliant fashion. I felt sure that I would follow this way in the future as soon as I had an opportunity."[83] Lye's influence on McLaren was profound, and for the Festival of Britain he was determined to induce the same "ecstatic" pleasure in viewers that he had experienced when he saw *Color Box*. In *Now Is the Time (to Put On Your Glasses)*, the parallax—the separation of the left and right images on the display screen—was drawn into the animated shapes and sounds, while *Around Is Around* featured oscilloscope patterns that visualized sound, and a brilliant commentary on the Telekinema's incorporation of television. The fortuitous development of a dual 35mm 3D camera, interocular offset printing, and a projection system in 1951 enabled McLaren to experiment with stereoscopy, and he acknowledged that his own innovations relied upon the important technical work of the Spottiswoode brothers.[84] Indeed, McLaren and the Spottiswoodes knew one another well. Raymond Spottiswoode, who had also worked at the National Film Board of Canada, had advised McLaren on a number of his earlier projects.[85] Recognizing McLaren's groundbreaking exploration of the many dimensions of the medium, the Spottiswoode brothers dedicated their book, *The Theory of Stereoscopic Transmission and Its Application to the Motion Picture* (1953) to him: "To Norman McLaren, whose films in space (and in the flat) have been a delight to millions."[86]

The British film theorist and filmmaker Peter Wollen, who saw McLaren's films at what he spelled as the "Telecinema," recalls his own delight:

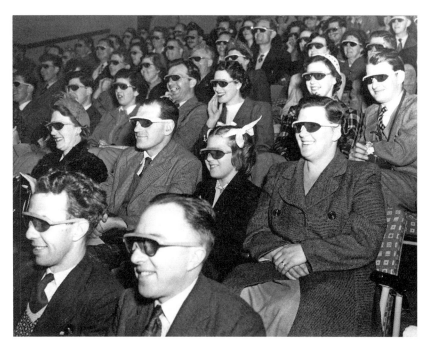

Figure 3.11
An audience wearing 3D glasses during the Telekinema's stereoscopic 3D film program at the Festival of Britain in 1951. Credit: Ronald Grant Archive / Alamy.

T is for Telecinema and Third Dimension. It is for Television too, cinema's domestic sibling, its rival which offers us, as Daney once complained, a "hemorrhaging of images," lacking a true aesthetic and the power to change us as "subjects," as human beings. The Telecinema was the first theatre specially built to project television onto a large screen—as you sat waiting for the films to come, you watched the rest of the audience as they were televised entering the theater and ascending the escalator to their seats. The main programme consisted of specially made 3D films for which you had to put on polarizing glasses, with one lens red and the other green. There were two animation films in the programme, made by Norman McLaren, and a demonstration film of the London Zoo. ... The Telecinema was my first introduction to the idea of experimental film, the search for new possibilities—both animated abstraction, with the McLaren dance of cathode ray patterns, and technical experiment, with the Pathé film of the zoo.

T is also for Technology. When the Lumière brothers and Méliès made their first films, the audience went for the spectacle—to see what the new medium was like, to experience the technology of cinema itself. The cinema has constantly reconstructed itself through waves of technological innovation—sound, colour, wide-screen, 3D, Dolby, IMAX, digital editing, new media. Experimental filmmakers, on the other

hand, have exploited its technical resources in their own subversive way, misusing (or travestying) them even, not to submit them to the law of narrative, but to develop new forms of filmmaking, to create new beginnings for the art of film."[87]

For Wollen, the films of the Telekinema revealed the central impulse of cinema—the spectacle and enchantment of *seeing the world anew*, of creating "new beginnings for the art of film," not merely by means of technological innovation, but by going against the grain of established filmmaking and technical protocols. Wollen also comments on intermedia forms, television and cinema together. By showing audience members outside the cinema, television expands the temporal and spatial boundaries of the cinema screens to the world outside. Telekinema's utopianism lay precisely in its embrace of experimentation and of new imaging technologies. And there was reason to believe that this enthusiasm for experimentation would continue long after the conclusion of the Festival. The National Film Board of Canada was certainly committed to experimentation, especially with sound; and subsequent technological innovation in large-screen cinema at world's fairs and 3D cinema were at least in part the result of the NFB's mandate to innovate. Furthermore, the Festival's director-general Gerald Barry was willing to wager that there was "not a layman alive of any imagination, who could fail to be excited by the possibilities that stereoscopy held for the future development of film, whose mind wouldn't be set speculating on the cinema of tomorrow."[88] Although a substantial portion of the funding allocated for the production of experimental and documentary films at the Festival was severely cut, the Telekinema was an important event because it convinced so many people of the value of experimental film, as Wollen testifies. It was certainly the catalyst to the BFI's launching its Experimental Film Fund in 1952, as Michele Pierson has explored.[89]

McLaren and Lambart: *Now Is the Time*

In *Now Is the Time (to Put On Your Glasses)*, McLaren and Lambart experimented with animating both sound and image. As McLaren described it, "no traditional musical instruments or noisemaking devices were used, nor were any microphones or sound recording apparatus. In their place was a small library of several dozen cards each painted with a drawing representing sound waves."[90] Using the same basic method as traditional animation, McLaren and Lambart photographed the "long narrow cards" in

sequence, frame by frame, on the soundtrack. When the developed film was run through a sound projector, the animated waves could be heard as a series of "musical" sounds unlike any conventional instrument or voice, but evocative of an electronic harpsichord. According to McLaren, "it [was] therefore logical to call the kind of sound produced in this way 'animated sound,' for it [was] made by the same method as animated pictures, and from a creative and artistic point of view it share[d] many of the [same] peculiarities."[91]

One such peculiarity was the liquescent and abstract quality of McLaren and Lambart's drawings, which imparted a strong impression of spatial acoustics. Lambart was hearing impaired, which might well have contributed to the sonic character of both films. Passing through two projectors, the sound, played like chords on a piano, is heard as a crescendo. The projector literally becomes an organ and the space is tuned. The accompanying images are simple. White clouds in a blue sky appear to move toward the viewer, creating a strong perspectival horizon. Appearing one by one, a multiplicity of red suns smile in the sky above. A stick figure, which appears superimposed over the entire scene, stretches and shrinks, morphing into a variety of playful shapes until it joins the suns in the sky. As with so many of McLaren's animations, the childlike quality of these drawings ensure both their popular appeal—they are accessible to all—and their imaginative brilliance, enabling objects, people, and nature to morph into constantly moving musical fractals. The emphasis on movement and constant change locates the experience in the "now" of the title—the animation occupies and serves a shared *now* rather than any representational realism.

The utopianism based in a collective experience of wonder that we see in early experimental stereoscopic 3D cinema also resides in the medium's multiple and diverse effects on the human sensorium. 3D is performative and self-reflexive in a manner that 2D cinema cannot be. I want to return to Wollen's comments about seeing the world anew at the Festival of Britain's Telekinema. Rather than providing the familiar image of perspectival realism, 3D produces an oceanic, untethered sense of swimming in space without coordinates, akin to Rudolf Arnheim's description of Cousteau's *World without Sun* (1964), and it could easily apply to *Silent World* as well: "a complete suspension of the familiar vertical and horizontal coordinates of space."[92] Such an experience of spatial disorientation belongs to space that has become liquid or, to use Eisenstein's terminology, "plasmatic."[93] In

Figure 3.12
A still from Norman McLaren and Evelyn Lambart's pioneering 3D animated film *Now Is the Time* (1951). Credit: National Film Board of Canada, Ronald Grant Archive / Alamy.

Around Is Around, their second 3D film commissioned by the BFI for the Festival, McLaren and Lambart give us the universe as an infinitely unfolding space, like the final images in Jennings's *Family Portrait*: "the blank spaces of the Milky Way … the fantastic antennae of modern science reaching out to the unknown."[94] The background to the oscilloscope images resembles a Möbius strip, with no inside or outside. Such strips are dynamic spheres that move against a backdrop of stars in an expanding universe. The cinematic experience of three-dimensional space provides the sense of ecstasy and wonder that Wollen describes—a sense of swimming in a newly imagined, freshly created space. Yet at the same time, 3D cinema creates a unique singularity—each spectator experiences being touched by the image, and fusing with the image, differently. Indeed, this present-tense aspect of 3D film (the illusion of depth comes together in the spectator's mind) works to transform the film into a live event. The self-reflexive mode of address of 3D film emphasizes the act of looking, of wearing glasses, of seeing pictures

that seem to address the spectator particularly in the context of collective viewing. Unlike representational cinema, which aims to bring the past back to life on the screen, 3D films enact an immediate communication. This performative nowness is related to the temporality of early television's "liveness" which is the link that McLaren and Lambart make explicit.

For *Around Is Around*, McLaren and Lambart incorporated sound waves into the visuals, developing a technique pioneered by the American artist Mary Ellen Bute, for whom McLaren had worked in New York assisting with her film *Spook Sport* (1940). Following Bute, McLaren photographed moving oscilloscope patterns, but for *Around Is Around* he did so stereoscopically, shooting from different camera positions, one for the left eye and one for the right. Combining animation with the recording of electric wave impulses, *Around Is Around* perfectly encapsulated the features of the Telekinema. Like *Now Is the Time*, the film was designed with a stereo soundtrack, that is, the sound was recorded on two separate pieces of film. Particularly interested in creating visual music (he not only used painted

Figure 3.13
A still from McLaren and Lambart's *Around Is Around*, the first stereoscopic animated film ever made using a cathode ray oscilloscope to create the illusion of three-dimensionality. Credit: National Film Board of Canada, Ronald Grant Archive / Alamy.

cards to create "music," but also scratched and perforated both the image and the soundtrack), McLaren was excited by 3D's synesthetic potential.[95] The images and sounds of *Around Is Around* beautifully illustrate a newly emerging sensibility in postwar Europe and North America where new communications technologies were contributing to the emergence of a cosmic sense of space. *Around Is Around*'s dislocated soundtrack disorients the viewer in a fluid and seamless space.

McLaren and Lambart's unique drawings on film in addition to their use of animation and hand-painted images to create sound produced an integrated and embodied aesthetic that demanded the most self-reflexive spectatorship. By pushing the materials of film toward the most physically embodied and materialist ends, both *Now Is the Time* and *Around Is Around* ultimately subvert the rationalist, realist character of cinema. Instrumentalizing time and invisibility, the artists literally imprinted their own bodies on the most abstract phenomenon—the sound wave. The corollary to this materialization is the sensory experience of 3D spectatorship, in which the image, even as it is split apart, is (re)made whole, thus constituting a world.

As a medium, 3D film has been described as having haptic qualities,[96] which refers to its qualities of "absorption" and "fastening." Art historian Alois Riegl described a "haptic" (fastening) rather than a "tactile" look in his theorization of different visual registers. David Trotter explains that Riegl "did not want this look to be understood as a literal touching. The optical manner of seeing stands back from the world, withholds itself in and for survey, or surveillance ... the haptic, so fast (in both senses) in its fastening, is a form of attachment."[97] Though Merleau-Ponty was not describing 3D film in "The Film and the New Psychology," he was seeking to delineate film in terms of its capacity to convey depth; the filmic experience is "a being-thrown into the world and [being] attached to it by a natural bond."[98] It is expressly this capacity to be absorbed into a world, to be fastened into it, that McLaren was exploiting with his Festival of Britain films. As Wollen describes, the 3D films gave audiences a new connectivity to an expansive image.

McLaren's characteristic playfulness is present in both films and relates to his long-standing interest in synesthetic media and in "cinema as music" rather than language. He conceptualized 3D film *not* as representational realism but, as Bazin put it in "Un nouveau stade du cinéma

en relief," as a synthesis of spatial realism and perceptual experience. The illusion of stereoscopic, three-dimensional depth is located nowhere, but nevertheless exists virtually in the mind and bodily experience of the spectator. It exists as an event, a *now*. Bazin would review McLaren's painterly poetic films at the Festival of Britain as a "new and decisive step toward total cinema."[99]

As a medium, it would be wrong to say that 3D film is utopian; it is a matter of the ends to which the medium is put. McLaren and Lambart's stereoscopic 3D films are utopian in a specific way. Their animations reveal unending, unfolding universes that perform the ontological aspects of the technology, which at the Festival of Britain offered audiences new spaces of experience—both urban and cinematic/televisual—that were highly individualized and yet collective. The fact that urban planners like Tyrwhitt and architects like Coates were interested in these media is testimony to their desire to design open and inclusive spaces, environments which they did not see as separate from the spatiotemporal experiences being opened by media.

I conclude this chapter with Sergei Eisenstein's last essay, "O Stereokino" (1947), which features his final words on cinema. Eisenstein believed that stereocinema was the future of cinema and art, and he, along with the BFI programmers, wanted to bring this new futuristic art form into the present:

The time has come for an explosion and thorough re-evaluation of the fellowship of traditional arts in the face of new ideologies, new opportunities for new men and women—with their new means of mastering nature.

What of the eye that can see in the dark with the aid of "night vision" infrared goggles?

What of the hand that can launch missiles and pilot planes in faraway skies by means of radio signals?

What of the brain that instantly carries out calculations, which at one time would have kept an army of accountants busy for many months, with the aid of electronic machines?

What of consciousness, struggling tirelessly in these post-war years to forge a concrete model of a genuinely democratic international ideal?

Are they not clamoring for artistic expression of wholly new, never-before-seen forms and dimensions, far beyond the limits of the palliatives proffered by traditional theater, traditional sculpture, traditional … cinema?

To be sure, the new, dynamic stereosculpture will toss traditional, static sculpture … beyond the limits of dimensions and unique qualities.

We must not fear the advent of a new era in art.

We must make room in our minds for new themes, consistent with and enhanced by technological advances, which will require a new aesthetic to incarnate them in the astonishing artworks of the future.

To lay the groundwork for these is the great and sacred duty of any individual that would presume to call himself an artist.[100]

The fate of the Telekinema was a disappointing one, especially for Wells Coates, who tried on various occasions throughout his life to revive it with ambitious business plans, but to no avail. The Telekinema was a popular attraction when the Festival concluded; it was transformed into the National Film Theater (NFT). But in 1957, when the NFT was relocated, the building was demolished.

4 Terre des Hommes / Man and His World: Expo 67 as Global Media Experiment

If national dreams are obsolete and only a global vision of improvement now is viable, who can quarrel with Buckminster Fuller's assertion "that man on earth is clearly faced with the choice of utopia or oblivion."

—Herbert I. Schiller, "The Slide toward Violence in the Hungering World"

Expo 67, held in Montreal, Quebec, to celebrate Canada's centenary, located its identity in the futuristic architectures of space exploration and communications media. During the Cold War, MoMA, under the auspices of the USIA, exported one fantasy of global humanity—Steichen's "Family of Man" to countries in Europe, Asia, and Latin America. At the same time, another fantasy of global humanity was taking shape. Just as footage and photographs of the H-bomb test in the Pacific were being, respectively, broadcast on American television and circulated in magazines around the world, Walt Disney's Tomorrowland, a theme park devoted to a vision of the future, opened in Disneyland in 1955, offering a more reassuring conception of science. *Man in Space* (1955), a short documentary film that was part of a popular-science series produced by Disney for the ABC television network, presented the projected future of space travel (enabled either through chemical fuels or atomic energy) and featured, along with other scientists, the Nazi rocket designer Wernher von Braun. A very Americanized Von Braun spoke directly to the camera, asking for the public's support in funding a new science program that would (most probably) be able to offer space tourism within the decade. With humorous cartoons about weightlessness and the challenges of living in space, Disney's television program helped to domesticate and materialize the imaginary representation of space exploration. Though Von Braun's direct appeals were unsuccessful in 1955, the "space race," inaugurated by Sputnik's successful orbiting of

the earth in 1957, secured him a central position in the development of the US space program.

One year after Sputnik's triumphant orbit, the United States and the USSR signed a bilateral agreement for an exchange of national exhibits featuring their developments and accomplishments in science, technology, and culture. The Soviet Union's exhibit would occupy the New York Coliseum, and the United States agreed to build an exhibition space in Moscow for its own exhibit. Intended to present an image of the United States and the American way of life to Soviet citizens, the American National Exhibition in Moscow, organized by Harold McClellan and held in 1959, equated freedom with consumerism, commodity culture, and the typical American family. In the context of new forms of international competition within an emerging global economy, far surpassing the photographic representation of humankind's unity promoted by Steichen, the exhibition's defining symbol of American affluence was expressed in innovative forms of electronic media. "The Family of Man," which was included in the Moscow exhibition, was effectively upstaged by films and "events." These included Buckminster Fuller's two-hundred-foot, gold-anodized geodesic dome; multiscreen projects such as Walt Disney's *Circarama*, a twenty-minute, 360-degree motion picture featuring American cities and tourist attractions, first presented at the 1958 world's fair in Brussels; and Ray and Charles Eames's 35mm film *Glimpses of the USA*, which was projected on seven twenty-by-thirty-foot screens suspended inside Fuller's dome. Although Steichen's exhibition, influenced by Herbert Bayer's Bauhaus theories, had created installations that decentered a mobile gaze, static photographs were simply unable to compete with the dynamics of multiscreen projection. While both Disney's and the Eameses' films offered Soviet audiences a portrait of the United States, *Glimpses* did more than merely envelope spectators in American landscapes. It literally encapsulated the forms of technological sensing—telescopes, radar, microscopes, aerial photography, night vision, etc.—that had been developed during World War II, and incorporated some 2,200 photographs and films that "illustrate[d] such aspects of daily life as where Americans live, work and play, how they get around, what they eat, and how they dress."[1] The Eameses' film brought together a dynamic collage of images that, as Beatriz Colomina has argued, was consolidated into a "hyperviewing mechanism that is hard to imagine outside the very space program the exhibition was

trying to downplay."[2] Rather than simply presenting a way of seeing the world, the Eameses' multiscreen experiment gave form to a mode of perception associated with both the atomic bomb and Sputnik—the capacity to transcend physical boundaries absolutely. George Nelson, the exhibition designer for the American Exhibit in Moscow, described the creation of an atomic mentality: "The Bomb was programmed, designed, built, and exploded by people who presumably knew exactly what they were doing. It is, I think, this new sense of intellectual mastery over the physical world that is making us so acutely and unhappily aware of the world over which seemingly we have no mastery at all."[3] Such a contradiction—a contradiction that facilitated death at a distance—was already apparent to Steichen in the concrete abstraction of aerial photography during World War I. It was this experience that had planted the seed for "The Family of Man."[4]

Although it relied upon different media, the Montreal world's fair—known as Expo 67—extended both Steichen's humanist aspirations and Jacques Cousteau's ecological ambitions by creating a planetary media experiment with a variety of screen and communication technologies. Indeed, Expo 67 boasted one of the first satellite-assisted world broadcasts for its opening ceremonies, just a few months after the BBC's 1967 global satellite broadcast, *Our World*.[5] Not surprisingly, both Steichen's "Family of Man" (the traveling version) and Cousteau's famous underwater saucer, the "soucoupe," and unseen footage from his early underwater films, along with a live performance by a deep-sea diver in a water tank (located in the "Man in the Arctic Region" Pavilion) were iconic events presented at Expo 67.

The notion of the "biosphere," developed by the Russian geochemist and mineralogist Vladimir Vernadsky, which influenced both Buckminster's geodesic dome and Marshall McLuhan's notion of a "global theatre,"[6] was a symbolic aspect of Expo 67's environmentalism. This environmentalism was articulated through a number of architectural and media experiments at the exposition. Though Vernadsky spent many years developing the concept—he had worked on it since World War I—his account of the biosphere and the noosphere as a new planetary phenomenon of interconnection was not published in English until 1945. As I discussed in the second chapter, Vernadsky argued that "the evolution of living matter" had created a new, shared consciousness that would increasingly recognize the

interdependence of human and nonhuman forms of life on the planet. Importantly, Vernadsky's ideas were tied up with his research into nuclear energy, which he believed would be used to harness great energy for the world and to support world peace. These ideas were certainly central to the Science Dome at the Festival of Britain, but due to the theme of Expo 67—"Terre des Hommes / Man and His World"—energy was communicational, ecological, and ephemeral.

The theme "Terre des Hommes / Man and His World" was taken from the title of a 1939 novel by French writer and pioneering aviator Antoine de Saint-Exupéry, famous for his subsequent book *The Little Prince* (1944). Saint-Exupéry was a reserve pilot for the French military during World War II. His *Terre des hommes* won the grand prize from the Académie française in 1939, and an adaptation for an American audience published in the United States under the title *Wind, Sand and Stars* won the National Book Award. A memoir of his years flying over the African Sahara and the South American Andes as an airmail carrier for Aéropostale, the book's chapters are united by Saint-Exupéry's experiences of the earth's various landscapes. The book's most dramatic episode, based on Saint-Exupéry's actual experience, is a plane crash in the Sahara; crashing somewhere between Benghazi and Cairo, Saint-Exupéry and his mechanic, André Prévot, barely survived. Near death, they were rescued by a Bedouin tribe. This experience so deeply moved Saint-Exupéry that it formed the center of his reflections on life, friendship, humanity, and peace, along with his conception of the earth's diverse cultural and natural ecologies. This formative experience was, of course, a result of and mediated by the technology of aviation. Saint-Exupéry's abstract view of space and disembodied experience of time was very different from that of wartime aerial photography that haunted Steichen. It was a humanist vision of a shared world, a world without borders, which perfectly encapsulated the sensibility of Expo 67's whole-earth mentality.[7]

With attendance at just over fifty million, Expo 67 was one of the most successful world expositions ever held.[8] Although it may well be true that world expositions serve as training grounds for commodity consumption in ways that "raise spectatorship to a civic duty,"[9] Expo 67's spectacular showcasing of audiovisual technologies distinguished it from all previous expositions. Space exploration and communications media (especially satellites and television) were one and the same at Expo 67. American film

and media scholar Gerald O'Grady maintains that Expo 67 represented the most important artistic experiment of the twentieth century—a harbinger of the digital era to come, and a precursor to the multiplication and interconnectedness of screens that characterize twenty-first-century digital architectures.[10] More than three thousand films were produced for the event, and several film festivals, including the Montreal Film Festival and a student film festival, were connected to it. Moving pictures were presented in approximately 65 percent of the pavilions and complexes, many of which dazzlingly displayed a new flexibility of the screen and the new synesthesia of visual cultures of the world as mediated by technology in the 1960s. As Judith Shatnoff has described it, "Film came on two screens, on three, five, six, nine in a circle, 112 moving screen cubes, a 70mm frame broken into innumerable screen shapes, screens mirrored to infinity, a water screen (at the Kodak pavilion), a dome screen."[11] New names were invented for these proliferating screens: Circle-Vision, Polyvision, Kino-Automat, Diapolyecran, Kaleidoscope. While the 1964 New York World's Fair had presented dozens of multiscreen projections (including *Glimpses of the USA*, which was projected on fourteen screens at the IBM Pavilion), nothing that had come before compared to Expo 67's reinvention of screens and theaters to accommodate new forms of projection and spectatorship. In his book *Remember Expo: A Pictorial Record*, Canadian critic Robert Fulford commented that Expo 67 changed not the way films were *made*, but the way they were *seen*.[12]

This chapter deals first with the architectural conception and overall design of Expo 67 in terms of a postwar humanist approach to architecture and urban planning, and, second, closely examines one of the most complex of the multiscreen pavilions at the Expo—Labyrinth/Labyrinthe, designed by Colin Low and Roman Kroitor, both of whom were established documentary film directors at Unit B of the National Film Board of Canada (NFB). With the Labyrinth project, Low and Kroitor proposed an audiovisual experience that they believed could—by creating a new medium—transform the future of cinema. This expanded form of cinema did, in fact, provide the basis for the subsequent development of IMAX, by Kroitor and Graeme Ferguson three years later for the Osaka Expo in 1970, and IMAX 3D, by Colin Low for the Vancouver Expo in 1986. Gene Youngblood theorized the new media language created by many of the film experiments at Expo 67 as "expanded cinema."[13] He argued that these expanded cinema

experiments sought to create a communicative bond with viewers by using multiscreen technology to s(t)imulate a state of mind.

Like all world expositions, Expo 67 was driven by the broader economic and political interests of globalization.[14] Yet perhaps the utopian energies of *mondialisation*[15] were particularly strong at Expo 67 because it not only coincided with, but arguably, enabled the birth of Quebec nationalism. Inherent to Expo 67 as well was the emergence of a global ecology, informed by the technological humanism expressed in the utopian thinking of Buckminster Fuller and Marshall McLuhan. Indeed, because of its emphasis on expanded media, Expo 67 was dubbed "McLuhan's fair."[16]

In terms of Karl Mannheim's theory, discussed in the previous chapter, that utopian consciousness is "wishful thinking," Expo 67 can certainly be read as a utopian undertaking: it was process-oriented, experimental, and pedagogical. Mannheim's notion of utopian consciousness as "wishful thinking" dovetails nicely with Umberto Eco's theory of expositions as "teaching machines," a theory inspired by Expo 67. In a review of this exposition for the journal *Dotzero*, Eco differentiated modern expositions of nineteenth-century industrial society from the collections of an earlier era—royal and state collections, museums, *Wunderkammers*. Eco argues that these premodern collections can be seen to exhibit a kind of "apocalyptic insecurity," guarding the past against impending oblivion by means of collecting.[17] The expositions of the nineteenth century—a product of industrial capitalism in which commodities were displayed in order to be fetishized rather than exchanged or used—were, on the contrary, future-oriented. As Marx so astutely described it, in their displays of accumulated goods, the "mystical veil" of the commodity defined those early exhibitions.[18] The expositions of the twentieth century went further, inventing a new form. While earlier fairs had broken ground in terms of architecture— the Eiffel Tower, the Crystal Palace, and the Ferris wheel, all of which negotiated coherent views for visitors amid vast displays of goods—the modern exposition used goods "as a pretext to present something else. And this something else [was] the *exposition itself*." In other words, "the exposition exposes itself."[19] Architecture thus became the preferred medium with which to communicate national identity. The exhibition of national identity and economic strength has been the organizing principle for world's fairs and expositions since their inauguration in England in 1851 in the Great Exhibition of the Works of Industry in All Nations, which was held

in the Crystal Palace in Hyde Park. This exhibition was a precursor to the modern museum as well as offering a global economic stage for the marketing of industrial commodities.

While Eco's theory of expositions provides us with insights into the importance of architecture as a medium both utopian and pedagogical, it fails to grasp the uniqueness of Expo 67 as a "world city" which made an explicit link between media and urban space. It is the mixture of media and urban technology designed on a large scale that distinguishes the modern exposition, and Expo 67 in particular, as an ecstatic world. I define such a world in terms of its exorbitant nature, its potential or aspiration to be universal. As we saw in the previous chapter, although the Festival of Britain celebrated Britain and its history while also recognizing the importance of planning for the future in a globalizing world, its scope was narrowly defined. The Telekinema was extraordinary because it served to connect the people of Britain. Expo 67 as we shall see, took as its mandate the interconnectivity of the earth and transformed it into one world possessed by humans—*Man and His World*.

Humanism and Architecture

Some filmmakers who participated in Expo 67 offered a number of striking observations when interviewed over the course of a research project, "The Films of Expo 67," between 2010 and 2013.[20] The first is that they did not regard the exposition as a commercial undertaking; indeed, as a Category One designation, it was not a commercial or specialized exposition but was intended for the international community. Consequently, many artists experienced it as the last great utopian exposition. Of course, commercial and government interests were present at Expo 67, but the fact that participating artists were not used by corporations to showcase their latest technology was conducive to experimentation.

Secondly, as Donald Theall's report on the exposition's media experiments highlights, Expo 67, unlike its predecessors, demonstrated in McLuhanesque fashion that "the medium is the message." Theall, a professor of English at McGill University in Montreal at that time, and a longtime student and collaborator of McLuhan, was sensitive to the landmark nature of media at Expo 67. As a student of McLuhan at the University of Toronto in the 1950s, he participated in the Explorations seminar (1951–1953), a

think tank inspired by the work of Sigfried Giedion and Harold Innis. As Theall notes, the Expo 67 theme "Terre des Hommes / Man and His World" was intended to foreground a new humanism made possible through technology. Quebec writer Gabrielle Roy, who assisted with the selection of the theme, maintained that it was concerned to express a collaborative and cooperative vision:

These words would be heard throughout the world, drawing people everywhere to the concept and vision of humanity united. ... This would be its distinct and personal share in the common effort of the seventy-odd countries that would join with us to create Expo 67. The theme pavilions, with consistent emphasis on the idea of human interdependence would then form the hub of the great wheel of men and nations. We also wanted to invite the participating countries to collaborate on the theme itself. At any rate, since this was *Man's Earth*, belonging to everyone, we thought it desirable that contributions to the project should blend, complement one another, forming one complete whole, like perfectly balanced instruments of an orchestra.[21]

Expo 67, not unlike "The Family of Man," was divided into universal themes: "Man the Explorer," "Man and His Community," "Man and His Health," "Man the Creator," "Man the Producer." But the unifying principle was not simply the world of Man; it was also Expo 67 itself as a city of the future—as a world city. Instead of multiple interpretations of an overarching theme, Expo 67 was designed as a "total environment; as a "city," it was conceived as a total work of art or, as Henri Lefebvre characterized it at the time, as an oeuvre rather than a mere collection of pavilions. This oeuvre was the planet earth itself—*terre des hommes*; literally, man's earth. Visitors to Expo 67 were issued passports instead of tickets to the event, which were stamped at the entrance to the various national and cultural pavilions, transforming attendees into global citizens. This global citizenship enabled visitors to experience the multiplicity of the world—a festival of cultures displayed through a diversity of foods, music, clothing, art, and cultural artifacts, alongside an extensive exhibition of public sculptures in the common spaces and rest areas throughout the site.[22]

As a future-tense city, Expo 67 was described as cinematic, its structures made of webs and screens that refracted and reflected images, bodies in movement, and atmospheric variations. Indeed, its chief architect Edouard Fiset's proposal—the "master plan design intent"—recommended that designers and architects explore new possibilities of webs and filmlike materials. Frei Otto's groundbreaking tent architectures for the West

German Pavilion, made with newly available polyester materials draped over a net of steel cables and held in place by eight columns, found an eloquent expression for this idea.[23] Otto, who like Fuller was a utopianist intent on making buildings for poor people in difficult circumstances, spent his career creating lightweight architecture. Because so many pavilions were constructed with such materials, creating structures that could be dismantled and transported, Expo 67 was called the "Space-Frame Fair." This quality of the immaterial, the impermanent, the nonlinear, and the ephemeral gave Expo 67 its modern, futuristic sheen, which mirrored the recent, dematerialized commodity culture of North America.[24] The monumentality of earlier world expositions—described by Tom Gunning as "disposable imperial cities, expressing man's dominance over the earth"—was thus not to be found at Expo 67.[25] Instead, we find the flexibility of a city in movement.

Unsurprisingly, transportation and the orchestration of traffic were key components of Expo 67's plan, with trains linking vast areas of the complex site; a particular highlight was the entrance of the train into the geodesic dome. The train system presented a complicated network of movements and connections, operating at different heights and speeds, which offered riders a variety of views and vistas.[26] Expo 67's thousand acres and two manmade islands (Île Notre-Dame and Île Sainte-Hélène), built on the Fleuve Saint-Laurent, constituted something unique in urban design. Albert Rorai's internal report on "Architecture at Expo 67" highlights the comments of many critics on the beauty of the site: "To avoid the clutter typical of many exhibitions, and to create broad vistas, Expo has taken a town planning approach. Four separate areas were laid out, each having its own distinctive character. ... Lakes, ponds, lagoons, and the Saint Lawrence divide the site, affording many varied perspectives. One feature of the site planning was the use of water, an element that gives visual unity to the diversity of the architecture and landscaping."[27] Indeed, architects were required to use 40 percent of their sites for landscape to provide green space around and inside the exhibition. Unlike previous expositions, Expo 67 created a unified system of signs, designed by Paul Arthur, which both promoted and enacted a new global sensibility. This novel signage, along with urban furniture designed by Luis Villa (lighting, benches, phone booths, and trash cans), produced a distinct and unified visual culture.

Arthur, who had worked in Switzerland as an assistant editor at *Graphis*, an international journal of visual communication, in the 1950s, had moved into the emerging field of environmental graphics and way-finding in three-dimensional space when he returned to Canada. For Expo 67, he used a systems approach to graphics and signage, designing his signs according to the International Style in graphic typography, which had grown out of the Bauhaus's New Typography.[28] Arthur's conceptualization was also influenced by the work of Rudolph Modley, who had developed a practice of graphic design in the United States based on Otto Neurath's psychological principles for a universal system of symbols.[29] Although Expo 67 helped to inaugurate Canada's policy of bilingualism, officially adopted in 1969 (the word "Expo" was used because it compressed French and English), the exposition developed a system of icons that, in fact, minimized or superseded language.

Theall's extensive report on Expo 67 argues that it was designed, in Bauhaus style, as a "total environment."[30] As a city of the future, it encompassed the Constructivist principles laid out by Walter Gropius in "Idee und Aufbau des Staatlichen Bauhauses" ("The Theory and Organization of the Bauhaus"): "The old dualistic world-concept which envisaged the ego in opposition to the universe is rapidly losing ground. In its place is rising the idea of a universal unity in which all opposing forces exist in a state of absolute balance. This dawning recognition of the essential oneness of all things and their appearances endows creative effort with a fundamental inner meaning. No longer can anything exist in isolation."[31] The Montreal fair manifested this holistic thinking in its reconstitution of the relation between screen and architecture—not only reconfiguring the screen *as* architecture, but importantly, using architecture as screen in order to effect "total architecture," to use the term coined by Gropius and Bruno Taut in the 1920s. This approach to spatial planning, which was inspired by the concept of *Gesamtkunstwerk*, incorporated all of the arts and crafts, and opened them up to the projections and imaginings of citizens. Thus, central to the humanism at the heart of Expo 67's design aesthetic was the idea of an integrated environment—that is, one in which architecture extended beyond buildings into environments and screens that were inherently architectonic.

Classic depictions of dehumanization often position the cinema screen as precisely that which alienates humans from the social fabric of everyday

life. Think, for example, of Fritz Lang's massive screens in *Metropolis* (1927) or the "telescreen" in George Orwell's *1984* (1949)—in both instances, social control is encapsulated by the image of the screen. Expo 67's image of the screen, on the contrary, was not that of a closed circuit, but one of open, intercultural connectivities located in an excess of visual media: a plethora of experimental films that communicated through images and sounds rather than printed or spoken language.

Expo 67 reflected certain trends in international art and architecture of the 1950s and 1960s. As discussed in the previous chapter, these trends were first articulated at CIAM 8, the eighth meeting of the Congrès Internationaux d'Architecture Moderne. The congress, founded in Geneva in the late 1920s by Le Corbusier and Sigfried Giedion, held its eighth iteration in 1951 in Hoddesdon just outside of London, England. Coinciding with the Festival of Britain, the congress addressed Europe's postwar needs of redesigning and rebuilding war-torn cities. Town planner Jaqueline Tyrwhitt was one of the organizers of the congress, and was also involved in creating the town planning exhibit, "Live Architecture," at the Festival of Britain. CIAM 8's great contribution to the discourse on urban planning and, I would argue, to novel experiments in the urban media ecologies that were articulated at Expo 67 was to consider the space of the city as an interactive medium—a dynamic environment of interdependent parts. Expo 67 was an island city designed precisely for such interactive networks and forms of circulation between the built environment and media of all kinds—sound, television, photographs, and film.

Although Tyrwhitt did not participate directly in the planning of Expo 67 (she was advising on a new planning program in Singapore),[32] she nevertheless served as a link between CIAM 8 and the exposition. She was a close collaborator with both McLuhan (as part of the 1951–1953 Explorations seminar studying media effects)[33] and architect John Bland, who was instrumental in designing the building in which *Labyrinth/Labyrinthe*, one of Expo 67's major film events, was housed. Bland also mentored Moshe Safdie, the architect of Habitat, which along with R. Buckminster Fuller's geodesic dome and Frei Otto's tent architecture were, without doubt, the central symbols of Expo 67's humanist conception of integrated urban planning.[34] Just as the city was being reconceived as a dynamic interactive artwork, so too were media experiments being conceived in terms of networks and environments. This radical reconceptualization belongs to the

rich history of the mutual influence of urban planning and media practices that we can trace back to the Bauhaus.[35] According to McLuhan, a new sense of "auditory" or "acoustic" space could be attributed to electric culture. In a letter to Tyrwhitt on May 11, 1964, McLuhan writes:

Last night I was reading Finnegans Wake pages 492 to 505. I thought at once of writing to Giedion about it. In these pages Joyce runs through the letters of the alphabet from A to Z as a social cycle. When he gets to Z, the cycle begins again. He explicitly indicates the return to primal undiscriminated auditory space, then begins again the discovery of the vertical plane and enclosed space and numbers and measurement. Joyce is quite explicit that as the alphabet ends its cycle we move out of visual space into discontinuous auditory space again. This he mentions as the return to "Lewd's Carol," that is, through the looking glass into the world of non-Euclidean space once more, lewd, ignorant, tribal, involved totally as in group singing. In his "Beginnings of Architecture" Giedion cites the evidence several times that there is no architectural enclosing of space before script. Giedion does not know why this should be. Visual space alone of all the space discriminated by our various senses is continuous, uniform and connected. Any technology that extends the visual power imposes these visual properties upon all other spaces. Our own return in the electric age to a non-visual world has confronted us suddenly with this tyrannical and usurping power of the visual over the other senses. Kevin Lynch doesn't understand this matter at all. My own phrase for city planning is that the city has become a teaching machine. The planner's job is to program the entire environment by an artistic modulation of sensory usage. Art is a CARE package dispatched to undernourished areas or the human sensorium. What the artist has formerly done on a private entrepreneurial basis the planner now must do on a corporate or group basis. This is equally true of education and government. Instead of worrying about program content, the job is now to program the total sensorium.[36]

McLuhan's book *Understanding Media: The Extensions of Man* was about to be published, and certainly what he wrote in this letter to Tyrwhitt contains many of the ideas that he was putting forward in the book about media and space. There is a sense in what he wrote that with the multiscreen projects, filmmakers were reprogramming the human sensorium.

Mind-Expanding Screens

The relation between screen and architecture—the screen *as* architecture— was integral to the humanist design of Expo 67. Far from dehumanizing, Expo 67's image of the screen was liberatory and expansive. Fuller, whose architecture was a revelation for many of Expo 67's multiscreen

experimenters,[37] wrote the wonderful introduction to Gene Youngblood's book *Expanded Cinema*. Fuller's planetary vision of "earth space" challenged the conventional, partitioned view of the earth as static parcels of property, a view based on a two-dimensional image of the world that excluded the space above the ground, that is, the universe. To that limited view, Fuller counterposed Einstein's larger idea of a complex of frequencies, waves, broadcasts, and instantaneous communication within the context of a nonlinear universe. For Fuller, Youngblood's book was important because it invoked the "Scenario-Universe principle": "A scenario of non-simultaneous and only partially overlapping transformative events." Most valuable for its educational potential, synesthetic art such as that at Expo 67 promised to synchronize the senses and humankind's knowledge in sufficient time to ensure "the continuance of the ... Space Vehicle Earth."[38] New ecological art forms would ultimately lead to the "Expanded Cinema University," that is, to universal knowledge.

Fuller's first successful geodesic dome was built in Montreal in 1950 by the Canadian division of the Fuller Research Foundation. After his dome's "glittering career as a trade-fair pavilion," the opportunity to return to Montreal inspired Fuller to create his most sensational dome—a three-quarter sphere with a 250-foot-diameter sealed with a transparent skin of acrylic glass panels. Retractable indoor sunshades, which controlled the light by means of a computer that adjusted them according to the sun's position, made the dome into an active sculptural projection.[39] Inside the dome, large-scale paintings by Andy Warhol and Roy Lichtenstein were installed alongside artifacts from an Apollo spacecraft (a space suit, a parachute, and parts of the craft itself). Importantly, a painting by Jasper Johns of Fuller's icosahedral Dymaxion Air-Ocean World Map—a map that does not distort the polar regions and that, like his dome, corresponds to the shape of the earth—helped to illustrate the vision of the earth represented by the dome.

Just as Fuller's geodesic dome was designed for a world in movement (that is, for new forms of mobility), so too was synesthetic cinema designed for process-oriented, decentered experiences. The notion that film technology could create an expanded consciousness for the new age of simultaneity was repeated in a number of experiments at Expo 67. The cover story of the July 14, 1967, issue of *Life* magazine, "A Film Revolution to Blitz Man's Mind," described a revolution that "showed us the future": "London's

Crystal Palace in 1851 did this with iron and glass architecture, the Paris 1889 fair with steam engineering, the 1904 St. Louis Fair with the auto. Expo 67 does it with film and, through images that assault the senses and expand the mind, explodes the world into a revolution in communications."[40]

Expo 67 offered a plethora of new forms of participatory multiscreen cinema. *Canada 67*, a film by Robert Baclay produced by Walt Disney Studios shown in the Telephone Pavilion, was among the most spectacular and nationalistic of these. Using a nine-camera apparatus (larger than any of Disney's previous circular films) to create a 360-degree Circle-Vision screen, the spectacle enveloped 1,500 viewers at a time. Beginning on Canada's East Coast with the Royal Canadian Mounted Police, Baclay's twenty-two-minute film featured Quebec's Winter Carnival, a Toronto Maple Leafs hockey game, the Wild West, and many of Canada's national parks. The Canadian Pacific-Cominco Pavilion's *We Are Young*, by filmmakers Francis Thompson and Alexander Hammid (who also made the award-winning film *To Be Alive* for the 1964 World's Fair in New York), used six screens for a documentary about the trials and tribulations of life as a teenager. *Polar Life*, by Graeme Ferguson, featured eleven screens, three of which were visible at a time to viewers seated in the revolving theater set on one large turntable. Perhaps the most theatrical presentation, and certainly one of the most popular, was the Czechoslovakian pavilion's *Kino-Automat* (Movie vending), which used three screens and incorporated live theater. Devised by cinematographer Raduz Cincera, *Kino-Automat* invited each audience member to vote on the actions to be taken by the characters in the film by pressing either a red or a green button in front of them. An actor from the film emerged on stage at various points and asked the audience to vote. The voting itself was a ruse, and although each putative vote offered two choices, all paths led to the same outcome. Cincera intended this illusion of interactivity as a comedic comment on democracy.[41]

Expanded cinema at Expo 67 also experimented with compression within the image. Christopher Chapman produced *A Place to Stand*, a film that compressed seven hours of filming into an 18-minute film. Optically printing multiple frames—as many as fifteen—inside one frame, Chapman created an innovative split-image film of tremendous beauty. The rhythmic juxtapositions of images of industry in Ontario created a new form of montage, garnering an Academy Award for Chapman and influencing numerous split-screen films of the period.

Figure 4.1
A still from Christopher Chapman's 1967 film *A Place to Stand*, showcasing its "multi-image" effect. Credit: *A Place to Stand,* 17 mins, 70mm, color, English. Directed by Christopher Chapman. Produced by Christopher Chapman and David Mackay.

Many of the multiscreen filmmakers at Expo 67 developed complex working strategies for shooting and editing multiple-screen events. It is important to remember that these experiments were undertaken before the development of digital editing systems and the flexibility they provide. Chapman, for example, relied upon detailed sketches that juxtaposed sequences of images, visualizing how the materials would work together before sending them to a lab in Los Angeles where they were optically printed. Maquettes were built for many of the projects in order to experiment with projection and to anticipate effects. Ferguson built a special slide rule that enabled him to foresee what audiences would see in his eleven-screen theater. While the films at Expo 67 did indeed change the way films were seen, they also changed the way they were made.[42]

Influenced by both McLuhan and Fuller, as well as by the multiscreen experiments at Expo 67, Gene Youngblood posited synesthetic cinema as a new, revolutionary art form. In the age of "cosmic consciousness," in which intuition and reason were joined once more,[43] Youngblood theorized that the role of cinema was to approximate consciousness, which he defined, in accordance with the philosopher and historian R. G. Collingwood's specification, as "the kind of thought which stands closest to sensation or mere feeling." All thought, according to Collingwood, grows out of sensation

and "deals with feeling as thus transformed into imagination."[44] Not simply static, consciousness was understood to be in the process of expanding through technology; as Youngblood put it, "This consciousness expansion is created on the one hand by mind manifest hallucinogens and on the other by a partnership with machines." Synesthetic cinema, "with its multidimensional simulsensory network of information sources," provided the only language suited for a postindustrial, postliterate age. An increasing number of people, wrote Youngblood, were living in another world, and synesthetic cinema belonged to that countercultural world, a world that was "other" to commercial media.[45]

The multiscreen form had existed at the turn of the twentieth century. One of silent cinema's most monumental and extraordinary attempts to deconstruct the colonizing effects of monocular vision was Abel Gance's *Napoléon vu par Abel Gance* (1927). Gance's spectacular Polyvision—superimpositions and multiple frames within frames, for example, projected across three screens—sought to delinearize and extend cinema's sensational spatial and temporal capabilities and, at the same time, to problematize historical narration. It embodied a field of vision that gathered together vast heterogeneous spaces under the rubric "vu par." Separate from the history they recount, the images typify the "art of film" and foreground the visionary "auteur" at the height of cinematic expressionism.[46]

We may well wonder why multiscreen experiments such as those mounted at Expo 64 in New York, and especially Expo 67, reappeared so forcefully in the 1960s. The answer is simple, according to Youngblood: "television is the software of the earth."[47] Rendering film obsolete as a documentary technology, television both shifted film into and helped to consolidate the "intermedia network" of magazines, books, radio, recorded music, and photography. Cinema screens became architectonic because of television's self-reflexive ubiquity—televisual images have no outside or inside: "The videosphere is the noosphere transformed into a perceivable state."[48] It is not that the screen disappeared; rather, the screen as support was materialized as an object alongside or within another screen, ad infinitum.

From his 1962 book *The Gutenberg Galaxy* onward, McLuhan argued that the media of the postwar period had created a new "electric" environment. If the "medium is the message," the screen, and the building that houses the screen, and the city that houses the theater are all part of

the ever-expanding and imploding picture of the earth that Sputnik had delivered to television screens across the world. Though there were screens within screens in the history of cinema, multiple screens and video walls became a common prop in the popular (especially American) television culture of the 1950s and 1960s. Science fiction space-travel programs and spy serials often used television monitors to connote the surveillance and high-tech control of space.[49] This use of the screen marked a fundamental shift in the popular imaginary toward understanding simultaneity as space to be controlled. In *War and Peace in the Global Village*, McLuhan declared: "As visual space is superseded, we discover that there is no continuity or connectedness let alone depth and perspective."[50] Space thus becomes acoustic (space-time). While the filmmakers of the Labyrinth project sought to control simultaneity, they also aimed to give filmgoers a profound mind-altering experience of it.

Labyrinth/Labyrinthe (the Film)

The idea of cinema as environment was intrinsic to the Labyrinth project. Unlike other film events at Expo, the film *Labyrinth* boasted its own specialized building and environment. The influence of television on the NFB's Unit B directors, including Colin Low and Roman Kroitor, is well known. The shift from theatrical to nontheatrical distribution of NFB films in the early 1950s began a relationship with television that would change the way documentaries were made. Not only was there a need for more films, but they also had to be produced more rapidly. The NFB was faced with increasing demand for material that explored everyday Canadian realities. Essentially, when the Film Board began to produce content for the Canadian Broadcasting Corporation (CBC), Unit B in particular, beginning with *The Candid Eye* series, started to make short documentaries for television. These films, akin to Kracauer's "found stories"—stories with an "anonymous" core and without beginning, middle, or end[51]—were heavily influenced by the realist aesthetics of Henri Cartier-Bresson, according to which everyday life is revealed photographically and phenomenologically in a "decisive moment."[52]

One fact that often goes unrecognized is the NFB's substantial technological innovations in the areas of sound recording, film cameras, and projection.[53] All of these contributions were geared toward greater mobility

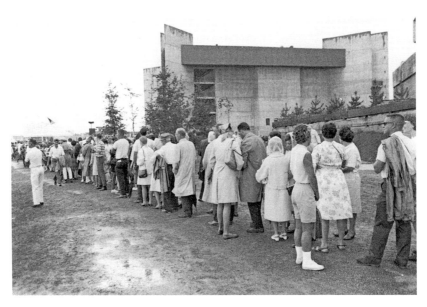

Figure 4.2
An exterior view of a crowd lining up outside of the Labyrinth Pavilion before a screening at Expo 67. Credit: In the Labyrinth © 1979 National Film Board of Canada.

of the camera, for both animation and live-action shooting, and greater mobility of film exhibition. One of the most important innovations in this "quest for mobility," as Gerald Graham has called it, was the synchronous sound-recording technology produced in 1955, which enabled greater flexibility in location shooting and helped to consolidate the NFB's reputation in direct cinema.[54] The second and equally important innovation, pioneered for Expo 67, was the development of large-screen projection using 70mm and 35mm film, which eventually evolved into IMAX's 70mm film projection. For the Labyrinth project, the NFB constructed a synchronous multicamera shooting apparatus—five Arriflex cameras mounted in a cruciform shape. The cameras could be operated together in various combinations. The films were then projected using five synchronized projectors arranged in a similar configuration. Both the camera and projection apparatuses adapted the principles of television-studio switching technology to enable greater flexibility in filming simultaneous actions.

Thus, the NFB's innovations expanded cinema in two distinct ways. Their innovation in sound recording expanded the content within the

frame; no longer tied to the studio, the camera and sound-recording apparatus were set free to document the outside world, thereby collapsing the division between outside and inside. Their second innovation, which built on the first, was the expansion of the screen itself, which set the spectator free, immersing him or her in a new cinematic architecture that offered multiple and individualized views on screens that exceeded any one person's perspective or viewing capacity.[55] Both of these innovations resulted in greater participation by and interactivity between filmmakers and spectators. Without doubt, this increased mobility and expansion, the opening up of new spaces of apprehension, was tied to the contradictory forces of capitalist media expansion in general, which simultaneously produced greater democracy in image production and consumption, and greater social and economic control of images themselves. This consolidation of media ownership is nowhere more visible than in the twenty-first-century multiplatform environments—which give viewers greater choice in the context of a fierce media oligopoly.

Both Low and Kroitor believed that the synesthetic cinema they designed for Expo 67 constituted a new medium that could revolutionize visual culture. *Labyrinth* originated from Colin Low's idea for an *in situ* film: "The audience walks through a door into a darkened room and everything is subdued. Suddenly, the room lights go out and they are standing on a glass floor looking down 1,000 feet into the middle of Montreal."[56] The first image was this aerial view of the city above which the audience was suspended in space. Although the experiment didn't quite work (the sense of immersion the filmmakers wanted was not achieved), the entire structure of *Labyrinth* evolved from this idea of space travel, an idea they had pioneered in their earlier award-winning animated film, *Universe* (1960). Stanley Kubrick was so impressed by *Universe* that he invited Low to work on the design for his film *2001: A Space Odyssey* (1968). However, Low was unable to participate in Kubrick's film as he was then occupied with the Labyrinth project, which included the design of the building, the design of the different cameras and editing systems, and the overall interior design, and finally Kubrick's film took five years to make.[57]

Low had been interested in a 1958 novel by Mary Renault, *The King Must Die*, a popular reworking of the Greek myth of Theseus and the Minotaur, a half-man, half-bull creature that lived inside the labyrinth of Crete. By unspooling Ariadne's thread, Theseus made his way through the labyrinth

and slayed the Minotaur.[58] In consultation with Northrop Frye, Low and Kroitor used the story as a frame for a narrative about self-realization, wherein the beast to be conquered dwells within each of us. Their aim was to produce a "ritual" or "artistic" experience, to create a "state of mind." Like "The Family of Man," the Labyrinth project was based on and directed toward the commonalities shared by humankind. Low and Kroitor's production notes describe their methodology:

We are making a pictorial labyrinth of "life," as it now is on this planet. In a labyrinth, the point is to choose the path that leads to the goal, i.e., to avoid the false turns, the cul-de-sacs. In life, there is no way of knowing beforehand what these false turns may be before one gets into them. There is no royal road to wisdom. Only experience can teach that, if it ever does. The labyrinth we are making is therefore not with the point; "do this" or "do that." The only "guide" there can be in life is a state of mind. ... The point of the labyrinth is the discovery that such a state of mind exists. In order that this discovery can take place (to whatever degree), a journey is undertaken, in "ritual" form. By ritual form is meant that the participant partakes of certain experiences, but is not actually personally involved in them.[59]

The Labyrinth project thus adopted a "common" or "proto" story, structuring it as stages that corresponded to various "states of being," which the exhibition was designed to induce in its viewers.

Acting as a consultant to the project, Northrop Frye attended meetings at various stages of the project's development, and several of his essays appear alongside Tom Daly's production notes (Daly was the Labyrinth project's film editor). An excerpt from Frye's newly published book *Fables of Identity: Studies in Poetic Mythology* sheds some light on the objective of "artistic" experience. Referring to poet Wallace Stevens's speculations on the imagination, Frye explains that art is "a unity of being and knowing, existence and consciousness, achieved out of the flow of time and the fixity of space."[60] With its emphasis on multiplicity and facticity, Stevens's poetry illuminates the simultaneity and experiential quality of synesthetic cinema. These aspects are palpable in Stevens's "Thirteen Ways of Looking at a Blackbird":

The river is moving.
The blackbird must be flying.

It was evening all afternoon.
It was snowing

And it was going to snow.
The blackbird sat
In the cedar-limbs.[61]

So, too, the logic of the coming together of temporal flow and spatial fixity was manifested in the merging of architecture and cinema.

The architecture designed to house the multiscreen presentation was itself a labyrinth—a five-story, poured-concrete edifice with two viewing theaters (Chamber 1 and Chamber 3). Intended to effectuate disorientation and reflection, a transitional zigzag space—called "The Maze"—linked them. Working with John Bland's architectural firm, which also included Roy E. LeMoyne, Gordon Edwards, and Anthony Shine, with Harry Vandelman as project supervisor, Colin Low designed the building. The entire space was able to accommodate approximately 720 people at a time, and there were ten shows a day. The viewer's path through the space represented the thread of a person's life, from childhood through old age. The Expo 67 guidebook promised a visceral and unforgettable experience:

They [the spectators] will be distributed in groups through the three chambers, and at one stage will be surrounded by reflected images on all sides. At another point, they will gaze down from ramps on a huge screen 40 feet below and be subjected to sensations so strong that some will want to grab the handrail. Film for *Labyrinth* has been specially shot by cameramen in many countries. There are no name stars to this movie—the main character is Man! In the second chamber, visitors move along walkways set between mirrored glass prisms. In the final chamber, the audience faces a multi-screen battery of unparalleled scope—using five screens, so that areas of the mind are exercised that almost certainly have not been exercised before.[62]

Labyrinth proved to be one of the most popular highlights of Expo 67, with audiences waiting for up to seven hours to see the forty-five-minute screening.[63]

Chamber 1: Childhood, Confident Youth (70mm x 2)

The theater in the first chamber of the Labyrinth Pavilion was designed in a horseshoe formation, with the two screens arranged in an L shape, one vertically and the other horizontally. From four tiers of balconies on both sides of the chamber, viewers gazed out at a vertical screen that rose forty feet in height and looked down at a long horizontal screen on the floor. Five independent sound systems and 288 smaller speakers throughout the theater ensured that the sound amplified the visual and spatial

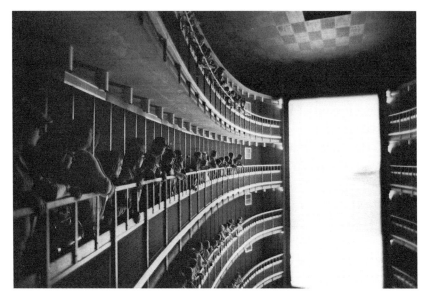

Figure 4.3
An interior view of the audience watching one of two fifty-foot screens in the first chamber of the Labyrinth Pavilion. Credit: In the Labyrinth © 1979 National Film Board of Canada. All rights reserved.

effects, and intensified the sensation of vertigo induced by having to look both up and down at the images. In fact, Chamber 1 so powerfully reproduced sensations of moving through space that NFB officials worried that the film might arouse anxiety, depression, or even suicidal feelings.[64] No such thing happened, but the possibility, of course, increased the excitement surrounding each screening.

Chamber 2: The Maze

"The Desert," also known as "The Maze," was to be, as Frye suggested, like "the city on a hot summer day."[65] Journalist Wendy Michener described the experience of it as akin to an "acid trip."[66] According to its designer, Colin Low, "[t]he maze was three prisms in an octagonal room full of mirrors on all the walls, floor and ceiling. The prisms were made of partial-silvered glass so when the lights were on the audience, it would be the audience reflected back to itself, and when the lights went off the audience and came on in the prisms, it made an infinity of stellar lights. A cosmos."[67] A zig-zagging passageway of mirrored glass, the maze featured an experimental

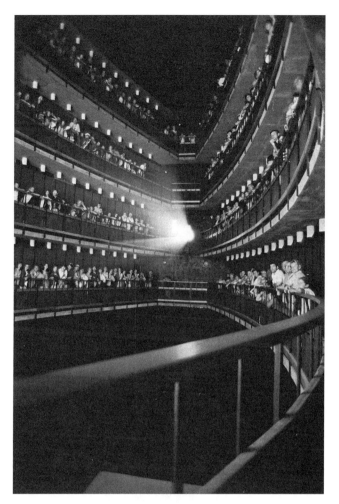

Figure 4.4
During a screening in Chamber 1, the audience watches a film from the venue's four stacked rows of elliptically shaped balconies. Credit: In the Labyrinth © 1979 National Film Board of Canada. All rights reserved.

soundtrack of electronic and animal sounds that triggered a multiplicity of flashing lights, which were reflected and transmitted by the glass. The installation was meant to disorient viewers, to dissolve boundaries between identities, between human and nonhuman, creating an endless, acoustic, decentered space. When briefly illuminated, a spectator's reflected image was dispersed across an infinity of spaces by the mirrors. Traversing the intimate corridor, viewers entered the final phase of their journey.

Figure 4.5
A couple pauses in Chamber 2's mazelike passage to examine the structure's two-way mirrors through which they can see thousands of small lights. Credit: In the Labyrinth © 1979 National Film Board of Canada. All rights reserved.

Chamber 3: Death/Metamorphosis (35mm x 2)

The third and final chamber resembled a standard cinema, with conventional theater seating. However, the images were projected onto five screens arranged in a cruciform shape—a reference to the tree of life—creating a stunning visual climax. Each of the films produced for Chambers 1 and 3 presented images from half a dozen countries and ran close to twenty minutes long. Including all ages, races, and genders, the films focused on cultural rituals and everyday gestures throughout the world: a crocodile hunt in southern Ethiopia, a baptism in Greece, a childbirth in Montreal, a ballet lesson in Russia, Montreal streets during a snowstorm, a traffic officer, commuters, landscapes. The soundtracks of both films included snippets of voice-over, recorded location sound, and a score composed by NFB staff composer, Eldon Rathburn. For each film, Tom Daly devised a special system of vertical editing that juxtaposed lengthy unedited sequences so as not to "oversaturate" viewers with too much information.[68] Therefore, scenes were sometimes continuous across several screens; in Chamber 1, for example, a boxer fell to the ground, dropping from the vertical screen onto the horizontal screen below. In another sequence, a child appearing on the upper screen fed a goldfish swimming on the lower screen. Actions were fragmented and repeated across multiple screens. Colin Low itemized the new compositional possibilities offered by this technology, declaring that the "ultimate image" would no doubt be "electronic, with stereoscopic images, perhaps ... holograms":

(1) flexibility in alteration of image composition;
(2) simultaneous representation of events:
 (a) different events occurring at different times or in different locations
 (b) different time segments of the same event, and
 (c) the same event seen from different positions and points of view;
(3) enrichment of image by juxtaposition of several elements of the same event or location;
(4) possibility of a kind of visual metaphor or simile; and
(5) representation of two or more events converging and merging into a single event or a single event fragmented into several images.[69]

Mentored by the NFB's chief animator, Norman McLaren, who had hired him as a summer intern in the animation department in the early 1950s, Low had earlier done extensive research into 3D film. Having produced a 3D film for the Festival of Britain in 1951, McLaren, according to Low, was "obsessed" with 3D and believed that it would prove to be the future

of cinema.[70] Though the multiscreen cinema was not 3D, its principal aesthetic quality was stereoscopic—in other words, it offered simultaneity in an expanded field. As McLuhan, likely referring to the multiscreen experiments at Expo 67, wrote: "Multi-screen projection tends to end the story-line, as the symbolist poem ends narrative in verse. That is, multiple screens in creating a simultaneous syntax eliminate the literary medium from film."[71]

Labyrinth's producers understood the synesthetic medium of multiscreen cinema as a new language, capable of accessing the unconscious mind and releasing associations deeply buried in the human psyche. And multichannel soundtracks helped to create focal points in relation to the "total image." Indeed, the multi-image was conceived *as* sound, that is, as boundless, simultaneous, and multidirectional. Sound had liberated the image from the constraints of the single screen, but multiple screens merged images

Figure 4.6
Early tests conducted with Labyrinth's cruciform screen in an airplane hangar rented by the National Film Board of Canada, 1966. Credit: In the Labyrinth © 1979 National Film Board of Canada. All rights reserved.

"in the same way it is possible to merge sounds."[72] The image in the multi-screen cinema is liberated not only from the single screen, but also from the constraints of traditional forms of drama, story, and plot. For Youngblood, this represented the natural evolution of the cinema. Synesthetic cinema transcended old forms of language just as television transformed the earth into software. The reflexivity of television brought everything, including the act of viewing, into a world of simultaneous becoming.[73]

English architectural critic Reyner Banham described Expo 67 as a megacity,[74] and the Labyrinth theater, which the NFB described as replete

Figure 4.7
A view of Chamber 3's unprecedented viewing experience that presents the audience with five 35mm projections arranged in a cruciform, which was meant to represent the tree of life. Credit: In the Labyrinth © 1979 National Film Board of Canada. All rights reserved.

with "mechanical movement, a multiplicity of levels, emphasis on fun or ludic experiences, people in complex environments, and information saturation," exhibited all of the megacity's spatial attributes. A master programmer strictly controlled traffic flow, which was organized "like a sausage machine," as Youngblood put it.[75] Given that movement was so thoroughly orchestrated, one might wonder how the Labyrinth theater was able to function as a space of drift and imagination that exercised generally unused areas of the brain. Yet it was the space between the theaters and the maze—in the multiplicity and arrangement of screens and mirrors, and in the extensive range of documentary information—that created the opportunity for audience participation. It was there that the senses were stimulated; the mind invited to wander and encouraged to peruse manifold paths of possibility, which required the use of both memory and imagination. There, synesthetic cinema and *flânerie* came together in the future city, as Youngblood explained it:

We have learned that synesthetic cinema is an alloy achieved through multiple superimpositions that produce syncretism. Syncretism is a total field of harmonic opposites in continual metamorphosis: this metamorphosis produces a sense of kinesthesia that evokes in the inarticulate consciousness of the viewer recognition of an overall pattern event that is in the film itself as well as the subject of the experience. ... A mythopoetic reality is generated through post stylization of unstylized reality.[76]

The Labyrinth Pavilion's design was not conceived merely as a way to incorporate multiple screens; rather, it aimed at the creation of a fluid space in which viewing would become a transformative, "artistic" activity. Low spent considerable time designing the mezzanine area, which included several dramatic displays of historical labyrinths. Moreover, the material space of viewing and the act of viewing were understood as integral parts of the films. All of these elements constituted Labyrinth's temporal dynamic, which was manifested as a theatrical performance of expanded screens and intermediality—the merging of screen and architecture. Even the pavilion's exit was conceived and designed in these terms—audience members exited with a view of the Fleuve Saint-Laurent. In keeping with the humanist spirit of *Labyrinth*, this final view also included architect and urban designer Moshe Safdie's utopian vision, Habitat.

Of central importance to the overall success of Expo 67 and an inherent aspect of its utopian energies was the sudden visibility of Quebec's distinct

cultural identity, and with it, a burgeoning national movement. This was especially true when Charles De Gaulle made the fateful statement, "Vive le Québec ... Vive le Québec libre." This period in Quebec's history has been characterized as the Quiet Revolution / *la révolution tranquille*. The French language was foregrounded at Expo 67 (the majority of the exposition's hosts were young Francophones), and the city of Montreal was then undergoing a massive architectural transformation that highlighted its cosmopolitan character.[77] Several documentary films produced about Expo 67 have made the observation that it suddenly allowed French Quebec, which had been "held back" by conservative Catholicism, to become visible on a technologically advanced world stage.

Cultures of DIY and Speed

There were at least two contradictory and interrelated experiences of media at Expo 67: the highly specialized architectonics of cinema spectatorship, and amateur-made media, especially photography/filmmaking. There was, on the one hand, a celebration of the new performative, multisensory aspects of the projected image onto a diversity of large screens and in particular the multiscreen presentation. While 3D film was present at Expo 67, the big innovation as I have been exploring was the multiscreen film—filmmakers (for *Labyrinth* and *Kaleidoscope*, for example) spoke of "detuning" the physical effects of the cinema projections by editing down the images and changing the sound to avoid oversaturating audiences. The new multiscreen film was seen as a medium that would reshape the human sensorium. As Francis Thompson and Alexander Hammid, the makers of the six-screen film *We Are Young*, explain in their 1966 pamphlet *Expanding Cinema*,

[t]he use of multiple screen opens up responses in ways formally restricted to sculpture and painting. The multiple screen operates in two basic ways: 1) it enlarges a single panoramic picture area to more nearly envelop the audience, thereby causing them to share almost physically the world through which the film moves and unfolds its story; 2) it projects different images side by side in carefully worked out juxtapositions to produce a variety of results, such as revealing human universality beneath superficial cultural differences.[78]

This universality may seem to be at odds with the new forms of do-it-yourself (DIY) culture that opened up the participatory spaces of conviviality

and spontaneous expression which CIAM urban planners and architects had been advocating since the 1940s. Indeed, there is another story that could be told about Expo 67's smaller screens, which, like the enormous multiscreen installations, broke down the division between production and consumption. A random sampling of these films are available on YouTube, many of which were shot on Super 8, the automatic-load camera that had replaced regular 8mm as the first affordable recording technology of choice in 1965. The films all tend to look alike, simply because they share a certain visual professional discipline as anonymous documentations of buildings, with crowds moving through the carefully manufactured views without the expressive intimacy or focus on the family that would give them a distinguishing mark. At Expo 67, Kodak Canada advertised the new Super 8 camera with an elaborate water screen through which "pictures [appeared to] grow ... out of nowhere," and offered to teach people how to shoot the exposition in a professional manner, that is, by making the filmmaker invisible.[79] Kodak's rival Polaroid instigated a very undisciplined look through its outmoded black-and-white film (which Eastman Kodak actually produced from 1963 to 1969), as well as its 1966 launch of the Swinger camera—a perfect technology of mobility, mutability, and portability marketed especially to a young generation picturing itself active and on the move. Ali MacGraw was featured walking along the beach in a bikini with her Swinger camera—"It's more than a camera, it's almost alive. It's only $19.95," the commercial proclaimed.[80]

McLuhan saw the multiscreen events and smaller forms of recording at Expo 67 as being perfectly commensurate with a new participatory way of engaging with the world. As he stated in a 1967 CBC interview before his participation in BBC's satellite broadcast *Our World*: "What is happening today around the world is what is happening at Expo. A huge mosaic has been created which is in effect a kind of X-ray of world cultures. Not a storyline, not a perspective, not a point of view but a kind of X-ray through this mosaic is created in which everybody can participate. Everybody is surprised at Expo at how deeply they appreciate and participate in the show. No one seems to realize why it is so unlike other world fairs."[81] The X-ray is how McLuhan describes television; the avisuality of the X-ray is all part of an auditory space, a characteristic of the "centre-without-margins" mediated world of 1950s live television that was the zeitgeist of Expo 67.

Indeed, the aesthetics of the multiscreen films, the small gauge movie cameras, and television shared a similar processual *sui generis*. As Thompson

and Hammid state in "Expanding Cinema," multiscreen films represented a return to painting and sculpture not because they are rendered motionless, but because they bring emotional and temporal impact back to the art of cinema by connecting the spectator to the physical and material space of the film. Indeed, like an X-ray, the multiscreen film, they suggest, penetrates beneath superficial differences between people, to foreground their essential oneness in a new nonperspectival, non-Euclidean space.

Writing for *Print* magazine in 1970 the communications designer Logan Smiley pondered the future of multiscreen technology:

the next breakthrough in multi-screen may involve Super 8 and the consumer film market. Kodak could well see enormous gain in creating a marketing program which would, in effect, set up seminars at department stores, universities and film retail outlets to promote multi-screen for home use. It would be easy enough to do and would certainly challenge the uniscreen efforts of the professionals whose material is growing increasingly tiresome in plot and technique. These seminars would also sell four times as much film for Kodak—theoretically that is.[82]

While this development of the medium for the home market might, as Smiley suggests, have presented a challenge to the "tiresomeness" of television and traditional forms of cinema and have had economic benefits for Kodak (at a time the company was enjoying its greatest profits from the very same home market), there was nevertheless something confusing about Smiley's proposal. His description of spectacular multiscreen experiments seems to contradict the simplicity of the do-it-yourself program of home use. He cites the documentary *Woodstock* (1970), which used "five synchronous Graflex projectors, ... four-track stereophonic sound, ... and three film editors," as the most successful utilization of multiscreen technology,[83] making his suggestion that it could be done in one's backyard seem completely misguided. Yet Smiley's proposal conveys a sense that the technologies might, or should, become available to the home market. His desire to find a wider application for the new medium, and indeed his suggestion that multiscreen might become the new home movie format, indicate an understanding that, as cinema expanded, so might the world. He intuitively grasped that these technologies (or others, such as "punch tape" or "cybernetic-like solar cell buttons") were transforming cinema into complex forms that would enable us to simultaneously inhabit multiple realities.

After Expo 67, Colin Low left the multiscreen project just as it was preparing to launch as a commercial technology at the 1970 Osaka exposition.

Roman Kroitor, along with Graeme Ferguson, went on to redevelop it as the large, single-screen technology known as IMAX. Low moved to the NFB's antipoverty program, Challenge for Change. A citizens' action-media experiment that began on Fogo Island in Newfoundland in 1968, this community-based project used 16mm, Super 8, and video to foster inter-community communication among the islanders, and between the islanders and federal government agencies.[84] Such a project resonated powerfully with the media revolutions that were taking place elsewhere, particularly in France during the events of May 1968. The future of the audiovisual revolution, for Low, lay not only in IMAX (which he was still involved with) but in the small screens, the do-it-yourself technologies of video and community-based television that enabled greater citizen participation and democratic expression. While the synesthetic multiscreen cinema did not grow into the revolutionary medium many hoped for, one can see in the expanded-screen experiments at Expo 67 a foreshadowing of the intermedia networks, the mobility of images, and the cultures of the Internet, along with the concomitant multiplication of screens that now pervade everyday life in industrialized cities around the world.

Part III Planet

If one lesson has emerged in recent decades, it is that the Ivory Tower of the artist has become the Control Tower of society. ... Today the top artists in painting and poetry have given their utmost attention to the meaning and value of the new media to the highest artistic endeavors. And they have said, "It is from now on a do-it-yourself world."[1]

—Marshall McLuhan

According to architectural historian Anthony Vidler, ecological thought has had three significant moments in architecture/urban studies—the early twentieth century, represented by the likes of Scottish town planner Patrick Geddes; the postwar period of reconstruction in both Europe and the United States inspired by this earlier period; and the present moment, dealing with the devastating effects of climate change.[2] My hope in this book is that we can look back to earlier utopian ecological thinkers, Geddes, Uexküll, Tyrwhitt, Bataille, Merleau-Ponty, Buckminster Fuller, and others, to see how their insights into ecology might help us to think creatively and collectively in the present age of the Anthropocene. Although the term "Anthropocene"[3] is not accepted as scientifically accurate[4] and is seen by some as ideologically suspect—as we can discern in such counterterminology as the capitaloscene (Moore), the plantationocene (Haraway et al.), the anthrobscene (Parikka) or anthro-obscene (Ernstson and Swyngedouw), and even the anthropo-not-seen (Cadena)[5]—one could argue that it does describe a new geologic age in which human beings have taken on geophysical "force" with the power to change planetary systems as evidenced by global warming. Indeed, 2016 was the hottest year on record for the planet. For some, "the Anthropocene" offers a productive term for enabling us to rethink our entanglements with nature, resource use, and social and

ecological inequities not exclusive to humans. Philosopher Catherine Mala-
bou draws upon the work of historian Dipesh Chakrabarty to argue for
the need to reconceptualize history itself in a manner that gives nature a
central role in human-induced climate change.[6] Global warming, Malabou
underscores, is not identical with globalization. While global warming is a
major consequence of globalization and capitalism, its consequences are
far broader, connected to what Chakrabarty calls the "deep history of the
earth." There is a new consciousness that must accompany the Anthro-
pocene, one that collapses the previously separate dimensions of natural
history (earth) and human history (worlds). This is Chakrabarty's biggest
assertion: that history itself has expanded—that human history and geo-
logical or natural history, which some like Fernand Braudel in his study
of the Mediterranean characterize as "slow history" because of nature's
repetitive cycles,[7] are now so completely intertwined that a new conceptual
framework is needed, tied to "deep history" combining earth and worlds.
He asserts:

To call human beings geological agents is to scale up our imagination of the human.
Humans are biological agents, both collectively and as individuals. They have always
been so. There was no point in human history when humans were not biological
agents. But we can become geological agents only historically and collectively, that
is, when we have reached numbers and invented technologies that are on a scale
large enough to have an impact on the planet itself. To call ourselves geological
agents is to attribute to us a force on the same scale as that released at other times
when there has been a mass extinction of species.[8]

Humans are part of "a force" that combines three histories—the history of
planetary systems, the history of life on the planet, and the history of capi-
talism. These histories operate at different scales and speeds. Chakrabarty
argues that human imagination and creativity will necessarily serve as the
basis for a new conceptual framework for understanding these new entan-
glements. One of the most significant aspects of this claim, and one that
interests Malabou, is the idea that the tools of ideological critique (whether
Marxist or postcolonial) are not sufficient to deal with the absolute indiffer-
ence and anonymity of natural forces and systems that are beyond human
interests, even if the present situation was created by these capitalist and
imperialist interests. Malabou builds on Chakrabarty's position by bringing
in the central importance of the brain and subjectivity as mediating factors
in this new, enlarged thinking at the scale of the planet which, as we will

explore in this chapter, is so central to Bataille's proposed framework in *The Accursed Share*. While Chakrabarty rejects the deep biological history proposed by Daniel Lord Smail in his book *On Deep History and the Brain* (2008), Malabou in contrast believes that the two approaches to deep history, geological and biological, are compatible and could forge a new path for ecological thinking that includes human subjectivity.

At the end of her proposal, she turns to Marshall McLuhan's *Understanding Media: The Extensions of Man* (1964) and Félix Guattari's *Three Ecologies* (2000) for further direction. First she quotes McLuhan's famous lines: "After three thousand years of explosion, by means of fragmentary and mechanical technologies, the Western world is imploding. During the mechanical ages we had extended our bodies in space. Today, after more than a century of electric technology, we have extended our central nervous system itself in a global embrace, abolishing both space and time as far as our planet is concerned."[9] For Malabou, McLuhan's work on media takes on new meaning in the context of climate change. The medical paradigm and emphasis on addiction in his theory of media are particularly fascinating and potentially productive for her. McLuhan draws upon Hans Selye's stress theory of disease to theorize the impact of the media on our bodies as a metamorphosis akin to disease and addiction. The first symptom of this new electric environment, which is the result of the extension of the human nervous system, is numbness and narcosis. McLuhan relates the effects of the media amplification of our senses to a "collective surgery" upon the whole social body. He writes: "For in operating on society with a new technology, it is not the incised area that is most affected. The area of impact and incision is numb. It is the entire system that is changed. The effect of radio is visual, the effect of the photo is auditory. Each new impact shifts the ratios among all the senses."[10] McLuhan sees the electric environment as a homeostatic system. According to Selye's theory of adaptation and disease, any physical extension will need to maintain equilibrium, and as such he regards any technological extension as an "autoamputation." In the midst of the electric environment, we "numb" our (extended) central nervous system "or we will die." The new media support an awareness of others and of social responsibility, yet they also produce anxiety and indifference; that is the only way to live with the reality that in "the electric age we wear all mankind as our skin."[11] Malabou is concerned with the new sensory experiences and collective sensibilities that McLuhan describes as the cosmic consciousness

produced by the narcotic cultures of media. This notion of addiction is especially useful for understanding the way in which media (smart phones, games, television serials, social media connectivity) are fundamentally addictive. Media as extensions—phones, watches, or wearables—develop functions as extensions of the human senses, technologies which become so implicated in our quotidian life that we cannot be without them; they are part of our physical nature. McLuhan was always wary of the effects of media on the human sensorium, and devoted a program of media studies to understanding these fundamental transformations.

In a way that complements McLuhan's sensory aesthetic paradigm, Guattari proposes a philosophical approach to ecology and subjectivity, *ecosophy*, in terms of a "resingularization of the collective." The three ecological registers that Guattari refers us to are the environment, social relations, and subjectivity, which might be aligned or might create three optics to invent a relation of the subject to the body:

> Through the continuous development of machinic labour, multiplied by the information revolution, productive forces can make available an increasing amount of time for potential human activity. But to what end? Unemployment, oppressive marginalization, loneliness, boredom, anxiety and neurosis? Or culture, creation, development, the reinvention of the environment and the enrichment of modes of life and sensibility? ... The only true response to the ecological crisis is on a global scale, provided that it brings about an authentic political, social and cultural revolution, reshaping the objectives of the production of both material and immaterial assets. Therefore this revolution must not be exclusively concerned with visible relations of force on a grand scale, but will also take into account molecular domains of sensibility, intelligence and desire.[12]

Guattari's *Three Ecologies* radically redefines ecology to include subjectivity, and this is where Malabou finds a crucial interface between the earth, the world, and the planet. It is a subjectivity that "is able to install itself simultaneously in the realms of the environment, in the major social and institutional assemblages, and symmetrically in the landscapes and fantasies of the most intimate spheres of the individual." Importantly, this new ecology is not reducible to the personal or to individuals, who must become both more united and increasingly differentiated through processes of resingularization: "it will be a question of literally reconstructing the modalities of 'group-being' (*l'être-en-groupe*), not only through 'communicational' interventions but through existential mutations driven by the motor of subjectivity." Guattari is interested in process as opposed to structure, in

"the logic of intensities, or eco-logic."[13] Thus he describes the emergence of dynamic cultural and psychic energies that ecosophy might generate as a response to the global ecological crisis.

For both McLuhan and Guattari, artists provide the most incisive acumen and insights into environmental, bodily, and psychic modalities. The aesthetic modes created by artists certainly help us to think about the porous boundaries between inside and outside that Malabou wishes to emphasize for a new ecological framework without collapsing one into the other—the key is to understand that they are intertwined. As I explained in the second chapter, the notion of the "intertwining" of the interior and exterior of nature is the new ontology of nature that Merleau-Ponty developed in *The Visible and the Invisible*. This is a space created from the phenomenal experience of the interiority of the external world of nature between inside and outside, which he calls a "chiasm." It is a space between one's flesh and the flesh of the world. Merleau-Ponty describes an experience of spatial depth, which envelops one's flesh, which is integral to the process of perception and (in)visibility. As we will see in the last two chapters of this book, these are issues that Georges Bataille, Alfred Whitehead, and others have also considered. In the fifth chapter, I explore the manner in which media create pluralistic environments connected to the planetary—architectural extensions or creative assemblages. In the sixth chapter, I consider how media are biological and cosmological by looking at a series of different art projects that explore the new frontiers of the planetary, including transspecies communication.

Part III asks how can we decenter, transcend, implode, or augment the human in our conceptualization of the planetary? How can we create a more expansive way of understanding the living planet, the relation between "the dew drop and the solar system," as Geddes proposed? And finally, as Malabou so astutely incorporates into her reflections on the Anthropocene, what is the role of media and art in this new mode of expanded ecological consciousness?

5 Inflatable Media: Film Festivals, Microcinemas, and Ephemeral Media

For Scottish biologist and geographer Patrick Geddes, the media (camera obscura, episcope, periscope, prisms, panoramas, georama, globes, and more) were always an important factor in the creation of an ecological mode of thinking. Media give us access to a world beyond the senses and help us to see the intertwining between inside and outside spaces. As we saw in the third chapter, his Outlook Tower project connected the tower, the city of Edinburgh, and the region beyond through the camera obscura, which allowed the visitors to his museum to see the interconnectedness of geography (land), architecture, and what he called the bios. Along with other radical geographers of his age, such as his friend Élisée Reclus in France, Geddes was well ahead of his time in thinking about a web of life, acknowledging the symbiotic nature of the living world based on the life force (or in Henri Bergson's words, *élan vital*). He articulated his triad of Organism-Function-Environment as the Cosmosphere—the world of things ("from solar systems to dewdrops"), the Biosphere (the realm of organisms), and the Sociosphere (the Kingdom of Man). The relationship between the dewdrop and the solar system, the local and the global, is of concern in what follows and is reminiscent of Guattari's three ecologies: the environment, the social, and subjectivity. In his attempt to create a machine for thinking about outer and inner realities, "acts and facts, deeds and dreams," Geddes developed "The Notation of Life," a grid for interpreting fundamental relationships between the bios, the cosmos, and human life.[1] Media ecology, a term first coined by Neil Postman in 1969, refers to the idea that media are environments and that environments are also media.[2] But media ecology has a much longer history. James Carey suggests that Geddes was one of the first media ecologists of the twentieth century in that his work strove for a holistic approach to understanding the way

technology—specifically electricity—transformed civilization and nature.[3] Jakob von Uexküll and those he influenced, such as Martin Heidegger, Maurice Merleau-Ponty, André Bazin, Gilles Deleuze, and Félix Guattari, practiced forms of media ecology and dealt directly with the problem of anthropocentrism (recall from chapter 2 that Bazin spoke of "degrees" of anthropocentrism, for instance) as well as the forms of mediation that can move us into new perceptual modalities and sensations that decenter the human and open up the cosmos. Thinkers like Uexküll and Geddes, both influenced by Bergson, teach us that media are not simply discrete, ahistorical, technologically enabled texts for representing reality or the fantastical. Rather, they are inherently part of the environment, embedded in and transforming the complex spatiotemporal fabric of the landscapes in which they are produced and circulated. In unique instances, they shape and are shaped by the particular, local spaces and subjective realms of their exhibition, the idiosyncratic places and techniques of display. There is no doubt that the meanings and experiences fostered by Edward Steichen's "Family of Man" exhibition changed according to the different contexts it was staged in.

At the 1951 Festival of Britain, the Telekinema with its 3D films and television projections connected a new "spectator-citizen" to instantaneous communicative dimensions, and at the same time or in the same place, to spaces of wonder—to and beyond human subjectivity. McLaren and Lambart's 3D films *Now Is the Time* and *Around Is Around*, although they could be projected in different cinemas around the world, were marked by the particularities of the Festival primarily because they were made for the creative and technical specificities of one cinema and one event. But what united the films and the media at the Telekinema was the Festival itself as an event, best relayed through the new medium of live television, which both helped to unify the diverse experiences of the Festival and created new kinds of synchronicity and nonsynchronicity across the country and indeed the globe. The great theorist of utopia Ernst Bloch, writing in 1932 Germany, reminds us: "Not all people exist in the same Now."[4] Bloch highlights different relationships to national heritage, and different memories, in order to comprehend the popularity of fascism in Germany. This essential and profound truth provides a starting place for him. Indeed, it is important for the projects studied in this book.

THE NOTATION OF LIFE

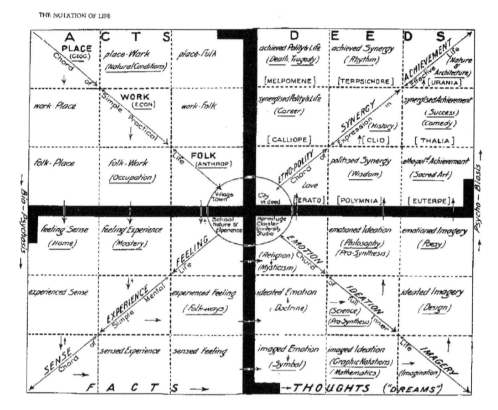

Figure 5.1
Patrick Geddes's "Notation of Life," from Amelia Dorothy Defries, *The Interpreter Geddes: The Man and His Gospel* (London: George Routledge and Sons, 1927). Image courtesy of the University of Strathclyde, Department of Archives and Special Collections.

Discrete spaces and events offer unique experiences tied to subjectivity (past experiences), personal history, and the phenomenologies of place. My specific focus in this chapter is on DIY cultures, new forms of media distribution and mobile spectatorship that grew out of the experimental cultures of the 1950s and 1960s in the United Kingdom and later in Canada. While this chapter straddles analog and digital media, I am interested in how digital media do not represent a break from postwar experimental media but work to enhance certain characteristics (asynchronicity, assemblage, expanded cinema, etc.) present in "older" forms of media like photography, video, film, radio, etc. The rise of translocal and transnational

networks of artist cultures, film and media festivals, cultural events, and activist cultures emphasizing locatedness—the temporalities of being there, of performance and events as against global media[5]—might well represent the design aesthetic needed in the age of the Anthropocene, one that Bruno Latour describes as a "modest," nimble, flexible, responsive design architecture in our dematerializing/disappearing and deeply present world.[6] It is also through such events that a common world—utopian in an imminent way—might be created. As Michael Hardt and Antonio Negri put it in *Multitude* (2004), "The Common we share, in fact, is not so much discovered as it is produced." Communication and collaboration are not based on the common but rather "produce the common in an expanding spiral relationship." Here we might comprehend the critical role of diverse forms of creative, social, and digital practice as that of creating places for "uncontrolled conversation" and being together (whatever form that takes in digital age).[7]

Writing in 2005, Thomas Hale and Anne-Marie Slaughter summarize the intentions of Hardt and Negri's book: "The multitude is not 'the people,' but rather many peoples acting in networked concert. Because of its plurality, its 'innumerable internal differences,' the multitude contains the genus of true democracy. At the same time, the multitude's ability to communicate and collaborate—often through the very capitalist networks that oppress it—allows it to produce a common body of knowledge and ideas ('the common') that can serve as a platform for democratic resistance to Empire."[8] Hale and Slaughter are critical of the book, though they praise the authors for recognizing the new forms of democracy growing out of the decentralized and diverse global networks that "define the contemporary zeitgeist." Indeed, over ten years later the book may not seem so "silly" given the emergence of so many new forms of protest pushing for democracy, pushing against Empire and oppressive political regimes—from the protests and demonstrations across the Middle East and North Africa in 2010 (the "Arab Spring") to the iterations of the Occupy movement and the 99%. In Canada the spread of Idle No More's "peaceful revolution, to honour Indigenous sovereignty, and to protect the land and water"[9] has become a global movement supporting diverse forms of solidarity connected to a multiplicity of political networks in the environmental movement. And what better illustration of the "expanding spiral" of solidarity than the protests of January 21, 2017, when an estimated 673 Women's Marches were held in cities

around the world protesting the newly elected US government and affirming that "Women's Rights Are Human Rights."[10] All this makes Hardt and Negri's 2005 book incredibly prescient.

Festival cultures, art biennales, microcinemas, site-specific "urban interventions", and diverse forms of locative urban media all reflect the dynamic, networked, mobile cultures of the "Media City" as Scott McGuire has described it.[11] The media city reframes the way that media function, not as representations nor simply as dematerialized circuits, but as experiences that co-constitute, and help us navigate, our environments. Such a conceptualization of the public domain emerges in the complex interface between material and immaterial spaces and requires us to rethink how we understand the place of media, and how they function to make our ecologies and mobile umwelts.

Ecology of Images

I begin with images in movement. Susan Sontag's notion of an "ecology of images" will give us some understanding of how images function to intertwine (Merleau-Ponty) the inside and the outside, to create environments that are not separate from their imaging but deeply connected to and embedded in them. In her celebrated book *On Photography* (1977), Sontag detected a new cultural ecology in which the "real world" is not separate from its imaging; rather, through this ecology, a new ethics of making and reading photographs might develop. Sontag explains: "Images are more real than anyone could have supposed. And just because they are an unlimited resource, one that cannot be exhausted by consumerist waste, there is all the more reason to apply the conservationist remedy. If there can be a better way for the real world to include the one of images, it will require an ecology not only of real things but of images as well."[12] The idea of an ecology of images, as I have been arguing throughout this book, concerns the dynamic and changing ontologies of photographic and digital images of the world. Most people live in and through a kinetic ecology of images that are of the world, which augment the world and sometimes make it legible. Such an ethics of the image works against any simple understanding of either appropriation or remediation as one-way actions that depart from originary sources and simple ownership. We live in a world drenched seemingly in discontinuous assemblages that interact with one another, with

our bodies and with the physical environment. Images are both ubiquitous and precious, anonymous and personal. This phenomenological dimension necessarily underscores any ecological approach. Not simply visual, images are also auditory and tactile; they are intricately bound up with embodied experience. While they can, as it were, take us out of ourselves, they also affect our bodies in a singular manner.

In her last book of nonfiction, *Regarding the Pain of Others* (2003), Sontag complicated her earlier position, which she characterized as "a defense of reality and the imperilled standards for responding more fully to it."[13] Sontag is critical of the idea that we live in an image-saturated world that assumes the existence of a reality which can be rehabilitated outside the realm of images. Jean Baudrillard affirms this idea, however, in his classic book *The Ecstasy of Communication* (1988), in which he decries the spectacular "pornographic objectivity of the world" that has colonized reality. Baudrillard's brilliant reconstruction of the world through the eyes of an "imaginary traveler" (à la Borges)[14] describes a cool universe (in McLuhan's sense of the term) that thrives on "Ecstasy, fascination, obscenity" (rather than desire, passion, or seduction), and enforces the "extraversion of all interiority" and the "categorical imperative of communication."[15]

As has been well rehearsed, Baudrillard's diagnosis, articulated through a metaphor drawn from psychopathology, is a new form of schizophrenia: "no more hysteria, or projective paranoia as such but a state of terror which is characteristic of the schizophrenic, an over-proximity of all things ... the absolute proximity to and total instantaneousness with things, this overexposure to the transparency of the world."[16] In Baudrillard's narrative, this victim of (post)modernity becomes a medium, an ecstatic screen of "influent networks." Sontag challenges this totalizing view, which, she claims, "universalizes the viewing habits of a small, educated population living in the rich part of the world."[17] She proposes instead that we think about images in terms of affects, as bearing witness to the specific and particular situations in which images are made, experienced, and contemplated. She cites the example of photojournalists in Sarajevo during the war in Bosnia, who worked at great personal risk to produce their images—images that cannot simply be reduced to the commodification of atrocity, as Baudrillard would characterize them. According to Sontag, "the Sarajevans did want their plight to be recorded in photographs: victims are interested in the representation of their own sufferings."[18] But she adds a caveat. In a crumbling

art gallery in Sarajevo, Paul Lowe, the celebrated English photojournalist who had worked in the besieged city for more than a year, mounted an exhibition of his photographs. He chose to include in the show photographs he had produced a few years earlier in Somalia. Sarajevans, while eager to see images of the ongoing decimation of their city, were offended by the juxtaposition. "To set their suffering alongside the sufferings of other people was to compare them," Sontag commented, "demoting Sarajevo's martyrdom to a mere instance."[19] Sontag is critical neither of the Sarajevan response nor of Lowe's desire to show his other work; rather, she underscores the incommensurability of the experiences depicted in the photographs of the Sarajevans and the Somalians. Lowe's credits include many of the major events of the late twentieth century: the fall of the Berlin Wall, the 1989 Romanian revolution, the release of Nelson Mandela, famine and civil war in Somalia and Sudan, and the conflicts in the former Yugoslavia and Chechnya. Lowe's exhibition of photographs from the Somalian famine and civil war, shot a few years earlier and placed alongside photographs of an ongoing war that people were then enduring made evident a number of incongruous and interdependent spheres: the profound struggles of the people in Sarajevo and Somalia, the photojournalist's body of work as an "envoy" bearing witness, and perhaps most importantly, the political economy of global media news and photojournalism. To create an exhibition that pairs the seemingly unrelated events in Sarajevo and Somalia moves them out of their respective local situations and into a visual register in which their situatedness and complexity is, arguably, distanced and serialized, rather than lost.

Such a juxtaposition would not have seemed so disturbing had the photographs not been exhibited in a gallery in Sarajevo during the Bosnian war. Certainly, Sontag's review of Steichen's "Family of Man" was critical of the exhibition's use of decontextualized photographs for the same reason. The juxtaposition that Lowe created in his exhibition is familiar to cosmopolitan gallery-goers and consumers of most contemporary forms of media, at least those able to access the multifarious networks of the global media. These juxtapositions of "influent networks,"[20] the ubiquity of screens that create "giddy transparencies,"[21] are part and parcel of the fragmentary and confused experience of Baudrillard's imaginary traveler. This incredible proliferation of images is a contributing factor to the financial crisis currently facing the global practice of photojournalism. It is not that there

isn't sufficient space for these images, but rather that a surfeit of images is being produced everywhere in the world. At the same time, large news services increasingly control the stock of images and photo archives, and are prone to use generic scenes as stand-ins for particular wars and specific events. Sontag's engagement with the ecologies of images—her questioning of the function (affective and political) of photographs and images in our everyday lives, and of how these images connect us to one another and to the world—provides a materialist frame for situating the "blizzard" (to use Kracauer's term) or hemorrhaging of images that surrounds everyday lives in the industrialized cities of the world. I construe this materialism to include an understanding of the ubiquity of images, as well as their fantastic decontextualization and incommensurability, which Baudrillard eloquently described. Though it may be difficult to think about "the outside" of ideology—the world beyond the image—it is precisely by thinking this outside in a manner inspired by Bataille that Baudrillard is able to describe the fundamental shift in the technological mediation of reality that took place in the postwar era. This is why someone like McLuhan is so useful to read. Working with the Explorations Group at the University of Toronto,[22] he and the group's other members were among the first to think about and compare the effects of these media on the human sensorium in the early 1950s; to focus on medium specificity; to develop comparative media studies using television, public lectures, and radio; and to analyze these media in terms of their pedagogical potential.[23]

Both Sontag and Baudrillard draw on Bataille's concept of ecstasy. Bataille, like McLuhan, recognized that an important transformation had occurred in postwar forms of media, especially with the invention and commercial development of television. As we saw in our examination of Jacques Cousteau's underwater explorations, remote sensing and changes in media technologies (underwater television) served to render accessible previously remote parts of the earth. Bataille died a year after the publication of his book *Tears of Eros* (1961), which concerned the communifying aspects of images. Writing in ill health and anxious about his eldest daughter, who had been arrested for her political activities on behalf of Algeria, Bataille was seeking to understand the relationship between eroticism and death as a challenge to scientific codification: "The ambiguity of this human life is really that of mad laughter and of sobbing tears. It comes from the difficulty of harmonizing reason's calculations with these tears … with this horrible laugh."[24]

Bataille's last book brings together a historical and cross-cultural archive of images—drawings, engravings, paintings, and photographs—that engage, in one way or another, with the meeting of eroticism and death. Censored when it first appeared, the book aimed to "[open] up ... consciousness" to this relationship through the visual traces ("remnants") of its pulsions, and was intended to elicit an emotional response through its juxtaposition of images. Bataille entreats us to know the world through death in life (a gap opened by Eros), to consider new epistemologies in which seemingly opposite affects (e.g., repulsion/attraction) become indistinguishable.[25]

Remarking upon Bataille's book, Sontag focused on one particular photograph of an anonymous man's execution by ling chi—death by a thousand cuts—taken in 1905. Bataille reportedly kept the photograph in his desk, forcing himself to look at it every day. Including it in *Tears of Eros*, he wrote: "This photograph had a decisive role in my life. I have never stopped being obsessed by this image of pain at once ecstatic and intolerable." Bataille is uncertain about the expression of pain on the man's upturned face, which, though it belongs to a mutilated and tortured body whose arms have been cut off, looks up in a manner that resembles that of ecstatic saints of the Italian Renaissance. According to Sontag,

> Bataille is not saying that he takes pleasure at the sight of this excruciation [the photo of "death by one thousand cuts"]. But he is saying that he can imagine extreme suffering as something more than just suffering, as a kind of transfiguration. It is a view of suffering, of the pain of others, rooted in religious thinking that links pain to sacrifice, sacrifice to exaltation—a view that could not be more alien to a modern sensibility that regards suffering as a mistake or an accident or a crime; something to be fixed; something to be refused; something that makes one feel powerless.[26]

With this book, Bataille's aim was not to shock (he was a bad surrealist); he wanted to elicit a response, forge an affective connection with the world. For her part, Sontag was interested in a depiction of suffering that leads to action rather than a turning away from the world, writing: "Compassion is an unstable emotion. It needs to be translated into action, or it withers."[27] But she was also sympathetic to Bataille's fixation on this image and the complexity of his relationship to it. *The Tears of Eros* suggests that representations (all different kinds of media from painting and engraving to photography) can be "communifying" environments that force us into recognition or empathy of a shared corporeality—what we share as sentient

animals. Sontag's essays are premised on a materialist approach to the analysis of the place of images. She considers not only who produces images and for what purposes they are produced, but also how they circulate and in what contexts and for what purposes they are consumed.

Sontag's involvement with the project *SA-Life* (1993) and the North American version of the film *Sarajevo Ground Zero: SaGA's Films of Crime and Resistance* (1993), which sought to mobilize responses to the Bosnian war, might well have given her insight into the critical role played by new forms of distribution. *SA-Life* is a collective compilation film put together by one of Bosnia's foremost filmmakers, Ademir Kenović, along with other filmmakers in Sarajevo who used small documentaries and video diaries to document the atrocities of the war as they unfolded around them. *SA-Life* was distributed through the important international film festival circuit, which I discuss below (Cannes, San Francisco, New York, Montreal, and others) to educate the general public about the war in Bosnia.[28] Kenović and SaGA, a multiethnic group of Bosnian filmmakers, worked with American producer Danny Schechter to reedit the images into a news magazine called *Sarajevo Ground Zero* to be shown on American television. After failing to secure a broadcaster, the filmmakers decided to make a video chain letter that included a fervent commentary by Sontag (who was directing Samuel Beckett's play *Waiting for Godot* in Sarajevo) and *New York Times* correspondent John Burns about the atrocities of the Bosnian genocide. A flyer accompanied the video letter:

Most chain letters are idiotic. Or a way of having fun. This one is serious. Deadly serious. It is about a city and its people. Who face death. In this holiday season of 1993. Sarajevo is the city. Genocide is the threat. No joke. That's why we have sent you this video tape. So that you can't say you didn't know. So you will act. And get your government to respond. A documentary that TV stations won't show. Please watch it. Bosnians are "living" it. Show it to at least five friends. Alert the Press. Lives are at stake. Don't Break the Chain.[29]

Scott MacKenzie has noted that the images in these documentaries could not be separated from their processes of distribution:

What is left, then, is not images themselves, but the process of distribution. The "video chain letter" is based on the premise that the simple existence and distribution of images will lead to social awareness and political intervention. It does not matter if the images offer access to the "real" in an unmediated fashion; what matters is their circulation in a manner whereby each viewer decides who the next one will be, and thereby becomes part of a process which builds a web of connections

that is intended to produce discourse and action in the public sphere, away from the video monitor. Image-makers, then, no longer need to be concerned with "accurate" representations of the unrepresentable; instead they should be concerned with distributing their images in ways that generate discussion, debate, and affinities within the public sphere.[30]

The images in this video chain letter, as MacKenzie points out, were somewhat secondary to the very process of distribution which creates a network, an opportunity for social exchange, for talking, for discovering political affinities and planning actions.

In effect, SaGA's videos would necessarily undergo degradation as the video chain grew. The image quality would become "poor," in the sense that German artist Hito Steyerl describes in her manifesto, "In Defense of the Poor Image": "The poor image is a copy in motion. Its quality is bad, its resolution substandard. As it accelerates, it deteriorates. It is a ghost of an image, a preview, a thumbnail, an errant idea, an itinerant image distributed for free, squeezed through slow digital connections, compressed, reproduced, ripped, remixed, as well as copied and pasted into other channels of distribution."[31] Though the video letters were analogue, Steyerl's analysis of poor images is still relevant. Images that are created to be shared and exchanged trade "quality" for "accessibility."[32] This tradeoff is indeed part of the history of DIY, from the Lettrists to the Situationists—as Amy Spencer has described in *DIY: The Rise of Low-Fi Culture* (2008)—which either consciously or by happenstance works to build community by relying on smaller, lower forms of media.[33] It is in this spirit that Steyerl cites the landmark Third Cinema manifesto "For an Imperfect Cinema" by Cuban filmmaker Julio García Espinosa; that is, a revolutionary cinema that breaks down the divide between artists and spectators, that "rejects exhibitionism in both (literal) senses of the word, the narcissistic and the commercial," that celebrates the amateur and the popular, and that incorporates the very conditions of production into the process of making. For Espinosa, the new DIY media of the 1960s enabled a democratic transformation away from elite perfect cinema toward new forms of making and seeing films:

Imperfect cinema is no longer interested in quality or technique. It can be created equally well with a Mitchell or with an 8mm camera, in a studio or in a guerrilla camp in the middle of the jungle. Imperfect cinema is no longer interested in predetermined taste, and much less in "good taste." It is not quality which it seeks in an artist's work. The only thing it is interested in is how an artist responds to

the following question: What are you doing in order to overcome the barrier of the "cultured" elite audience which up to now has conditioned the form of your work?[34]

Thus, like "Imperfect Cinema," the "Poor Image" is defended as a practice tied to freeing the image, to opening images up to as many voices, subjectivities, and experiences as possible, fostering an infinite number of remixes and appropriations. Steyerl argues that the poor image acquires a new value "defined by velocity, intensity, and spread." Of course she recognizes the darker side of the utopian mandate of her defense of poor images, which cannot escape the contradictions of capitalism and the commodification of everything. Take, for example, the photographs of the torture of Iraqi prisoners of war by American soldiers at Abu Ghraib, which Sontag reflects upon in her essay "Regarding the Torture of Others" (2004). There, Sontag addresses the double horror of photographs that represent torture and the act of photographing torture: "what is shown in the photographs cannot be separated from the horror that the photographs were taken—with the perpetrators posing, gloating, over their helpless captives."[35] The fact that the photographs contain victims and torturers within the same frame is, Sontag tells us, exceedingly unusual. Like American photographs of black victims of lynching produced as "trophies" between the 1880s and 1930s, the photographs of torture at Abu Ghraib are "souvenirs" of sorts. Yet they reflect an important shift in the purpose and function of photographs as well as the ways in which photographs are collected and stored. The photographs at Abu Ghraib were taken "less [as] objects to be saved than [as] messages to be disseminated, circulated."[36] Indeed, this marks an important change in what motivates the photographic act; even the most private moments of criminal behavior are subjected to, even driven by, the "extraversion of all interiority," the "categorical imperative of communication," as Baudrillard, following McLuhan and William Burroughs, put it.[37] It is precisely the material reality of circulation—of images being inseparable from their mode of circulation, from their mobility—that marks twenty-first-century images.

In this new context, Sontag has argued in "The Decay of Cinema," cinephilia too has undergone a profound transformation. She attributes this transformation to two things. On the one hand is the loss of the traditional movie theater, which cannot be replaced by domestic home screens, no matter how big they are. "To be kidnapped, you have to be in a movie

theater, seated in the dark among anonymous strangers," she comments. This is a perfect definition of an ecstatic experience. On the other hand, she attributes the transformation to the "sheer ubiquity of moving images which has steadily undermined the standards people once had both for cinema as art and for cinema as popular entertainment."[38] Similarly, Francesco Casetti asserts that two of the most characteristic traits of cinema—"its status as a photographic medium and its identity as a collective show"[39]—have been profoundly transformed in the twenty-first century. Inadvertently, both Sontag and Casetti are referring to what Steyerl and Espinosa were espousing, which is the democratization of image making, the reality that there are more films and media *being made* around the world than are *being widely seen*. As Jean-Michel Frodon has emphasized, there are more people making media than ever before—"it is not only about quality; it is about diversity of style, geographical and cultural origin, format, purpose, etc."— which can be understood as a product of globalization and of digital media in the last decade of the twentieth century. The contradiction is that this exponential growth coincides directly with the narrowing of traditional distribution channels for both television and film.[40] The expansion also coincides with the invention and reinvention of smaller, fragmentary, and distributed forms of collective and ecstatic experience.

Festival Effervescence

Over the last three decades, cultural festivals have emerged as important channels for the distribution and promotion of independent, experimental, and commercial media. Film festivals, in particular, have grown in number from a dozen international festivals in the early 1960s to a network of over one thousand synchronized annual "events" and innumerable nonsynchronized festivals and parties in cities around the world—and this does not include the innumerable local scenes and specialized film screenings that appear alongside the larger festivals.

For Bataille, the festival is everything; it is "the only serious language."[41] He developed his theory of general economy inspired by the idea of the *potlatch*, a form of gift giving tied to social life studied by Marcel Mauss in precapitalist indigenous cultures. Mauss and his uncle Émile Durkheim profoundly influenced the surrealists, including Bataille, in their understanding of the central importance of collectivity as energy, as enthusiasm,

and as communication/community. The phenomenon of the potlatch is articulated through complex social rituals in which expenditure is privileged over acquisition. Such relational forms are completely foreign to the linear rationality of production and restriction that defines capitalist modes of production. The idea of "expenditure without return" and personal and collective enthusiasm, along with the movement *hors de soi* (beyond the self), were concepts that Bataille developed through Durkheim's sociology. As Bataille puts it in "L'économie à la mesure de l'univers" (Economy on the scale of the universe):

You are only, and you must know it, an explosion of energy. You can't change it. All these human works around you are only an overflow of vital energy. … You can't deny it: the desire is in you, it's intense; you could never separate it from mankind. Essentially, the human being has the responsibility here [*a la charge ici*] to spend, in glory, what is accumulated on the earth, what is scattered by the sun. Essentially, he's a laugher, a dancer, a giver of festivals. This is clearly the only serious language.[42]

Festivals are forms of intimacy, giving, and community. Durkheim developed the idea of "collective effervescence" in his work on religion to understand how collective experience at communal gatherings intensifies and augments individual experiences: the gathering of crowds in close proximity "generates a kind of electricity that quickly transports them to an extraordinary degree of exaltation."[43] Bataille extended Durkheim's ideas into his own theory of religion and to wider spheres of experience including sacred festivals: "The festival is the fusion of human life. For the thing and the individual, it is the crucible where distinctions melt in the intense heat of intimate life. But its intimacy is dissolved in the *real* and individualized positing of the ensemble that is at stake in the rituals." For Bataille the festival, like "the essence" of religious experience, is always "limited," because the "fusion of human life" which breaks down the borders of the self fails at the very limits of self-consciousness.[44]

On a less sacred note, Bataille's ideas can tell us something about the feeling of excitement, effervescence, and shared affinity that film festivals, at their very best, can foster. The expansion of the film festival circuit in the twenty-first century can be seen as a significant cultural expression of globalization and of media democracy organized around a "circuit" of events and screenings.[45] On the one hand, it represents unequal economic development that defines neoliberalism, as large corporate festivals

dominate the circuit with timetables and locations. On the other hand, the growth of grassroots festival cultures and their changing appearance—the development of social media (YouTube, Twitter, Facebook etc.), database cinema (i-docs), and different media platforms (augmented reality, virtual reality, architectural projection) and games as new screens—enable different kinds of stories and documentary forms to develop. As a result, diverse public spheres are created that can give a voice to what Guattari calls "collective singularization," thus expanding the democratic public sphere as visual media become more integrated and embedded into everyday environments.

Film festivals are a postwar phenomenon, and the mid-1960s in particular represents the moment when they expanded film cultures globally. National cinemas (Italy, Spain, Poland, France, Sweden, Argentina) and art cinema (often one and the same) were valued by a new generation of cinephiles who recognized film's distinct expressive capacity to reflect on modernity and to disseminate political messages through festival circuits. During this period, the notion of a global political stage defined a new mandate for international film festivals, as they became forums for the assertion of cultural difference, political views, and counterpublics. It is fair to say that the new global reality of the mid-1960s was not only captured on American television, but was also created through television, particularly the idea, inaugurated by TV reporting and satellite technology during the Vietnam War, that "the world is watching."[46] This sense of an international viewership was reinforced through the cosmopolitan film festival circuit.

Third World film collectives challenged the art cinemas of Western Europe just as these art cinemas had denounced the commercial distractions of mainstream media. In the 1960s and 1970s, the Third Cinema movement emerged in Latin America, Africa, and Asia, where filmmakers were called upon to help to create a politicized film culture that would engage with issues of neocolonialism and subdevelopment as well as race, religion, and national identity. The pivotal manifesto "Towards a Third Cinema: Notes and Experiences for the Development of a Cinema of Liberation in the Third World" by Fernando Solanas and Octavio Getino (published in Havana in 1969) defined "first cinema" (commercial cinema) and "second cinema" (art films) as modes of production that create a film language conducive to their respective national concerns. Solanas and Getino called for

both types of cinema to be challenged by a "third cinema" that would undo their universalist discourses.[47]

Films from directors such as Ousmane Sembene, Patricio Guzman, Glauber Rocha, and Julio Garcia Espinoza supported collective practices and used international festivals as a means to spread political messages. Moreover, films censored in one country could be screened in the new international public sphere. Many larger events contained dynamic and ephemeral film festivals at their core, as we saw with both the Festival of Britain and Expo 67. It is not surprising that film festivals were tied not only to cities[48] but also increasingly to social identities—women's and feminist film festivals, film festivals by diasporic communities or indigenous communities, LGBTQ festivals, festivals centered on mental illness, and more. Such film festivals sought to consolidate a community voice and gain recognition within the collective fabric of civil society while creating spaces for the particular community to gather to be together and to participate in cultural exchanges. Festivals enable alternative public spheres and open spaces for the incommensurable.[49] As events, they must often balance the demands of governments with those of the commercial media industries that are often their sponsors. Today film festivals are spaces of contradiction as capitalist enterprises. Indeed, there is little doubt that the larger corporate festivals bear little trace of the search for intimacy (the "fusion of human life") of the sacred ethos described by Bataille.[50]

In many ways, in the context of the "Decay of Cinema" described by Sontag at the turn of the twenty-first century, and in the context of the ubiquity of images and media, the film festival serves to reinstate into the filmgoing experience the aura that Benjamin described as "the unique phenomenon of a distance."[51] Film festivals are distinctly exciting, mimetic forms of leisure. All festivals bring a sense of excitement to a place. While they highlight mechanically reproduced art, they reinvent a role for the original and the singular in the age of the poor image: the premiere, the presence of stars, and the sensorial materiality of the event (architecture, landscape, live music, food, fashion, general ambiance) are all central to bringing people together and creating a sense of excitement through the event.

In their sociology of leisure, Norbert Elias and Eric Dunning situate excitement as a quality characteristic of certain kinds of social occasions. In highly organized, postindustrial state societies, the "civilizing process"

has relegated violent and spontaneous outbursts of passion and overt emotionality to the sphere of leisure (or crime). Leisure replaces the older functions of religious "enthusiasm" as described by Aristotle. Mimetic activities "from sports to music and drama, from murder films to Westerns, from hunting and fishing to racing and painting, from gambling and chess to swinging and rocking" are "quests for excitement" that serve as a kind of escape from the self-restraint practiced in everyday life.[52] What unites film festivals with this list of leisurely activities is that they incorporate the object of consumption with the action of consuming in a performative mix that belongs to the expressive order of the cosmopolitan experience. No individual film stands out in particular (although there are discoveries by the ever-more-important film critic and audience preferences conveyed through social media), but what is experienced is the collective adventure of movie going, of experiencing an ecology of images. Indeed, while the festival ecology is collectively experienced, the festival program is also highly individualized, as viewers must chart their own viewing trajectories because the program content, even for smaller festivals, generally exceeds any one viewer's screening capacity—it is generally impossible to see everything. Biennales offer expressly this sense of an open cultural database, an environment that invites visitors to carve out their own creative pathways. This collective experience is a counterpoint to the solitary act of spectatorship in the private sphere that mirrors the decentralized media spectatorship of the global mediascape. Moreover, the cultural offerings of films, videos, art installations, and new media that stretch the boundaries of screen culture (cross-platform, VR, etc.), conferences, and technical and creative workshops are far more diversified than what is usually on offer. This is best summarized in the Toronto International Film Festival's most successful advertising campaign, its 2003 slogan "Lose yourself in film."

I would like to turn now to examine another aspect of ephemeral festival culture that is often neglected—the sites and places of projection, and the work of extraordinary projectionists who materialize the technological complexities of festivals with their different viewing formats, theater spaces, and distribution and projection mechanisms. In particular, I will ground this discussion in a more specific focus on the place, ecology, and economy of these new kinds of ephemeral viewing, by examining a highly robust microcinema called CineCycle that was established in 1991

by artist-projectionist Martin Heath in Toronto. Heath's commitment to microcinema began with his involvement in the rich cinematic landscape of London. But, first, a few words about microcinemas and what Allan Stoekl has called "the postsustainable economy."[53]

Projecting in a Postsustainable Economy

The term "microcinema" was first established by Rebecca Barten and David Sherman in 1994 with their project *Total Mobile Home microCINEMA* in San Francisco, a few years after Heath founded CineCycle, but with a shared aesthetic sensibility for mobility, portability, and movement. The word encompasses both inexpensive forms of media production and small, makeshift cinemas in which to show such works. I situate these media practices in the cinematic experiments and DIY cultures of the 1960s that we saw were an intrinsic aspect of Expo 67's utopian energies. Such media practices are very much tied to, and in Heath's case, grow out of the rich experiments with cinema, place making, and architecture that defined London of the 1950s and 1960s. Very small spaces, often improvisational architectural forms, harken back to an earlier time in the film culture of nickelodeons, storefronts, and small cinemas. They also point toward a future of maker cultures that belongs to what Stoekl has called the "postsustainable economy"—an economy that is beyond a sustainable economy, that is the aftermath of anthropogenic climate change. This economy makes its first appearance with the oil crisis of the 1970s and early 1980s when many of the industrialized nations of the world (the United States, Canada, Western Europe, England, Japan, Australia, and New Zealand) were severely affected by the Organization of the Petroleum Exporting Countries (OPEC)'s oil embargo of October 1973. The embargo, which was imposed to retaliate against the economic aid that the United States had given to Israel, was lifted by March 1974. By then the cost of oil had gone from US$3 per barrel to nearly $12 globally.[54] The repercussions of this "crisis," described as an "oil crisis," were felt in many areas of the North American economy, especially the car industry—leading to a shift away from the large "gas-guzzling" American cars that dominated the 1960s and to the development of a political discourse in the United States about crisis that could be used to justify all kinds of political maneuvers, wars, and invasions against oil-rich countries.[55]

Many countries were awakened to the idea that fossil fuels were limited and that alternative energy sources would have to be found. Energy itself became visible. US President Jimmy Carter is famous for having introduced energy policies and conservation measures for dealing with this scenario of future scarcity.[56] Stoekl's book *Bataille's Peak* situates notions of the postsustainable economy within a context of energy use (in particular oil) and depletion. As I shall examine, many artists were deeply responsive to this problem and began experimenting with inflatable forms of sustainable architecture. Martin Heath's longtime practice as a projectionist and a builder of inflatable cinemas will guide us through this very fertile period of creative and utopian experimentation.

Heath's interest in cinema began with his involvement in the film societies in London, England. The Festival of Britain, fueled by the British Film Institute's pedagogical imperative, had encouraged cinephilia and created an openness to film culture in Britain that is still alive today. Heath was first exposed to the architectonics of cinema circuits through his job at Contemporary Films in London in the mid-1960s. Established in New York in the late 1940s by the socialist film distributor Charles Cooper, Contemporary Films became one of the foremost nontheatrical distributors in the postwar 16mm market, expanding distribution to school libraries, film societies, churches, and community groups. Cooper's ambitions, however, exceeded the limits of underground film distribution. When he was blacklisted during the McCarthy era, Contemporary Films was taken over by Leo Dratfield, who continued to build on Cooper's political mandate. Cooper then created another branch of the company in London. During the early 1950s, the Communist Party of Great Britain experienced a mini-renaissance. The New Era Film Club, conceived as a film society, a 16mm projection service for clubs and trade unions, and a production group, established branches in several cities.[57] Through Cooper's connections with a number of Soviet film directors, Contemporary Films Ltd., along with Ivor Montagu's Plato Films Ltd. (which replaced the defunct Progressive Film Institute in 1951), received some of its funding from the British-Soviet Friendship Society. Committed to distributing the work of socialist directors from the Soviet Union, Eastern Europe, and China, both Plato and Contemporary Films used the motto "See the Other Half of the World." Cooper was licensed to show the re-released prints of many of Eisenstein's films.[58] With an extensive 16mm library of international art and avant-garde films, Cooper built

a distribution circuit in England much as he had done earlier in the United States, and by the late 1960s he had purchased two cinemas in London. It was in this context that Martin Heath began a lifelong career in film when, as a young man, he was hired to manage the film library at Contemporary Films.

Heath also began to build his own film collection. Although he was required to destroy damaged film prints (respecting the integrity of the original film), only a photograph of someone taking an axe to the film can was needed as evidence of a print's destruction. Adept at faking these deaths by axe, Heath rescued many films. Thus began his love affair with film repair and projection. But the job also introduced him to Cooper's highly politicized vision of film distribution, according to which the creation of circuits of distribution was an implicit but all too often neglected component of politically committed filmmaking. The refinement of 16mm projection technologies enabled the development of film screenings outside the realm of commercial cinemas. Although Cooper opened several conventional cinemas in the late 1960s, his early strategy focused on distributing films and projectionists to alternative screening spaces.

As a result of his employment at Contemporary Films, Heath was hired to help construct a cinema for the Russian Pavilion at Expo 67, an experience that further influenced and extended his conception of film distribution and exhibition. Heath had earlier been impressed by the Canadian National Film Board's mobile cinema experiments, which took filmmaking into more remote parts of Canada. Such experiments were themselves inspired by the Soviet mobile-cinema projects (using trains and automobiles) of the 1920s.

Heath left Contemporary Films and began working for the English event producer Rita Jarvis at a company called Fair Enterprises, which screened music films like *Monterey Pop* (D. A. Pennebaker, 1968) and *Don't Look Back* (D. A. Pennebaker, 1967) at makeshift venues and concert halls across England. Heath also worked as an independent projectionist offering his skills and services to small venues and for special screenings. In 1968, he joined forces with the Electric Cinema Club, a cinema operated by several Canadians, including Deanne Taylor, who was fresh out of film school. The group had rented a defunct porno theater on Portobello Road with the intent of creating an avant-garde cinema. Heath worked with Taylor to update the facility and install proper 16mm and 35mm projection. Taylor had starred

in Jean-Luc Godard's political collage *One Plus One* (1968) which intercut footage of the Rolling Stones in a London sound studio recording "Sympathy for the Devil" with images of the Black Panthers in a Battersea junkyard, a movie production crane and crew shooting a film on a beach, and a reading from *Mein Kampf* in a bookshop, among many other elements—all geared toward conceptualizing a post-1968 anticapitalist revolution. When Godard discovered that the film's producer, Iain Quarrier, had retitled the film *Sympathy for the Devil* and added a complete version of the Rolling Stone's song to the end of the film, he told an audience at the London Film Festival to come and watch his own version of the film at the Electric Cinema Club. This event, of course, became mythic for the club. All of these activities throughout the 1960s served to support what would become Heath's one true love: inflatables.

Inflatable City

Heath's mobile structures and events owe much to the rich architectural and art experiments that came of age in 1960s London. Heath's ideas for mobile structures grew out of a utopian spirit, influenced by, among other things, Cooper's Contemporary Films, the dynamic designs for public space developed through the work of the Eventstructure Research Group, the pneumatic artist Graham Stevens, the radical architecture magazine *Archigram*, and especially the Fun Palace project imagined by Cedric Price and Joan Littlewood which sought to reinvent urban public space. All of these activities were commonly inspired by the ecological designs of Buckminster Fuller and grew out of the dynamic art discourse of the Institute of Contemporary Arts (ICA) along with the Independent Group.

Anthony Vidler maintains that Buckminster Fuller's 1958 lecture delivered at the Royal Institute of British Architects (RIBA) exerted a tremendous influence over a new generation of architects and artists in the United Kingdom. As Vidler recalls it, Fuller spoke for three hours about his world system project which was materializing an integrated framework of ecology and economy. As Fuller's own chronology underlines, 1957 was the first International Geophysical Year and the year "the first satellite (Sputnik) was launched by Earthians" as "humanity initiate[d] the Space Age."[59] Vidler, a student at Cambridge University's neo-Corbusian School of Architecture, recalls that Fuller's ideas were fervently received

by a new generation of architects and artists hungry for more contemporary aesthetic engagements with the environment and ecology. This new generation's appreciation was grounded in another enthusiasm to reconnect man, machine, and nature—a connection that had been ripped apart by the dehumanizing atrocities of the Second World War.[60] In particular, architects, designers, and critics involved with the ICA and the Independent Group, such as Richard Hamilton, Eduardo Paolozzi, Magda Cordell, Reyner Banham, Nigel Henderson, Alison and Peter Smithson, James Sterling, Lawrence Alloway, John McHale,[61] and others, were creating a rigorous and dynamic art-science discourse that sought to challenge the established regimes of architectural and planning practices associated with Le Corbusier and the Athens Charter. In his landmark essay of 1955, Banham described the aesthetics of the Independent Group in terms of "New Brutalism" for its emphasis on materials and structures minus the gloss and elegance of the older movement.[62] These artists sought to reimagine architecture in terms of time, form, and nature. Beginning a few months after the Festival of Britain opened in 1951, they staged a series of polemical and experimental exhibitions at the ICA, starting with "Growth and Form" which engaged with the work of Scottish mathematical biologist D'Arcy Wentworth Thompson. These explorations culminated with the polemical proto-consumerist sci-fi exhibition "Living City" by Archigram in 1963.[63] For Vidler, these nonutopian research-oriented exhibitions— which included "Parallel of Life and Art" (Reyner Banham, 1953), "Man, Machine and Nature" (Richard Hamilton, 1955), and "This Is Tomorrow" (Bryan Robertson, 1956)—stood in stark contrast to the nostalgic longing for the past celebrated by the Festival of Britain.[64]

The sardonic humor and pop art sensibility of the Independent Group offered a much more discursive approach to the past and future than did the Festival of Britain—a standout is McHale's extraordinary Americana collage poster *Just What Is It that Makes Today's Home So Different, So Appealing?* produced for Group Two's (Hamilton and John Voelcker) contribution to the landmark exhibition "This Is Tomorrow." The poster, which was a collage made from magazines McHale had brought back from the United States, featured all the consumer items of the new home (television, tape recorder, vacuum cleaner, and Spam!); significantly, McHale placed on the ceiling of the home a cutting from *Look* magazine of the first photograph

of a half earth as seen from a mile-high rocket in orbit, predating NASA's photograph of the whole earth by over a decade.[65]

Martin Heath was exposed to this artistic context in London over a decade later, in the 1960s and early 1970s. His ambition was to create shared spaces and collective cinematic experiences that were adaptable to different environments as well as mobile and portable. This desire was furthered by his collaborations with the great pneumatics artist and environmental scientist Graham Stevens, who was among the first to create massive inflatable balloon-like structures in the mid-1960s as environmental conceptual art forms. Beginning with early experiments such as *Elastic Touch* (1965), which featured three balloons filled with liquid, gas, or solid material, Stevens's ideas were expanded into a 75-foot-by-30-foot *Spacefield* (1966), the first "monochromatic" pneumatic environment, where participants experienced physiological sensory changes in situ. Stevens's kinetic sculpture *Walking on Earth, Air, Fire and Water* (1966) invited participants to interact with the elemental environment by stepping inside pneumatic shapes. Heath would reproduce a similar experimental structure in Canada. Due to their size, the works were exhibited outside gallery spaces to interact with environments, which became an inherent part of the project.

One of Stevens's largest and most famous constructions was *Desert Cloud* (1972), a massive inflatable flying Mylar platform which he filmed in Kuwait as it drifted through the desert like a large cloud, creating shade patches on the ground. The inflatable cloud housed tools that conducted a multifaceted exploration of the transformation of energy in weather systems (particularly evaporation, condensation, and precipitation). This experiment with sustainable energy offered a potential tool against drought.

In his article "Pneumatics and Atmospheres" published in *Architectural Digest* in 1972, Stevens describes the new medium of air:

Air is in our bodies, our bodies live in air and the planet earth we live on is housed in air. Air is the physical connection between us and our environment, transmitting our sense experience of light, heat, sound, taste, smell and pressure. But its very transparency prevents us from observing its continuous transformations. Atmosfields and pneumatic environments aim to reveal the aesthetic of air, both in the natural states which make up the atmosphere and by using thin membranes to manifest their motions and forces, in order to extend and change our direct experience of air and our relation to our atmospheric environment.[66]

Such experiments were openly inspired by Buckminster Fuller's concern with energy and natural resources, and responded to his Design Science Decade challenge to find expedient solutions to environmental problems. Architecture was no longer a static construction, imposed on the environment; it *was* the environment: responsive, transparent, interactive, flexible, and immersive. Often only two elements were needed in the construction: soft, flexible membranes often made of polyethylene (plastic) and air.[67] Stevens's inflatables expressed a new affective materialization of the atmospheric environment as immersive architecture.

Heath and Stevens met in 1971 at a large outdoor cinema event called Phun City held in Brighton. Stevens produced a large inflatable "atmosfield" that could hold four hundred people and accommodate different performances, happenings, and events. The event included film screenings, music, and readings by the likes of William Burroughs—no doubt organized through one of the many alternative book stores in Brighton, which was also known to be a haven for hippies, gay men, and lesbians in the 1960s and 1970s. Heath was the projectionist for the Phun City event, where he was also enlisted by Stevens to fill up hundreds of inflatable water seats which served as anchors to keep the structure from floating away. After Phun City, Heath collaborated with Stevens on numerous other inflatable architectures for cultural events in the United Kingdom.

According to Stevens, Phun City was the brainchild of architect Cedric Price who, along with the radical theater director Joan Littlewood, had imagined a new kind of public gathering called Fun Palace.[68] As Littlewood would lay out the project in the *New Scientist* (1964):

In London we are going to create a university of the streets—not a gracious park—but foretaste of the pleasures of the future. The "Fun Arcade" will be full of the games that psychologists and electronics engineers now devise for the service of industry, or war. Knowledge will be piped in through jukeboxes. ... An acting area will afford the therapy of the theatre for everyone: men and women from factories, shops and offices bored with their daily routine, will be able to re-enact incidents from their own experience, wake to a critical awareness of reality. ... But the essence of the place will be informality—nothing obligatory—anything goes. There will be no permanent structures.[69]

As early as 1961, Littlewood imagined a nonsegregated open space that preserved the best of the pleasure gardens and working men's institutes. Visitors from all backgrounds were invited to stroll or sit for hours—educational

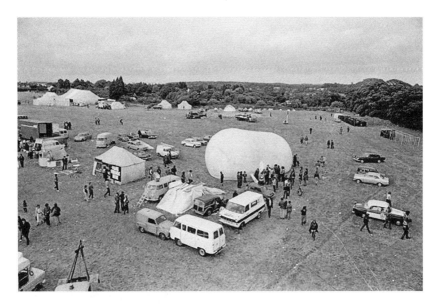

Figure 5.2
Exterior view of Graham Stevens's "Pneumatic Environment (1968)" at Phun City, 1970–1971. Photographer: Andrew Tweedie. GASACT © Graham Stevens.

and creative activities ranging from the theatrical and artistic to the cybernetic and scientific were multiple, variable, and intended to commingle in a novel interdisciplinary pedagogical experience. To build this "University of the Streets," Littlewood approached the young architect Price, whom she had met in 1962, to design this structure. Price was the perfect architect for the project. He was heavily influenced not only by Buckminster Fuller's ideas of architecture in movement (time), but also by the work of the Independent Group and by the discourses of cybernetics. Price was also interested in a new kind of "active and dynamic architecture which would permit multiple uses by constantly adapting to change."[70] As Stanley Mathews points out, it was a space that was conceived in temporal terms, and in terms of process: "The Fun Palace would have to be an entity whose essence was continual change, which permitted multiple and indeterminate uses. His designs began to describe an improvisational architecture of constant activity, in a continuous process of construction, dismantling, and reassembly."[71] If Phun City was an experimental offshoot of Fun Palace, its combination of media and architecture enabled a

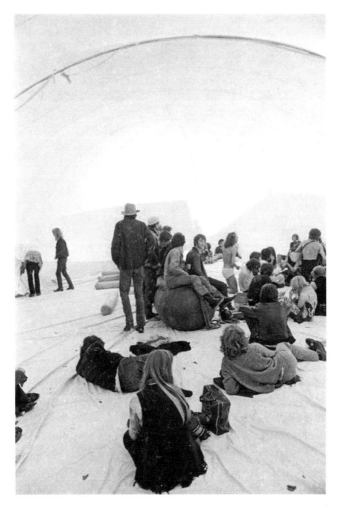

Figure 5.3
Interior of "Pneumatic Environment (1968)" at Luton Arts Festival, January 1970.
Photograph courtesy of Graham Stevens. GASACT © Graham Stevens.

decentered gathering of people from different backgrounds to escape their everyday lives for a weekend "laboratory of fun."[72] In effect, Stevens's and later Heath's inflatable architectures were the quintessential answer to the process-oriented architecture that Price was looking to devise for the Fun Palace.

When Heath moved to Toronto in the early 1970s, he lived for two years at Rochdale College, an experiment in student-run education at the University of Toronto that opened in 1968. Canada's first free university, Rochdale was also the largest cooperative student-housing residence in North America, and was named after a town in England that had been home to the first cooperative society, founded in 1844—the Rochdale Society of Equitable Pioneers. Rochdale College, some would argue, was the quintessential, utopian expression of the "Expanded Cinema University,"[73] and certainly it was framed, and is remembered, as a utopian undertaking.[74] Opening as a non-degree-granting pedagogical experiment with more than eight hundred students, the residence consisted of a large high-rise tower at the center of the city specifically designed for communal living. The residence housed a theater specifically devoted to film and performance and was inspired by the ideas of McLuhan, who was teaching his unique vision of media studies only a few blocks away.[75] Film and theater were regarded as the principal experimental media for creating new kinds of awareness at Rochdale in the late 1960s.

While at Rochdale, Heath worked with Deanne Taylor, whom he had met at the Electric Cinema Club in London. Together they made the rock documentary *Son of Tutti Frutti* (1972), an anthology of clips from the history of rock 'n' roll music (1955–1965), which screened weekly at Toronto's Roxy Cinema throughout 1972. Taylor and Heath adapted the film from an eight-hour, two-screen happening that they had designed for various music events in England in the late 1960s and 1970s, including a very successful Grateful Dead concert. In Toronto, Taylor cofounded VideoCabaret with Michael Hollingsworth, which combined video, performance, and theater. Heath worked with both of them on many of their early presentations and innovative events that incorporated multiple video broadcasts of live screen performances—benchmarks in the early history of video and performance art.

Heath was always interested in the performative aspects of distribution. When he decided to remain in Toronto, he initially worked with Linda

Figure 5.4
Sale held at Rochdale College on August 26, 1971, to raise funds for legal fees the
residents believed would be needed when Canada Mortgage and Housing (CMHC)
assumed management. Photograph courtesy of John Wood.

Beath at New Cinema Enterprises, a distribution company. Beath, along
with Taylor and others, organized the Toronto Women and Film Inter-
national Festival (WFIF) in 1973, one of the first women's film festivals
in the world, which was tied to a growing network of feminist film events
and publications.[76] As codirector of VideoCabaret, Taylor would continue
to experiment with live video performance at various theaters and alterna-
tive gallery spaces throughout Toronto.

From the mid-1970s onward, Heath became involved in most of the
major film events in the city, either as a technology consultant, a "revision-
ist," a projectionist, or a builder of cinemas. WFIF was the precursor to the
Toronto International Film Festival (TIFF, formerly the Festival of Festivals),
established in 1976. While continuing to work on different events involv-
ing film and video, Heath invented a position for himself at TIFF as a "film
revisionist" and projectionist, managing two screens at the St. Lawrence
Centre. He argued, correctly, that union projectionists would be unable
to handle the varied and special needs of diverse film materials arriving
from around the world. He continued in this position for more than three
decades—a position unique to the Toronto Festival, now the largest film
festival in the world. So omnipresent was he in Toronto's film community

that the first photograph in Brian Johnson's *Brave Films Wild Nights* (2000), a history of TIFF, is a full-page photo of Heath at the helm—spooling films onto 35mm reels.

In 1975, Heath received a Canada Council for the Arts Explorations Grant along with artist Chris Clifford to produce a series of inflatable mobile cinemas that would tour throughout Ontario and other parts of Canada for three summers (1976–1978). The inflatable "Cinema Mobile" expanded out of a van, inverting the meaning of what was originally a large sculpture produced from an inflatable penis created by Harry Pasternek and Michael Hayden, which Heath and Clifford transformed into a womblike vessel that could contain people, film projections, and screens.[77] Able to seat about thirty people at a time, this inflatable cinema was transported to and set up in communities, in parks, and on beaches in cities and small towns across Canada to create an ephemeral sense of togetherness and a mobile experience of cinema.

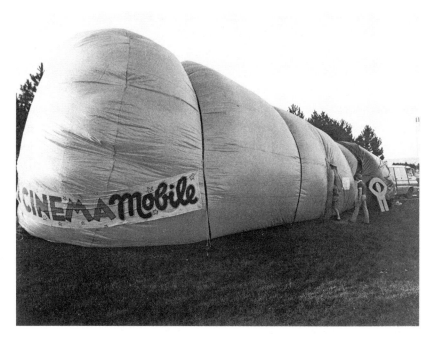

Figure 5.5
Martin Heath's "Cinema Mobile" on location in northern Ontario. Photograph courtesy of Martin Heath.

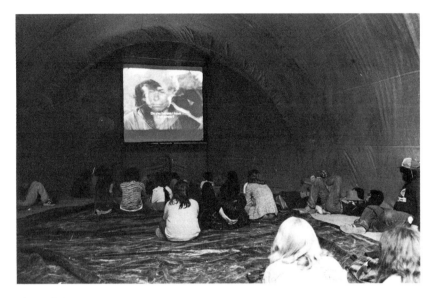

Figure 5.6
Inside Martin Heath's inflatable cinema during a screening in northern Ontario.
Photograph courtesy of Martin Heath.

The inflatables used a portable aircraft heater, formerly property of the
Royal Canadian Air Force, to preheat the inflatable, the cinema projectors,
a generator, and a sewing machine. Inside his inflatables, Heath screened
works from his growing collection of art and avant-garde films (today num-
bering two thousand) by using a variety of projectors from his collection
of historical and state-of-the-art film projectors (numbered at more than
fifty). He also screened National Film Board documentaries for some of the
more organized community-based screenings, especially among Aboriginal
communities in northern Ontario. Along with his inflatable mobile cin-
ema, Heath produced a series of inflatable *Walking on Water* structures as
part of his overall mobile cinema experience. No doubt Heath had learned
the technique from Stevens, who had produced a piece called *Walking on
Air*. For *Walking on Water*, cubes or spherical membranes were filled with air
to allow participants literally to walk on this element, offering a utopian
expression of architecture as corporeal extension.

All of these environmental structures emphasized the relation
between inside and outside, which shifted depending on the nature of the
construction—encouraging reflection on the elemental connection (air,

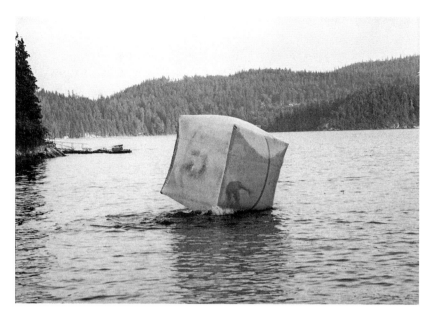

Figure 5.7
Martin Heath, *Walking on Water* sculpture (1975). Photograph courtesy of Martin Heath.

water) to the outside and inside of our bodies. These environments also created new kinds of acoustics and ways of being together as a collective. Stevens explains: "as internal pressure varies so does body movement." He writes that participation in environmental structures is bodily because

1. People are completely integrated and become part of the structure.
2. Body Energy activates the structure.
3. The structures are tools, relating the body to the environment and relating people to people.
4. Mental Valency—the ability to combine with the minds and lives of the participants.
5. Practicality—the experience is easy is to repeat.
6. The structures respond on the human scale.[78]

Stevens goes on to discuss a waterbed that had been the first *Walking on Water* structure, which was repurposed as a floor in the "Structures gonflables" (Inflatable Structures) exhibition in Paris in 1968.[79]

Experiments with inflatable structures and pneumatic art forms were unfolding all over Europe (especially in France and Germany) and the

United States from the late 1960s onward. Knowledge and techniques were shared through international experimental art and performance events, DIY magazines, through popular music cultures (the Rolling Stones' inflatable penis was their concert icon from the mid-1970s on), through protest cultures, and through a growing industry in sustainable architecture. As discussed in the previous chapter, along with Fuller, Frei Otto was a forerunner in lightweight tensile and membrane construction. Fresh from his massive success at Expo 67, Otto hosted the first International Colloquium on Pneumatic Structures at the University of Stuttgart. Convened by the International Association for Shell and Spatial Structures (IASS), the colloquium had an impressive list of attendees,[80] and this is where Stevens first met Cedric Price.[81]

CineCycle

With his semipermanent cinemas of the late 1970s, Heath found the perfect combination of elements to reimagine mobile and sustainable architecture. It was the inclusion of a bicycle repair shop that distinguished Heath's first two permanent cinema designs, Bathurst Street and G.A.P., and in fact made them sustainable. The synergy between bicycles and films seemed obvious to Heath, who had been an avid cyclist since childhood. But the original design was, in fact, yet another version of the inflatable mobile cinema. Both bicycles and cinema came of age at the same time, and in his collection, Heath has several silent films that document the bicycle craze of the late nineteenth and early twentieth centuries. The antagonism between bicycles and cars afflicts most Western cities, and that antagonism may have been what Heath had in mind when he devised the name "CineCycle." Both experimental alternative cinema and the bicycle occupy urban spaces in marginal ways, and yet, because of their flexible forms, they are able to transgress the virtual and physical infrastructures of media and cities. Indeed, there is a survivalist aesthetic in all of Heath's designs.

In 1989, Heath established Access Bicycle Works, and in 1991 he opened CineCycle at 317 Spadina Avenue, in a back alley behind an abandoned factory. Like his previous spaces, CineCycle launched with a series of parties. The front half of the Spadina Avenue space was a bicycle repair shop and espresso bar. Cinema patrons had to walk through the shop, which

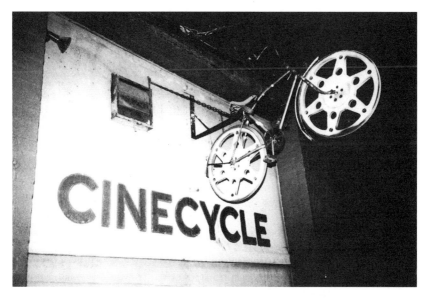

Figure 5.8
The sign above the entrance at CineCycle's first location (1991–1995), behind 317 Spadina Avenue, Toronto. The bicycle was built by George McKillop using 16mm film reels for the wheels and chain ring. Photograph courtesy of John Porter.

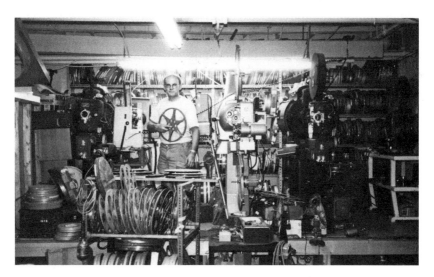

Figure 5.9
Martin Heath in the unfinished projection booth at CineCycle, 317 Spadina Avenue, 1991. Photograph courtesy of John Porter.

was littered with old bike parts, to get to the eighty-seat theater in the back. Importantly, it was a space that was not dependent on government funding for its subsistence. Heath had seen or been involved in numerous cinemas that had failed because they depended on unreliable government subsidies.[82] In trying to create a sustainable theater, he recognized the importance of being able to accommodate multiple formats, and Cine-Cycle uniquely offered 35mm, 16mm, regular 8mm, and Super 8 film as well as VHS and ¾" video projection. Heath's commitment to this wide variety of formats quickly earned the venue the appreciation and support of the local film and video community. The space became very busy, with regular screenings programmed by the Pleasure Dome Artist Film Exhibition Group (established in 1989), which used CineCycle for most of its bimonthly screenings and which, at present, accounts for about 75 percent of CineCycle's regular programming.

Despite Heath's ongoing efforts to sustain CineCycle, increasing rental costs made the Spadina Avenue space too expensive to maintain. Heath needed to find a new location, and the owners of 401 Richmond Street, a historical warehouse in the heart of Toronto owned by the Zeidler family, offered CineCycle the coach house behind the building at a subsidized rate.[83] Despite its location at 401 Richmond, CineCycle, like Heath's previous spaces, can only be accessed through a back alley. While it is not difficult to find, patrons need to be "in the know." Its "hiddenness" is part of its appeal as an underground space, providing a sense of marginality that both creates and evokes the aura of a historical avant-garde that never existed in Toronto.

Unmade Space

CineCycle's urban vernacular, intimate size, and idiosyncratic blurring of the boundaries between work and leisure, bikes and films (referencing a post-Fordist economy), and finally its insistence on the ride rather than the destination, are intrinsic aspects of its character and design. The fact that Heath must clear his bicycle shop out of the way and set up chairs before each screening produces the sense of a collapsible, mutable space. Indeed, as Littlewood had conceived of the Fun Palace, CineCycle is constantly being made and remade—it is adaptable; it can be appropriated by different events and media. There is something else about CineCycle,

something rarely mentioned, which is nevertheless very much part of its blurring of "the rim of the frame": CineCycle is also where Martin Heath lives. The space has no visible evidence of this domesticity, however; it is something that is just known. But this, perhaps, is what produces, in the experience of entering the cinema, a feeling of belonging or being at home.

Designed and built by a cinephile, CineCycle is a space dedicated to film and media history, with old bicycles and film posters mounted on the walls, a variety of projectors stored at the back (now including a hand-cranked 35mm projector), and the old espresso machine brewing freshly roasted coffee beans. It is very much like specialized music scenes, which Will Straw has argued can be read as spaces "organized against change," through which "regularized obsolescence" can be resisted and minority tastes supported by networks of small-scale institutions.[84] Resistance to obsolescence—the use of recycled, historical or found footage, and home movies—is common to many alternative and experimental film and media practices. These methods of appropriation correspond perfectly with Cine-Cycle's original mandate to maintain a screening space for obsolete formats such as 8mm film (artist Petra Chevrier custom-built Toronto's only Xenon-lamp 8mm projector, which features a 2,000-foot reel), technologies such as Fisher-Price's PixelVision, and famously, the bicycle-powered Super-8 projector built by Heath himself. As the locus of a scene, CineCycle constitutes a shared project of giving that exceeds the simple avant-garde dictate to create the new. Cinema is more than movies; it consists of the place, the material culture of film/media, the projectors, the spaces of gathering, the events, and the people who are part of it. It is the web of relationships, networks, systems of exchange and energy. In that way, CineCyle, like Heath and Stevens's inflatable structures, is an umwelt—a shared environment. Human relations (labor and imagination) are embedded in and performed through the material culture of Heath's cinema (bikes, wheels, reels, film, cameras, projectors, screens, chairs, coffee, etc.). The cinema fosters a scene, which makes of history an unfinished project—a living archive that is found, given, and shared collectively. CineCycle is not simply the vision of a single individual. Rather, as Hardt and Negri describe "the common," it belongs to the "spiral" that is produced by a dynamic experimental film scene, by a network of artists, places, events, films and media, projectors, programmers, curators, and archives.

In this sense, I want to situate CineCycle within the framework of post-sustainable culture. Allan Stoekl proposes the term "postsustainable" as an extension of Bataille's notion of general economy, writing: "The peak of consumption and the revelation of the finitude, the depletion, of the calculable world is the opening of another world of energy expenditure and the opening of a wholly different regime."[85] Stoekl is referring to forms of culture that take an integrated approach to expenditure. Bataille's system, presented in the three volumes of *The Accursed Share*, is based on his knowledge of the history of expenditure (he was, after all, a medievalist and a librarian) and his notion of general economy, which, as noted above, derived from the potlatch. His conceptualization of general economy, then, begins by proposing an *integrated* view of energy expenditure. Taking the car industry as an example, Bataille declares that it is possible to change a tire without considering "the whole, of which the tire ... is an integral part." He goes on:

Between the production of automobiles and the *general* movement of the economy, the interdependence is rather clear, but the economy taken as a whole is usually studied as if it were a matter of an isolatable system of operation. Production and consumption are linked together, but, considered jointly, it does not seem difficult to study them as one might study an elementary operation relatively independent of that which is not. ... In other words, isn't there a need to study the system of human production and consumption within a much larger framework?[86]

Bataille advocates a transformation of the ethics upon which capitalist economies have been erected. He calls for a shift from a restrictive economy (i.e., an economy based on scarcity) to a general economy that does not uncritically encourage economic growth without considering the materiality of the earth. He proposes a cosmic ecology in which processes of energy expenditure (economies) and the nature on which these processes depend are considered together. Finally, he articulates that "[a]n immense industrial network cannot be managed in the same way that one changes a tire. ... It expresses a circuit of cosmic energy on which it depends, which it cannot limit, and whose laws it cannot ignore without consequences. Woe to those who, to the very end, insist on regulating the movement that exceeds them with the narrow mind of the mechanic who changes a tire."[87]

In reading *The Accursed Share*, one is struck by a seeming shift in Bataille's writing from eroticism and sacrifice to a focus on the material life of human

existence and a radical proposal for rethinking political economy and community in ecological terms. Indeed, Cédric Mong-Hy has argued that the book is in actuality the work of two men. Bataille's correspondence indicates that he and his longtime friend and advisor, the nuclear physicist Georges Ambrosino, were both involved in its early formulation. Since Ambrosino was Bataille's scientific tutor and intellectual companion from 1934 to 1947, Mong-Hy speculates that in all likelihood Ambrosino introduced Bataille to Vernadsky's thought.[88] Yet the book also takes an approach to culture that is consistent with Bataille's earlier work: the "unemployed negativity," or unproductive consumption, like the capacity for slippage and excess, enables thinking beyond oneself in order to disclose the world in relation to a universe beyond. Such a project, Giorgio Agamben suggests, is a kind of "epilogue" in which "human negativity is preserved as 'remnant.'"[89] Such an undertaking arguably culminated in Bataille's final book, *Tears of Eros* (1961)—a historical/anthropological/archaeological collection of representational "remnants" of the relationship between death and eroticism across the ages, building on ideas he developed in *Eroticism* and *Prehistoric Painting*.

Though Bataille still relies on the fundamental oppositions of life and death, eroticism and horror, luxury and waste, and so on, he proposes a practice of philosophy through negation: philosophy as a practice, and theory as a processing, that is incomplete, unfinished, and open: "We are discontinuous beings, individuals who perish in isolation in the midst of an incomprehensible adventure, but we yearn for our lost continuity." Bataille reclaims and redeems this lost continuity through fusion with another body or object in extreme moments when the singular self dissolves into unity, like "one wave lost in a multitude of waves."[90] And both laughter and eroticism are pathways into the unknowable, the sacred, or the beyond.

Stoekl analyzes the practices of gleaning, collecting, and recycling in Agnès Varda's beautiful film *Les glaneurs et la glaneuse / The Gleaners and I* (2000) as an engagement with the concept of general economy. He argues that this film captures the zeitgeist of new forms of "remediation" or gleaning in the digital age. Defining history as an intrinsic aspect of postsustainable culture, Stoekl asserts: "The recycled object is also violently riven by the trace, the scar of its former appropriation."[91] This materiality of media is inherent to Varda's film, which reflects upon its means of production in

a manner that is constantly folding back on itself and is deeply reflexive of its own material conditions. In this small and profound documentary about gleaning objects and food, images of waste situate the act of recycling in the contexts of Varda's aging body, her own collection of things, and her travels, which she archived with the then newly available lightweight camcorder (Sony DV CAM DSR 300), itself becoming part of her collection.[92] Varda breaks down without collapsing the tension between subject and object, objectifying and losing herself (she records her gray hair and her wrinkled hands). The camera is the tool by means of which fragments of her life and her own connection to the land will endure as memory objects (including the camera) long after she is gone. *Les glaneurs et la glaneuse* frames Varda in a history and ecology of gleaning, and ultimately connects her to the world of things—networks, relations, and histories. Her film is not, therefore, about death, but about life after death—with its myriad of things, the film is a kind of festival of general economies, each object pointing beyond itself. While it was shot using the small-scale video camera, its intimate views nonetheless offer a larger vantage point onto the terrestrial world, onto discarded objects, disregarded people, invisible histories, and their connection to the planet. Varda is able to link an ethics of the real with an ethics of capitalist consumption. Her integrated approach to expenditure reveals scarcity for what it is (in this instance, an unethical fiction), and her documenting of gleaning practices in a postsustainable context, as Stoekl argues, suggests possible futures.[93] Varda not only succeeds in tapping into the turn-of-the-twenty-first-century zeitgeist, but effectively foregrounds, in a most prescient manner, the crisis—of hunger, poverty, homelessness—that is now upon us and will continue to grow. She sees the profound disconnection between earth, worlds, and planet within capitalist modes of production and consumption, and within the capitalist agricultural model.

In the film, small gestures of gleaning food, objects, and images are juxtaposed to create a kind of manifesto on food and material security—one of the major issues facing twenty-first-century cities around the planet (which is why Varda's film has aged so well). This act of gleaning is framed as a simple "right to the city," to use Henri Lefebvre's now famous decree: "the right to the city is like a cry and a demand … a transformed and renewed right to urban life."[94] Gleaning speaks to the smaller economies of scale, of sharing and gifting. It points to the need for setting up alternative locally based food

economies alongside the support of new kinds of maker cultures—from crafting recycled things into new artistic collages to small-scale media making. I am reminded of Hito Steyerl's thesis on "the poor image," discussed above, which refers to images made to be shared and circulated rather than copyrighted and commodified, or Espinoza's "For an Imperfect Cinema," which demands a more democratic and open public sphere for audiovisual cultures. And it is with the poor image and the imperfect cinema that Cine-Cycle stands as a public space that is open to being appropriated.

6 Dolphins in Space, Planetary Thinking

And then the fling of hope, the finding of a shadow Earth in the implications of enfolded time, submerged dimensions, the pull of parallels, the deep pull, the spin of will, the hurl and split of it, the flight. A new Earth pulled into replacement, the dolphins gone.

Then stunningly a single voice, quite clear.

"This bowl was brought to you by the Campaign to Save the Humans. We bid you farewell."

—Douglas Adams, *The Hitchhiker's Guide to the Galaxy: So Long and Thanks for All the Fish*[1]

"At present I am a passenger on Spaceship Earth," and "I don't know what I am. I know I am not a category, a highbred specialization: not a thing—noun. I am not flesh. At eighty-five, I have taken in over a thousand tons of air, food, and water, which temporarily became my flesh and which progressively disassociated from me. You and I seem to be verbs—evolutionary processes. Are we not integral functions of the Universe?"

—R. Buckminster Fuller, *Critical Path*[2]

Our bid for a sustainable culture is informed by the reality that we are living through a transition that is both planetary and, as I will suggest in this chapter, archival in nature. Deep History, as Catherine Malabou points out, must recognize that we live in worlds and landscapes that are both earthy and virtual.[3] Arguably, we live in one vast archive—the geological—that is more visible with the massive acceleration in the geohistory of the earth, and in the ongoing deluge of mediated memory and virtual worlds, whose exponential growth defines our daily environments around the planet. New ecological approaches to media studies, or media studies approaches to ecology, ask us to see relationships between things in terms of a broader continuum rather than as discrete temporalities and objects.

In his 1978 essay "Problems of Materialism," literary theorist Raymond Williams urged his readers to "re-emphasize, as a fundamental materialism, the inherent physical conditions—a specific universe, a specific planet, a specific evolution, specific physical lives—from which all labor and all consciousness must take their origins."[4] Williams was announcing the end of nature via its ascendance into new networks and assemblages, but as geographer Nigel Clark has emphasized, this essay was also a prelude to a profound and substantive return to the earth.[5] Williams proposed a reflexive understanding of the physical-material conditions of existence, which emphasize comradeship, solidarity, and the future. Here, archives come to play a central role in our consideration of the future more than of the past, for as Jacques Derrida tells us, archives are not a question of maintaining the past, but rather are a responsibility to the future.[6]

In this chapter I look at different projects involving the planetary and expanded thinking with a focus on designing spaces at "the scale of the universe," as Bataille put it.[7] I begin by considering the approaches to planetary resources offered by Bataille and by Buckminster Fuller, who devised a "World Game" for Expo 67. I move on to consider the work of the architectural collective Ant Farm, which proposed strategies for planetary and interspecies communication and media. Ant Farm also created several time capsules in order to understand collective fantasies about the future. After the group disbanded in 1978, founding member Doug Michels designed a space station called Bluestar, meant to be completed in the year 2025, where dolphins and humans could interact in a water bubble in earth's outer orbit.

In the second part of the chapter, I move from interspecies communication to transhumanism with the archival project of Finnish artist and inventor Erkki Kurenniemi, who has spent the past forty years archiving his daily life so that one day it might be collected in a game to be played and reassembled on Mars by disembodied beings. Finally, I look at two projects by San Francisco artists who may well be the artistic successors to Ant Farm. The first is Trevor Paglen's satellite project *The Last Pictures*, which features an ultra-archival disc micro-etched with one hundred photographs and encased in a gold-plated shell attached to the communications satellite Echostar XVI that was launched into orbit in November 2012. The second is an earthbound project by Amy Balkin, Malte Roloff, and Cassie Thornton

entitled *A People's Archive of Sinking and Melting*, a collection of objects from places on earth in the process of disappearing through climate change. Each project is an example of expansive archival thinking in the age of the Anthropocene. I frame the entire chapter with some concepts of energy expenditure and sustainability proposed by two thinkers—Georges Bataille and Buckminster Fuller—whose ideas I have touched upon throughout this book and who are part of the history of post-World War II approaches to sustainability.

Bataille and Fuller: Energy as Wealth

Georges Bataille and Buckminster Fuller stand diametrically opposed in their ecological appeals to energy resources—one agnostic and the other deeply religious. Even so, their ideas are remarkably complementary. Importantly, both wrote their most significant books on energy after World War II and under the rubric of crisis and emergency.[8] Both were also fully cognizant of the ways governments use "crises" to justify wars and colonization.[9] In volume 1 of *The Accursed Share*, Bataille writes about energy in a way that is both historically and scientifically informed and less provocative than his other works. Here he is more focused on providing the "key" to "all the problems posed by every discipline concerned with the movement of energy on earth—from geophysics to political economy, by way of sociology, history and biology." Other disciplines from philosophy and psychology to art and literature "have an essential connection" to this field of study—"that of excess energy, translated into the effervescence of life."[10] Solar energy lies at the center of his theory of expenditure: "Solar Energy is the source of life's exuberant development. The origin and essence of our wealth are given in the radiation of the sun, which dispenses energy—wealth—without any return. The sun gives without ever receiving."[11] Bataille wrote under the influence of Russian geochemist Vladimir Vernadsky and took on the latter's notion of the biosphere as a new form of freedom and planetary unity at the end of the Second World War, a mindset "which issues from the global resources of life, a freedom for which, instantly, everything is resolved, *everything is rich*—in other words everything is commensurate with the universe."[12] Bataille's freedom of mind, Allan Stoekl tells us, is "rare—in fact, unique—among twentieth century

thinkers in that he puts energy at the forefront of his thinking of society: we are energy, our very being consists of the expenditure of quantities of energy."[13]

As stated in the previous chapter, Bataille was writing and researching under the tutelage of the nuclear scientist Georges Ambrosino, whom he thanks in the introduction and who introduced him to Vernadsky's concept of the biosphere and his geocentric perspective.[14] Bataille's theory of General Economy employs a concept of complexity derived from the third law of thermodynamics and relies upon a systems approach to understanding the environment. Solar energy supports the lifeworld and connects all aspects of it—from vegetation to animals (human and nonhuman). Thus, expenditure infuses society and the natural world alike, and helps us to recognize their interdependence. This is "l'économie à la mesure de l'univers"—economy at the scale of the universe—in a decidedly secular universe, as Stoekl puts it: "Bataille argued that Solar energy is above all expended through disorganized, erotic, and anguished physical movement that overturns the spurious ideals of God and Man."[15] Bataille is interested in a self-consciousness found in the movement toward nothingness—the "nothingness of pure expenditure," of a "pure interiority which is not a thing"—through contemplation.[16] Such ideas remind me of Merleau-Ponty's notion of the intertwining of inside and outside, of a pure interiority that is also connected to everything in the universe. I shall return to Bataille's relationship to Merleau-Ponty and the planetary in this book's epilogue.

For now, Bataille's book, arguably one of his most important, has much to contribute to an expanded thinking about energy in the era of climate change. General Economy insists on an *integrated* view of energy expenditure that breaks down the divide between nature and culture, and situates consumption in terms of a utopian and ethical epistemology, asking us to consider the impact of production on the whole environment. Bataille does not, however, offer an overall program to steer an ethics of consumption, and here lies the source of some of the limitations of his proposal. Derrida points out that the fifth section of the book devoted to "The Present Data," which discusses Russia and gives an overly positive evaluation of the US economy's role in maintaining a "dynamic peace" (the so-called disinterested generosity of the Marshall Plan), is filled with "conjectural

approximations."[17] Though Bataille clearly states that he was deferring "detailed calculations of growth and waste entering into the manufacture of a hat or a chair" until another book (which was never written), we must take seriously the fact that he doesn't mention the specifics of energy production beyond limitless solar energy. In this sense, we might read Bataille's book as a space age ideology of nuclear abundance. Stoekl rightly points out that Bataille and Ambrosino conceive of the solar in atomic terms. Certainly Vernadsky was involved in thinking through the peaceful applications and development of atomic energy. And we saw such positive views of atomic energy at the Festival of Britain's celebration of a new global energy program in 1951. There is in Bataille a similar "naïve faith," as Stoekl puts it, that, "indeed, there always will be an abundance of refinable, usable energy and that spending energy to get energy, inevitably results in an enormous surplus of energy."[18] For Stoekl, Bataille's solar thesis is limited in its application and is inadequate for helping us to understand the intricacies and limits of solar energy technology, which does not provide the kind of abundance Bataille describes.[19]

Buckminster Fuller's approach to energy is decidedly more empirical and programmatic but equally utopian—that is, hopeful. He sees the universe and its design in terms of the unfolding of a nonanthropocentric, nonsimultaneous scenario of eternal principles that need to be deciphered and followed if "Spaceship Earth" is to survive. His design ideas originate from nature, but at the same time, like Bataille, he does not separate nature and culture. In *Operating Manual for Spaceship Earth* (1963), *Utopia or Oblivion: The Prospects of Humanity* (1969), and *Critical Path* (1981), Fuller gives readers a choice to either live under the ideology of scarcity and survival of the fittest à la Malthus and Darwin, which leads to wars and the unequal distribution of resources around the world, or to make the world "work" for 100 percent of humanity. He optimistically writes: "Our technological strategy makes it incontrovertible that we can live luxuriously entirely on our daily Sun-radiation-and-gravity produced income energy."[20] Fuller's critical path for Spaceship Earth phases out *forever* "all use of fossil fuels and atomic energy." Like Bataille, Fuller sees energy in terms of economy and wealth, and believes it is an infinitely renewable resource. He would write presciently in *Utopia or Oblivion* (1969):

It is now also dawning upon industrial society that it could be even more success-
ful while depending exclusively upon the potentially enormous energy income—in
contradistinction to living almost exclusively by burning up our capital principal,
that is our "savings-account" energy in the form of fossil fuels.

The natural energy "income" for instance, the harnessable ocean tides, wind,
sunpower and alcohol-producing vegetation, can be made to flow through the wires
and pipes to bring adequate energy to bear on the levers, to step-up man's physical
advantage efficiently to take care of all of humanity.[21]

Fuller's cosmic ecology is deeply ethical—resources should be distributed
so that *all of humanity* can enjoy a "luxurious" standard of life—i.e., food
and shelter. As Robert Arens points out, a concern with low-cost housing
for all was central to Fuller's undertakings from the beginning of his career
in 1927 with the design of the 4D house, and culminating in the Dymax-
ion Dwelling Machine[22] and "the house of the century" in 1946. As Arens
underlines, both houses offered "practical efficiency and spatial flexibility
and represented a modern approach to the domestic landscape."[23] More-
over, as with all of Fuller's housing designs, time—the fourth dimension—is
a key element. And indeed, from the beginning, Fuller's structures were
conceived to be in motion, starting with the way in which they were to
be air-delivered, and prefabricated, making them most suitable for war
zones, as his earliest architectural projects were, in fact, for the military. The
modernist ambition to create perfection in design and architecture was in
Fuller's case tempered by his ongoing engagement with technology, which
revealed, according to Banham, a "quasi-Futurist bent." Futurism eschewed
perfectionism since it was "dedicated to the 'constant renovation of our
architectural environment,'" which "precludes processes with definite ter-
minations such as a process of perfection must be." This approach is what
made Fuller's design "entirely radical."[24]

Like Steichen and Cousteau,[25] Fuller served in the navy, and many of
his earliest insights about world systems and his sensitivity to the earth's
physical elements (ocean, air, light, gravity, and land) grew out of his expe-
riences at sea. In particular, he was most impressed with the communica-
tions systems aboard ships, and saw the navy as a site of technological
experimentation.[26] The *Inca*, a ship under Fuller's command, saw the first
ship-to-plane voice transmission by Lee De Forest, inventor of the Audion
vacuum tube, the key component in all radio, telephone, radar, television,
and computer systems.[27] Not only did the navy expose Fuller to remote
sensing and its capacity to compress space and time, but it also introduced

him to lightweight design for airplanes and ships. Moreover, it was here that Fuller gained insight into the military industrial complex and its commitment to "ephemeralization," which generally goes hand in hand with acceleration (or "the acceleration of acceleration" enabled through communications and industrialization). Ephemeralization is the evolution of complex systems toward increasingly lighter, smaller, more efficient, and eventually, invisible materials.[28]

While Fuller produced one of the most iconic architectural buildings of Expo 67—the United States Pavilion's geodesic dome—the building was intended to have included a 100-foot-diameter advanced data visualization geoscopic sphere (a miniature earth) as a platform for his World Game project, which he designed with John McHale and the Japanese-American architect Shoji Sadao. Fuller recollected his proposal in "World Game Series: Document 1," which I quote at length to give a sense of the project's sheer ambition:

In the basement of this building would be housed an extraordinary computer facility. On entering the building by 36 external ramps and escalators leading in at every ten degrees of circumferential direction the visitors would arrive upon a great balcony reaching completely around the building's interior quarter-mile perimeter. The visitors would see an excitingly detailed one hundred foot diameter world globe suspended high within the 400-foot diameter sphere main building. Cities such as New York, London, Tokyo, and Los Angeles would appear as flattened out basketball sized blotches with the tallest buildings and radio towers only about one-sixteenth of an inch high.

Periodically the great spherical Earth would seem to be transforming slowly into an icosahedron—a polyhedron with twenty (equilateral) triangular facets. The visitors would witness that in the processes of these transformations there are no visible changes in the relative size and shape of any of the land and water masses of the 100 foot diameter miniature Earth. Slowly the 100 foot diameter icosahedronal Earth's surface will be seen to be parting along some of its triangular edges, as the whole surface slowly opens mechanically as an orange's skin or an animal's skin might be peeled carefully in one piece. With slits introduced into its perimeter at various places it would be relaxed to subside into a flattened-out pattern as is a bear skin rug. The icosahedronal Earth's shell thus will be seen to gradually flatten out and be lowered to the floor of the building. The visitors would realize that they were now looking at the whole of the Earth's surface simultaneously without any visible distortion of the relative size and shape of the land and sea masses having occurred during the transformation from sphere to the flattened-out condition which we call a map. My cartographic projection of the "SKY OCEAN WORLD" functions in just such a manner.[29]

This stretched out football field sized world map would disclose the continents arrayed as one world island in one world ocean with no breaks in the continental contours. The great map would be wired throughout so that mini-bulbs, installed all over its surface, could be lighted by the computer at appropriate points to show various, accurately positioned, proportional data regarding world conditions, events, and resources. World events would occur and transform on this live world map's ever evoluting face. ... The objective of the game would be to explore for ways to make it possible for anybody and everybody in the human family to enjoy the total earth without any human interfering with any other human and without any human gaining advantage at the expense of another.[30]

Fuller's proposal echoes Geddes's desire to produce a miniature earth at scale for the Paris Exposition of 1900, with the aim of furthering an integrated, interdisciplinary perspective and pedagogy geared toward universal understanding. Fuller's "Geoscope," however, was to have been more far-reaching, as it was to be the basis for his World Game project. Relying on computers, the sphere would transform into a living, responsive Dymaxion map capable of displaying all of the ecological and world events affecting the resource information of the planet both past and present.[31] Given all the available information from the Geoscope (physical resources, demographics, "trendings," and important needs of "world man"), players of Fuller's World Game would work noncompetitively to figure out "how to make the world work."[32] Teams from around the earth would play the game to test their theories, but if one theory caused a war, the team that introduced it would lose the game.

Fuller's choice of a computer game platform rather than a simple map or exhibition reflects the pedagogical mission of his work. Like McLuhan, Geddes, and others, Fuller displayed a drive to educate the public through his architectural projects. As a futurist, Fuller wanted to demonstrate the evolution of humankind, an evolution that he believed was being enabled for better or worse through the capitalist and technological innovations of the military industrial complex. His plan was to redirect this production of efficiency toward peace and ecological stability for the earth. Indeed, the overall sense of emergency that pervades Fuller's work reflects the militaristic and Cold War politics it grew out of. Most prescient for twenty-first-century readers of his work are his focus on renewable energy and, like Bataille, his thinking at the scale of the universe.

The sovereignty of nations, or what Fuller called "local focus hocus pocus," would lead to "oblivion," that is, the destruction of the planet

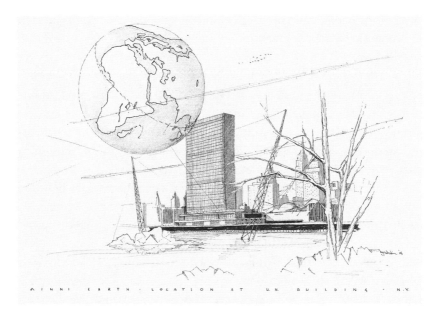

Figure 6.1
Buckminster Fuller's Geoscope proposed for Expo 67.

through warfare and environmental catastrophe—which he viewed largely in Cold War terms (i.e., caused by the atomic bomb), but also through the lens of ecology. Such nation-state interests were the basis of the "World War Games," which Fuller learned about while in the navy and by studying the history of empires—the most successful being the British Empire.[33] Sovereign power is founded on the control of resources and oceans, which also provide the bases for conflicts geared toward hoarding and protectionism. Fuller proposed instead "closing the gaps in the world electric power grid. The world-unifying electric power accounting will be the beginning of the omnienergy accounting for the world economic management." This grid would be an initial phase in the "desovereignification" of the planet: "There can be no planetary equity until all the sovereign nations are abolished and we have but one accounting system—that of the one family of humans aboard Spaceship Earth." This first step toward one governmental system replaces politics with technology.[34]

Fuller was never interested in cities or nations. Even his concern with housing bypassed them, jumping directly from planet to cosmos, with his tensile (tension-compression) dome offering the perfect encapsulation of

this holistic natural formation—globes within globes. Fuller participated in the American National Exhibition in Moscow in 1959 along with Edward Steichen, whose "Family of Man" exhibition appeared alongside a Fuller dome. The notion of "one family" was no doubt already part of Fuller's discourse, yet the added idea of a spaceship brought the family into a cosmic realm. His notion of the whole earth and his geodesic domes would inspire a generation of 1960s avant-garde, psychedelic, and countercultural artists in Europe and North America including, to name just a few, the British architectural collective Archigram; John McHale in London, who came to direct Fuller's resource inventory at the University of Illinois and who wrote several important books on ecology and the future;[35] Stewart Brand, who created the *Whole Earth Catalog* premised on the famous photograph of earth photographed from Apollo 11 in July 1969;[36] and Stan VanDerBeek, who imagined the Movie-Drome, a cinema experience that transcended language. As Felicity Scott explores in her book *Architecture or Techno-Utopia* (2010), Fuller's "doing more with less" mass-produced, low-income housing did not present a contradiction to countercultural artists (the creators of Drop City, for example), but rather afforded a new way of working connected to the land and to the cosmic, mystical elements of the earth. Certainly for McHale and VanDerBeek, Fuller's futurism and technological humanism represented new possibilities for creating a socially engaged popular art, and for confronting the urgent ecological problems connected to the antiwar movement.[37]

But Fuller's energy proposals are not without problems. If Bataille did not provide enough detail by focusing on the science of General Economy instead of on the social aspects of its implementation, Fuller's proposals are far too programmatic and undemocratic in their instrumentality. Like Steichen's "Family of Man" exhibition and so many "one world" projects, the undifferentiated notion of humanity makes difference the same the world over. Most critically, as Felicity Scott emphasizes, "If we can recognize in the World Game a noble ideal of emancipating the world's population from poverty, inequality, hunger, warfare, and illness, we must also identify in its universalizing mandate the logic of a consensus formed without space for contestation, one facilitated through the eradication not only of nation-states but of the democratic political and juridical institutions."[38] There is in Fuller's proposition a loss of politics, and beyond playing the game as a participatory, interactive form—the terms of which Fuller's team

designed—there is no space for challenging the global oneness put forward. Scott continues that, "far from sponsoring a new cosmopolitics," Fuller's game "dangerously reiterated the very machinations of the military industrial logic of an emerging global Empire."[39] I would add that Fuller's technological humanism has an imperial (American) tone in its assumption of an all-encompassing planetary epistemology that claims to be beyond ideology in its scientific representation of the planet and its desire to make the planet work for all humanity.

Bearing these criticisms in mind, we might approach Fuller's proposal dialectically without dismissing his ideas outright, since they offer a radical vision of ecology as context, as a way of conceiving of resource use. I would include McHale's important book *The Ecological Context* (1970) as part of Fuller's program of research. With an emphasis on thinking about resources from a planetary rather than a local or national perspective, McHale writes: "We have now reached the point in human affairs at which the ecological requirements for sustaining the survival of the world community take precedence over, and are supererogative to, the more transient value systems and vested interests of any local society."[40] McHale's report calls for the "swiftest increase in the use of other than fossil fuel energies … and the swift development of locally autonomous power sources, for example from solar, wind, and hydropower."[41] McHale and Fuller were calling for a new kind of "world resource authority" able to decide "upon conflicting scientific claims in terms of the real needs of the human community."[42] This call for cooperation around resources—though it did not anticipate climate change—recognizes the critical importance of moving toward renewables and a new ecological design, and takes technology to be an inherent part of ecology. In a passage that gives a nod to McLuhan's notion of technology as bodily extension, McHale writes: "We have referred to technology as an extension of the human metabolism—one which processes millions of tons of materials each day; yet we have no very clear picture of its operation even to the extent that we have such knowledge of our own internal workings."[43] This, as McHale underlines, is Fuller's central argument in "spaceship earth": "The closed ecology of the future might similarly be called the 'spaceman' economy, in which the earth has become a single spaceship, without unlimited reservoirs of anything, either for extraction or for pollution, and in which, therefore, man must find his place in a cyclical ecological system which is capable of

continuous reproduction of material form even though it cannot escape having inputs of energy."[44] McHale then develops this concept of a cyclical ecological system into a recognition of "our complex interdependence on other organic life forms."[45] As we shall see, it is precisely this interdependence that Ant Farm explored in many of their works, most especially in the Dolphin Embassy.

Both Bataille's and Fuller's propositions can be situated in relation to Karl Mannheim's theory of utopias, which frames many of the projects discussed in this book. Mannheim posits that a utopian proposition must suggest a transformation of present social conditions in a manner that is not simply fantastical. A utopia created by direct action upon an existing reality dispels the argument that it is a "pie in the sky" idea, and therefore invites process, debate, and discussion rather than outright rejection for being unrealistic.[46] We can see that both Bataille's *The Accursed Share* and Fuller's World Game engage with existing social and physical reality. Both criticize architecture's monumental past and propose ways of building process-oriented cultures.[47] Fuller's proposal for a live map of the planet's resources, in particular, speaks to new forms of data collection and visualization, such as Google Earth, ocean mapping by Google Ocean, or NASA's recent images of Mars. To be sure, such scientific visualizations expand our knowledge and experience of the planet, but they are also ideologically imbued with American militarism, and layered with scientific data and modeling that need closer analysis for the way they inaugurate forms of objectivity, knowledge, and power.

Kathryn Yusoff has argued that certain forms of scientific modeling and digital renderings of the earth ("digital earth") give expression to the conceptualization of "excess" within economies of climate change. She argues that "unit-based accumulation of earth data" has actively instated prototypes which render the earth legible through forms of accounting (such as the *Stern Review* and carbon trading)—certainly this is one of the limitations of Fuller's attempt to rationalize and account for all of the earth's resources. Digital earth, Yusoff underscores, is the product of world views produced through globalization. She sees more possibilities in Bataille's concept of expenditure that can more readily account for a "wasting of the world."[48] As we shall see later in this chapter, this is the very approach taken by *A People's Archive of Sinking and Melting*.

If Fuller's game proposal was at times overshadowed by his techno-
logical ethos, which limited the possibilities for open, discursive spaces
of interaction and communication, a whole movement that he helped to
inaugurate around relational forms of interaction and mobile media was
certainly encouraging of diverse kinds of engagements and artistic interac-
tion. The international multimedia platform *World of Matter*, launched in
2013, takes account of resource exploitation and circulation in such a way
as to create a planetary perspective, showing networks, connections, and
interdependencies of world resources through an open-access archive.[49]
The project also includes international art and media exhibitions, con-
ferences, and publications investigating primary materials (fossil, mineral,
agrarian, maritime) and the complex global ecologies of which they are a
part. Overseen by an interdisciplinary group of artists and scholars,[50] the
project responds to the urgent need for new forms of representation that
shift resource-related debates from a market-driven domain to engage pub-
lic discussions in London, Belo Horizonte, Venice, Brussels, New York, and
Montreal. This interdisciplinary approach is both planetary and grounded
in locality through discursive and activist exhibitions. It is much more
open to nuances of the local, which the game structure that Fuller pro-
posed could not address. In the next section of this chapter, I look at some
of the relational nomadic forms of interaction and radical mobile media
that grew out of Fuller's ideas under the rubric of the radical architectural
collective Ant Farm.

Dolphins in Space

Before Burning Man, before The Yes Men, before *South Park*, before flash mobs, there
was Ant Farm, the prototypical underground, culture jamming architectural firm
and performance art and media collective whose antics and anarchic guerrilla
theatre paved the way for future armies of free-thinkers and public artists.
—Laura Harrison and Elizabeth Frederici[51]

Chip Lord and Doug Michels, fresh out of architecture school (Tulane and
Yale, respectively), established Ant Farm in San Francisco in 1968. Inspired
by the student protest movements they had been involved with in Cali-
fornia in the late 1960s, including antiwar protests against the Vietnam
War, the civil rights movement, and environmental activism, they decided

to create an underground architectural practice rather than a commercial venture—hence the name Ant Farm. As Chip Lord recalls, Stewart Brand's *Whole Earth Catalog*, first published in 1967, always featured a Buckminster Fuller section along with information on "whole systems," which greatly influenced the group. The architectural capers of prankster group Archigram, along with Marshall McLuhan and Quentin Fiore's *The Medium Is the Massage*, were also important inspirations for the group as it set out to create ephemeral forms of architectural design and media performances.[52] Their work was in line with the North American countercultural movement that challenged mainstream political and cultural institutions. Three other principal partners soon joined the group—Curtis Schreier in 1969, and Hudson Marquez and Doug Hurr in 1970—and Ant Farm continued to grow in the early 1970s.[53] The group's first experiments involved working with military surplus parachutes to create inflatable spaces. As we explored in the previous chapter, pneumatics were a growing phenomenon in the 1960s and early 1970s, with Graham Stevens's early experiments in London along with others in Austria, France, and Germany. Artists shared knowledge and techniques for working with inflatables across the continents. Ant Farm began using parachutes as temporary structures (calling them "dream clouds") at the University of Houston where they taught in the School of Architecture in 1969. The dream cloud allowed them to imagine new forms of lightweight, moveable, and ephemeral structures that they would photograph and collage to create new imaginary spaces and creative juxtapositions, like "Cowboy and SpaceMan = Space Cowboy." Space exploration would be an ongoing theme for the group, and for Michels in particular after the group broke up in 1978. Of course, being in Texas and in close proximity to NASA for the 1969 Apollo 11 moon landing made the Space Cowboy persona an appropriate symbol for their pioneering iconic work. In a film about Ant Farm's work, an Ant Farmer (Doug Michels) describes inflatables as experimental spaces: "it is like floating as well as being on something, as well as being swallowed up by something ... the inflatable allows a fourth dimension or a new dimension to take place where there are no rules as against static space."[54]

Because inflatables broke down the divide between inside and outside, they were a tool to reorient the senses and perception. The dream cloud created the ecstatic experience that Ant Farmers wanted to develop alongside the use of psychedelic drugs and the creation of media. Newly

available video Portapaks were an important component of the inflatable transformation of the environment. As Steve Seid has noted in relation to Ant Farm's use of video in their architecture explorations, video "itself was something of an inflatable: weightless yet embodying volumes, virtual and fluidic. An open-ended architecture, video extended into the environment as both physical object and flimsy image, all-seeing yet siteless."[55] Video is also described by many artists as a "mirror machine" that enables a feedback mechanism both in the moment and supporting a deeper self-reflexivity (as the moment could be immediately reviewed).[56]

Perhaps not surprisingly, for Expo 70 in Osaka, Japan, the group developed a proposal for a "non-pavilion" that brought these different elements together. The project was to be produced by the Austrian psychiatrist Dr. Harry Hermon, who was federally licensed to prescribe and administer LSD, marijuana, and mescaline/peyote, and who proposed to Lord and Michels that he could raise the funds to support the creation of "a world conclave on psychedelic studies." The Ant Farmers proposed three different kinds of environmental technologies: mobile audiovisual equipment, inflatables of all kinds, and "Environmachines." An important influence on their proposal was the relation between psychedelic drugs and architecture as discussed in the iconic 1966 essay "LSD: A Design Tool?," which the proposal cited.[57] Their design aimed to transform the relationship between self and environment. It would be a "display area for alternate futures, a place where the Expo visitor may experience a feeling for the lifestyle of the turned-on global community." Working with a "kit of parts," the group proposed creating a "mobile force of media nomads" whose dynamic interpenetration would result in a "Real City":

The reality of what the exhibit will be is left to the resources of the people brought together for the *Show of the Century*, these people would be leaders in their respective fields and might include such figures as Timothy Leary, Allen Ginsberg, Allan Watts, Ken Kesey, Michael McClure, The Mothers, Haus Rucker Co and The American Playground. They would live on the site in Osaka. ...

The global community will evolve a non-static life style by living art each day, each day, each day, each day. Day 24 celebrates the Whole Earth Ritual with Whole Earth Truck Store staff. ...

The next day life workshop in Phosphorous Dream cloud uses baby Llamas and other animals as reality props. While part of the community goes to Mount Fuji in a plastic Lake-of-the Moon capsule, recording an enviro-media package for Expo visitors, the rest of the community conducts an East/West Fantasy/Reality World

Game on a plaza in the Symbol area. It's Pancake day in the Tropical Forest and a pancake is worth admission to a Galactic Nude Encounter in the Ultra Violet Foam Landscape.

Living everyday in exotic prototype environments as if we were already in a leisure oriented Globe City of the future.[58]

Ant Farm's application is reminiscent of Littlewood and Price's Fun Palace discussed in the previous chapter, with its sense of improvisation, ecstatic pedagogy, and process-oriented co-created spaces of leisure for future citizens. Michels had studied at Oxford and would have been familiar with Price's work. Ant Farm's proposed pavilion would not have been out of place at Osaka 70, which was renowned for its heavy use of film and experimental projection techniques. In fact, Osaka is where Expo 67 filmmakers Graeme Ferguson and Roman Kroiter, along with Robert Kerr, would showcase their new IMAX cinema technology on a massive curved screen—an outgrowth of multiscreen projection—in the large inflatable Fuji Pavillion.[59]

Over its ten-year life and since, Ant Farm has been known mostly for its profoundly critical and yet simultaneously humorous parodic media works. *Media Van* (1971) and *Truck Stop Network* (1970) explored nomadic media networks, encouraging a new generation of on-the-road, media-connected lifestyles. *Cadillac Ranch* (1973), a site-specific sculptural installation in Amarillo, Texas, featured ten used Cadillacs dating from 1948 to 1963 buried nose-first in the ground with only their tail fins visible from the highway, portraying the rise and fall of conspicuous consumption. The *U.S. Media Burn* (1975), Ant Farm's most iconic performance, featured Michels driving a white Cadillac through a pyramid of burning television sets. Video recordings of *Media Burn* became staples of video art history classes, as did *The Eternal Frame* (1975), which features a reenactment of the assassination of President John F. Kennedy based on the Zapruder film footage, with Michels playing Jacqueline Kennedy, replete with pillbox hat and twin set suit. These landmarks in the history of video art reflect Ant Farm's call to establish alternative media networks through DIY video and to create new interfaces that challenged American "militarism, monopoly and mass media." These video performances also reflect the group's interest in McLuhan's theories of "media massage" as the creation of new spatial and sensory-temporal experiences and perceptions.

In 1968, McLuhan wrote to his friend, the town planner Jaqueline Tyr-whitt, on the topic of "space observations" in his latest book, *Through the Vanishing Point*, asserting that, "since Heisenberg the structural bond of all material forms has been regarded as 'resonance.' This is the world of the interface and the interval, which [coauthor Harley] Parker and I des-ignate as tactile space. ... All scientists are trapped in visual space as much as museum curators. The reason is simply that they don't know there is such a thing as visual space as contrasted with the multiple other spaces familiar to non-literate man."[60] For McLuhan, all nonvisual spaces were acoustic spaces. He recognized that "there are no connections in the mate-rial universe. Einstein, Heisenberg, and Linus Pauling have baffled the old mechanical culture and visual culture of the nineteenth century by remind-ing scientists in general that the only physical bond in nature is the resonat-ing interval or the 'interface.' It is hard for the conventional and uncritical mind to grasp the fact that 'the meaning of meaning is a relationship': a figure-ground process of perpetual change."[61] As McLuhan stated in *Coun-ter Blast*, "environment is process, not container."[62] Ant Farm's pneumatic sculptures, installations, and various time capsules exist in time. As a 2016 exhibition statement comments, their time capsules "deviated from typical examples of the form: they did not preserve stable cultural portraits able to persist through time. Rather, encased within everyday objects—refrigerators and a 1968 Oldsmobile Vista Cruiser (*Citizens' Time Capsule*, 1975)—they had little promise of endurance. Whether destroyed, stolen, lost, or deemed 'environmentally hazardous,' each work failed, underscoring the humor and countercultural critique at the core of Ant Farm's ethos."[63] Embed-ded in their critique was the impermanence and disposability of American commodity culture, and a correlative Fulleresque optimism for the future inherent to their very design, a vision of energy abundance and bountiful resources (the buried cars are anathema to their optimism).

But there is also a zoological line of inquiry in Ant Farm's architectural practice often implicated in or merged with technology, which is expan-sive, futuristic, and even cosmic. In his incisive essay on this aspect, Tyler Survant notes Ant Farm's "zoöpolitics" in the group's explorations of alliga-tors and automobiles (*House of the Century*, a commissioned house), the dol-phin fins in *Cadillac Ranch*, as well as inflatable snakes and turtles, insects, reptiles, and mammals (especially dolphins)—all inhabited Ant Farm proj-ects over its ten-year lifespan.[64]

In between their media performance projects, Ant Farm, with Schreier and Michels as leads, put together a proposal, published in 1975 by *Esquire* magazine, for a project they called the "Embassy to the Dolphins" (with detailed drawings by Schreier). Both Michels and Schreier were interested in interspecies communication and in the work of American neurophysiologist Dr. John C. Lilly, who experimented with the mind-altering potential of LSD and decoding the language of dolphins, in particular, bottlenose dolphins. Aware of the problems with Lilly's early work, in which he had tried to teach dolphins how to speak English (among other disturbing interspecies experiments) at his Communications Research Laboratory in the Virgin Islands,[65] Ant Farm designed an ocean-based research laboratory that would allow for prolonged interactions between humans and cetaceans. The structure aimed to allow humans and dolphins to "study each other up close." Obviously playing with the colonial history of anthropology and media, *Esquire*'s humorous subtitle to the article, "Bringing Media to the Least Developed Nation of All," was countered by the very design of a reciprocal meeting place in the ocean. Schreier's sketches for the "Embassy Platform," under the utopian banner "contact, communication, co-evolution," show a foil-run, sail-powered design named the R/V John C. Lilly, thus acknowledging the inspiration. The bright yellow nodes are reminiscent of Cousteau's *soucoupe*, and the reference would not have been out of place since Lilly was a fan of Cousteau and had carefully read *The Silent World*.[66] As we saw in the second chapter, Cousteau was purposeful about the futuristic design of his instruments and vessels.

Steered by moveable hydrofoils at each of the three corners, the Dolphin Embassy relies on the flow of water throughout to stabilize and supplement the sails as a propulsion system. Two forward nodes are designated "interspecies living rooms." A third is the "Communications and Control Center (Conversation, Diagnostic and Medical Research etc.)," which contains the Embassy's bridge, "with dual human-dolphin controls." In the sketch we see dolphins swimming from the "helical stairway" into the "brain room" where both species communicate through a window by means of "light and sound pens"—the idea is that "the fluidics system may give the dolphins their own computer."[67] Finally, the development of an electronic-fluidic interface enables either dolphins or humans to steer the ship. Importantly, more than any other technology, video is a central communication tool for the Embassy. It is the tool used to facilitate communication between

dolphins and humans by recording, mirroring, and slowing down the complex of sounds and movements that dolphins make.[68]

In many ways, the Dolphin Embassy represents the culmination of Ant Farm's interest in animals both as a conceptual subject and as a basis for a new biopolitics that would expand the boundaries of the human-centered world. With the Embassy, which saw several iterations over the years, Ant Farm was looking for precisely those new world sensations and stratagems that Jussi Parikka explores in his book *Insect Media* (2010), most tellingly through the insights of biophilosopher Jakob von Uexküll and his concept of umwelt. Parikka's provocation in the introduction to the book draws our attention to the current state of distributed digital media. He asks us to take any entomology book, and to read it not as a description of the microscopic world of insects but instead to consider the descriptions in terms of what media can do as "a whole new world of

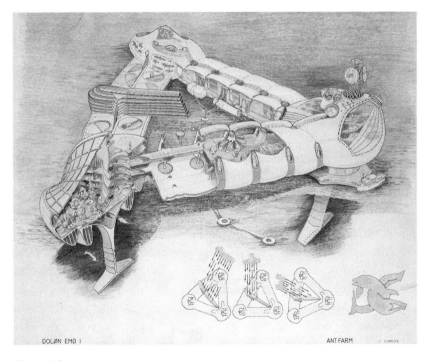

Figure 6.2
Ant Farm, DOLØN EMB 2 (drawing by Curtis Schreier), 1975, hand-colored brown-line. University of California, Berkeley Art Museum and Pacific Film Archive. Photo: Benjamin Blackwell.

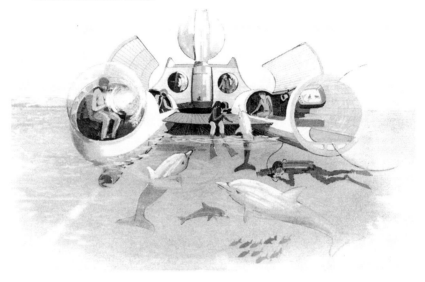

Figure 6.3
Ant Farm, *Dolphin Embassy Viewed from Directly Astern*, 1977, color photocopy.
University of California, Berkeley Art Museum and Pacific Film Archive. Photo:
Benjamin Blackwell.

sensations, perceptions, movements, stratagems, and patterns of organiza-
tion that work much beyond the confines of the human world."[69] With
this idea of distributed networks in mind, it would not be a stretch to
read Ant Farm's practice of working centrifugally and collectively through
media (defined in McLuhanesque fashion to include both manufactured
environments—cars, roads, televisions, nylons, ashtrays, sunglasses, etc.—
and the organic environment—air, ocean, land, stars) alongside actor-
network theory (ANT).[70] This theory, whose best-known architect is Bruno
Latour, originates with Michel Collon's study of the failed electric car in
France and the work of another sociologist, John Law, who describes ANT
as "a disparate family of material-semiotic tools, sensibilities and methods
of analysis that treat everything in the social and natural worlds as a con-
tinuously generated effect of the webs of relations within which they are
located. It assumes that nothing has reality or form outside the enactment

of those relations."[71] For Ant Farmers, ANT was a metaphor for an artist collective, "a mythopoeic note-to-self regarding collective values,"[72] with the ant as the ultimate zoological symbol of a way of working together but separately—resilient, synergistic and utopian.

Crucially, it is the "resonant interval," the interface (inflatables, drugs, video, the Embassy architecture, etc.), that transforms perception and enables interspecies communication. This utopian research laboratory on water promises an ecstatic experience. Recall Sergei Eisenstein's delineation of ecstasy in terms of "eternal shape-shifting" phenomena like fire, plasmatic forms, water, clouds, and music. The union with animals is seen as the earliest representation of this state, and the dolphin has a long, mystical history going back to Delphic civilization in 1600 BC. For Eisenstein, ecstatic states are a threshold, a shift in human consciousness that expresses at once "a unity with animals" and, critically, "non-identification with them" (presumably to minimize anthropocentrism).[73] Eisenstein, like the Ant Farm artists who came after him, was interested in a different mode of apprehending the world—the "plasmatic," Promethean quality of certain experiences enabling a return to a childlike sense of wonder—a liquid bonding to potentiality, the interpenetration and interconnection of all things in the world.

The Dolphin Embassy received funding from the Rockefeller Foundation and was featured in an exhibition at the San Francisco Museum of Modern Art. It was established as a nonprofit foundation that eventually relocated to Australia when Ant Farm disbanded in 1978 after a fire destroyed their studio at Pier 40 in San Francisco. From this period until his sudden death in 2003, Michels kept developing the Dolphin Embassy concept, working with ecologist Alexandra Morphett and others. By 1987, it had evolved into a space project, renamed Project Bluestar, a joint dolphin-human space station in earth orbit with a 250-foot-diameter sphere of water at its heart, "ultrasonically stabilized" and surrounded with research laboratories in a ring like Saturn's. The objective was to create "the first think tank in space, a research lab dedicated to the study of the mind's newly expanded horizons, to the investigation of thought liberated from earth's gravitational ties." This proposal presented an image of dolphins in space operating computers in a sphere of water "to nurture the growth of new non-earth-bound ideas by inventing an atmosphere in which the dimensions of weightless thinking can be expanded, observed, and understood." Project Bluestar,

Michels wrote, would "harbor the broadest possible range of inquiry, from the artistic to the psychological to the cybernetic, not merely the narrow experimentation of space engineering typical of its predecessors."[74]

Michels's new proposal pushed the Embassy into utopian science fiction that was perfectly in keeping with Lilly's ideas about dolphin communication—a belief that dolphins were descended from extraterrestrials and had special psychic abilities.[75] In order to promote Bluestar, Michels and Morphett developed a proposal for a feature film called *Brainwave*, "a pre-enactment of life aboard the Embassy that concludes with a collective human experience of transspecies telepathy."[76] As Survant points out, Michels's interest in parapsychological phenomena expanded Ant Farm's engagement with technology to encompass a broader framework that included "the body's potential as a biological machine."[77] Indeed, as a proposal, Embassy/Bluestar lines up with some of the most utopian ideas about the planetary consolidation of all living matter. After relocating to Australia, Michels devoted himself to dolphins, to educating people about

Figure 6.4
Doug Michels, interview about Project Bluestar on Japanese television in 1990. Image courtesy of Media Burn Archive.

dolphins, and to raising money for Bluestar.[78] In 2003, Michels died in Australia while doing research on a seacoast site for a film about a group of human whalers who had formed a longtime alliance with a local population of orcas for mutual aid in whale hunts between 1850 and 1930. This extraordinary story is told in the small museum at Eden Bay, Australia.[79]

Let me turn now to the idea of the Embassy as diplomacy. The architecture for the Embassy proposed by Ant Farm is without location; floating in the ocean, it eschews national boundaries. The Embassy also features *Oceania*, a sea craft conceived by Michels in 1976 to bring more mobility to the structure, allowing researchers to meet dolphins further out in the ocean. As a place for friendly and equitable exchange, the Embassy completely reconfigures land-based political institutions. It is a hybrid space—some sections of the station are wet, some are dry, some designed for humans, others for dolphins. It is what Ant Farm calls "aquaterrestrial," which lends a different semantic register than we are used to with terrestrial architectures, creating "a planetary agora" made, as Survant surmises, "not of two habitats distinct in space, but of a new, coextensive superhabitat."[80]

Figure 6.5
Doug Michels with dolphins in Dolphin Embassy publicity shoot, c. 1976, Australia. Photo: Ant Farm, courtesy University of California, Berkeley Art Museum and Pacific Film Archive. Photo: Benjamin Blackwell.

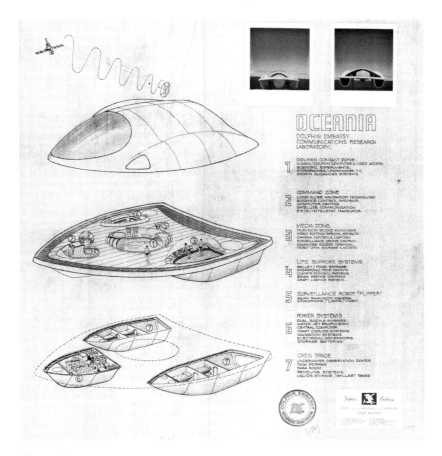

Figure 6.6
Ant Farm, *Oceania* (drawing by Doug Michels and Alex Morphett), 1977, two Polaroid pictures, graphite, and rubber stamp on blueprint. University of California, Berkeley Art Museum and Pacific Film Archive. Photo: Benjamin Blackwell.

This "superhabitat" is perhaps the place for diplomacy in the twenty-first century. As Isabelle Stengers has argued, while the work of the diplomat is always tied to a local problem,[81] it must take place outside the confines of the natural world, beyond what is known, away from established conventions in the context of artifice—what the Greek agora was before it hardened into convention with established scripts of behaviors. Peace, Stengers insists, must be an invention, not a renunciation.[82] It requires the construction of an ecology that is not "natural" or usual, but dynamic, responsive, and always in process, where every member is

recognized as belonging to an umwelt (which defines distinct phenom-
enologies of perception) and also invited into an *oikos* (a political ecology
constructed through the act of diplomacy, where enemies can encounter
one another). Acts of peace, bringing two warring sides together, require
imagination, not abstention.[83]

Stengers's efforts to rethink diplomacy grew out of a conference con-
vened by Bruno Latour in 2006 called "Les atmosphères de la politique:
Dialogue pour un monde commun" (Political atmospheres: Dialogue for a
common world). The conference brought together an impressive group of
thinkers to discuss the problem of democracy, politics, and the common.[84]
Both world politics and the ecologies of climate change provided the con-
text. At a time when the planet is increasingly being divided into large
gated nations, when the most vulnerable to both of these realities are being
uprooted, we need to reinvent our understanding of resources and energy,
as Fuller and McHale insisted in the 1960s, but now under very different
conditions and circumstances.

As part of a collaborative project with the architecture group WORKac,[85]
Curtis Schreier revised the design of the Dolphin Embassy for submis-
sion to the Chicago Architecture Biennial 2015. WORKac interpolated
Schreier's drawings to devise 3.C.City: Climate, Convention, Cruise, a
tetrahedral roving city-at-sea not bound by national borders that "pro-
poses a new symbiosis between ecology and infrastructure, public and pri-
vate, the individual and the collective."[86] The architectural model for the
ecstatic space of "aquaterrestrial" communion retains but expands upon
the Embassy's original utopian mandate to bring cetaceans into a global
conversation that now includes climate change. As in the *World of Matter*'s
open-access archive discussed above, the new proposal for the Dolphin
Embassy offers a matrix directed primarily toward an expanded discussion
and creative interface to include the heterogeneity of life that makes up
the biosphere.

More Than Human

Finnish inventor, mathematician, theoretical physicist, pioneer of elec-
tronic music, and experimental filmmaker Erkki Kurenniemi has, since the
early 1960s, not only designed a series of synthesizers, produced more than
a dozen experimental films, and built robots that helped to automate the

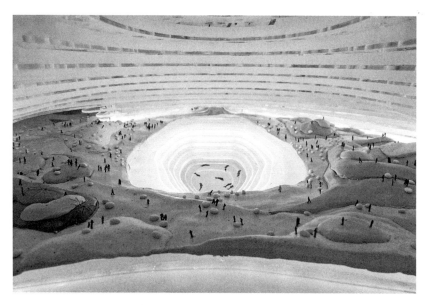

Figure 6.7
WORKac, inspired by the work of Ant Farm and especially the Dolphin Embassy, proposes a new model of utopia: 3.C.City, a floating city, unbound by national allegiances and designed to facilitate dialogue and debate—between people and other species. Photograph by Bruce Damonte.

milk industry in Finland, but also, in a variety of media, steadfastly documented his own life. Kurenniemi has been recording on audiocassettes hundreds of hours of stream-of-consciousness thinking; daily recounting his dreams over periods of months; recording and commenting on his encounters (often sexual) with friends and strangers in video diaries; preserving the objects of his everyday life (receipts, grocery lists, newspapers, etc.); and shooting twenty thousand photographs per year, as well as 16mm and 8mm film. Kurenniemi is creating what he calls a "hardcore sustainability project" that will provide an empirical document of the planet long after it has ceased to be inhabitable by humans:

Perhaps there is a logical end to the Information Revolution, a point of singularity which in retrospect will be understood to be the goal of it all. Perhaps this singularity will be reached when quantum computation and intelligent petahertz light beams make all matter a substrate for computing. (Perhaps the designers of the new IPv6 Internet addressing scheme are preparing for this: IPv6 will provide trillions of net addresses for each square metre on the Earth.) ... The material world, the planet and its

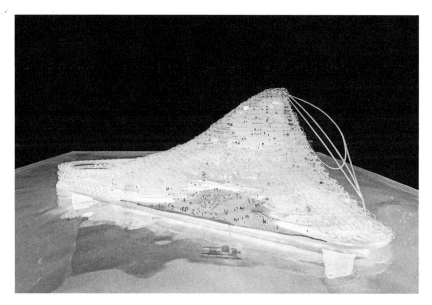

Figure 6.8
The 3.C.City vessel, a research lab, conference center, and vehicle of dreams designed by WORKac, inspired by the projects of Ant Farm. Photograph by Bruce Damonte.

biosphere, the human body, all material things, will be conserved in the planet-size museum, but our true descendants will be algorithms and data structures encoded by immaterial bit strings, roaming free of their slimy origins.[87]

Kurenniemi's archival project, and his view that "our true descendants will be algorithms" and our future world will lose the "slimy origins" of its past, would seem in its singularity to situate his activities in direct opposition to the utopian dialogical impetus behind the Dolphin Embassy. Even though dolphins and humans on Bluestar are telepathically connected, the actants still have bodies and the Embassy is an architectural augmentation to existing worlds. Kurenniemi's archive anticipates the end of the world as the planet becomes merely a lifeless museum. Made up of multiple and heterogeneous materials, Kurenniemi's archive is now partially online, and his intention is to make it available as a game or musical instrument "by 2048 on Mars." The Mars interface aside, Kurenniemi's project resonates with the explosion of social media, personal archives, and the culture of sharing, tracking, and the twenty-first-century realities of cyber hacking and surveillance.

Figure 6.9
Still image from *The Future Is Not What It Used to Be* (directed by Mika Taanila).
© Kinotar 2002. Kurenniemi documenting his surroundings for his personal archive.

In his film *The Future Is Not What It Used to Be* (2002), Finnish artist Mika Taanila creates a biographical portrait based mostly on information gathered in the archive. Hundreds of screens play the recorded realities from the archive simultaneously, helping to frame the problematic of a planetary museum and reminding us of the immensity of the collection, and at the same time of the exponential growth of user-generated data that is circulated, uploaded, and downloaded around the world every minute. This image has now become a clichéd icon of the digital age—the earth plastered with screens. In 2008, in an issue devoted to personal digital storytelling, the journal *Public: Art/Culture/Ideas* featured examples of several smaller aggregate archival projects. Among these is Hasan Elahi's post-9/11 self-surveillance project, *Tracking Transience: The Orwell Project*. As a "person of interest" who had been subjected to an intensive FBI investigation after 9/11, Elahi turned the tables on the government by placing himself under constant surveillance. Using a network device, a GPS tracker, and Google Earth maps and website, he made his exact location continuously available

to anyone with access to the Internet. In the process, Elahi amassed a huge amount of data, which is available on his website. His strategy is to overwhelm the viewer with the mass of details about his everyday life, including his travel, his exact whereabouts at every moment of the day, the meals he consumes, restaurant menus, where he parks his car, and much, much more. In an interview published in the *New York Times*, he commented:

> People who visit my site—and my server logs indicate repeat visits from the Department of Homeland Security, the C.I.A., the National Reconnaissance Office and the Executive Office of the President—don't find my information organized clearly. In fact, the interface I use is deliberately user-unfriendly. A lot of work is required to thread together the thousands of available points of information. By putting everything about me out there, I am simultaneously telling everything and nothing about my life. Despite the barrage of information about me that is publicly available, I live a surprisingly private and anonymous life.[88]

Elahi's project takes advantage of the new flexibility and capacity of digital storage and retrieval technologies enabled by programs such as MAXMSP.[89] Elahi's database is a labyrinth, a hostile dead end of noninformation. The content of his gesture and the narrative he constructs, which aim to turn the tables on governmental surveillance and in turn keep him safe from them, constitute a profound negation of the archive. Kurenniemi's self-surveillance is decidedly different.

A yet unrecognized figure in the prehistory of networking and shared database art, Kurenniemi is an innovator of this dynamic, complex, and "emergent meta-medium," as Vibeke Sorensen has called it,[90] a medium that will connect phenomena, fields, and cultures worldwide. It is the platform that, for example, enables the *World of Matter* website to continue to increase, respond to, and augment the information on its site. Elahi's archive is created as a means to block access to his life, for the overproduction of information overwhelms the visitor and crashes the system; he makes it impossible to translate those images of his life into anything tangible. Kurenniemi's archive, on the other hand, will create a bridge into the virtual world, "the singularity" that he believes will eventually replace the world of humans.

Singularity

The writings of futurologist and computer scientist Ray Kurzweil, a Google research scientist who has served as a luminary, have influenced

Kurenniemi. In Taanila's film, Kurenniemi cites Kurzweil's book *The Age of Spiritual Machines: When Computers Exceed Human Intelligence* (1999) as a major influence on his thinking. Kurzweil declares that in fifty years or less, computers will be able to simulate all human consciousness in electronic form. In this book and its follow-ups, *The Singularity Is Near: When Humans Transcend Biology* (2005) and *How to Create a Mind: The Secret of Human Thought Revealed* (2012), he predicts that with the exponential growth and progress of information technology (i.e., Moore's Law), computers will eventually replace human bodies.[91] In describing a future period (hypothetically by the year 2048) when human life will have been irreversibly transformed as a result of the rapid pace of technological advancement, Kurzweil suggests the "singularity will represent the culmination of the merger of our biological thinking and existence with our technology, resulting in a world that is still human but transcends our biological roots."[92] Leading a transhumanist movement in the United States that sees information technology in terms of a broader theory of evolution, Kurzweil projects that the rapid development of information technology will enable humans to transcend the biological and the planetary. In the merging of consciousness and computers, he not only sees the transcendence of death but also predicts that in the twenty-second century human intelligence will saturate the universe in the final stage of our cosmic evolution.[93]

The idea that humans can simply "transcend" biology underscores the difference between Kurzweil's projection and that of someone like Teilhard de Chardin, whom Kurzweil claims as his precursor. Like Kurzweil half a century later, Teilhard foresaw the coming of a singular point of convergence of human consciousness, which he called the "Omega Point." Teilhard was a professor at the Collège de France, a distinguished paleontologist, and Jesuit priest, who theorized the Omega Point as a point of evolution representing the "hyper personalization of the universe" within a decidedly theological and scientific framework. He proposed a theory of complexity explicated through Vernadsky's theory of the biosphere. In "Le Phenomène humain," an essay published posthumously in 1955, Teilhard maintained that the law of complexity in the universe can be understood as a tension between the "unified multiple" (*multiple unifié*) and the "unorganized multitude" (*multitude inorganisée*).[94] Teilhard theorized the Omega Point as bringing together a plurality of human consciousness with greater and greater complexity and unity. In this conception, Teilhard regarded

the earth as an environmental force containing its own intelligence. Under Vernadsky's influence, he saw human and nonhuman animals as inherent aspects of the matter of the universe. Unlike Teilhard's proposal, which sees the physical earth as an intrinsic aspect of human evolution, transhumanism brackets out difference from the social and cultural sphere, and the physical environment from its conception of the human brain, assuming that the brain can simply be replicated through reverse engineering. Transhumanism claims that a new evolutionary stage, rather than replacing human bodies, merges them with machines.

While Kurzweil's transhumanism claims to share in the relational attributes of posthumanist discourse, its technological determinism obfuscates the latter's materialist approach. The posthumanist ideas proposed by theorists such as Donna Haraway, Katherine Hayles, and Rosi Braidotti are grounded in a foundational materialism that insists upon a relation between human and nonhuman agents, between outside and inside, between bodies and machines. As Haraway has cautioned, the term "posthuman" needs to be problematized because it seems to suggest, erroneously, an end to humanism. Instead, it is intended to propose a reconfiguration of humanism's anthropocentric boundaries and limits:

I've stopped using the term [posthuman]. I did use it for a while, including in the "Manifesto." I think it's a bit impossible not to use it sometimes, but I'm trying not to use it. Kate Hayles writes this smart, wonderful book, *How We Became Posthuman*. She locates herself in that book at the right interface—the place where people meet IT apparatuses, where worlds get reconstructed as information. I am in strong alliance with her insistence in that book, namely, getting at the materialities of information. Not letting anyone think for a minute that this is immateriality rather than getting at its specific materialities. That I'm with, that sense of "how we became posthumanist." Still human/posthuman is much too easily appropriated by the blissed-out, "Let's all be posthumanists and find our next teleological evolutionary stage in some kind of transhumanist techno-enhancement." Posthumanism is too easily appropriated to those kinds of projects for my taste. Lots of people doing posthumanist thinking, though, don't do it that way. The reason I go to "companion species" is to get away from "posthumanism."[95]

Haraway explains that the goal of her earlier vision of posthumanism, and certainly of her present work on "SF—string figures, science fiction, speculative fabulation, speculative feminism"—comprises a methodology for envisioning the future.[96] This approach helps us to "stay with the trouble," and is tied to a feminist utopian politics of the 1980s that questioned the

parameters of what it means to be human, what it means to have a body, and that sought to answer these questions through the rubric of difference. Braidotti maintains that the anti-anthropocentric humanism that she and Haraway espouse uses the "hybrid, or body-machine, the cyborg, or the companion species" as "a connection-making entity; a figure of interrelationality, receptivity and global communication that deliberately blurs categorical distinctions (human/machine; nature/culture; male/female; oedipal/non-oedipal)." In this way, both Braidotti and Haraway can think through "specificity without falling into relativism in the quest for adequate representation of a generic post-naturalistic humanity." Braidotti emphasizes that this figure is not abstract but foundational and political: "It suggests how we should go about re-thinking the unity of the human being."[97] Forms of knowledge and "process ontologies" will take into account these conceptualizations of the individual as a "radically immanent intensive body" made of flows and assemblages.[98] This nomadic undertaking is aimed at a sustainable future in what Braidotti called the "Chaos/Cosmos." It is expressly this purpose that also underlies Braidotti's proposal for a radical postanthropocentric geocentered subject, for a "dynamic monistic political ontology" in the posthuman.[99]

Generative Archive

The starting point for Kurenniemi's archival project is the differently located subject of the Anthropocene that he imagines for the disembodied cosmic dweller. It comes in a dystopian guise, as a game to be played on Mars in 2048 after earth has ceased to be inhabitable. I want to propose that the Kurenniemi archive, though made for machines (future spectators) by humans (becoming machine), is an art project with consequences that are altogether different from Kurzweil's transhuman undertaking. In fact, as an act of imagination that is nevertheless empirically grounded, it is far closer to the postnaturalistic humanity that Haraway and Braidotti pursue.

To start, Kurenniemi's archive is based on a projection, a future archive on Mars in 2048, yet it also encompasses an ongoing process, an activity of archiving his quotidian activities, the result of which becomes an intrinsic and self-reflexive part of the life that he is archiving. How might the Kurenniemi archive relate to current theories of the archive? Jacques Derrida's now famous essay on the archive, "Mal d'archive," situates the archive in

terms of a fever, a repression, and a desire to return to an origin. Derrida looks to Freudian psychoanalysis, which offers us a theory of the archive through the model of the psychic apparatus and the unconscious. Freud conceives of the unconscious as a mechanism that operates like an archive; he used the mystic writing pad as an analogy for the operations of the unconscious that forgets nothing. The archive is fueled by the death drive, "an irrepressible desire to return to the origin, a homesickness, a nostalgia for return to the most archaic place of absolute commencement."[100] The archive, Derrida tells us, is based on a fundamental contradiction between the capacity to remember and to forget—one must forget the archive in order to remember.[101] Archives "take place," Derrida emphasizes, through this very contradiction—the term refers to "the arkhē in the physical, historical, or ontological sense," which is to say the originary, the first, the principal, the primitive; in short, "archive" refers us to the nomological sense of the term, "to the arkhē of the commandment." Thus, at the historical root of the archive is the notion of both "commencement" and "commandment," the institution and the law, which the architecture of the archive functions to erase. It is this erasure that allows us to use the archive as a place to remember.

The premise for Kurenniemi's archive is similarly based on a repression of origins. The current expansion of the digital world, which he asserts also includes his archive, corresponds directly with the devastation and death of the physical earth. Kurenniemi imagines a future population of disembodied citizens who will spend their time "re-membering," remaking his videos and composing experimental music, remixing and refashioning sounds and images from the database of his life into infinite collages. In this way, Kurenniemi's archive is a gift; it asks for nothing in return and it is generative.

With the exception of just two scenes, Mika Taanila's *The Future Is Not What It Used to Be* is constructed entirely out of materials from Kurenniemi's archive. It thus enacts Kurenniemi's intention of active and generative spectatorship, which becomes authorship through appropriation and collage. The images that Taanila has extracted from the archive are ontologically rich in their randomness and their materiality. They include many images from Kurenniemi's experimental films that record moments in his day—flowers, animals, shimmering light reflecting off water, friends enjoying a picnic—all bristling ontologies in movement. Excerpts from

the thousands of hours of Kurenniemi's audio diaries constitute the soundtrack of Taanila's film. We hear him relate matters of fact such as the cost of a cup of coffee, the appearance of someone in a bar, or the weather in Helsinki on a day in 1967: "I must say that this winter day is fantastic—typical yet ideal. The fields are covered with a light layer of snow. Well, not fully covered. The sun is shining." A description of what must have been a dream follows: "I went down a hallway, there was a note on the door, someone in a green bathrobe greeted me, I kept walking." And then in stream of consciousness, "I haven't done anything here, just let my mind drift, headache gone."

Kurenniemi describes the documentation of his life as the creation of a backup, as the transfer of his life, one day, into digital form so that an embodied history of the twentieth and twenty-first centuries as read through a life can be retrieved and studied. His collection of data is tied to his life experience and thus to the temporal fabric of his located world. Trained in theoretical physics at the University of Helsinki, Kurenniemi was

Figure 6.10
Still image from *The Future Is Not What It Used to Be* (directed by Mika Taanila). © Kinotar 2002.

never entirely satisfied with the conception of time in physics. For him, there is no single or simple answer to the question of whether time is definite or indefinite, continuous or discrete. His archive records his umwelt and he describes its future: "The future world belongs to people, communities, conscious and subconscious machines, talking animals, thinking cars, roads and cities. It understands itself in big and small entities. It is a self-destructing, continuously developing, renewing, decaying, unstable symbiosis which analyses its past and future with the speed of a superbrain and questions its own existence."[102] The future is now, contained in the archive that Kurenniemi is creating—in the present tense—as a process of becoming. It is an archive that is not so much always in the making, because Kurenniemi, who suffered a stroke several years ago, is not archiving anymore. Rather, it is open and incomplete; as both Alfred North Whitehead and Derrida have explained, the archive is always incomplete, and also necessarily outside (set apart) and public. According to Whitehead, "Expression is the most fundamental evidence of our presupposition of the world without."[103] In a similar vein, Derrida maintains that "there is no archive without a place of consignation, without a technique of repetition, and without a certain exteriority. No archive without outside."[104] This outside is part of the world in process that Kurenniemi documents by collecting the factual data generated by his life. In this conception of the archive, one needs to collect everything from tram tickets to coffee receipts (which he preserves in a scrapbook); one must constantly photograph, and record one's thoughts. These "facts," then, are neither simple nor discrete; they are continuous offerings of the world in process. In this way, Kurenniemi is not in his life so much as he is in between the archive (a stable form of storage) and his dynamic and changing life, which is defined in part by the process of recording his life.

This notion of the world in process differentiates Kurenniemi's archive from Ant Farm's time capsules containing a variety of quotidian objects (from a half-eaten sandwich to a piece of clothing to a car). Ant Farm's time capsules were discrete markers tied to particular calendar dates, and their political strategy was to objectively preserve a piece of American consumerist culture by storing it away. Time capsules are brought "out" or opened years later to create a radical temporal disjuncture—even if, as is the case with Ant Farm, the things to be preserved age badly. Kurenniemi's archive also differs from filmmaker and performance artist Carolee Schneemann's

Figure 6.11
From the film *The Future Is Not What It Used to Be* (directed by Mika Taanila). Photo:
Jussi Eerola. © Kinotar 2002.

long-standing diary project, produced as a series of books. Schneemann's
work, unlike Kurenniemi's archive, is a deeply personal artistic form of
recollection and reflexive life-writing—precisely a space of recollection in
which to comment upon events retroactively.[105]

Kurenniemi's archive may come closest in its intention to Fuller's exten-
sive autobiography, "The Dymaxion Chronofile," which goes back to Fuller
at age four, but started as a conscious methodology in 1917 and extended
to his death in 1983. Fuller collected things from each day, not only incom-
ing and outgoing correspondence, but drawings, blueprints, newspaper
clippings, and ephemera like doodles, dry cleaning receipts, and overdue
library notices. For Fuller, such documentation was an important aspect
of any design process—it gave him an objective view of his life, habits,
procedures. His aim was "to deal as objectively as possible with the compre-
hensively integrated self."[106] In Fuller's integrated scheme, his chronofiles
could no doubt be connected to his World Game inventory in which the
individual is rationalized as the smallest unit of consumption. One could
imagine a game being made out of the masses of daily details that compose
Fuller's chronofiles, if they were ever digitized.

Kurenniemi's ambition is less instrumental and more poetic than Fuller's—it is to create a picture of his own life that comes into being with the game, with the player. In one of the two non-archive-based scenes in Taanila's film, Kurennicmi comments that he must take even more photographs and make even more films of his life. His conception of his archive as future game is deeply phenomenological and process-oriented. It seeks to break down the oppositions between subject and object, nature and culture, individual and group, and between past and future. We can understand it in relation to Whitehead's radical empiricism. As Whitehead explains, "comprehending process involves the analysis of the interweaving of data, form, transition and issue. ... Rhythms of process produce pulsations, forming facts. Each fully realized fact has an infinitude of relations in the historical world. Thus any one pulsation of actuality consists of the full content of the antecedent universe as it exists in relevance to that pulsation."[107] This passage reminds us why Siegfried Kracauer so admired Whitehead's methodology for apprehending concrete facts in all their multivalent complexity.

Whitehead contends that matter cannot be abstracted from time. "Data," he says, "consists in what has been, what might have been, and what may be."[108] With this in mind, we can understand Kurenniemi's archive as a form of embodied cognition. It is filled with singularities and with his own individuality, which is an important facet of Whitehead's understanding of how experience is processed. Process and individuality are, in fact, inseparable; it is the individual who gives the process its form, and the character of the individual is derived from the processes in which it is embedded.[109] This idea, as noted earlier, is found in Guattari's *Three Ecologies* where he radically redefines ecology as intricately and integrally tied to subjectivity. It is a subjectivity that "is able to install itself simultaneously" across all realms of the environment.[110]

Kurenniemi bemoans the loss of the creativity heralded by computers. In fact, it was dissident computer processors who began to invent new uses for computers in the 1960s, making music with devices designed for other purposes. In a statement that sounds as if it were drawn directly from the surrealists, Kurenniemi declares that technology will never dominate humans so long as it is misused. Accordingly, this creative impulse toward alternative uses of technology led to the invention of computer music and the explosion of sound experiments conducted by composers from Sweden, Finland,

Figure 6.12
Still image from *The Future Is Not What It Used to Be* (directed by Mika Taanila). ©
Kinotar 2002.

and other Nordic countries in the 1960s and 1970s. Indeed, Kurenniemi's
early digital synthesizers of the 1960s were an expression of his desire to
create a virtual life as a piece of improvised music—shared, ongoing, and
open. It is easy to see that Kurenniemi has conceptualized his archive like
a musical instrument; it invites composers/viewers/users to "play" it, it is a
"connection making entity" (Braidotti)—it is generative.

Taanila was the first to take up Kurenniemi's invitation: his film "plays"
the archive, creating layered sound and image collages that offer insight
into a life by means (almost exclusively) of the bits and pieces of recorded
data of that life. The Belgian artist collective Constant also "played" the
Kurenniemi archive by creating the online archive "Erkki Kurenniemi (In
2048)." For Documenta 13, Constant, true to the spirit of Kurenniemi's
project, presented its work as "a database-body in progress"—that is, as
a living archive.[111] As an online archive, Constant's database is accessible
from many different places, which is contrary to the classical powers of
the arcanum and radically different in its nature from the archive, which

safeguards, stores, and sets apart in the same manner as a time capsule. According to the traditional definition of the archive, which is informed by the principles of provenance, incoming documents are not to be touched, but are kept in their original order. Search engines of the Internet create the database anew without regard for the genealogical contexts of documents. Wolfgang Ernst writes that the Internet is not an archive but "a performance theatre of regenerative e-poetry based on what Walter Ong called Secondary Orality."[112] For Ernst, the Internet "archive" is an "anarchive"—it is "hypertemporal rather than hyperspatial," based on the aesthetics of recycling, feedback, and sampling, "refreshing rather than the locked away storage." It is a mutable responsive space that is open to change—this is, of course, the utopian image of the Internet as public space.

Like the Bluestar research lab that Michels hoped would be up and running by 2022 (see note 78), Kurenniemi's heterogeneous, multimodal text of a life should be ready to be played on Mars by 2048. Both projects are future-oriented and utopian. Both are structured around a plurality of encounters and entanglements that are transformative, that affect the overall environment. For Kurenniemi, life "is a relation between system and environment."[113] The utopian dream underlying both projects is to find a common world through language—for Ant Farm and Dolphin Embassy, it is learning to share a language with dolphins; for Kurenniemi, it is a universal language of mathematics and music.

But here lies the problem that brings Kurenniemi's project back to earth: it is also about translation. His archive is stored at the Kiasma Museum of Contemporary Art in Helsinki. Thus, a question of its intention arises, and a problem of translation. Kurenniemi built his archive from a diversity of media, documents, and formats, which include notebooks, audio and video recordings, films, photographs, and machines, and at least in part from the spoken and written word, making it difficult for non-Finnish speakers to enter into its "structure of feeling." Translation presents an impediment to Kurenniemi's dream of a collective experience of his archived life. It is no coincidence that such a utopian archival project was conceived in a small Nordic country whose language is among the world's most difficult to learn. The task of the archivist, as Derrida remarked, can be likened to the task of the translator: "The archive always holds the problem of translation." And so, "the question of the archive is not ... a question of the past ...

it is a question of the future, the question of the future itself, the question of a response, of a promise and of a responsibility for tomorrow."[114]

For Taanila, the linguistic barrier around Kurenniemi's archive constitutes the limit of the archive, which will always require a form of translation and different structures of mediation. His film *The Future Is Not What It Used to Be* is drenched in the melancholy of its aspiration for universality, the impossibility of its promise. Yet this archive also helps us to grasp Kurenniemi's "utopian consciousness," which is an open-ended, experimental, process-oriented, embodied cognition that is the first step toward planetary thinking. For Kurenniemi, the true universal language and common culture is to be found in science, as he commented to Taanila:

> I have this idealistic and utopian hope that a hundred years from now all people will be somehow contributing to science, researching some obscure field of mathematics or something. In other words, instead of watching endless sports competitions on television they'd use their time accumulating the vast knowledge pool of science. Anyone could basically add tidbits of information to that pool, find larger patterns in nature, solve mathematical quandaries and in that way, be part of the larger structure.[115]

Like Bataille, Fuller, and Ant Farm, Kurenniemi looks to science to provide the ground for a shared collaborative knowledge (Wikipedia?), for a future planetary commons. While Kurenniemi doesn't value art's plurality, as I have explored throughout this book, it is precisely this alliance between art and science that may offer new pathways of hope and solidarity.

With that said, I will end with two melancholic projects, melancholic since each presumes an earth that is no longer or one that is disintegrating (sinking and melting). I touched upon the practice of creating time capsules earlier in this chapter with Ant Farm's purposely failed time capsules, which contained refrigerators and cars that disintegrated over time. Time capsules are intended to function like archives, as a standing reserve set apart from the messy temporal fabric of worlds, in sealed storage. They carry with them histories, waiting for the future interface. Trevor Paglen's *The Last Pictures Project* (2012) is a time capsule containing a hundred images that have been sent up into orbit on the satellite EchoStar XVI, which will circle the earth in outer space and in deep time. The images are micro-etched onto a specially engineered silicone disk fabricated to last potentially for billions of years—unless satellite debris interferes with it. The photographs were selected through a process of consultation with

scientists, artists, philosophers, mathematicians, and geologists who were asked to consider what images would communicate how and/or why the earth came to an end, the finitude of humanity, and along with that, what the world was like through the year 2012. The choice of images range from photographs of weather systems to the mechanics of the atomic bomb and children in a World War II Japanese internment camp, suburban developments, a surfer on a killer wave in California, a woman bowing to a killer whale in the Nagoya Public Aquarium. Unlike Carl Sagan's famous 1977 time capsule of earth "intended to communicate a story of our world to extraterrestrials" and which carried sounds, maps, diagrams, and cultural artifacts, Paglen's time capsule of black-and-white photographs is decidedly somber and speaks to a history of world wars, atomic bomb testing, scientific experiments, political protests, brutalities, cruelty to animals and to humans.

The project is one of the first artistic interventions into deep time, and is fueled by Paglen's longstanding interest in the hidden geopolitical and militaristic activities of the satellites that encircle the earth. As a totality, the hundred images give an overall impression of the earth's failures, and include "short texts by people who contributed images, ideas and critical questions" that produce a diverse, complex, and highly humanistic engagement with the different photographs. Instead of offering an overall thesis about what went wrong with civilization, these voices bring in a diversity of narratives that make the photographs split apart into a galaxy of experiences and a cacophony of umwelts that cannot be reduced to one overarching statement. Take, for example, the last image I mention above: the one of the woman bowing to an orca. Many of the photographs carry a printed narrative that describes the complex lives depicted in them, the things that the photographs cannot tell us: "One weekend in 2007, Paul Synnott and his wife Koyuki took a shinkansen [bullet train] from Izumi City to Nagoya to hear her favorite singer perform in a shopping mall." Afterward, they went to the aquarium to watch Ku, the orca, being fed. A staff member bowed to her before and after she was fed, as a ritual. The narrative goes on to describe the whale's life—one of exploitation and cruelty; she had been diagnosed with herpes before her eventual death on September 19, 2008. Synnott and Koyuki now live in Northern Ireland. These facts mixed in with the personal anecdote that marked the moment of the photograph represent a contextualizing strategy that was

absent from Steichen's decontextualized but much more hopeful "Family of Man. In Steichen's exhibition, humankind had the power to stop the atrocities of war. In Paglen's project, the planet is no more. The time capsule communicates the end of the end—an Oblivion which is, at least in part, countered by the gesture of sending the satellite up into space to tell the diversity of stories that make up the end. *The Last Pictures Project* functions as a bridge to other planets, a connection-making overture that is a modestly utopian gesture.

In a similar vein, *A People's Archive of Sinking and Melting,* an open-access archive designed by Amy Balkin, Malte Roloff, and Cassie Thornton to document the effects of global warming around the planet, brings together a diversity of things that speak to one overarching and shared reality. The growing collection of contributions uploaded to an image/text platform was supplied from a diversity of places that may soon "disappear due to the combined physical, political, and economic impacts of climate change, including glacial melting, sea-level rise, coastal erosion, and desertification." As with Paglen's project, *A People's Archive* is about the future anterior which is upon us.[116] Visitors to the online site of the *People's Archive* can choose to submit artifacts which are "natural, manufactured, found, made, or discarded, including trash." While the thing imaged need not originate from the place from which it was sent, it must have existed there at the time the image was uploaded to the site. Importantly, the materials each carry the singularity of a narrative from the places that are in the process of disappearing. The archive is a complex, growing quilt, marking places in time that belong to a world that is wasting away. The things that are chosen are extraordinary for their diversity: confetti from Venice; a train ticket before flooding closed down the station in Jeßnitz (Anh), Germany; a piece of seaweed from Dorset where a cliff eroded due to climate change and collapsed, killing a passerby; instant-noodles packaging from New Orleans; carved whale vertebra from Kivalina, Alaska; a 35mm film from Iceland ...[117]

A People's Archive is a dynamic and devastating tapestry of things human and more than human, of ongoing floods, bits of buildings destroyed by storms, detritus, weird organics (rocks, seeds, nuts), and seemingly random materials (nails, candy wrappers, broken bottles, a plastic fork) that have some kind of emotion or story attached to them. In effect, the traces of heterogeneous things, and the messages from the people who contributed

Figure 6.13
Antarctica Collection (2011–2012) in *A People's Archive of Sinking and Melting*, featuring a scientific sample bottle, a wrench, a fire extinguisher inspection tag, an Antarctica embroidered patch, a photo magnet, and a pair of steel crampons.

these mediated things to the archive, do not provide one overarching vision of catastrophic climate change, but rather an image with cracks and fissures, dead ends, fragments of utopias, and chronic silences. It stands in opposition to the "whole earth" or to the smooth digital renderings that we see in some scientific modelings of climate change scenarios. Kathryn Yusoff has argued that when "atmospheres are atomised through their encoding as data, accumulated, then mobilised as an aesthetic experience, then rearticulated as data again (carbon credits), data morphs into a unified 'vision of the world.'"[118] That is, the "whole earth," as a discrete singular artifact, is reinstated as an effect of national power, as Denis Cosgrove warned against. As Yusoff explains:

It is a vision of destruction on such a scale that it exceeds all the bounds of its informational inscription. When we see a model of future desertification or sea ice melting and connect this with species loss, irredeemable extinction, drought, famine, displacement, war, the consequences begin to accelerate; irreversible loss, on a global scale. This vision is an intermedia event (digital, scientific, political aesthetic) that resonates with historical conceptions of disaster that are a prevalent force in modernity's various endgames.[119]

For Yusoff, Bataille's General Economy encourages new forms of knowledge to engage with a world that is wasting away: "He suggested thinking in terms of a general, rather than restricted, economy in order to expand the terms of inquiry to that which might seem excessive, but might turn out to be generative and vital."[120] Bataille's exorbitant and expanded economy, which includes the biosphere, also includes the sphere of non-knowledge, the sphere of the impossible, which enables us to question the limits of knowledge—to expand the messy emissions of what counts as knowledge, and to make room for the certainty and the uncertainties of planetary transmutations.

Epilogue: An Ecological Approach to Media Studies

Bataille, his friend the physicist Georges Ambrosino, Maurice Merleau-Ponty, and British philosopher A. J. Ayer all met in a Parisian bar on the evening of January 11, 1951, following a lecture by Ayer. Bataille would reflect on the meeting in his own lecture, entitled "Les conséquences du non-savoir," delivered at the Collège Philosophique the next day. He recounted: "We finally fell to discussing the following very strange question. Ayer had uttered the very simple proposition: there was a sun before men existed. And he saw no reason to doubt it. Merleau-Ponty, Ambrosino, and I disagreed with this proposition, and Ambrosino said that the sun had certainly not existed before the world. I, for my part, do not see how one can say so."[1] The four debated this question until the early hours of the morning. For Bataille, Ayer's "simple proposition" is an example of "non-savoir," an object existing without a subject. It marks a moment that is troubling—like thinking about one's own death or the contents of a coffer which is closed to us—we know that we cannot know, that error is necessarily a part of the experience. Recall that Bataille, with Ambrosino's help, had just completed the first volume of *The Accursed Share* in which he theorized a general economy in macro terms that frames things to the scale of the universe and encourages transversal, interdisciplinary ecologies. Likewise, Merleau-Ponty's famous argument in *Phenomenology of Perception* mirrors the debate with Ayer. His chapter on "Temporality" concludes by questioning the possibility of a world before humans, arguing, "there is no world without an Existence that bears its structure." In his dialectical style, he anticipated critics who would argue that the world precedes humans, because "the earth emerged from a primitive nebula where the conditions for life had not been brought together." Nevertheless, Merleau-Ponty argued, "[n]othing will ever lead me to understand what a nebula that could not be seen by

anyone might be. [Pierre] Laplace's nebula is not behind us, at our origin, but rather out in front of us in the cultural world."[2]

It is precisely this kind of argument that fuels criticism of phenomenology and post-Kantian philosophy by object-oriented ontologists like Graham Harman and, similarly, by the speculative realism of Quentin Meillassoux. In *Guerrilla Metaphysics*, Harman uses the nebula argument as a means to dismiss Merleau-Ponty's human-centered view of the world, which limits the scope of the cosmos by reducing the "carpentry of things" to the body—the "flesh" as the ultimate sensorial medium. Harman instead posits nonrelational things unmediated by humans and inanimate substances—a "global ether" that is the larger medium, "that makes the entire network of entities possible."[3] Similarly, Meillassoux argues in *After Finitude: An Essay on the Necessity of Contingency* that the post-Kantian "correlationism" of phenomenology—by which all meaning depends on the human mind and can never be independent of it—makes engaging with "ancestrality," with the deep temporality of the earth, impossible. Post-Kantian philosophy is not useful, Meillassoux argues, for supporting scientific research that seeks to understand the earth beyond the human senses, and thus to widen the scope of scientific knowledge. Merleau-Ponty's philosophy is too narrow because it insists on maintaining human perception as the central epistemological frame.[4]

What does deep time mean in the context of the Anthropocene? And what does it mean for an ecological approach to media studies? As noted earlier in this book, Catherine Malabou rejects the idea of separating subject and object, biology and geology, at this time when there is a need, more than ever before, for what Guattari called "the articulation of a nascent subjectivity; a constantly mutating socius; and an environment in the process of being reinvented."[5] She points out that deep time need not be separated from media (McLuhan) or from a theory of transversal subjectivity (Guattari). I would argue that media technology, especially in the second half of the twentieth century, has been central to imaging the world beyond the individual sensorium, and that this has long been the case with media such as telescopes and microscopes, and especially with the invention of mechanical reproduction. The projects examined in this book all concern our sensorial experiences of the world, aiming to reinvent/ expand/augment shared environments through media that are able to access spaces beyond the human sensorium in order to create new kinds

of collectivity that are inclusive of a multiplicity of singularities, including the nonhuman. From Cousteau's underwater cameras, television, and sonar, meteorites on film (Jennings), Geddes's camera obscura, 3D cinema (Telekinema), and expanded screens and mobile media experiences (Expo 67), to inflatable interfaces that make air into a medium, mobile video units, seacraft and transspecies communication interfaces (Ant Farm), and Fuller's geoscope—all offer examples of how media augment the human sensorium, combining immersive and interactive forms of spectatorship that are "extensions" (as McLuhan describes media) of the human sensorium: more-than-human environments that break away from their anthropocentric origins to become "things" not reducible to humans.

But neither should human agency and labor be left out of the equation. Looking at how Merleau-Ponty developed this argument, especially his reading of Whitehead, Ted Toadvine and others have countered the criticisms of object-oriented ontologists to endorse the Merleau-Ponty/Bataille/Ambrosino position in the old debate: "the sun exists only within a world, and a world emerges only at the confluence of a perceiver and the perceived. But this does not deny the insistence of a time before the world, a primordial prehistory that haunts the world from within, which is the truth of the naturalist's conviction about a time prior to humanity. Yet only the resources of phenomenology can clarify this encounter with an elemental past that has never been for anyone a present."[6]

Several recent books have sought to develop an expanded framework for media studies and media ecology, proposing the critical tools of pragmatism, phenomenology, and actor-network theory, as well as combinations thereof, to theorize the centrality of media in the twenty-first century.[7] In particular, John Durham Peters's "thought experiment," *The Marvelous Clouds: Toward A Philosophy of Elemental Media* (2015), in suggesting an expanded approach to media that includes the elements (earth, sky, wind, and weather), complements the arguments I have been developing in *Ecstatic Worlds*. Peters writes: "The black of night gives us our most exact science, astronomy; clouds that vanish yield some of our most beautiful paintings, and clouds that obscure give us some of our most precious meteorological knowledge. Above all, media capture and fail to capture time whose fleetingness is the most beautiful and difficult of all natural facts."[8] Here, the elemental and nonhuman animals serve to broaden the field of media studies in the age of the Anthropocene.

Peters argues that the ocean is both "a medium free zone" because it is invisible to its inhabitants, and "the medium of all media" because it is the origin of life on the planet.[9] Famously, McLuhan proclaimed that all environments are invisible. He used the example of fish not being able to understand what water is because they live inside it. In order to understand environments, he maintained, we need antienvironments such as those created by artworks to materialize their effects.[10] Drawing upon an array of media theories, but most pointedly the writings of communications historian Harold Innis on infrastructures and McLuhan on media forms, Peters grounds his theory of elemental media more concretely in his discussion of the ocean and films like Cousteau and Malle's *The Silent World.* He posits the necessity of the *ship* for humans to make sense of the ocean—the media are environments and they allow us to access environments. They are specific to habitats and to inhabitants: "Cetaceans are born in the ocean medium, but humans cannot live there without a craft. The two live in worlds with very different kinds of materiality." Peters focuses on various nonhuman animals to compare the intelligence embedded in media. It is different media interfaces in different umwelts that Peters entertains, the human-nonhuman communication through media that he seeks to study as spatial interactions. The key to *Ecstatic Worlds*, and to an ecological approach to media studies, is precisely such a comparative methodology— to expand our understanding of how media broadly defined, whether elemental, informatic, handmade, or otherwise, function to create ecologies that constitute worlds both human and more-than-human.

I began this book with a question: Do we live in one world or many? My answer is found in the structure of the book—earth, worlds, planet. The more pressing question now is: How do we reconcile them? As Isabelle Stengers asks, how do we create dialogic structures or forms of translation and semantic bridges to lay the ground for a planetary ecology that includes and is constructed through different umwelts?[11] This challenge has provided the source of much speculation for philosophers, as we can see in concepts such as the "singular plural" (Nancy), "universal singularity" (though interpreted differently by Badiou, Deleuze, and Guattari), the "multitudes" (Virilio, Hardt and Negri), political ecology (Isabelle Stengers and Bruno Latour), and "spheres" (Sloterdijk, inspired, like Deleuze and Guattari, by Uexküll's umwelt theory). However distinct these approaches may be, relationships, ecologies, complexity, and the outside are fundamental to

thinking the planet as an aggregate or as a web of connections independent from humans, yet integrally tied to our existence. This book has sought to consider some of the efforts and projects that media artists, architects, and filmmakers have made to imagine and create an expanded ecological thinking, forms of ecstatic wonder, and utopian narratives over the second half of the twentieth century. I have also sought to foreground the importance of media as a central component in the creation of semantic bridges to support and connect ecologies. The projects in this book are precursors to, and therefore help us to comprehend, the collaborative and active forms of spectatorship, media production, and design enabled through the cultures of the Internet and the myriad dynamic, temporary, and ephemeral cultural festivals, art exhibitions, performances, and multimedia participatory platforms that support interdisciplinary research. There is no doubt that our mediated worlds are expanding. They are also becoming more fragmented, more virtual, more insular, more entrenched; and the more utopian projections are focused on compensation rather than on change.

Speaking in Halifax, Canada, in 2002, Mary Louise Pratt made an impassioned case to the Learned Societies, an interdisciplinary body of humanities and social science researchers, for the need to rethink global—not universal—humanism. Such a rethinking must not return to modernity, whose "structures of otherness" have supported the inequalities and exclusions, privileges, and hierarchies that have infected and constricted the term for over two centuries. Instead, following Caribbean thinker Sylvia Wynter, Pratt argued for a new "semantic register" to define the "global human" grounded in the histories of different cultures around the world, cultures that have relied upon notions of the planetary to define a totality of humans.[12] What might this semantic charter look like in media terms? By way of a conclusion, let me turn to the artwork of French artist Tania Mouraud, and the cinematic essay *Nostalgia de la luz / Nostalgia for the Light* (2010) by Chilean filmmaker Patricio Guzmán. Both Mouraud's installations and Guzmán's film will help us to think about expanded mentalities and the global human within a twenty-first-century context.

Mouraud's Ecological Approach

Since the late 1960s, Mouraud has been creating environments. Her early meditation spaces, *Initiation Room* (1969–1979) and *Initiation Space no. 2*

(1971), consist of rooms lacquered a pure white. These formless spaces are made of unfathomable dimensions. The walls and floors are curved and smooth. The refracted light makes it impossible to determine where the horizon begins and ends. Mouraud's spaces produce absolute immersion, a space where a relation between self and other, visible and invisible, inside and outside can be experienced yet not appropriated. What is gauged are the room itself, the shiny white coating, and the curved surfaces with no edges. What is experienced in these rooms is the work of art itself as Heidegger described it, which "holds open the Open of the world."[13] Even in Mouraud's early work, these "initiation rooms" especially, the material origin of the work of art, which includes the art world in which the room is given meaning, are presented as open spaces. In this way, Mouraud's art from these early years onward is defined by an ecological approach.

Over thirty years later, her ecological approach is clearly articulated in *La fabrique* (2006), a video portrait of handloom weavers in Kerala, India, where they have a long history. Their workshops are often located in rural areas and form an integral part of everyday life and culture in the community. Mouraud spent many years in the area and understands the weavers' cultural worth, skill, and working conditions. She offers phenomenological portraits of 104 weavers at work—women and men of different ages. Each video portrait lasts between five and sixteen minutes and brackets one act of weaving—a process of making. The 104 videos are displayed on twenty-five television screens (four per television), along with four wall projections and twenty-nine speakers. Though the portraits were created in separate workshops in Kerala, when displayed they are brought together and assembled in one room. Seen together, the screens form a sculptural interlace of images to create a multiplicity of singular acts of weaving, human expressions, tools, and materials.

Two things hold this spatial environment together. The first is a soundscape filled with the resounding reverberations of the looms that overwhelm the visitor. Mouraud has subtly shaped the sound to emphasize the repetitive rhythms of the equipment, the acoustic patterns, and noises of the work environment. The second element that grips our attention is attention itself. The weavers look into the camera to meet our gaze. What does this looking mean? Derrida explains it: "The right to look. The invention of the Other."[14] Nicholas Mirzoeff builds on Derrida's insight, explaining: "[i]t begins at a personal level with the look into someone else's eyes to

express friendship, trust, solidarity, or love. That look must be mutual, each inventing the other, or it fails. As such, it is unrepresentable. The right to look claims autonomy, not individualism or voyeurism, but the claim to a political subjectivity and collectivity."[15]

In this instance, the right to look is the right to look back—to return the gaze, to look into the camera. The look in this instance is not autonomous or simply mutual because it is contained by the representation. Yet it also shatters the videographic gaze and the cohesion of the video's diegetic space, creating complicity between the artist and the weaver. *La fabrique* incorporates the artist's different relation to power by incorporating the act of looking back, thus foregrounding her positionality outside the frame. Indeed, Mouraud mirrors the work of each weaver on a formal level by staging a clear relation between the work of weaving and the work of art, not as equal but as connected. This relation between inside and outside is what defines the artist's ecological approach.

In order to understand Mouraud's approach more fully, let me turn to Heidegger's interpretation of the origin of the work of art, which begins in the historically grounded relationship between matter and form. Mouraud's materialist methodology grounds her representation of human labor in the making rather than the creation of things, in a dialectic between earth and world. Heidegger's essay "The Origin of the Work of Art" begins with the insight that the origin needs to be situated through this relationship, one we have forgotten but which art might help us to rediscover. Art might help us to rediscover the earthly origins of the world.[16] His critique of traditional aesthetics is tied to the manner in which "thing," "equipment," and "work" are defined as simply "self evident."[17] Heidegger would argue that art theory operates with a preconceived reflection on the work of art that interrupts "the way toward the thingly character of the thing as well as toward the equipmental character of the equipment and the workly character of the work."[18] The origin of the work of art needs to be understood in terms of these three integrally connected aspects if we are to apprehend its essential truth.

Heidegger suggests that we look to the work of art not only to understand art but also to get to the essence of things. Thus, in order to understand Mouraud's ecological tactics, we must begin with her initiation rooms, which exist for no other reason than to be things themselves. "In the course of the history of truth about beings," Heidegger identifies three ways

that things have been defined: as designations attached to the property of things, which keep things far away from us;[19] as a "manifold" collection of sensations, which keep things "pressed too physically upon us"; and as "formed matter." In these first two interpretations, the "thing vanishes."[20] In the third interpretation, however, "the thing solicits us by its outward appearance." While this third approach is as problematic as the first two, it does contain the most productive possibility for an interpretation of the thing. Both Mouraud's initiation rooms and *La fabrique* create spaces that we live inside, which mediate our experience of the artwork. With *La fabrique*, Mouraud foregrounds the human figure in the act of making, and what Heidegger would call the "equipmental." Heidegger adds this notion as an intermediary quality through which thing and work are mediated. The "equipmental being of the equipment consists indeed in its useful-ness" and its "reliability," which allow the essence of the thing to emerge.[21] Using the example of a well-known painting of a peasant woman's shoes by Vincent van Gogh, Heidegger asks us to pay attention to the truth of the artwork. He tells us, "The Art work lets us know what shoes are in truth." He is interested in how the shoes as equipment "belong to the earth and [the way in which] it is protected in the world of the peasant woman." The relationship between earth and world encompasses the matter-form rela-tionship that lies at the origin of the work of art. The nature of art is "the truth of beings setting itself to work."[22]

The work of art must include forms of labor, political economies, and social relations that are inherent to its truth; it must be situated "within the realm that is opened up by itself."[23] This is quite precisely what Mouraud has done with *La fabrique*, bringing into her installation the craft of textiles that has a long history and a central place in the ecology and economy of Kerala. Thus, she connects the two worlds of weaving and art, of Kerala and the art world, of India and Canada, where I first saw the installation, and all the countries where the installation has been exhibited. She asks us to think about the connections that might exist between these worlds. And in between these connected worlds is the earth—the matter that is formed by the making (craft) and by creation (art).

The artwork is distinguished from craft through the process of creating as opposed to making. Though the Greeks did not distinguish between craft and artworks, Heidegger looks to the Greek term *technê*, which defines a way of knowing that brings forth that which is hidden.[24] Therefore, art as

technê brings forth unconcealed and concealed nature, which he defines through the dialectics of earth and world. Heidegger states, "beauty is the one way in which truth occurs as unconcealedness."[25] Art "belongs to the disclosure of appropriation by way of which the 'meaning of Being' can alone be defined."[26]

The installation raises questions about the textile industries and the sweatshops (almost all located in the Asia-Pacific region) that feed the insatiable and unsustainable capitalist desires for fashion in the West. It asks about the difference between the handloom that preserves the craft of weaving in a sustainable way, and the power loom that enables mass production. It asks about the working conditions of the weavers we see, and it asks about the textiles that are being woven, their connection to and destructive impact on the earth. This material reality, the process of making textiles, is mostly concealed from view in the Western world, which consumes such products without asking where they come from. The ontology of Mouraud's installation points toward origins by connecting worlds; the installation maintains a dialectical tension between work and earth in the sense that it provides a deeply humanistic reflection upon a reality constructed through a multiplicity of looks and sounds.

La fabrique lays the ground for a political solidarity that is so vitally needed today. It is such forms of imagined solidarity that Edward Steichen had in mind in "The Family of Man" or Humphrey Jennings brought forward in his polyvocal films representing a plurality of experiences during the Second World War, that Ant Farm imagined in their *Dolphin Embassy* designed for transspecies communication, or that *A People's Archive of Sinking and Melting* invites in asking for submissions from around the world. These expanded perspectives, as Hannah Arendt would declare in "Truth and Politics," enable forms of "representative thinking" so essential to democracy:

Political thought is representative. I form an opinion by considering a given issue from different viewpoints, by making present to my mind the standpoints of those who are absent, that is, I represent them ... this is a question ... of being and thinking in my identity where actually I am not. The more people's standpoints I have present in my mind while pondering a given issue and the better I can imagine how I would feel and think if I were in their place, the stronger will be my capacity for representative thinking and the more valid my final conclusions, my opinion. (It is this capacity for an "enlarged mentality" that enables men to judge; as such, it was discovered by Kant—in the first part of his *Critique of Judgment* ...).[27]

In another work, her installation *Ad Infinitum*, Mouraud conveys this desire to expand representative thinking through a profound and melancholic solicitation to the nonhuman sphere. In 2007, Mouraud took her video camera to Mexico to document the gray whales that for thousands of years have migrated to bear their young in the warm waters off Baja California. The video is striking. A montage of close-up and medium shots of whales with their calves shows them playfully rolling on the surface of the water and diving down into the black stream of the gulf. The saturated black-and-white images are peppered by shards of sunlight glistening on their slick bodies, concealing and revealing them. The soundtrack is made up of electronically modified field recordings of whale and dolphin songs, birds, water, and a motorboat. The resulting mesmerizing liquid cadence elicits our desire to touch these giant ancient mammals that were nearly extinct just ten years ago. If the video inspires our desire for proximity, the installation suspends it in a sacred moment of sensuous reflection. Staged in Nantes, France, at the heart of the Chapelle de l'Oratoire, the video installation is projected in large format along a wall as a kind of religious mural. Not far from the video projection lies a small wooden boat that is obviously adrift. Could this be Rimbaud's "drunken boat," whose inception was inspired by Jules Verne's extraordinary vessels of exploration? For Mouraud, this installation might represent a new possible interface, a connection to that "primal continuity linking us with everything that is."[28]

In *The Visible and the Invisible*, Merleau-Ponty responds to Heidegger's invocation of truth by bringing human perception into our understanding of appearance. He describes a space that is created out of the experience of the interiority of the external world of nature. As noted earlier, this space between inside and outside he calls a "chiasm," which is an "intertwining" of interior and exterior, a space between one's flesh and the flesh of the world. Merleau-Ponty describes an experience of spatial depth that envelops one's flesh as part of the process of perception and visibility: "Between the massive sentiment I have of the sack in which I am enclosed, and the control from without that my hand exercises over my hand, there is as much difference as between the movements of my eyes and the changes they produce in the visible." He continues, "[H]e who sees cannot possess the visible unless he is possessed by it, unless he *is of it*, unless … he is one of the visibles, capable by a singular reversal, of seeing them—he who is one of them."[29] His own body is "*surrounded* by the visible. This does not place

it on a plane of which it would be an inlay, it is really surrounded, circum-vented. ... Thus the body stands before the world and the world upright before it, and between them there is a relation that is one of embrace."[30] For Merleau-Ponty, nature is an active, dynamic interrelation "enveloping" and "surrounding" the body in the world. He posits a relationship between organism and environment in such a way that he surpasses, as do William James and Whitehead, the subject-object distinction, and instead posits a uniting of all life in the flesh of the world: "Flesh of the World—Flesh of the Body—Being."[31] It is by creating such fundamental connections to the world, both visible and invisible, that Mouraud opens us up to it.

Seeing *Ad Infinitum* comes close to being an ecstatic experience. Ecstasy "sensitizes us to the contingency of identity and the in-dependence of the Other," Costas M. Constantinou writes. "It is a recognition that one's state, however personal or collective, is never an authentic or stable condi-tion but a product of strange, contradictory or ever-changing forces. From this perspective *ekstasis* liquidates the 'positivist' boundaries of meaning, brings forth 'the experience of an extra dimension, an expansion of the human condition' that entices the logos of the Other."[32] The location of the installation in a church redirects an earlier religious spirituality to another altogether different task, that of creating a unity with animals and, at the same time, a "non-identification with them."[33] With the small boat left unmoored and abandoned to one side of the installation, Mouraud points toward a certain dark and silent ecology—leaving a space open for thinking the more-than-human.

Star Dust

Patricio Guzmán's *Nostalgia de la luz / Nostalgia for the Light* brings us back to the cosmos and the question of whether the sun existed before humans. The film is a profound rumination on two incommensurable realities at work in the Atacama Desert in Chile. The first is one of the most powerful telescopes on the planet and the group of astronomers from around the world that gather there to research our cosmic past. They are working in the driest place on the planet, which, thanks to its high altitude, is also one of the best locations to conduct astronomical observations. The second real-ity is the ongoing labor of a group of Chilean women who regularly go out into the desert, some 5,000 meters beneath the astronomical observatory,

to search for the remains of their loved ones, disappeared during Augusto Pinochet's military dictatorship.[34] These are the women of Calama. The research of the astronomers and the searching of the women form two distinct ecologies that Guzmán brings together to provide a unifying thread for this expansive meditation on the desert and the cosmos, archaeology and astronomy, deep time and the recent past. The desert, whose harsh heat preserves a plurality of histories and bodies across time, provides the right atmospheric conditions for telescopes to peer out into galaxies.

Nostalgia permeates the two pursuits documented in the film—both activities unfold in an existential past. The *Oxford English Dictionary* defines nostalgia as "a form of melancholia caused by prolonged absence from one's home or country or a severe homesickness." It is defined by the desire, and ultimately the inability, to return to origin. Light is the substance that allows us to measure the distance between past, present, and future. Guzmán's film is framed by the human and the scientific desire to uncover pasts—one traumatic, the other utopian. These two spaces, the desert and the cosmos, like the two communities that explore them, provide the intricate architectonics, heterotopian and utopian, of the film.

Desert (Atacama)

Nostalgia for the Light transforms the Atacama Desert into a palimpsest where diverse histories—the indigenous cultures of the Americas, pre-Columbian shepherds, nineteenth-century explorers, and enslaved salt-peter miners, as well as Pinochet's political prisoners and concentration camps, coexist in nature. As Merleau-Ponty argued, nature is the "Memory of the World";[35] the distinction between the natural and the cultural is merely "abstract: everything is cultural in us ... (our perception is cultural-historical) and everything is natural in us (even the cultural rests on the polymorphism of the wild Being)."[36] The desert in Guzmán's film functions as a polymorphous memory of the world, and as such contains numerous heterotopias (especially in its sprawling cemeteries from previous work camps and towns) and, arguably, is one large heterotopia—as one archaeologist reflects, the desert, permeated with salt, is a "condemned land where human remains are mummified for 10,000 years and objects are frozen in time." Certain parts of the desert have been compared to Mars in terms of soil and the absolute absence of life. The Atacama is un/other worldly, used

not only to simulate Mars in popular television serials (such as the BBC's *Space Odyssey: Voyage to the Planets*) but also by NASA as a test ground for future missions. When we meet two women who are searching for loved ones in the desert, we are shown tiny shards of bone picked up randomly from the ground that could have been swept by winds from an unknown mass grave or dispersed by Pinochet's soldiers, instructed to dispose of the bodies in the desert either by removing them and dropping them into the sea or by breaking them up into pieces. The official count of the murdered and tortured in Chile has recently been revised to 40,000; Guzmán tells us it is probably double that number. Essentially, what the film communicates is that the desert is a one large grave.

The women of Calama, a town in the center of the Atacama Desert, formed a secret group to search for the remains of their loved ones not long after the military coup of September 11, 1973, which inaugurated a reign of torture that lasted seventeen years. The women searched together in Arica, Iquique, Pisagua, La Serena, Colina, Paine, Lonquén, Concepción, Temuco, and Punta Arenas. In 1985, with the help of human rights organizations in Santiago, they formalized their group as the Agrupación de Familiares de Ejecutados Políticos and went public. They began to march through the streets of Calama demanding justice and answers about the whereabouts of family and friends who had disappeared. The women searched for twenty-eight years until 2002. Some of them persist in their searching as bodies continue to be found in the desert (including one discovered during the making of *Nostalgia*). We meet two of the women in the film—Vicky Saavedra and Violeta Berrios—whose stories are heart-wrenching. But every time they go into the desert, each woman is filled with hope at the thought of being reunited with her loved ones. While only six women now remain in the group, they are still forcefully determined as they face the expansive desert landscape.

Cosmos (Constellations)

In contrast to the women searching for tiny pieces of bone in the desert and the mass graves they believe Pinochet left behind, 5,000 meters above them on the Chajnantor plateau lies ALMA, the world's largest ground-based facility for celestial observations. ALMA, a collaboration of numerous countries, consists of sixty antennae that listen to the stars whose light does

not reach earth, with the aim of tracing the universe backward to its origins in the big bang. While Guzmán sets up what seems like an irreconcilable opposition—human bodies and celestial bodies, desertscapes and the beautiful and ecstatic "fly-throughs" of data galaxies—this impossible contiguity nevertheless coalesces.

The Pinochet coup d'état is one of the most written about in the history of Latin America. This is so, according to Alan Angell, because it unfolded in a country that had a long history of democracy, and "because it brought to an end an unusual attempt to create socialism through parliamentary and constitutional means."[37] The Pinochet coup was a violent and traumatic intervention into what was for many, Guzmán included, the manifestation of a utopian experiment. *Nostalgia* opens with Guzmán's childhood memory of the old German telescope in the Santiago Observatory, opening out to the sky above, through which we see the hollowed surface of the Moon (or it could be Mercury). Guzmán recalls the time before the coup d'état, a slower time in the countryside when he read science fiction, learned about lunar eclipses, memorized maps of the stars, and watched the sun through a piece of smoky glass. His nostalgia here is for a past before politics, before his forced exile to France. The materiality and rhythms of the things in the filmed house, which closely resembles his own childhood home—the radio and sewing machine, tablecloths and knitted cushions, kettle and old stove—all form part of the matter of memory, the fabric of nostalgia, which is not only sentimental but also scientific.[38]

The film, it should be emphasized, is an essay film, one of the most elastic, process-oriented, and multimodal cinematic forms ever invented.[39] From the very beginning, we are presented with a dark gateway, a threshold into the two spaces of desert and cosmos that occasionally dematerialize into dust, shimmering particles that resemble celestial vistas and/or desert salt crystals. *Nostalgia* was inspired by astrophysicist Michel Cassé's book *Nostalgie de la lumière* (2010), and the title sentiment is given a scientific, post-Bergsonian explanation by ALMA astronomer Gaspar Galaz, who explains that we never get to experience the present because of the time it takes for light to reach a viewer and for the viewer's senses to process the information. We live in the past, he tells us, and the film explores how the past lives in our bodies and in things, human and nonhuman. We feel the complex intermingling of past, present, and future in the film. Guzmán asks Galaz if his cosmic search into the past is comparable to the work of

the women of Calama that takes place in stark contrast to the work of the astrological observatory, on hands and knees, nose to the ground, far below. "Yes" and "no," he responds. "Yes," because both are looking to reconstruct the past, to bring it into the present. And "no," because the women do not sleep at night after a day's work. He also adds that the women of Calama should be recognized for their efforts to not let the past fade away into oblivion, for their work in keeping human memory, for toiling to write history.

In another scene, Luis Hernández recounts his experience as a prisoner in Chacabuco, the largest concentration camp created in the desert under Pinochet. The prisoners formed an astronomy group and used to identify constellations at night until their guards cut off this activity, believing that they were plotting an escape using the stars as their guide. Hernández memorized the constellations, a mental map that allowed him to feel free, even inside the camp. He also memorized the exact dimensions of the camp, using his footsteps as a measure. After he was released, he was able to draw detailed architectural renderings of the camp. This capacity to memorize, to "learn by heart"—embodied memory—is a powerful tool that Guzmán returns to often, although, as several of his films explore, Pinochet and his army were never held accountable for their crimes.

Throughout the film, Guzmán also moves between an archaeologist working to find traces of the first peoples in the desert and the astronomers working in the same place to find the origins of the "whole system." The film cuts between images of pre-Columbian engravings on the sides of rock formations and breathtaking fly-throughs of multicolored galaxies and datasets of star clusters obtained through the Hubble Telescope. Geology and astronomy, the desert and the cosmos, are increasingly interwoven, their shapes confused. In one of the film's pivotal scenes, American cosmologist George Preston, while looking at spectrometer graphs of the calcium in a star, explains that "some of the calcium in my bones was made from atoms dating back to shortly after the big bang ... we live among the trees. We also live among the stars. We live among the galaxies. We are part of the Universe. And the calcium in my bones was there from the beginning." Powerful juxtapositions reinforce this statement—bones and asteroids, skulls and planets, and the image of dust particles that works to dismantle the oppositions between them. This scene conveys a sense of the film that Guzmán had wanted to make, an impossible film about

archaeology, astronomy, memory, and human rights—to show the connections between all the elements that together form our history.

George Preston's observation is fundamental, and from this perspective answers Ayer's proposition as to whether there was a sun before humankind existed. We are connected to the past and to the future, as the astronomers in the film argue. There is no before or after, there is only process.

In recent work on Merleau-Ponty's later phenomenology, which incorporated Whitehead's process philosophy and Bergson's notions of time and matter, scholars have argued that his concept of the "chiasm" and the "flesh" offers up fertile insights into our understanding of time and perception. Merleau-Ponty writes that time is replaced "with a cosmology of the visible in the sense that, considering endotime and endospace, for [him] it is no longer a question of origins, nor limits, nor of a series of events going to a first cause, but one sole explosion of Being which is forever." He reminds himself in his notes published posthumously: "Describe … 'rays of the world.'"[40] Could Merleau-Ponty be referencing Whitehead's "radiant sunset" discussed in chapter 1?

Ted Toadvine describes an aspect of the elemental continuity in Merleau-Ponty's later thinking that might help us make sense of it:

If the geological scale of time means anything more to us than numbers on a line, this is because our experience—our levels, our perceptual norms, our earth—opens us to a past, and even to an incomprehensibly ancient prehistory. It does so because, as Merleau-Ponty emphasizes in his reading of Whitehead, we are ourselves embedded, mind and body, within the temporal passage of nature; its pulsation runs across us. … And this pulsation transcends the past-present distinction in such a way that past and present are enveloping-enveloped, *Ineinander*, each moment entering into relations of exchange and identification, interference and confusion, with all the others.[41]

In *Nostalgia*, this cosmic connection is always located dialectically, and does not obviate the powerful effect that the traumatic past exerts on the bodies of Pinochet's victims. For this reason, the film cannot be accused of romanticism.

One of these victims, Valentina Rodríguez, an astronomer whose parents were murdered by the junta, describes herself as a "product with a manufacturing defect." Her grandfather introduced her to astronomy at a young age and she has always found comfort in the celestial expanse of the universe, which reminds her that nothing comes to an end—the stars connect her

life to the continuity of the cosmos. The very next scene in the film reflects upon this continuity as the camera pans over a public memorial made of photographs of hundreds of disappeared people. Passport photos lie next to casual family portraits, some so faded they are no long discernible. The photocards look like ill-fitting, decaying tiles whose multiple temporalities and contexts have been pulled as if by gravity into this public space of loss and memorialization.[42] Guzmán later comments that memory has its own distinct gravitation, like that of the planets. The memorial is massive and suspends the photographs in a world apart, making a place for embodied collective reflection that links a past rupture to the future, when it can never be fully apprehended. Like the beautiful galaxies we return to gaze upon throughout the film, the faces of the disappeared, though lost and without home, are anchored in history through the act of remembering that is never finished, never completed.

In one of the last scenes in the film, Guzmán brings the two Calama women, Vicky and Violeta, into the observatory to meet with astronomer Gaspar Galaz and to look through one of the large telescopes at the stars. The scene is short and seemingly uncomfortable for everyone, as Guzmán later recounted in an interview. The scene concludes with dust particles— that is, with the "rays of the world" that will bring the parts of the picture that don't add up to a totality to land firmly on the ground. It is a scene that is a part of Guzmán's utopian script, which imagines an expanded consciousness that includes various scientific and political registers of memory, history, and human rights activism; that brings together, as Stengers notes, different umwelts under the rubric of a shared ecology.

The very last scene in *Nostalgia for the Light* is not the multifaceted, variegated, ecstatic images of celestial bodies that we might expect from the film. Rather, what we get is a wide-angle view of the city of Santiago at night, sirens blaring, lights shimmering like the stars in the sky. It is precisely with the image of the sprawling cosmopolitan city that was once Guzmán's home, in all its plurality and borderless cacophony, that this project of expanded memory must begin.[43]

Notes

Introduction

1. Paul J. Crutzen and Eugene F. Stoermer, "The Anthropocene," *IGBP* [*International Geosphere-Biosphere Programme*] *Newsletter* 41 (2000): 17.

2. Donna Haraway, "SF: Science Fiction, Speculative Fabulation, String Figures, So Far," acceptance speech for Pilgrim Award, Science Fiction Research Association, Lublin, Poland, July 7, 2011, 1–17.

3. Kathryn Yusoff, "Excess, Catastrophe, and Climate Change," *Environment and Planning D: Society and Space* 27 (2009): 1012.

4. Karl Mannheim, *Ideology and Utopia*, trans. Louis Wirth and Edward Shils (1936; repr., San Diego: Harcourt Brace Jovanovich, 1985), 236.

5. Zygmunt Bauman, *Globalization: The Human Consequences* (New York: Columbia University Press, 1998), 5.

6. "The 'European language' is not a code but rather a permanently changing system of different linguistic customs, which are constantly involved in the process of meeting each other, in other words: It is a translation … it is the reality of social translation practices." Étienne Balibar, *We, the People of Europe? Reflections on Transnational Citizenship* (Princeton: Princeton University Press, 2004), 289.

7. Some of the first online exhibitions were curated by Steve Dietz: for example, "Beyond Interface: Net Art and Art on the Net" (1998) and "Shock of the View: Artists, Audiences, and Museums in the Digital Age" (1999). He was responsible for the traveling exhibition "Telematic Connections: The Virtual Embrace" (2000–2002) for Independent Curators International; "Translocations" (2003), part of "How Latitudes Become Forms" at the Walker Art Center; and "Database Imaginary" (2004), Walter Phillips Gallery, Banff Centre. Dietz was also the curator of the section "Public Spheres" for Media Art Net in conjunction with the ZKM exhibition "Making Things Public" (2005).

8. Alfred North Whitehead, *Science and the Modern World* (New York: Macmillan, 1925), 248.

9. Mary Louise Pratt, "Planetary Longings," paper presented in Spanish at the Learned Societies in Halifax, Canada, 2002, p. 7. See http://www.nyupoco.com/Mary_Louise_Pratt__Planetary_Longings.pdf.

10. John Durham Peters, *The Marvelous Clouds: Toward a Philosophy of Elemental Media* (Chicago: University of Chicago Press, 2015).

11. Neil Brenner and Christian Schmid, "Planetary Urbanization," in Matthew Gandy, ed., *Urban Constellations* (Berlin: Jovis, 2012), 10–13.

12. Some recent books on ecomedia include: Sean Cubitt, *EcoMedia* (Amsterdam: Rodopi, 2005); Richard Maxwell and Toby Miller, *Greening the Media* (New York: Oxford University Press, 2012); Anders Hansen, *Environment, Media and Communication* (London: Routledge, 2010); Antonio Lopez, *Greening Media Education: Bridging Media Literacy with Green Cultural Citizenship* (New York: Peter Lang, 2014); Libby Lester, *Media and Environment: Conflict, Politics and the News* (Cambridge: Polity, 2010); Nicole Starosielski and Janet Walker, eds., *Sustainable Media: Critical Approaches to Media and Environment* (New York: Routledge, 2016); Rayson K. Alex and S. Susan Deborah, eds., *Ecodocumentaries: Critical Essays* (Basingstoke, UK: Palgrave Macmillan, 2016); and Stephen Rust, Salma Monani, and Sean Cubitt, eds., *Ecomedia: Key Issues* (London: Routledge, 2016).

13. Anne Friedberg, *The Virtual Window: From Alberti to Microsoft* (Cambridge, MA: MIT Press, 2006).

14. Fred Turner, *From Counterculture to Cyberculture: Stewart Brand, the Whole Earth Network, and the Rise of Digital Utopianism* (Chicago: University of Chicago Press, 2006); Fred Turner, *The Democratic Surround: Multimedia and American Liberalism from World War II to the Psychedelic Sixties* (Chicago: University of Chicago Press, 2013).

15. Nigel Clark, *Inhuman Nature: Sociable Life on a Dynamic Planet* (London: Sage, 2011), 217.

16. Martin Heidegger, "The Age of the World Picture," in *The Question Concerning Technology and Other Essays*, trans. William Lovitt (New York: Harper, 1977), 134.

17. Quoted in Fred Botting and Scott Wilson, eds., *Bataille: A Critical Reader* (Oxford, UK: Blackwell, 1997), 94.

18. Quoted in ibid., 59.

19. Jean-Luc Nancy, *The Inoperative Community*, ed. and trans. Peter Connor (Minneapolis: University of Minnesota Press, 1991), 19.

20. Ibid., 29.

21. Jean-Luc Nancy, *The Creation of the World; or, Globalization*, trans. François Raffoul and David Pettigrew (Albany: State University of New York Press, 2007), 34–35.

22. Jean-Luc Nancy, *Being Singular Plural*, trans. Robert D. Richardson and Anne E. O'Byrne (Stanford: Stanford University Press, 2000), 53.

23. Nancy, *The Creation of the World*, 28.

24. Ibid., 34.

25. Ibid.

26. Ibid., 35.

27. Denis Cosgrove, *Apollo's Eye: A Cartographic Genealogy of the Earth in the Western Imagination* (Baltimore: Johns Hopkins University Press, 2001), 265–266.

28. Siegfried Kracauer, *Theory of Film: The Redemption of Physical Reality* (New York: Oxford University Press, 1960), 310.

29. See Turner, *The Democratic Surround*.

30. Charles P. Kindleberger, *The World in Depression, 1929–1939* (Berkeley: University of California Press, 1973), 241.

31. Inspired by Le Corbusier's *La ville radieuse*, the charter encouraged planners to use statistical information for designing city zones. The Athens Charter was criticized by people like Lewis Mumford who were suspicious of its functionalism.

32. Allan Stoekl, *Bataille's Peak: Energy, Religion and Postsustainability* (Minneapolis: University of Minnesota Press, 2007).

33. See ibid., 189.

34. Clark, *Inhuman Nature*, 217; Clark quotes Bataille on p. 21.

Chapter 1

1. Twenty-first-century rereadings of "The Family of Man" have been steadily accumulating. This list is not exhaustive and includes essays I do not reference in this chapter: Jean Back and Viktoria Schmidt-Linsenhoff, *The Family of Man 1955–2001: Humanismus und Postmoderne: eine Revision von Edward Steichens Fotoausstellung / Humanism and Postmodernism: A Reappraisal of the Photo Exhibition by Edward Steichen* (Marburg: Jonas Verlag, 2004); Blake Stimson, *The Pivot of the World: Photography and Its Nation* (Cambridge, MA: MIT Press, 2006); Fred Turner, "The Family of Man and the Politics of Attention in Cold War America," *Public Culture* 24, no. 1 (Winter 2012); Sarah E. James, "A Post-Fascist Family of Man? Cold War Humanism, Democracy and Photography in Germany," *Oxford Art Journal* 35, no. 3 (2012); Ariella Azoulay, "The Family of Man: A Visual Universal Declaration of Human Rights," in

Thomas Keenan and Tirdad Zolghadr, eds., *The Human Snapshot* (Feldmeilen, Switzerland: Luma Foundation, 2013); Kerstin te Heesen, "From the Madonna lactans to The Family of Man: Tracing a Visual Frame of Reference through History," in Karin Priem and Kerstin te Heesen, eds., *On Display: Visual Politics, Material Culture, and Education* (Münster: Waxmann, 2016); Eric J. Sandeen, "The Family of Man on the Road to Clervaux: From Temporary American Installation to Permanent Site of World Memory," in Priem and te Heesen, *On Display*.

2. Edward Steichen and Museum of Modern Art, *The Family of Man: The Greatest Photographic Exhibition of All Time—503 Pictures from 68 Countries* (New York: Museum of Modern Art and MACO Magazine Corp, 1955), 4.

3. Edward Steichen, *A Life in Photography* (Garden City, NY: Doubleday, 1963), chapter 5, p. 5.

4. Roland Barthes, *Mythologies* (New York: Hill and Wang, 1973), 100.

5. Cited in Steichen, *A Life in Photography*, chapter 5, p. 6.

6. Allan Sekula, "The Traffic in Photographs," *Art Journal* 41 (1981): 16–20.

7. Miriam Bratu Hansen, introduction to Siegfried Kracauer, *Theory of Film: The Redemption of Physical Reality* (Princeton: Princeton University Press, 1997), xv. Subsequent references to *The Theory of Film* are to this edition.

8. Kracauer, *Theory of Film*, 310.

9. Joanna Steichen, third wife of Edward Steichen, writes of this period: "Between 1905 and 1914, Steichen served as European art scout for Alfred Stieglitz and the Photo-Secession. First, he convinced Stieglitz to show other media along with photography. Then he designed the Little Galleries of the Photo-Secession in his former studio at 291 Fifth Avenue. And then he made 291 the first gallery in America to show many of the seminal painters and sculptors of the twentieth century." Joanna Steichen, ed., *Steichen's Legacy: Photographs 1895–1973* (New York: Alfred A. Knopf, 2000), xx.

10. Catherine T. Tuggle, "Eduard Steichen and the Autochrome, 1907–1909," *History of Photography* 18, no. 2 (Summer 1994): 146.

11. Joel Smith, *Edward Steichen: The Early Years* (Princeton: Princeton University Press, 1999), 32.

12. Edward Steichen, "Color Photography," *Camera Work* 22 (April 1908): 24.

13. Quoted in Robert M. Crunden, *American Salons: Encounters with European Modernism, 1885–1917* (New York: Oxford University Press, 1993), 282.

14. Smith, *Edward Steichen: The Early Years*, 33–34.

15. Steichen, *A Life in Photography*, chapter 5, p. 5.

16. Ibid.

17. Ibid.

18. Tobia Bezzola, "Lights Going All Over the Place," in William A. Ewing and Todd Brandow, eds., *Edward Steichen in High Fashion: The Condé Nast Years 1923–1937* (Minneapolis: Foundation for the Exhibition of Photography; New York: W. W. Norton, 2008), 192.

19. Patricia A. Johnston, *Real Fantasies: Edward Steichen's Advertising Photography* (Berkeley: University of California Press, 1997), 155.

20. Ibid., 157.

21. Chris Vials, "The Popular Front in the American Century: Life Magazine, Margaret Bourke-White, and Consumer Realism, 1936–1941," *American Periodicals: A Journal of History, Criticism, and Bibliography* 16, no. 1 (2006): 96.

22. See Catherine A. Lutz and Jane L. Collins, *Reading National Geographic* (Chicago: University of Chicago Press, 1993), 33–36; Erika Lee Doss, *Looking at Life Magazine* (Washington, DC: Smithsonian Institution Press, 2001), 12–13; Carolyn L. Kitch, *Pages from the Past: History and Memory in American Magazines* (Chapel Hill: University of North Carolina Press, 2005), 17–18.

23. Steichen, *A Life in Photography*, chapter 13, p. 4.

24. Ibid.

25. Steichen and Museum of Modern Art, *The Family of Man*, 4.

26. Eric J. Sandeen, *Picturing an Exhibition: The Family of Man and 1950s America* (Albuquerque: University of New Mexico Press, 1995), 22–23.

27. Ibid., 25.

28. Steichen and Museum of Modern Art, *The Family of Man*, 3.

29. Mary Warner Marien, *Photography: A Cultural History* (London: Laurence King, 2002), 310.

30. Peder Anker, "Graphic Language: Herbert Bayer's Environmental Design," *Journal of Environmental History* 12 (April 2007): 256.

31. Herbert Bayer, "Fundamentals of Exhibition Design," *PM magazine* 6, no. 2 (1939): 17.

32. Gestalt (shape, form) is a theory of human perception developed by German psychologists at the Berlin School of experimental psychology. Gestalt psychology proposes a universal theory of human perception whereby the parts of a perceived environment are synthesized into a whole by the mind. While the influence of Gestalt psychology on the Bauhaus pedagogy is still widely debated, we know that

perceptual psychology and psychophysics were very important to teachers like László Moholy-Nagy and others who experimented with visual media (photograms, film, kinetic sculptures) at the Bauhaus. Moholy would later write *Vision in Motion* (1947), which was concerned to account for dynamic perceptions in a space. Lectures (1930–1931) at the Bauhaus in Dessau by Karlfried Graf von Dürkheim, who taught Gestalt psychology, are also an important point of contact. A rich exchange on this topic between Bauhaus scholars and Gestalt psychologists in the journal *Gestalt Theory* makes a strong case for influence: "Gestalt Theory and Bauhaus: A Correspondence between Roy Behrens, Brenda Danilowitz, William S. Huff, Lothar Spillmann, Gerhard Temberger and Michael Wertheimer," introduction and summary by Geert-Jan Boudewijnse, *Gestalt Theory* 34, no. 1 (2012): 81–98.

33. Bayer, "Fundamentals of Exhibition Design," 17.

34. Bayer quoted in Arthur A. Cohen, *Herbert Bayer: The Complete Work* (Cambridge, MA: MIT Press, 1984), 300.

35. Sandeen, *Picturing an Exhibition*, 44.

36. Cited in Cohen, *Herbert Bayer*, 365. See also Ulrich Pohlmann, "El Lissitzky's Exhibition Designs," in Margarita Tupitsyn et al., eds., *El Lissitzky: Beyond the Abstract Cabinet* (New Haven: Yale University Press, 1999), 52–64.

37. Steichen had had the Kodak laboratory in Rochester reproduce a large color transparency of the photograph, according to Sandeen, *Picturing an Exhibition,* 67. For an insightful discussion of the photograph published in *Life* and in the "Family of Man" exhibition see John O'Brian, "The Nuclear Family of Man," *Asia Pacific Journal* 6, no. 7 (2008): 5–6.

38. Christopher Phillips, "The Judgment Seat of Photography," *October* 22 (1982): 46.

39. Marien, *Photography: A Cultural History*, 310–311.

40. See O'Brian, "The Nuclear Family of Man"; Sandeen, *Picturing an Exhibition*.

41. O'Brian, "The Nuclear Family of Man," 11.

42. Eric J. Sandeen, "The Family of Man in Guatemala," *Visual Studies* 30, no. 2 (2015): 127.

43. Ibid.

44. Perhaps the reason Herbert Bayer was not available to design the exhibition for "The Family of Man" was because he was busy working on a comparable global project called "World Geo-graphic Atlas," commissioned by the Container Corporation. This map of the world was most certainly inspired by Richard Buckminster Fuller's "Dymaxion World," *Life*, March 1, 1943. The project began in 1949 and took five years to complete. See Anker, "Graphic Language."

45. As John O'Brian explains: "In deference to the experience of Hiroshima and Nagasaki, however, a large black and white photographic image of a mushroom cloud included in other traveling versions of the exhibition was omitted. Instead, photographs taken by Yamahata in Nagasaki on the day following the explosion were substituted. These images showed, as the photographs in The Family of Man did not, the human toll and devastation caused by the bomb. Soon, however, they were censored as well. When the emperor visited The Family of Man in Tokyo, Yamahata's photographs were curtained off and then removed altogether from the exhibition." O'Brian, "The Nuclear Family of Man," 3.

46. Quoted in Steichen and Museum of Modern Art, *The Family of Man*, 4–5.

47. Sigfried Giedion, *Mechanization Takes Command: A Contribution to Anonymous History* (1948; repr., New York: W. W. Norton, 1969), 714.

48. Sigfried Giedion, *Bauen in Frankreich, Eisen, Eisenbeton* (Leipzig and Berlin: Klinkhardt & Biermann, 1928), 10.

49. Ibid., 13.

50. Giedion, *Mechanization Takes Command*, 2.

51. Siegfried Kracauer, "Photography," in Kracauer, *The Mass Ornament: Weimar Essays*, ed. and trans. Thomas Y. Levin (Cambridge, MA: Harvard University Press, 1995), 58–59.

52. Kracauer, *Theory of Film*, 72.

53. Hansen, introduction to Kracauer, *Theory of Film*, xv.

54. Ibid.

55. Kracauer, *Theory of Film*, 21–22.

56. Ibid., 15.

57. Ibid., 18.

58. Siegfried Kracauer, "Marseille Notebooks" (Kracauer Papers, Deutsches Literaturarchiv, Marbach am Neckar, 1940), 2:9, quoted in Hansen, introduction to Kracauer, *Theory of Film*, xvii.

59. Kracauer, *Theory of Film*, 170–171.

60. Ibid., 21.

61. Ibid., 300.

62. Ibid., 301.

63. Steichen, *A Life in Photography*, chapter 13, p. 3.

64. Frank had difficulty securing an American publisher for these photographs, which were published in Paris under the title *Les Américains* in 1958 by Robert Delpire. The book included texts by Simone de Beauvoir, Erskine Caldwell, William Faulkner, Henry Miller, and John Steinbeck. It was published the following year in the United States by Aperture, Inc., with an introduction, not surprisingly, by Jack Kerouac. But not long after the publication, Frank changed his more distanced approach to shooting strangers on the street and began making personal films. A diary entry states: "1960. A decision: I put my Leica in a cupboard. Enough of lying in wait, pursuing, some times catching the essence of the black and the white, the knowledge of where God is. I make films. Now I speak to the people who move in my viewfinder." See Marlaine Glicksman, "Interview: Robert Frank—'Highway '61 Revisited' (1987)," American Suburb X, February 14, 2012, http://www .americansuburbx.com/2012/02/interview-robert-frank-highway-61-revisited-1987. html, accessed December 30, 2016.

65. Steichen, *A Life in Photography*, chapter 13, p. 3.

66. David MacDougall, *Transcultural Cinema*, ed. Lucian Taylor (Princeton: Princeton University Press, 1998), 259.

67. Kracauer, *Theory of Film*, 246.

68. Alfred North Whitehead, *Science and the Modern World* (New York: Macmillan, 1925), 248; quoted in Kracauer, *Theory of Film*, 296.

69. Ibid., 297. Since his arrival in the United States in 1939, Kracauer had been closely interested in Cohen-Séat's work and the work of the Institut de Filmologie, publishing in their journal *Revue internationale de filmologie*. For more on this relationship see Leonardo Quaresima's excellent essay "De faux amis: Kracauer et la filmologie," *Cinémas* 19, nos. 2–3 (Spring 2009): 333–358.

70. Hansen, introduction to Kracauer, *Theory of Film*, xv.

71. Kracauer, *Theory of Film*, 300.

72. Erich Auerbach, *Mimesis: The Representation of Reality in Western Literature* (Princeton: Princeton University Press, 2003), 550; quoted in Kracauer, *Theory of Film*, 310.

73. Auerbach, *Mimesis*, 489.

74. Kracauer, *Theory of Film*, 310.

75. Ibid., 304.

76. Hansen, introduction to Kracauer, *Theory of Film*, ix.

77. Auerbach, *Mimesis*, 550; quoted in Kracauer, *Theory of Film*, 310.

78. Herbert G. Luft, "Rotha and the World," *Quarterly of Film, Radio and Television* 10, no. 1 (1955): 89–99.

79. For an in-depth engagement with *World without End* see Zoe Druick, "Visualising the World: British Documentary at UNESCO," in Scott Anthony and James G. Mansell, eds., *The Projection of Britain: A History of the GPO Film Unit* (Basingstoke: Macmillan, 2011), 272–280; or Richard MacDonald, "Evasive Enlightenment: World without End and the Internationalism of Postwar Documentary," *Journal of British Cinema and Television* 10, no. 3 (2013): 452–474.

80. Kracauer, *Theory of Film*, 310–311.

81. Kracauer, *Theory of Film*, 69. See Lucien Sève, "La filmologie en retour arrière (1943–1947)," *1895: Mille huit cent quatre-vingt-quinze* 66 (2012), 92–99, http://1895.revues.org/4464.

82. See Sekula, "The Traffic in Photographs"; Phillips, "The Judgment Seat of Photography"; Sandeen, *Picturing an Exhibition*.

83. Sandeen, *Picturing an Exhibition*, 95–96.

84. Sandeen, "The Family of Man in Guatemala."

85. Ibid., 123–124.

Chapter 2

1. Lorraine Daston, "Wonder and the Ends of Inquiry," *The Point* 8 (Summer 2014), accessed December 12, 2014, http://thepointmag.com/2014/examined-life/wonder-ends-inquiry.

2. Ibid.

3. Roland Barthes, *Mythologies*, trans. Annette Lavers (New York: Hill and Wang, 1973), 66–67.

4. For the emergence of "The World" as a concept and project in science and government bureaus in the late nineteenth century, see Marcus Krajewski, *World Projects: Global Information before World War I*, trans. Charles Marcrum II (Minneapolis: University of Minnesota Press, 2014).

5. On July 19, 1950, Cousteau, with the financial assistance of the family of his wife, Simone Melchior Cousteau, was able to purchase the now legendary *Calypso*, a British Royal Navy minesweeper that he would convert into a scientific laboratory for oceanic research and a floating film studio.

6. Herbert E. Bragg, "The Development of CinemaScope," *Film History* 2, no. 4 (1988): 368–369.

7. Trailer for *20,000 Leagues under the Sea* (1954, USA), directed by Richard Fleischer, screenplay by Earl Felton. Collection at the Academy Film Archive. Courtesy Walt Disney Studios.

8. Brian Jay Jones, *Jim Henson: The Biography* (New York: Random House, 2013), 454.

9. Peter Stackpole, "New Film World: Jules Verne Movie Produces 20,000 Headaches under the Sea," *Life*, February 22, 1954, 111–117.

10. James W. Maertens, "Between Jules Verne and Walt Disney: Brains, Brawn, and Masculine Desire in *20,000 Leagues under the Sea*," *Science Fiction Studies* 22, no. 2 (1995): 209.

11. Michel Foucault, "Behind the Fable," in *Essential Works of Foucault*, vol. 2: *Aesthetics, Method, and Epistemology*, ed. James D. Faubion, trans. Robert Hurely and Others (New York: New Press, 1999).

12. Sergei Eisenstein, *Eisenstein on Disney*, ed. Naum Kleinman, trans. Alan Upchurch (New York: Methuen, 1988), 21–22.

13. Ibid.

14. Ibid., 50.

15. Ibid., 46.

16. Quoted in ibid., 63.

17. André Bazin, *Qu'est-ce que le cinéma?* (Paris: Editions du Cerf, 1976), 48; translation mine.

18. Ibid., 49–61.

19. Rebecca Erin Miller, "The Animated Animal: Aesthetics, Performance and Environmentalism in American Feature Animation," PhD dissertation (New York University, 2011), 77–83.

20. André Bazin, "Les périls de Perri," *Cahiers du Cinéma* 83 (1958): 51.

21. Ibid., 52.

22. Ibid., 53.

23. Ibid.

24. See Pia Tikka, *Enactive Cinema: Simulatorium Eisensteinese* (Helsinki: University of Art and Design Helsinki, 2008), 74–75; Inga Pollmann, "Invisible Worlds, Visible: Uexküll's *Umwelt*, Film, and Film Theory," *Critical Inquiry* 39, no. 4 (2013): 777–816.

25. Jakob von Uexküll, *A Foray into the Worlds of Animals and Humans: With A Theory of Meaning* (Minneapolis: University of Minnesota Press, 2010), 41.

26. Ibid., 42.

27. Ibid., 43.

28. Geoffrey Winthrop-Young, afterword to Uexküll, *A Foray into the Worlds of Animals and Humans*, 213.

29. Jakob von Uexküll, *Umwelt und Innenwelt der Tiere* (Berlin: Verlag von Julius Springer, 1909), 6, quoted in Janelle Blankenship, "Film-Symphonie vom Leben und Sterben der Blumen: Plant Rhythm and Time-Lapse Vision in *Das Blumenwunder*," *Intermediality: History and Theory of the Arts, Literature and Technologies* 16 (Fall 2010): 84.

30. Étienne-Jules Marey, *La méthode graphique dans les sciences expérimentales* (Paris: Masson, [1878]), 108.

31. See Brett Buchanan, *Onto-Ethologies: The Animal Environments of Uexküll, Heidegger, Merleau-Ponty, and Deleuze* (Albany: State University of New York Press, 2008), 7; Torsten Rüting, "History and Significance of Jakob von Uexküll and His Institute in Hamburg," *Signs Systems Studies* 32, no. 1 (2004): 35–72.

32. Peter Sloterdijk, *Terror from the Air* (Los Angeles: Semiotext(e), 2009), 108.

33. Stephen Rust, "Ecocinema and the Wildlife Film," in Louise Westling, ed., *The Cambridge Companion to Literature and the Environment* (New York: Cambridge University Press, 2013), 213.

34. Jacques-Yves Cousteau and Frédéric Dumas, "Photographic Essay: Underwater Wonders," *Life* 29, no. 22 (November 1950): 119–126.

35. Ibid., 124.

36. Jacques-Yves Cousteau and Frédéric Dumas, "Fish Men Explore a New World Undersea," *National Geographic* 102, no. 4 (October 1952): 431–472.

37. Lorraine J. Daston, and Katharine Park, *Wonders and the Order of Nature, 1150–1750* (New York: Zone Books, 1998), 56.

38. Richard Munson, *Cousteau: The Captain and His World* (New York: William Morrow, 1989), 33; Brad Matsen, *Jacques Cousteau: The Sea King* (New York: Pantheon, 2009), 40.

39. It later became the GERS (Groupe d'Études et de Recherches Sous-Marines, the Underwater Studies and Research Group); later still, it became the COMISMER (COMmandement des Interventions Sous la MER, the Undersea Interventions Command). More recently, it has been reconfigured as the CEPHISMER. For more, see Tim Ecott, *Neutral Buoyancy: Adventures in a Liquid World* (New York: Grove Press, 2001).

40. Franck Machu, *Un cinéaste nommé Cousteau* (Monaco: Rocher, 2011).

41. Matsen, *Jacques Cousteau: The Sea King*, 86.

42. Machu, *Un cinéaste nommé Cousteau*, 84.

43. Bazin, *Qu'est-ce que le cinéma?*, 36.

44. Ibid., 35.

45. Maurice Merleau-Ponty, *The Visible and the Invisible*, trans. Alphonso Lingis (Evanston: Northwestern University Press, 1968), 134–135.

46. Ibid., 271.

47. Brett Buchanan, *Onto-Ethologies: The Animal Environments of Uexküll, Heidegger, Merleau-Ponty, and Deleuze* (Albany: State University of New York Press, 2014).

48. Merleau-Ponty, *The Visible and the Invisible*, 251.

49. Buchanan, *Onto-Ethologies*, 146.

50. David Abram, "Merleau-Ponty and the Voice of the Earth," *Environmental Ethics* 10, no. 2 (Summer 1988): 101–120. For a more in-depth study of the relation between the Gaia hypothesis and Merleau-Ponty's philosophy, see David Abram, "The Perceptual Implications of Gaia," *Ecologist* 15, no. 3 (1985). Abram points out that although the notions of the biosphere and Gaia are remarkably similar, James Lovelock declared that he and Lynn Margulis were not aware of Vernadsky's work at the time they proposed their Gaia hypothesis. As we shall see in chapter 6, Vernadsky's notion of the biosphere served as the foundation for Bataille's "general economy," which he put forth in *The Accursed Share*.

51. Merleau-Ponty, *The Visible and the Invisible*, 169.

52. Gary Kroll, *America's Ocean Wilderness: A Cultural History of Twentieth-Century Exploration* (Lawrence: University Press of Kansas, 2008), 184.

53. See especially Jacques-Yves Cousteau, *The Ocean World of Jacques Cousteau*, vol. 13, *A Sea of Legends: Inspiration from the Sea*, rev. ed. (1973; repr., Toronto: Prentice-Hall of Canada, 1975), 38–44.

54. See Nigel Clark, *Inhuman Nature: Sociable Life on a Dynamic Planet* (London: Sage, 2011), 22.

55. Jacques Grinevald, "Introduction: The Invisibility of the Vernadskian Revolution," in Vladimir I. Vernadsky, *The Biosphere* (New York: Copernicus, 1998), 26.

56. Vladimir I. Vernadsky, *The Biosphere* (New York: Copernicus, 1998), 77.

57. Ibid., 76.

58. Cédric Mong-Hy, *Bataille cosmique: Georges Bataille, du système de la nature à la nature de la culture* (Paris: Lignes, 2012), 52.

59. Vladimir I. Vernadsky, "Scientific Thought as a Planetary Phenomenon; The Biosphere and the Noosphere," in David Pitt and Paul R. Samson, eds., *The Biosphere*

and Noosphere Reader: Global Environment, Society and Change (New York: Routledge, 1999), 99.

60. Maurice Merleau-Ponty, "The Film and the New Psychology," in *Sense and Non-Sense*, trans. Hubert L. Dreyfus and Patricia A. Dreyfus (Evanston: Northwestern University Press, 1964), 58.

61. Gilles Deleuze, *The Logic of Sense*, ed. Constantin V. Boundas (New York: Columbia University Press, 1990), 99; Gilles Deleuze, *Cinema 1: The Movement-Image*, trans. Hugh Tomlinson and Barbara Habberjam (Minneapolis: University of Minnesota Press, 1997), 56–57.

62. Merleau-Ponty, "The Film and the New Psychology," 53.

63. Ibid., 59.

64. Canadian filmmaker James Cameron later based his 3D methodology on a Cousteau-like "immersion" and envelopment rather than the emersion of some of the early experiments. Cousteau instilled in Cameron a love of and fascination with the oceans, and showed him early on that there was an alien world on earth. See James Cameron, "Before *Avatar* … a Curious Boy," TED Video, 17:08, filmed February 2010, posted March 2010, http://www.ted.com/talks/james_cameron_before _avatar_a_curious_boy/transcript?language=en. Thomas Elsaesser points out that the aesthetics of Cameron's blockbuster 3D film *Avatar* (2009) are subtly inflected by "the presence of water, fluids and the liquidity of metamorphosis and transformation," which produces a kind of cognitive dissonance in the spectator because the film takes place on land or in outer space. See Thomas Elsaesser, "James Cameron's *Avatar*: Access for All," *New Review of Film and Television Studies* 9, no. 3 (September 2011): 255.

65. Rudolf Arnheim, "Art Today and the Film," *Art Journal* 25, no. 3 (1966): 243.

66. R. P. Anand, *Origin and Development of the Law of the Sea* (The Hague: Martinus Nijhoff, 1982), 162.

67. Martin Heidegger, *The Question Concerning Technology and Other Essays*, trans. William Lovitt (New York: Harper, 1977), 14.

68. The National Geographic Society helped to publicize Cousteau's underwater explorations by sending Marden on the "silent world" expedition and featuring photographs from the film's production. Indeed, National Geographic had been publishing an increasing number of articles, maps, and photographs about the oceans from 1950 onward, as well as numerous articles and photo essays by Cousteau. His first such article was "Fish Men Explore a New World Undersea," but there was also "Fish Men Discover a 2,200 Year Old Greek Ship," *National Geographic* 105 (January 1954): 1–36, and "*Calypso* Explores for Underwater Oil," *National Geographic* 108 (August 1955): 155–184.

69. Machu, *Un cinéaste nommé Cousteau*, 75.

70. Ibid., 76.

71. Ibid., 77; translation mine.

72. Matsen, *Jacques Cousteau: The Sea King*, 127.

73. Carson's second published book, *The Sea around Us*, has retrospectively been designated the second title in her trilogy of sea-related books, which includes *Under the Sea-wind*, published in 1941, and *The Edge of the Sea* in 1955.

74. See Kroll, *America's Ocean Wilderness*, 144. These books built upon an already established culture for all things aquatic in the United States, as witnessed by the dramatic growth of public aquariums as new kinds of living museums, from the late twenties onward.

75. Quoted in Matsen, *Jacques Cousteau: The Sea King*, 127.

76. Following the publication in 1962 of *Silent Spring*, her now-famous, highly impactful exposé about pesticides, Carson became a leading environmental activist and was less concerned with enticing governments than with raising public awareness.

77. Matsen, *Jacques Cousteau: The Sea King*, 26.

78. Ibid., 34.

79. Ibid., 73.

80. See Jean Painlevé, Jacques-Yves Cousteau, Alain Resnais, et al., "Declaration of the Group of Thirty (1953)," in Scott Mackenzie, ed., *Film Manifestos and Global Cinema Cultures: A Critical Anthology* (Berkeley: University of California Press, 2013), 461.

81. Kristin Ross, *Fast Cars, Clean Bodies: Decolonization and the Reordering of French Culture* (Cambridge, MA: MIT Press, 1995), 7.

82. Jacques-Yves Cousteau and Frédéric Dumas, *The Silent World: A Story of Undersea Discovery and Adventure, by the First Men to Swim at Record Depths with the Freedom of Fish* (New York: Harper, 1953), 16.

83. Ibid., 202.

84. Bazin, *Qu'est-ce que le cinéma?*, 38.

85. James Cahill, "Tracing the World: André Bazin, Jacques Cousteau, and France's Cinema of Exploration," paper presented at the annual conference of the Film Studies Association of Canada, Brock University, St. Catharines, Ontario, May 28, 2014.

86. See Cousteau, "Fish Men Explore a New World Undersea," 463. Cousteau explains the relationship between France and Saudi Arabia that he was instigating by including a photograph of officials from Lith, an Arabian port, preparing to board the *Calypso*. The caption reads: "Flying Saudi Arabia's flag as a courtesy, Captain Cousteau and First Officer François Saout stand on Calypso's bridge. ... A burnoosed figure in bow is Lt. Jean Dupas, a French paratrouper assigned to the expedition. He is trained in the Arab Dialects." Another photograph of Dupas has the caption: "Arab and Frenchman have much to talk about: In turban and loin cloth, Lt. Dupas can pass among Red Sea fishermen as one of their own. An army officer attached for years to a Moroccan unit, Dupas learned to live, talk and think like an Arab."

87. Bazin, *Qu'est-ce que le cinéma?*, 38.

88. Ibid., 40.

89. Ibid.

90. Kroll, *America's Ocean Wilderness*, 184–185.

91. See Ker Than, "Jacques Cousteau Centennial: What He Did, Why He Matters," *National Geographic News*, June 1, 2010, http://news.nationalgeographic.com/news/2010/06/100611-jacques-cousteau-100th-anniversary-birthday-legacy-google/.

92. Kroll, *America's Ocean Wilderness*, 187.

93. *Offshore-Interactive.com*, i-doc directed by Brenda Longfellow, Glen Richards, and Helios Design Labs (Canada, 2013).

Chapter 3

1. Alison Ravetz, *Council Housing and Culture: The History of a Social Experiment* (London: Routledge, 2001), 104.

2. Matthew Hollow, "Utopian Urges: Visions for Reconstruction in Britain, 1940–1950," *Planning Perspectives* 27, no. 4 (2012): 574.

3. Ibid., 572.

4. Ibid., 574.

5. Harriet Atkinson, *The Festival of Britain: A Land and Its People* (London: I. B. Tauris, 2012), 24.

6. As Atkinson points out (ibid., 76), the aluminum saucer, which was "supported on light tabular steel struts," though intended to contain an exhibition on pioneering Britons, was one of the most celebrated pavilions at the South Bank. It also spoke to the lightweight inflatables and lightweight structures that would define Expo 67 and Osaka's architectural innovations.

7. For a summary of each of the exhibitions, see Atkinson, *The Festival of Britain*, xix–xxix.

8. Becky E. Conekin, *The Autobiography of a Nation: The 1951 Festival of Britain* (Manchester: Manchester University Press, 2003), 4.

9. Paul Wright, "Projecting the Festival of Britain," *Penrose Annual* 45 (1951), 60–61.

10. Atkinson, *The Festival of Britain*, 21.

11. Ben Jones and Rebecca Searle, "Humphrey Jennings, the Left and the Experience of Modernity in Mid-Twentieth-Century Britain," *History Workshop Journal* 75 (2013): 204; Robert Colls and Philip Dodd, "Representing the Nation: British Documentary Film, 1930–45," *Screen* 26, no. 1 (1985): 21–33; Anthony Aldgate and Jerry Richards, *Britain Can Take It: British Cinema and the Second World War* (London: I. B. Tauris, 1986), 218–245; Peter Stansky and William Abrahams, *London's Burning: Life, Death and Art in the Second World War* (Stanford: Stanford University Press, 1994), 71–125; Brian Winston, *Fires Were Started* (London: British Film Institute, 1999); Geoff Eley, "Finding the People's War: Film, British Collective Memory, and World War II," *American Historical Review* 106, no. 3 (2001): 818–838.

12. See John Scott and Ray Bromley, *Envisioning Sociology: Victor Branford, Patrick Geddes and the Quest for Social Reconstruction* (Albany: SUNY Press 2013), 77.

13. Kenneth J. Robson, "Humphrey Jennings: The Legacy of Feeling," *Quarterly Review of Film Studies* 7, no. 1 (1982): 37.

14. Charles Madge and Tom Harrison, *Mass Observation* (London: Frederick Muller, 1937), 15–16. Jones and Searle ("Humphrey Jennings," 201 n21) underline that Jennings is thanked for his help in this text and that pages 13–28 read a lot like his writing.

15. Tom Harrison and Tom Hodgkinson, "Humphrey Jennings and Mass Observation: A Conversation with Tom Harrison," *Journal of the University Film Association* 27, no. 4 (Fall 1975): 32.

16. In 1934, Jennings had joined the GPO Film Unit, a branch of the UK General Post Office, established in 1933 to produce documentary films for the post office, then under the direction of John Grierson.

17. Harrison and Hodgkinson, "Humphrey Jennings and Mass Observation," 33.

18. Jones and Searle, "Humphrey Jennings," 195.

19. Ibid., 206.

20. Kevin Jackson, ed., *Humphrey Jennings Film Reader* (Manchester, UK: Carcanet Press, 2004), ix.

21. Ibid., 162–172.

22. Lindsay Anderson, "Postscript," reprinted in Mary-Lou Jennings, ed., *Humphrey Jennings: Film-maker: Painter: Poet* (London: British Film Institute, 1982).

23. Transcribed from *Family Portrait* (1950), directed by Humphrey Jennings.

24. Jones and Searle, "Humphrey Jennings," 201.

25. Ibid., 205. As Jones and Searle argue, "one does not need to look far to find major figures who shared this sort of politics: J. B. Priestley, G. D. H. Cole and George Orwell all articulated both radical and social patriotism in the early 1940s. ... [T]hey were of the generation which came to political maturity during the Popular Front period and which both looked to past socialisms for inspiration and engaged in documentary-style investigation in order to make the case for change."

26. Mary Louise Pratt, *Imperial Eyes: Travel Writing and Transculturation* (London: Routledge, 1992).

27. See Scott and Bromley, *Envisioning Sociology.*

28. Anthony Vidler, "Whatever Happened to Ecology? John McHale and the Bucky Fuller Revival," *Architectural Design* 80, no. 6 (November 2010): 24–33.

29. For an excellent discussion of the new geography, see Pierre Chabard, "Towers and Globes: Architectural and Epistemological Differences between Patrick Geddes' Outlook Towers and Paul Otelet's Mundaneums," in Boyd Raward, ed., *European Modernism and the Information Society: Informing the Present, Understanding the Past* (Farnham, UK: Ashgate, 2008).

30. Lewis Mumford, introduction to Philip Boardman, *Patrick Geddes: Maker of the Future* (Chapel Hill: University of North Carolina Press, 1944), x.

31. Helen Meller, *Patrick Geddes: Social Evolutionist and City Planner* (London: Routledge, 1990), 201–235.

32. Sigfried Giedion, *Space, Time and Architecture: The Growth of a New Tradition* (Cambridge, MA: Harvard University Press, 1967), 786.

33. Rachel Haworth, "Patrick Geddes' Concept of Conservative Surgery," *Architectural Heritage* 11, no. 1 (2000): 37–42.

34. Philip Boardman, "Not Housing but Home-Building: The Life-Centered Approach of Patrick Geddes," *Teknisk Ukeblad*, no. 30, (1948): 8; Volker M. Welter, *Biopolis: Patrick Geddes and the City of Life* (Cambridge, MA: MIT Press, 2002).

35. As he would explore in Victor Branford, *Whitherward? Hell or Eutopia* (London: Williams and Norgate, 1921).

36. Ruth Levitas, *Utopia as Method: The Imaginary Reconstruction of Society*, 2nd ed. (London: Palgrave, 2013), 91.

37. Giedion, *Space, Time and Architecture*, 786.

38. See Meller, *Patrick Geddes*, especially chapter 4, "Museums, Actual and Possible," for a good overview of his diverse proposals for different museums and exhibitions.

39. Anthony Vidler, *The Scenes of the Street and Other Essays* (New York: Monacelli Press, 2011), 300.

40. Meller, *Patrick Geddes*, 73.

41. Chabard, "Towers and Globes," 111.

42. Ibid., 116.

43. Ibid.

44. Meller, *Patrick Geddes*, 102.

45. Ibid.

46. Quoted in ibid., 107.

47. Geddes, quoted in ibid., 92.

48. Giedion, *Space, Time and Architecture*, 27.

49. Ibid., 489.

50. Ibid., 880.

51. Ibid., 877.

52. Ibid., 700.

53. Sigfried Giedion, "The Heart of the City: A Summing Up," in Jaqueline Tyrwhitt, José Luis Sert, and E. N. Rogers, eds., *The Heart of the City: Toward the Humanisation of Urban Life* (London: Lund Humphries, 1952), 161.

54. Hardin McGregor Dunnett, *Guide to the Exhibition of Architecture, Town-Planning and Building Research* (London: HMSO, 1951), 7.

55. "General Supplement to Joint Press Notice dated 6th June, 1950, relating to the development of the Lansbury, Poplar, and the 'Live Architecture' Exhibition," TYJ\14\2\4\3, The Jaqueline Tyrwhitt Collection, Drawings & Archives Collections, British Architectural Library, Royal Institute of British Architects, London.

56. "Joint Statement to the Press by the London County Council and the Council of the Festival of Britain. Development of Lansbury, Poplar, in the Stepney-Poplar reconstruction area," "Live Architecture" Exhibition, Festival of Britain 1951,

TYJ\14\2\7\3, The Jaqueline Tyrwhitt Collection, Drawings & Archives Collections, British Architectural Library, Royal Institute of British Architects, London.

57. Dunnett, *Guide to the Exhibition of Architecture*, 38.

58. "Script for the Town Planning Exhibition, 29th March 1950," TYJ\14\7, The Jaqueline Tyrwhitt Collection, Drawings & Archives Collection, British Architectural Library, Royal Institute of British Architects, London.

59. Atkinson, *The Festival of Britain*, 182.

60. Ellen Shoshkes, "Jaqueline Tyrwhitt: A Founding Mother of Modern Urban Design," *Planning Perspectives* 21 (April 2006): 185.

61. Kenneth Frampton, *Modern Architecture: A Critical History*, rev. ed. (1980; repr., London: Thames and Hudson, 1990).

62. Karl Mannheim, *Ideology and Utopia: An Introduction to the Sociology of Knowledge*, trans. Louis Wirth and Edward Shils (1936; repr., San Diego: Harcourt Brace Jovanovich, 1985), 205.

63. Ruth Levitas, *The Concept of Utopia* (Syracuse: Syracuse University Press, 1991), 88.

64. Mannheim, *Ideology and Utopia*, 205.

65. Ibid., 206.

66. Ibid., 210.

67. The interdisciplinary reading lists that Tyrwhitt put together for students included Mannheim's work along with thinkers as diverse as urban planner, designer, and educator Otto Neurath. Neurath's Isotypes were used by the Association for Planning and Regional Reconstruction and by Tyrwhitt in her mapping reports, as well as for the live architecture at the Festival of Britain. For more on the Urban Planning program designed by Tyrwhitt, see the detailed account in Ellen Shoskes, *Jaqueline Tyrwhitt: A Transnational Life in Urban Planning and Design* (Farnham, UK: Ashgate, 2013), chapter 7, "Training Planners for Post-war Reconstruction."

68. Ibid., 70.

69. Association for Planning and Regional Reconstruction, *Broadsheet* no. 3 (April 1943), 1. Quoted in Shoshkes, *Jaqueline Tyrwhitt: A Transnational Life*, 18.

70. Ibid.

71. Jaqueline Tyrwhitt, "The Size and Spacing of Urban Communities," *Journal of the American Institute of Planners* 15 (Summer 1949): 13.

72. Conceived by Ebenezer Howard (1850–1928) in 1898, the garden city move-ment advocated a system of urban planning based on the design of self-sufficient communities, each of which would contain residential, industrial, and agricultural areas and would be surrounded by a greenbelt.

73. The neighborhood unit, a diagrammatic model for functional, self-contained, pleasant residential development in industrialized cities, was developed by Clarence Perry (1872–1944) in 1929.

74. Tyrwhitt, "The Size and Spacing of Urban Communities," 17.

75. Coates did succeed in bringing a modernist aesthetic to England. In 1932, he designed the interiors for the new headquarters of the BBC, and in 1934–1935, he created the ultramodern EKCO wireless radio made out of Bakelite for E. K. Cole Ltd. The highly successful radio was widely distributed throughout England. Coates is most renowned, however, as the architect of the beautifully minimalist Lawn Road Flats (also known as the Isokon building), completed in London in 1934.

76. British Film Institute, *How to Organize Film Shows during the Festival of Britain* (London: BFI, 1951).

77. Festival of Britain V&A Blythe House Archives—AAD 5-1-1979 to A … 5-07-15 11-30 (draft press book).

78. John Huntley, "The Telekinema in London," in National Film Music Council, ed., *Film Music*, vol. 9 (London: Forgotten Books, 1949), 220–221.

79. R. M. Hayes, *3D Movies: A History and Filmography of Stereoscopic Cinema* (Jefferson, NC: McFarland, 1989), 15.

80. Ibid., 19.

81. According to Hayes, "The group selected two Newman-Sinclair cameras for their system. These were mounted, face-to-face, with a 90-degree mirror positioned between them. The cameras would take their images from the mirror device. Addi-tionally it was determined to employ the new monopack Technicolor film (actually Kodachrome) for some of the several shorts to be made. Unfortunately the color test footage was unsatisfactory, and it was necessary to utilize twin three-strip Tech-nicolor cameras" (ibid., 15).

82. McLaren was very involved in making two other 3D films commissioned by the British Film Institute: Evelyn Lambart's *O Canada* (1952) and *Twirligig* by Greta Ekman (1952).

83. Quoted in Roger Horrocks, *Len Lye: A Biography* (Auckland: Auckland University Press, 2001), 144–145.

84. Norman McLaren, "Technical Notes," in *Norman McLaren on the Creative Process*, ed. Donald McWilliams (Montreal: National Film Board of Canada, 1991), 57.

85. Lenny Lipton, *Foundations of the Stereoscopic Cinema: A Study in Depth* (New York: Van Nostrand Reinhold, 1982), 37.

86. Raymond and Nigel Spottiswoode, *The Theory of Stereoscopic Transmission and Its Application to the Motion Picture* (Berkeley: University of California Press, 1953), viii.

87. Peter Wollen, *Paris Hollywood: Writings on Film* (London: Verso, 2002), 17.

88. Gerald Barry, "Films and the Festival," in *Films in 1951: Festival of Britain* (London: Published by Sight and Sound for the BFI, 1951), 39. Quoted in Michele Pierson, "Amateurism and Experiment: The British Film Institute's Experimental Film Fund (1952–1966)," *Moving Image* 5, no. 1 (Spring 2005): 73.

89. Pierson, "Amateurism and Experiment," 72–74.

90. Norman McLaren, "Some Notes on Animated Sound as Developed at the NFB by the Card Method," in *Technical Notes by Norman McLaren (1933–1984)* (Montreal: National Film Board of Canada, 2006), 77.

91. Ibid.

92. Rudolf Arnheim, "Art Today and the Film," *Art Journal* 25, no. 3 (1966): 243.

93. Sergei Eisenstein, *Eisenstein on Disney*, ed. Naum Kleinman, trans. Alan Upchurch (New York: Methuen, 1988), 46.

94. Transcribed from *Family Portrait* (1950), directed by Humphrey Jennings.

95. Though my argument in this book is that the technologies and experiences of the Second World War gave rise to a new spatial dimension created through media, this expanded sense of space was also evident in the arts after the First World War. Having attended art school in Glasgow, McLaren would no doubt have encountered the work of Patrick Geddes in the set design department at the Glasgow School of Art. While there, McLaren was deeply influenced by German abstract (nonobjective) filmmakers such as Viking Eggeling, Walter Rittman, and Hans Richter. Oskar Fischinger, a painter and filmmaker with an interest in animation, abstraction, and "visual music," would exert a lifelong influence on McLaren. In the years after World War I, Fischinger experimented with painting, cinema, movement, time, and space. In his pursuit of a perceptual synthesis between the experience of space and perception, Fischinger produced a number of stereo paintings as well as the 3D film *Stereo Film* (1952).

96. Miriam Ross, *3D Cinema : Optical Illusions and Tactile Experiences* (New York: Palgrave Macmillan, 2015). Ross reinterprets Laura Marks's formulation of "haptic visuality" as "hyperhaptic." As a way of seeing and knowing "haptic visuality" encompasses multiple senses, and proposes a method of sensory understanding that is not tied to literal touch, smell, taste or hearing.

97. David Trotter, "Stereoscopy: Modernism and the Haptic," *Critical Quarterly* 46, no. 4 (December 2004): 39. See also Alois Riegl, *Problems of Style: Foundations for a History of Ornament* (1893), trans. Evelyn Kain (Princeton: Princeton University Press, 1993).

98. Maurice Merleau-Ponty, "The Film and the New Psychology," in *Sense and Non-Sense*, trans. Hubert L. Dreyfus and Patricia A. Dreyfus (Evanston: Northwestern University Press, 1964), 53.

99. André Bazin, "Cinema in 3D and Color: Amazing," ed. and trans. Dudley Andrew, in *André Bazin's New Media* (Berkeley: University of California Press, 2014); André Bazin, "Un nouveau stade du cinéma en relief: Le relief en équations," *Radio-Cinéma-Télévision* 131 (July 20, 1952).

100. Sergei Eisenstein, "On Stereocinema" (1947), trans. Sergey Levchin, in Dan Adler, Janine Marchessault, and Sanja Obradovic, eds., *3D Cinema and Beyond* (London: Intellect Books, 2014), 20–59.

Chapter 4

1. John Neuhart, Marilyn Neuhart, and Ray Eames, *Eames Design: The Work of the Office of Charles and Ray Eames* (New York: Harry N. Abrams, 1989), 241.

2. Beatriz Colomina, "Enclosed by Images: The Eameses' Multimedia Architecture," *Grey Room* 2 (Winter 2001): 13.

3. George Nelson, *Problems of Design* (New York: Whitney Publications, 1957), 63.

4. Edward Steichen, *A Life in Photography* (Garden City, NY: Doubleday, 1963), chapter 12, p. 1.

5. On June 25, 1967, the BBC aired *Our World*, which was the first-ever live international satellite television broadcast. The two-and-a-half-hour broadcast featured various performances by artists from nineteen different countries around the world and reached between 400 and 700 million people worldwide, making it the most viewed television production of the time. McLuhan was interviewed in Canada about the Global Village. During the concluding UK segment of the broadcast, the Beatles first performed their song "All You Need Is Love."

6. The Global Theater was the original idea for an image of mediated interconnectivity which McLuhan replaced with the neologism "global village." McLuhan was deeply influenced by Teilhard de Chardin and by extension by his Russian inspiration, Vladimir Vernadsky, as discussed in chapter 2.

7. Stewart Brand, the creator of the *Whole Earth Catalog*, was deeply influenced by Expo 67's emphasis on ecology and, in particular, by Buckminster Fuller's ideas and geodesic domes.

8. Expo 67 was held in Montreal from April 28 to October 27, 1967. Sixty-one countries participated. The Library and Archives of Canada has an excellent site which brings together many of the original documents and photographs of the event. See Library and Archives of Canada, "Expo 67," http://www.collectionscanada.ca/expo/.

9. Tom Gunning, "The World as Object Lesson: Cinema Audiences, Visual Culture and the St. Louis World's Fair 1904," *Film History* 6, no. 4 (1994): 423.

10. Gerald O'Grady, "Media at Expo 67," lecture, School of Image Arts, Ryerson University, Toronto, January 24, 2008.

11. Judith Shatnoff, "Expo 67: A Multiple Vision," *Film Quarterly* 21, no. 1 (1967): 2.

12. Robert Fulford, *Remember Expo: A Pictorial Record* (Toronto: McClelland and Stewart, 1968), 59.

13. Gene Youngblood, *Expanded Cinema* (New York: Dutton, 1970).

14. With the creation of the Bureau International des Expositions (International Exhibitions [BIE/IEB]) in 1928, an intergovernmental body intended to schedule and regulate world exhibitions and fairs, ninety-two countries agreed: "The Exposition 'official' or 'officially recognized exhibition' shall be deemed to include every display, whatever its designation, to which foreign countries are invited through the diplomatic channel, which is not generally held periodically, of which the principal object is to demonstrate the progress of different countries in one or several branches of production, and in which, as regards admission, no distinction is made in principle between buyers and visitors" (International Convention Relating to International Exhibitions, Paris, 1928). Expo 67 was a Category One designation, the first of its type to be held in North America.

15. The term is from Jean-Luc Nancy, *The Creation of the World; or, Globalization*, trans. François Raffoul and David Pettigrew (Albany: State University of New York Press, 2007), 36.

16. Donald Theall, "A Report on the Film Experiments at Expo 67," unpublished manuscript, Library and Archives Canada, 1967.

17. Umberto Eco, "A Theory of Exhibitions," *Dotzero* 4 (1967): 5.

18. Karl Marx, "The Fetishism of Commodities and the Secret Thereof," in *The Process of Capitalist Production*, vol. 1 of *Capital: A Critique of Political Economy*, ed. Friedrich Engels, trans. Samuel Moore and Edward Aveling (New York: International Publishers, 1967), 71.

19. Eco, "A Theory of Exhibitions," 6.

20. The project was hosted at York University and was devoted to excavating eight films from Expo 67 and interviewing the filmmakers or producers: *Labyrinth* (Roman

Kroitor and Colin Low), *Kaleidoscope* (Morley Markson), *We Are Young* (Francis Thomson and Alexander Hammid), *A Place to Stand* (Chris Chapman), *Polar Life* (Graeme Ferguson), *Citérama* (Jacques Languirand), *The Eighth Day* (Charles Gagnon), and *Canada 67* (Robert Barclay). Funded through the Social Sciences and Humanities Research Council of Canada, researchers included Seth Feldman, Caitlin Fisher, Monika Gagnon, and myself. The results were published in Monika Kin Gagnon and Janine Marchessault, eds., *Reimagining Cinema: Film at Expo 67* (Montreal: McGill University Press, 2014).

21. Gabrielle Roy, *Man and His World* (Montreal: Compagnie Canadienne de l'Exposition Universelle de 1967, 1967), 27.

22. Johanne Sloan, "Humanists and Modernists at Expo '67," *Revista Mexicana de Estudios Canadienses* 13 (2007): 80.

23. We now know that polyester, being petroleum-based, is not as sustainable and earth-friendly as it was then thought to be.

24. "Expo 67: An Experiment in the Development of Urban Space," *Architectural Record* 140 (October 1966): 169–176.

25. Gunning, "The World as Object Lesson," 423.

26. "Expo 67: An Experiment in the Development of Urban Space," 170.

27. Albert Rorai, internal report "Architecture at Expo 67" (1967), 10, George Soulis personal papers.

28. Michael Large, "Communication among All People, Everywhere: Paul Arthur and the Meaning of Design," *Design Issues* 17, no. 2 (Spring 2001): 81–90.

29. Modley also worked with Margaret Mead on the idea of universal communication. They published the results of their research the year following Expo 67. See Margaret Mead and Rudolph Modley, "Communication among All People, Everywhere," *Natural History* 77, no. 7 (1968): 56–63.

30. Donald Theall, "McGill Study of Expo 67," Library and Archives of Canada, National Film Board fond (R1196-0-7E), vols. 2–15, microfilm reels C4509–C4510, 1967.

31. Walter Gropius, "The Theory and Organization of the Bauhaus," in Herbert Bayer, Walter Gropius, and Ise Gropius, eds., *Bauhaus: 1919–1928* (New York: Museum of Modern Art, 1938), 20.

32. Ellen Shoshkes, *Jaqueline Tyrwhitt: A Transnational Life in Urban Planning and Design* (Farnham, UK: Ashgate, 2013), 202.

33. Michael Darroch and Janine Marchessault, "Anonymous History as Methodology: The Collaborations of Sigfried Giedion, Jaqueline Tyrwhitt and the Explorations Group 1953–1955," in Andreas Broeckmann and Gunalan Nadarajan, eds.,

Place Studies in Art, Media, Science and Technology: Historical Investigations on the Sites and Migration of Knowledge (Weimar: Verlag und Datenbank für Geisteswissenschaften, 2009), 10–15.

34. Although CIAM never had a New York chapter, Fuller was a longtime contributor of funds and ideas to the organization. See Eric Mumford, *The CIAM Discourse on Urbanism, 1928–1960* (Cambridge, MA: MIT Press, 2000), 124.

35. See Michael Darroch and Janine Marchessault, eds., *Cartographies of Place: Navigating the Urban* (Montreal: McGill University Press, 2014).

36. Marshall McLuhan to Jaqueline Tyrwhitt, May 11, 1964, Tyrwhitt file in the McLuhan Fonds, Library and Archives Canada, Ottawa, MG 31 D 156 Vol 39 File 59.

37. Author's interview with Morley Markson (director of *Man and Color*, 1967, mirrored film screened in Kaleidoscope Pavilion), December 16, 2016, Toronto. According to Markson, Fuller was a significant influence on filmmakers at Expo 67.

38. R. Buckminster Fuller, introduction to Youngblood, *Expanded Cinema*, 35.

39. Michael John Gorman, *Buckminster Fuller: Designing for Mobility* (Milan: Skira Editore, 2005), 127–134.

40. Yael Joel, "A Film Revolution to Blitz Man's Mind," *Life* (July 1967), 2, 8.

41. See Jeffrey Stanton's impressionistic account in "Experimental Multi-Screen Cinema" at Expo 67, available at http://www.westland.net/expo67/map-docs/architecture.htm, accessed January 7, 2017; and Michael Naimark's interview with Radúz Činčera, "Interval Trip Report: World's First Interactive Filmmaker, Prague" (1998), available at http://www.naimark.net/writing/trips/praguetrip.html.

42. See Gagnon and Marchessault, *Reimagining Cinema*, which includes filmmakers' statements as well as interviews, scripts, and notebooks to understand how many of the Expo 67 filmmakers were working in an expanded way with film.

43. Youngblood, *Expanded Cinema*, 136.

44. R. G. Collingwood, *Principles of Art* (Oxford: Clarendon Press, 1938), 223.

45. Youngblood, *Expanded Cinema*, 77.

46. Nelly Kaplan, *Napoleon* (London: BFI Publishing, 1994), 42–46.

47. Youngblood, *Expanded Cinema*, 78.

48. Ibid.

49. A few space programs that appeared on US and British television were *The Conquest of Space* (1954), *Man in Space* (1955), *The Jetsons* (1962), *Lost in Space* (1965), and *Star Trek* (1966), among others; spy serials included *James Bond* (1954), *The*

Avengers (1962, 1964), and *Mission Impossible* (1966). All of these shows used screens as shorthand for high technology.

50. Marshall McLuhan, *War and Peace in the Global Village* (New York: Bantam, 1968), 13.

51. Siegfried Kracauer, *Theory of Film: The Redemption of Physical Reality* (New York: Oxford University Press, 1960), 245–246.

52. Henri Cartier-Bresson, "The Decisive Moment," in Vicki Goldberg, ed., *Photography in Print: Writings from 1816 to the Present* (Albuquerque: University of New Mexico Press, 1981), 384–386. See also Seth Feldman, "The Days before Christmas and the Days before That," in Jim Leach and Jeannette Sloniowski, eds., *Candid Eyes: Essays in Canadian Documentary* (Toronto: University of Toronto Press, 2003), 31–47.

53. Gary Evans, *In the National Interest: A Chronicle of the National Film Board of Canada from 1949 to 1989* (Toronto: University of Toronto Press, 1991), 70–71.

54. Gerald Graham, *Canadian Film Technology 1896–1986* (Newark: University of Delaware Press, 1989), 189–237.

55. Marc Glassman and Wyndham Wise, "Interview with Colin Low, Part II," *Take One* 26 (2000), 32.

56. Ibid., 23.

57. Marc Glassman, and Wyndham Wise, "Interview with Colin Low, Part I," *Take One* 23 (1999), 29–30.

58. Mary Renault, *The King Must Die* (New York: Pantheon, 1958).

59. Roman Kroitor, Colin Low, et al., "Minute no. 3, Labyrinth Design Committee Meeting," April 11, 1964, National Film Board of Canada Archives.

60. Northrop Frye, *Fables of Identity: Studies in Poetic Mythology* (New York: Harcourt Brace, 1963), 241.

61. Wallace Stevens, "Thirteen Ways of Looking at a Blackbird," in *The Collected Poems of Wallace Stevens* (New York: Knopf, 1972), 94–95.

62. Expo 67, *Expo 67: Official Guide* (Toronto: Maclean-Hunter, 1967), 56–57.

63. Glassman and Wise, "Interview with Colin Low, Part II," 24.

64. National Film Board of Canada, "*Labyrinth* Technical Bulletin no. 8," National Film Board of Canada Technical Operations Branch, March 1968.

65. Northrop Frye, quoted in Kroitor et al., "Minute no. 3, Labyrinth Design Committee Meeting."

66. Wendy Michener, "Through a Multi-Screen Darkly," *Maclean's* 17 (September 1966), 58.

67. Glassman and Wise, "Interview with Colin Low, Part II," 24.

68. Colin Low, "Multi-Screens and Expo '67," *Journal of the Society of Motion Picture and Television Engineers* 77, no. 3 (March 1968): 185.

69. Ibid.

70. Cited in Pierre Pageau, "Colin Low, an Anglophone in Quebec," *Offscreen* 16, no. 2 (February 2012), http://offscreen.com/view/anglophone_in_quebec.

71. Marshall McLuhan, *Counter Blast* (Toronto: McClelland and Stewart, 1969), 24.

72. Low, "Multi-Screens and Expo '67," 185.

73. Youngblood, *Expanded Cinema*, 18–80.

74. Reyner Banham, *Megastructure: Urban Futures of the Recent Past* (New York: Harper and Row, 1976), 177.

75. National Film Board of Canada, "*Labyrinth* Technical Bulletin no. 8."

76. Youngblood, *Expanded Cinema*, 111.

77. André Janssen, "The Production of a Future Gaze at Expo '67," *Space and Culture* 10, no. 4 (2007): 418–436.

78. Francis Thompson, and Alexander Hammid, "Expanding Cinema," pamphlet, 1967, Harrison Engle, personal papers. Engle worked as assistant director on the six-screen film *We Are Young* by Thompson and Hammid.

79. Patricia Zimmermann, *Reel Families: A Social History of Amateur Film* (Blooming-ton: Indiana University Press, 1995). Zimmermann's social history of amateur mov-iemaking in the United States has foregrounded the importance of class, race, and gender in any examination of the amateur movie archive.

80. Vintage Swinger commercial, 1965, https://www.youtube.com/watch?v=9rIGrbo1MRA, accessed January 7, 2017. Another post on YouTube describes and shows the Swinger technology from a 1967 Polaroid camera: Polaroid Swinger, Vintage Unboxing, 1967, https://www.youtube.com/watch?v=ZvVSE_qmHpM, accessed January 7, 2017.

81. Marshall McLuhan, *Our World*: *1967 TV Experiment Links Five Continents by Satellite*, CBC television special, June 25, 1967, accessed July 16, 2016, http://www.cbc.ca/archives/entry/our-world-five-continents-linked-via-satellite.

82. Logan Smiley, "TV Film/Tape in the '70s," *Print* (January 1970): 76–77.

83. Ibid., 68.

84. For an extensive overview and discussion of Challenge for Change/Société nou-velle, see Tom Waugh, Brenden Baker, and Ezra Winten, eds., *Challenge for Change:*

Activist Documentary at the National Film Board of Canada (Montreal: McGill-Queen's University Press, 2010).

Part III: Planet

1. Marshall McLuhan, "Our New Electronic Culture: The Role of Mass Communications in Meeting Today's Problems," *National Association of Broadcasters Journal* (October 1958): 25.

2. Anthony Vidler, "Whatever Happened to Ecology? John McHale and the Bucky Fuller Revival," *Architectural Design* 80, no. 6 (November 2010): 24–33.

3. Paul J. Crutzen and Eugene F. Stoermer, "The Anthropocene," *International Geosphere-Biosphere Programme Newsletter* 41 (2000), 17.

4. See Daniel Chernilo, "The Question of the Human in the Anthropocene Debate," *European Journal of Social Theory* 19 (June 2016): 1–17; Andreas Malm and Alf Hornborg, "The Geology of Mankind? A Critique of the Anthropocene Narrative," *Anthropocene Review* 1, no. 1 (April 2014): 62–69.

5. See Marisol de la Cadena, "Runa: Human but *Not Only*," *HAU: Journal of Ethnographic Theory* 4, no. 2 (2014): 253–259; Donna Haraway, "Anthropocene, Capitalocene, Plantationocene, Chthulucene: Making Kin," *Environmental Humanities* 6 (2015): 159–165; Donna Haraway et al., "Anthropologists Are Talking—About the Anthropocene," *Ethnos* 81, no. 3 (May 2016): 535–564; Jason W. Moore, *Capitalism in the Web of Life: Ecology and the Accumulation of Capital* (London: Verso, 2015); Jussi Parikka, *The Anthrobscene* (Minneapolis: University of Minnesota Press, 2014); Anja Kanngieser and Angela Last, "Five Propositions | Critiques for the Anthropocene," *GeoCritique* (April 20, 2016), http://www.geocritique.org/five-propositions-critiques-anthropocene. In the 2015 conference Rupturing the Anthro-Obscene: The Political Promises of Planetary Urban Ecologies (September 17–19, Stockholm), organizers Henrik Ernstson and Erik Swyngedouw created a provocative position paper to frame the event that has a strong utopian impulse: "We hope that the figure of the anthro-obscene can rupture an established order of how global-to-local problems, ecological crises and urbanization should be talked about, framed and dealt with. We hope this can be exploited by our participants and provoke reflection beyond reality-as-we-know-it and habits of thought and action. We hope this will take our seminar and public event into 'unbridled imagination' and 'theoretical searching' to build a vocabulary to sharpen our thinking of what is of importance, how to research, and how to struggle" (http://www.anthro-obscene.situatedecologies.net/framing.html, accessed January 7, 2017).

6. Catherine Malabou, "The Anthropocene: A New History" (lecture, Durham Castle Lecture Series, Durham University, England, January 27, 2016); Dipesh Chakrabarty, "The Climate of History: Four Theses," *Critical Inquiry* 35, no. 2 (2009).

7. Fernand Braudel, *La Méditerranée et le monde méditerranéen à l'époque de Philippe II* (Paris: LGF, 2010).

8. Chakrabarty, "The Climate of History," 206.

9. Marshall McLuhan, *Understanding Media: The Extensions of Man* (New York: McGraw-Hill, 1964), 3.

10. Ibid., 64.

11. Ibid., 47. Hans Selye (1907–1982) was a Hungarian endocrinologist who was the first to give a scientific explanation for biological stress (see Selye, "A Syndrome Produced by Diverse Nocuous Agents," *Nature* 138, no. 32 (July 4, 1936): 32, and numerous later publications). He founded the Institute of Experimental Medicine and Surgery at the University of Montreal in 1945 and devoted his life to studying the effects of stress on biology. McLuhan and Selye corresponded regularly in the 1960s and 1970s, and Selye invited McLuhan to join the board of his Institute. See Hans Selye, *The Stress of Life*, rev. ed. (New York: McGraw-Hill, 1976).

12. Félix Guattari, *Three Ecologies*, trans. Ian Pindar and Paul Sutton (London: Athlone Press, 2000), 28.

13. Ibid., 34.

Chapter 5

1. University of Strathclyde Archives, Geddes Papers, notes and charts by Patrick Geddes relating to the Notation of Life and the classification of the sciences (c. 1896–1906) (Creation), GB 249 T-GED/14/1/12. See Volker M. Welter, *Biopolis: Patrick Geddes and the City of Life* (Cambridge, MA: MIT Press, 2002), for an extensive discussion of the Notation of Life. For more on Geddes's "thinking machines," see the special issue devoted to Patrick Geddes in the *Journal of Generalism and Civics*, no. 6 (August 2005), http://hodgers.com/mike/patrickgeddes/people.html, accessed January 7, 2017.

2. Neil Postman, "The Reformed English Curriculum," in A. C. Eurich, ed., *High School 1980: The Shape of the Future in American Secondary Education* (New York: Pitman, 1970), 161.

3. Carey writes: "Geddes, perhaps more than anyone else, popularized the notion that there were two qualitatively different periods of industrialization, corresponding to the early and late Paleolithic periods. He termed these periods the paleotechnic and the neotechnic, differentiated among many dimensions but principally by their reliance on different forms of energy: steam and electricity." Geddes understood that electricity "had certain intrinsic potentials for producing a decentralized society," something that Mumford and after him McLuhan developed in their theories of technology. *James Carey: A Critical Reader*, ed. Eve Stryker Munson

and Catherine A. Warren (Minneapolis: University of Minnesota Press, 1997), 45, 46.

4. Ernst Bloch, "Nonsynchronism and the Obligation to Its Dialectics," trans. Mark Ritter, *New German Critique*, no. 11 (Spring 1977): 22.

5. Gene Youngblood, "What We Must Do," in Janine Marchessault and Susan Lord, eds., *Fluid Screens, Expanded Cinema* (Toronto: University of Toronto Press, 2007), 321–326.

6. Bruno Latour, "A Cautious Prometheus? A Few Steps toward a Philosophy of Design (with Special Attention to Peter Sloterdijk)," in Jonathan Glynne, Fiona Hackney, and Viv Minton, eds., *Networks of Design: Proceedings of the 2008 Annual International Conference of the Design History Society (UK), University College Falmouth, September 3–6* (Boca Raton, FL: Universal Publishers, 2009), 2.

7. Michael Hardt and Antonio Negri, *Multitude: War and Democracy in the Age of Empire* (New York: Penguin, 2004), xv.

8. Thomas N. Hale and Anne-Marie Slaughter, "Hardt and Negri's 'Multitude': The Worst of Both Worlds," *Open Democracy: Free Thinking for the World*, May 25, 2005, https://www.opendemocracy.net/globalization-vision_reflections/marx_2549.jsp, accessed January 10, 2017.

9. Idle No More (http://www.idlenomore.ca/) is an ongoing protest movement founded in December 2012 by four women: three First Nations women and one non-Native supporter. The grassroots movement began with the Aboriginal peoples in Canada comprising the First Nations, Métis and Inuit peoples and their non-Aboriginal supporters in Canada. The movement has spread internationally to create new kinds of solidarity around land rights disputes, and to halt environmentally harmful resource extraction. https://en.wikipedia.org/wiki/Idle_No_More.

10. See https://www.womensmarch.com/principles/.

11. Scott McGuire, *The Media City: Media, Architecture and Urban Space* (London: Sage Publications, 2009).

12. Susan Sontag, *On Photography* (New York: Farrar, Straus and Giroux, 1977), 180.

13. Susan Sontag, *Regarding the Pain of Others* (New York: Farrar, Straus and Giroux, 2003), 109.

14. Jean Baudrillard, *The Ecstasy of Communication*, trans. Sylvère Lautringer (New York: Semiotext(e), 1988), 10.

15. Ibid., 26.

16. Ibid., 27.

17. Sontag, *Regarding the Pain of Others*, 110.

18. Ibid., 112.

19. Ibid., 113.

20. Baudrillard, *The Ecstasy of Communication*, 27.

21. Ibid., 79.

22. Explorations Group members included Marshall McLuhan, Edmund Carpenter, W. T. Easterbrook, Jaqueline Tyrwhitt, and D. C. Williams.

23. Michael Darroch and Janine Marchessault, "Anonymous History as Methodology: The Collaborations of Sigfried Giedion, Jaqueline Tyrwhitt and the Explorations Group 1953–1955," in Andreas Broeckmann and Gunalan Nadarajan, eds., *Place Studies in Art, Media, Science and Technology: Historical Investigations on the Sites and Migration of Knowledge* (Weimar: Verlag und Datenbank für Geisteswissenschaften, 2009), 9–27.

24. Georges Bataille, *The Tears of Eros*, trans. Peter Connor (1961; San Francisco: City Lights Books, 1989), 20.

25. Ibid., 206.

26. Sontag, *Regarding the Pain of Others*, 98.

27. Ibid., 101.

28. The videos are diverse, and include *Blood and Water*, in which a truck collects mortared bodies in the street; *Wedding in Sarajevo*, the story of a young woman who marries the corpse of her lover and subsequently discovers she's pregnant; *Confession of a Monster*, a portrait of a captured Serbian soldier who recollects, with little emotion, cutting the throats of Bosnians and raping Bosnian women. For more information, see Scott MacKenzie, "Lists and Chain Letters: Ethnic Cleansing, Holocaust Allegories and the Limits of Representation," *Canadian Journal of Film Studies* 9, no. 2 (Fall 2000): 23–42.

29. Ibid., 34.

30. Ibid., 35.

31. Hito Steyerl, "In Defense of the Poor Image," *e-flux Journal* 10 (November 2009), http://www.e-flux.com/journal/10/61362/in-defense-of-the-poor-image/.

32. Ibid., n.p.

33. Amy Spencer, *DIY: The Rise of Lo-Fi Culture* (London: Marian Boyars, 2015).

34. Julio García Espinosa, "For an Imperfect Cinema," in Scott MacKenzie, ed., *Film Manifestos and Global Cinema Cultures: A Critical Anthology* (Berkeley: University of California Press, 2014), 229.

35. Susan Sontag, "Regarding the Torture of Others," *New York Times*, May 23, 2004, http://www.nytimes.com/2004/05/23/magazine/regarding-the-torture-of-others .html.

36. Ibid.

37. Baudrillard, *The Ecstasy of Communication*, 26.

38. Susan Sontag, "The Decay of Cinema," *New York Times*, February 25, 1996, https://www.nytimes.com/books/00/03/12/specials/sontag-cinema.html, accessed January 10, 2017.

39. Francesco Casetti, "Filmic Experience," *Screen* 50, no. 1 (Spring 2009): 56.

40. Jean-Michel Frodon, "The Cinema Planet," in Dina Iordanova, ed., *The Film Festival Reader* (St Andrews, Scotland: St Andrews Film Studies, 2013), 206.

41. Georges Bataille, *Oeuvres complètes*, vol. 7 (Paris: Gallimard 1976), 15–16; trans. in Allan Stoekl, *Bataille's Peak: Energy, Religion and Postsustainability* (Minneapolis: University of Minnesota Press, 2007), 189.

42. Ibid., 189–190.

43. Emile Durkheim, *The Elementary Forms of Religious Life*, trans. Joseph Ward Swain (New York: Dover, 2008), 230.

44. Georges Bataille, *Theory of Religion*, trans. Robert Hurley (New York: Zone Books, 1992), 215–216.

45. B. Ruby Rich, "State of the Cinema," address to the San Francisco International Film Festival, April 18, 2004.

46. Todd Gitlin, *The Whole World Is Watching: Mass Media in the Making and Unmaking of the New Left* (Berkeley: University of California Press, 1980), xiii–xv.

47. Fernando Solanas and Octavio Getino, "Towards a Third Cinema: Notes and Experiences for the Development of a Cinema of Liberation in the Third World," in Bill Nichols, ed., *Movies and Methods: An Anthology*, vol. 1 (Berkeley: University of California Press, 1976).

48. Among the first city-identified festivals were those in Venice (1932), Moscow (1935), Cannes (1946), Karlovy Vary (Czechoslovakia, 1946), Edinburgh (1947), Berlin (1951), Panjim (Goa, India, 1952), London (1953), Cork (1956), San Francisco (1957), Montreal (1960), Melbourne (1962), New York City (1963), Belgrade (1971), Hong Kong (1976), Toronto (1976), Cairo (1976), and Havana (1979). The list of film festivals has been growing by the year.

49. Dina Iordanova, "The Film Festival Circuit," in Iordanova, *The Film Festival Reader*, 115.

50. See chapter 18, "Sacrifice, the Festival and the Principles of the Sacred World," in Bataille, *Theory of Religion*.

51. Walter Benjamin, "The Work of Art in the Age of Mechanical Reproduction," in *Illuminations*, ed. Hannah Arendt, trans. Harry Zohn (1968; repr., New York: Schocken Books, 2007), 217–252.

52. Norbert Elias and Eric Dunning, *Quest for Excitement: Sport and Leisure in the Civilizing Process* (Oxford: Blackwell, 1986), 66.

53. Stoekl, *Bataille's Peak*, 146.

54. Blake C. Clayton, *Market Madness: A Century of Oil Panics, Crises and Crashes* (New York: Oxford University Press, 2015).

55. Stephanie LeMenager, *Living Oil: Petroleum Culture in the American Century* (New York: Oxford University Press, 2014), 133.

56. Stoekl, *Bataille's Peak*, x.

57. Tony Shaw, *British Cinema and the Cold War: The State, Propaganda and Consensus* (London: I. B. Tauris, 2001), 80.

58. Ibid., 83.

59. R. Buckminster Fuller, *Critical Path* (London: St. Martin's Press, 1981), 389. For Fuller's friend Marshall McLuhan, Sputnik initiated a new ecological thinking: for the first time, the natural world was completely enclosed in a human-created container. "Ecological" thinking became inevitable as soon as the planet moved up into the status of a work of art. Marshall McLuhan, "At the Moment of Sputnik the Planet Became a Global Theater in which There Are No Spectators but Only Actors," *Journal of Communication* 24, no. 1 (1974): 49.

60. Anthony Vidler, "Whatever Happened to Ecology?," talk presented at Syracuse University, November 12, 2008, https://www.youtube.com/watch?v=1UA0N4huxlw, accessed January 7, 2017; published as Vidler, "Whatever Happened to Ecology? John McHale and the Bucky Fuller Revival," *Architectural Design* 80, no. 6 (November 2010): 28.

61. John McHale, the father of pop art and a founder of the Independent Group, left the UK to study design with Josef Albers at Yale and brought back the popular culture of the United States. He was also instrumental in popularizing Buckminster Fuller's ideas, as seen in his article "Buckminster Fuller," *Architectural Review* 120, no. 714 (July 1956): 12–20. In the 1960s he participated in and helped to direct Fuller's World Resources Inventory at Southern Illinois University, Carbondale.

62. Reyner Banham, "The New Brutalism," *Architectural Review* 118 (December 1955): 354–361.

63. The young architects who formed the Archigram group imagined the city in terms of movement (architecture + telegram) under the influence of Banham, Fuller, and Cedric Price.

64. However, as I argued in chapter 3, I would stress that the Festival's utopian experiments with film and media as well as urban planning and architecture can be interpreted as complementary future-oriented endeavors, engaging with questions of how to rebuild the city as a collective place—precisely by rebuilding the connections between humans, nature, and machines.

65. Vidler, "Whatever Happened to Ecology?," 28.

66. Graham Stevens, "Pneumatics and Atmospheres," *Architectural Digest* 3 (March–October 1972): 166.

67. These were expressly the flexible lightweight materials that were used by many architects at Expo 67, such as Frei Otto, who hosted one of the first pneumatic world congresses in 1972, which both Stevens and Cedric Price attended.

68. Graham Stevens, "Art, Science, Law," artist talk, Blacks Members Club, London, January 23, 2012.

69. Joan Littlewood, "A Laboratory of Fun," *New Scientist* 14 (May 1964): 432–433.

70. Stanley Mathews, "The Fun Palace: Cedric Price's Experiment in Architecture and Technology," *Technoetic Arts: A Journal of Speculative Research* 3, no. 2 (June 2005): 79.

71. Ibid.

72. While the Fun Palace was never realized, a two-day celebration of creativity took place in 2002 across the United Kingdom, with more than 120 "pop up" Fun Palaces in theaters, museums, and other venues to celebrate the centenary of Littlewood's birth.

73. "Tomorrow's Expanded Cinema University, as the word uni-verse—towards one—implies, will weld metaphysically together the world community of man by the flux of understanding and the spontaneously truthful integrity of the child." R. Buckminster Fuller, introduction to Gene Youngblood, ed., *Expanded Cinema* (New York: Dutton, 1970), 35.

74. Kelli Korducki, "Remembering Rochdale College, Toronto's Hippie Heart," *Globe and Mail*, November 8, 2013.

75. McLuhan and his collaborator, the radical anthropologist Edmund Carpenter, were rethinking university education, and proposed experimental curricula starting in their early essay "The Classroom without Walls," first published in their interdisciplinary journal *Explorations* in 1957. Within the pages of the journal, Carpenter and McLuhan would regularly espouse the need to understand the new grammars of

media: "Today we're beginning to realize that the new media aren't just mechanical gimmicks for creating worlds of illusion, but new languages with new and unique powers of expression. Historically, the resources of English have been shaped and expressed in constantly new and changing ways. The printing press changed not only the quantity of writing but also the character of language and the relations between author and public. Radio, film, TV pushed written English toward the spontaneous shifts and freedom of the spoken idiom. They aided us in the recovery of intense awareness of facial language and bodily gesture. If these 'mass media' should serve only to weaken or corrupt previously achieved levels of verbal and pictorial culture, it won't be because there's anything inherently wrong with them. It will be because we've failed to master them as new languages in time to assimilate them to our total cultural heritage." "Classroom without Walls," *Explorations* 7 (1957): 24–25. Though the text is not signed, it was later published under McLuhan's name in Edmund Carpenter and Marshall McLuhan, eds., *Explorations in Communication: An Anthology* (Boston: Beacon Press, 1960), 1–3.

76. B. Ruby Rich, *Chick Flicks: Theories and Memories of the Feminist Film Movement* (Durham: Duke University Press, 1998), 64.

77. According to Heath, the inflatable plastic form was intended as a mold to help create a penis made of ice, but the Toronto winter of 1975 was not cold enough to freeze the water (interview with the author, Toronto, June 28, 2016).

78. Stevens, "Pneumatics and Atmospheres," 166.

79. "Structures gonflables" was an international exhibition devoted to the art, technology, and imaginary of inflatable structures in all domains. The exhibition included marine, air, and spatial vehicles, and terrestrial engines; dispositifs, apparatuses, and tools; works of art; toys, furniture, and beach accessories; and arrangements for games and parties. The exposition was organized by the group Utopie at the Musée d'Art Moderne de la Ville de Paris / ARC from March 1 to 30, 1968. The Utopie group included theorists Jean Baudrillard, René Lourau, and Catherine Cot; architects Jean Aubert, Jean-Paul Jungmann, and Antoine Stinco; and landscape architect Isabelle Auricoste. Beginning in 1966 and lasting for more than a decade, the group sought in both theory and practice to develop a radical leftist critique of architecture, urbanism, and everyday life.

80. Attendees included Walter Bird (a pioneer in the field of pneumatic structures, which he further established with Birdair Structures), Victor Lundy, Heinz Isler, Dante Bini, Nikolaus Laing, Cedric Price, and Graham Stevens.

81. Will McLean, "Air Apparent Pneumatic Structures," *Architectural Review* 235, no. 1406 (April 2014): 105.

82. The cinemas he had seen fail were the Centre for Experimental Art and Communication (1974–1978), the Funnel Experimental Film Theater (1977–1988), and the Euclid Theater for Independent Film and Video (1989–1993).

83. Christina and Margaret Zeidler, whose father leads one of the most respected architectural firms in the city, manage 401 Richmond, a building of particular interest to urban researchers because, unlike many so-called creative spaces that use artists to bring color to the marketplace, it exists organically within the city. Through an unofficial policy that offers tenants a sliding scale for rent (with the proviso that they contribute to the cultural life of the building and the city), it houses many of Toronto's artist-run galleries, alternative presses, festival offices, independent designers, and other small creative enterprises.

84. Will Straw, "Scenes and Sensibilities," *Public: Art/Culture/Ideas*, no. 22–23 (2001): 255.

85. Stoekl, *Bataille's Peak*, 144.

86. Georges Bataille, *The Accursed Share: An Essay on General Economy*, vol. 1 trans. Robert Hurley (New York: Zone Books, 1988), 19.

87. Ibid.

88. Cédric Mong-Hy, *Bataille cosmique: Georges Bataille, du système de la nature à la nature de la culture* (Paris: Lignes, 2012), 20.

89. Giorgio Agamben, *The Open: Man and Animal*, trans. Kevin Attell (Stanford: Stanford University Press, 2004), 7.

90. Georges Bataille, *Eroticism: Death and Sensuality*, trans. Mary Dalwood (London: Penguin, 1962), 15.

91. Stoekl, *Bataille's Peak*, 147.

92. Agnès Varda and Melissa Anderson, "The Modest Gesture of the Filmmaker: An Interview with Agnès Varda (2001)," in T. Jefferson Kline, ed., *Agnès Varda: Interviews* (Jackson: University Press of Mississippi, 2014), 174.

93. Stoekl, *Bataille's Peak*, 144.

94. Henri Lefebvre, *Writings on Cities*, trans. Eleonore Kofman and Elizabeth Lebas (Oxford: Blackwell, 1996), 158.

Chapter 6

1. Douglas Adams, *The Hitchhiker's Guide to the Galaxy: So Long and Thanks for All the Fish*, 2nd ed. (1984; London: Pan Books, 2009), 139–140.

2. R. Buckminster Fuller, *Critical Path* (New York: St. Martin's Press, 1981), 132.

3. Catherine Malabou, "The Anthropocene: A New History," lecture, Durham Castle Lecture Series, Durham University, England, January 27, 2016, https://www .youtube.com/watch?v=JkTGZ7l7jcM.

4. Raymond Williams, "Problems of Materialism," in *Culture and Materialism: Selected Essays*, 2nd ed. (London: Verso, 2005), 108.

5. Nigel Clark, *Inhuman Nature: Sociable Life on a Dynamic Planet* (London: Sage, 2011), 11.

6. Jacques Derrida, *Archive Fever: A Freudian Impression*, trans. Eric Prenowitz (Chicago: University of Chicago Press, 1996), 36.

7. See Allan Stoekl, *Bataille's Peak: Energy, Religion and Postsustainability* (Minneapolis: University of Minnesota Press, 2007), 189.

8. While Bataille's book was first published by Les Éditions de Minuit in 1949, it was republished in 1967. Fuller's many books were written in the 1950s and 1960s.

9. Bataille writes that his proposal was fueled by fear and anxiety, which instigated his search for solutions, but he also insists that solutions will be found with the removal of these emotions in order to foster "freedom of mind." See Georges Bataille, *The Accursed Share: An Essay on General Economy*, trans. Robert Hurley, vol. 1 (New York: Zone Books, 1988), 12–14. Also: "That civilization is perhaps detestable; it sometimes seems to be only a bad dream; and there is no question that it generates the boredom and irritation that favor a slide toward catastrophe." Ibid., 170.

10. Ibid., 10.

11. Ibid., 28.

12. Ibid., 13.

13. Stoekl, *Bataille's Peak*, xiii.

14. Ibid., 191.

15. Ibid., 229.

16. Ibid., 197.

17. Jacques Derrida, "From Restricted to General Economy: A Hegelianism without Reserve," in *Writing and Difference*, trans. Alan Bass (Chicago: University of Chicago Press, 1978), 337 n.33.

18. Stoekl, *Bataille's Peak*, 39.

19. See Robert Foster, Majid Ghassemi, and Alma Cota, *Solar Energy: Renewable Energy and the Environment* (Boca Raton, FL: CRC Press, 2010).

20. Fuller, *Critical Path*, 199.

21. R. Buckminster Fuller, *Utopia or Oblivion: The Prospects for Humanity* (New York: Bantam Books, 1969), 301.

22. "Dymaxion" stems from the combination of "dynamic" with "maximum," referencing the minimum investment of energy and materials to maximum effects.

23. Robert M. Arens, "Houses at Fifty Cents a Pound: Buckminster Fuller's Conception of Domestic Space," Proceedings of the 86th Association of Collegiate Schools of Architecture (ACSA) Annual Meeting, March 14–17, 1998, Cleveland, Ohio, 354.

24. Reyner Banham, *Theory and Design in the First Machine Age*, 2nd ed. (London: Architectural Press, 1960), 326–327.

25. Cousteau served in the French navy during World War II, Steichen in both wars.

26. Michael John Gorman, *Buckminster Fuller: Designing for Mobility* (Milan: Skira, 2005), 21.

27. "The Audion," *Lee De Forest*, http://www.leedeforest.org/The_Audion.html, accessed August 5, 2016.

28. Fuller, *Critical Path*, 162–163.

29. The "Air-Ocean Projection," also known as the "Dymaxion Map," was designed by Fuller in the 1940s and was included in the Geodesic US Pavilion at Expo 67. The flat map reveals the entire surface of the earth as one island in one ocean, without any visually obvious distortion of the relative shapes and sizes of the land areas, and without splitting any continents.

30. R. Buckminster Fuller, *The World Game: Integrative Resource Utilization Planning Tool* (Carbondale: World Resources Inventory, Southern Illinois University, 1971), 473.

31. While the dome architecture was accepted for Expo 67 by the organizing committee overseeing the US Pavilion, the Geoscope was rejected. This is presumably because it would have been far too expensive—if not technically impossible, since Fuller was describing what has only recently become possible under the guise of big data and visualization in *real time*.

32. Fuller, *The World Game*, 1: "I will describe quickly the World Game. It is an organization of computer capability to deal prognosticatingly with world problems. It is played with the information contained in the six volumes entitled, 'Inventory of World Resources, Human Trends and Needs,' compiled and published by my office at Southern Illinois University. Game theory, as outlined by the late Princeton Professor John Von Neuman, is employed by all the powerful nations today in their computerized reconnoitering in scientific anticipation of hypothetical world wars III, IV, and V. The joint chiefs of staff of all the major power states of the world play their 'World War Games' on the working assumption of the validity of Thomas Malthus' 1810 dictum that there is not enough human sustenance aboard our planet to support all its people; that the people reproduce themselves at a geometrical rate, and their support resources only at an arithmetical progression rate. And the major

states compound Malthus' assumedly fundamental inadequacy of life support concept with Darwin's dictum of survival only of the fittest; wherefore all the world's military and political establishments assume eventual Armageddon."

33. Fuller, *Critical Path*, xxii: "All earlier empires were infinite systems—open systems. The British Empire was history's first spherically close, finite system. Building and maintaining the world's most powerful navy, the 1805 supremely victorious British Empire was to maintain its sovereignty over the world's oceans and seas for 113 years."

34. Fuller, *Critical Path*, 202.

35. John McHale had relocated to the United States to carry out his PhD at Yale and take up an academic position. He became the executive director of the World Game project, which was proposed to the International Union of Architects as a "World Retooling Design Decade … in order to render the total chemical and energy resources of the world, which are now exclusively preoccupied in serving only 44% of humanity, adequate to the service of 100% of humanity at higher standards of living and total enjoyment than any man has yet experienced." R. Buckminster Fuller and John McHale, "Inventory of World Resources, Human Trends and Needs," 1963, https://www.bfi.org/sites/default/files/attachments/literature_source/wdsd_phase1_doc1_inventory.pdf, accessed January 10, 2017.

36. The *Whole Earth Catalog* (1968–1998) was a paper database of "tools," products, and information for life improvement and self-sufficiency directed mostly toward counterculture communities and DIY practitioners. Stewart Brand, the publisher, was inspired by Fuller's assertion that our perception of the world as flat and infinite rather than round and small came from never having seen it from outer space. Subsequently, Brand used NASA's image of the whole earth as a guiding symbol of unity. Fuller's influence remained considerable in the early editions, as seen, in particular, in such concepts as "whole systems," "synergetics," efficiency, and waste reduction. For an in-depth discussion of Brand, see Fred Turner, *From Counterculture to Cyberculture: Stewart Brand, the Whole Earth Network, and the Rise of Digital Utopianism* (Chicago: University of Chicago Press, 2006).

37. For more on these influences, see Gloria Sutton, *The Experience Machine: Stan VanDerBeek's Movie-Drome and Expanded Cinema* (Cambridge, MA: MIT Press, 2015), 70–90; Felicity Scott, *Architecture or Techno-Utopia: Politics after Modernism* (Cambridge, MA: MIT Press, 2010), 187, 201–204.

38. Scott, *Architecture or Techno-Utopia*, 204.

39. Ibid.

40. Quoted in John McHale, *The Ecological Context* (New York: Braziller, 1970), 168; Kenneth E. Boulding, "The Economics of the Coming Spaceship Earth," in Henry Jarrett, ed., *Environmental Quality in a Growing Economy: Essays from the Sixth RFF*

Forum (Baltimore: Johns Hopkins University Press for Resources for the Future, 1966), 3–14.

41. McHale, *The Ecological Context*, 118.

42. Ibid., 123.

43. Ibid., 166.

44. Boulding, "The Economics of the Coming Spaceship Earth," 9.

45. Ibid.

46. Karl Mannheim, *Ideology and Utopia: An Introduction to the Sociology of Knowledge*, trans. Louis Wirth and Edward Shils (1936; repr., San Diego: Harcourt Brace Jovanovich, 1985), 197.

47. See, for example, Denis Hollier's *Against Architecture: The Writings of Georges Bataille*, trans. Betsy Wing (Cambridge, MA: MIT Press, 1989); and Fuller's criticism of the métier of architect (cf. *Critical Path*).

48. Kathryn Yusoff, "Excess, Catastrophe, and Climate Change," *Environment and Planning D: Society and Space* 27 (2009): 1010–1029.

49. *World of Matter* is an international art and media project investigating primary materials (fossil, mineral, agrarian, maritime) and the complex ecologies of which they are a part. http://www.worldofmatter.net/, accessed November 30, 2016.

50. The core group includes Mabe Bethonico, Ursula Biemann, Uwe H. Martin, Helge Mooshammer and Peter Mörtenböck, Emily E. Scott, Paulo Tavares, Lonnie van Brummelen, and Siebren de Haan.

51. *Space, Land, and Time: Underground Adventures with Ant Farm*, directed by Laura Harrison (Collective Eye Films, 2011), DVD.

52. Chip Lord, *Ant Farm: Then and Now*, YouTube video, 1:26:30, posted by Jordan Schnitzer Museum of Art, Eugene, Oregon, May 7, 2013, https://youtu.be/hIUMzJv7BhU.

53. The names of the Ant Farmers are Andy Shapiro, Kelly Gloger, Fred Unterseher, Hudson Marquez, Chip Lord, Doug Hurr, Michael Wright, Curtis Schreier, Joe Hall, and Doug Michels.

54. *Ant Farm Inflatable Instructions*, YouTube video, 2:19, posted by "hibirdie," December 4, 2009, https://www.youtube.com/watch?v=AZ9uIDP-o-o.

55. Quoted in Felicity Scott, *Living Archive 7: Ant Farm Allegorical Time Warp: The Media Fallout of July 21, 1969* (New York: ACTAR, Columbia GSAPP, 2008), 20; Steve Seid, "Tunneling through the Wasteland: Ant Farm Video," in Constance M. Lewallen and Steve Seid, ed., *Ant Farm 1968–1978* (Berkeley: University of California Press, 2004), 22–37.

56. Janine Marchessault, ed., *Mirror Machine: Video in the Age of Identity* (Toronto: YYZ Books, 1994).

57. "LSD: A Design Tool?," *Progressive Architecture*, August 1966, 147–153.

58. Ant Farm, "Ant Farm Proposal for Expo 70," *Architectural Design* (July 1969), 355.

59. Wolfgang Friebe, *Buildings of the World Exhibitions*, trans. Jenny Vowles and Paul Roper (Leipzig: Edition Leipzig, 1985), 200.

60. Marshall McLuhan, *Letters of Marshall McLuhan*, ed. Matie Molinaro, Corinne McLuhan, and William Toye (Oxford: Oxford University Press, 1987), 258.

61. Marshall McLuhan and Barrington Nevitt, *Take Today: The Executive as Dropout* (New York: Harcourt Brace Jovanovich, 1972), 86; quoted in Richard Cavell, *McLuhan in Space: A Cultural Geography* (Toronto: University of Toronto Press, 2002), 67. Cavell remarks that "McLuhan's negative allusion is to C. K. Ogden and I. A. Richards' *The Meaning of Meaning*" (251).

62. Marshall McLuhan, *Counter Blast* (Toronto: McClelland and Stewart, 1969), 30.

63. "The Present Is the Form of All Life: The Time Capsules of Ant Farm and LST," curated by Gabriel Florenz and Liz Flyntz, Pioneer Works, New York, September–October 2016.

64. Tyler Survant, "Biological Borderlands: Ant Farm's Zoöpolitics," *Horizonte* 8 (Fall 2013): 54; excerpt available at http://archinect.com/features/article/93011262/screen-print-7-horizonte.

65. Christopher Riley, "The Dolphin Who Loved Me: The NASA-Funded Project That Went Wrong," *Guardian*, last modified June 8, 2014, https://www.theguardian.com/environment/2014/jun/08/the-dolphin-who-loved-me.

66. D. Graham Burnett, *The Sounding of the Whale: Science and Cetaceans in the Twentieth Century* (Chicago: University of Chicago Press, 2012), 579. Burnett writes (ibid.): "Among Lilly's papers, in his 'Solitude' file, I discovered his copy of the English Translation of Jacques-Yves Cousteau's 1953 best-seller *The Silent World*, a book (and in 1956, a film) that introduced Cousteau and deep-sea scuba diving to hundreds and thousands of Americans. Lilly's annotations in the margins of this volume suggest that he read the text with care and took particular interest in Cousteau's reflections on the experience of weightlessness and isolation in the silent suspension of the underwater world."

67. Ant Farm, "Embassy to the Dolphins," *Esquire*, March 1975, 83.

68. Numerous highly respected scientific studies of cetacean-human communication currently under way are in fact using video and computers in a way that Ant Farm imagined in the early iteration of their project.

69. Jussi Parikka, *Insect Media: An Archaeology of Animals and Technology* (Minneapolis: University of Minnesota Press, 2010), ix.

70. Bruno Latour, *Reassembling the Social: An Introduction to Actor-Network Theory* (Oxford: Oxford University Press, 2009). See also Bruno Latour, "From Realpolitik to Dingpolitik or How to Make Things Public," in Bruno Latour and Peter Weibel, eds., *Making Things Public: Atmospheres of Democracy* (Karlsruhe: ZKM Center for Art and Media; Cambridge, MA: MIT Press, 2005), 14–41.

71. John Law, "Actor Network Theory and Material Semiotics," version of April 25, 2007, available at http://www.heterogeneities.net/publications/Law2007ANTandMaterialSemiotics.pdf, accessed May 18, 2007. Since helping to develop actor-network theory, John Law has been working on a project that would dovetail in interesting ways with the Dolphin Embassy's early iteration. Working with anthropologists Marianne Lien and Gro Ween (University of Oslo), he is developing an ethnography of salmon farming on a project called "Newcomers to the Farm." The "core questions" of the project are: "How do animals and people interact? How are those interactions mediated by technologies? How are human beings and animals being remade?" John Law, "Professional Biography: Current Research Projects," Open University, http://www.open.ac.uk/people/jl6987, accessed December 1, 2016.

72. Survant, "Biological Borderlands," 53.

73. Sergei Eisenstein, *Eisenstein on Disney*, ed. Naum Kleinman, trans. Alan Upchurch (New York: Methuen, 1988), 50.

74. Doug Michels, "Blue Star Human Dolphin Space Colony, 1987," ZKM's Space Place, last updated April 15, 2006, http://www.orbit.zkm.de/?q=node/248.

75. The 1980s were rich in dolphin narratives. The idea of cetaceans in space was explored in *Star Trek IV: The Voyage Home* (1986) in which Kirk and his crew must travel back in time to the twentieth century to save earth from an alien probe by connecting with humpback whales, the only beings who can communicate with the probe. In Douglas Adams's science fiction novel *The Hitchhiker's Guide to the Galaxy: So Long and Thanks for All the Fish* (1984), dolphins try to warn humans of impending disaster to which they are deaf. These cetaceans are louder than Cousteau's underwater life in *The Silent World*. As we saw in chapter 2, Walt Disney and Jacques Cousteau had a hand to play in this new acoustic space, and so did John Lilly's research, which paved the way for the popular TV program that starred a dolphin as a family pet—*Flipper* (1964–1967). Lilly's research with dolphins revealed "an alien mind" that he believed could help scientists to communicate with extraterrestrial intelligence. Not surprising, until it was discredited, Lilly's research was funded by NASA, the US Navy and Air Force, and the National Science Foundation.

76. Survant, "Biological Borderlands," 61.

77. This also lines up with Embassy muse John C. Lilly's like-minded telepathic experiences with dolphins. Survant, "Biological Borderlands," 58, 61.

78. In a 1990 interview on Japanese television, Michels, in suit and tie, describes the Bluestar project with the same kind of parodic humor he had used in the early days of Ant Farm when calling press conferences to announce projects. To the group of Japanese TV interviewers, he enthusiastically stated: "We are going to study the thought process liberated from gravity … we will think better in zero gravity and have better ideas," and "I hope to go there [Bluestar] in my lifetime, in the year 2022, and think up a storm." The interviewers were less certain once the dolphin drawings were added to the space station. The interview is documented on the Media Burn archive: https://www.youtube.com/watch?v=mmFK2DO0x.

79. Danielle Clode, *Killers in Eden: The True Story of Killer Whales and Their Remarkable Partnership with the Whalers of Twofold Bay* (Sydney: Allen and Unwin, 2002).

80. Survant, "Biological Borderlands," 58.

81. Isabelle Stengers, in Bruno Latour and Pasquale Gagliardi, eds., *Les atmosphères de la politique*, conference proceedings (Paris: Seuil, 2006), 136.

82. Ibid., 138.

83. Ibid., 139.

84. The conference speakers in "Les atmosphères de la politique" were Philippe Descola, Pasquale Gagliardi, François Julien, Gilles Kepel, Derrick de Kerckhove, Bruno Latour, Giovanni Levi, Sebastiano Maffettone, Angelo Scola, Peter Sloterdijk, Isabelle Stengers, and Adam Zagajewski.

85. In 2015, WORKac and Ant Farm's Chip Lord and Curtis Schreier came together to reconstruct the archive, which was lost in a fire. Focusing on the architectural scales of house, building, and city, WORKac created new drawings of the House of the Century, Dolphin Embassy, and Convention City. A conversation, recorded as "Hacking Ant Farm," identified a series of shared interests between the two practices and led to a new proposal: 3.C.City: Climate, Convention, Cruise. A utopian place, 3.C.City is a floating city, unbound by national allegiances and designed to engage with world problems such as climate change. The WORKac team for the project with Ant Farm included Amale Andraos (principal), Dan Wood (principal), Tom Goddeeris, Chije Kang, Laetitia Fontenat, Margaux Guillot, Trevor Hollyn Taub, Jun Deng, and Madeeha Merchant.

86. WORKac statement for the 2015 Chicago Biennale, http://work.ac/chicago -biennale/.

87. Erkki Kurenniemi, "Supermegatechnologies: Some Thoughts on the Future," in Joasia Krysa and Jussi Parikka, eds., *Writing and Unwriting (Media) Art History:*

Erkki Kurenniemi in 2048 (Cambridge, MA: MIT Press, 2015). This book provides an excellent overview of Kurenniemi's career and includes interviews, previously unavailable or untranslated writings, and critical essays that engage with the multiple aspects of his career as both a scientist and a media artist/musician.

88. Hasan M. Elahi, "You Want to Track Me? Here You Go, F.B.I.," *New York Times*, October 29, 2011, http://www.nytimes.com/2011/10/30/opinion/sunday/giving -the-fbi-what-it-wants.html, accessed July 2, 2013.

89. MAXMSP is a visual programming language for music and multimedia developed and maintained by San Francisco–based software company Cycling '74. Originally designed by Miller Puckette to provide musicians and composers with access to an authoring system for interactive computer music, MAXMSP has grown to become what has been described as the lingua franca for developing interactive music performance software.

90. Vibeke Sorensen, "Global Visual Music: From Audio-Video Synthesis to Transmodal Transmedia Art," keynote, Seeing Sound, April 9–10, 2016, Bath Spa University. Sorensen, along with Miller Puckette and others, runs the Global Visual Music Project at the University of California in San Diego.

91. Gordon Moore's prediction was first published in *Electronics* 38, no. 8 (April 19, 1965). His assertion that the number of transistors on a computer chip will double every two years is thus far holding true. For Kurzweil, this axiom can be applied to all facets of information technology, from computer power to bandwidth to brain scanning to DNA sequencing, and to all forms of knowledge production in general.

92. Ray Kurzweil, *The Singularity Is Near: When Humans Transcend Biology* (London: Viking Penguin, 2005), 9.

93. The critiques of Kurzweil's books and of singularitarianism focus on two points. The first is that the historical timeline for his evolutionary framework is crude and linear, folding millions of years of technological and human evolution into one simple graph. Based on this timeline, he has made many predictions about the information revolution, approximately half of which have been correct. Second, one of the most problematic of his proposals—the "uploading of consciousness" (thoughts, memory, personality)—is an impossible "dream," not least because, despite advances in the technological ability to probe and scan the human brain, it largely remains a mystery. Though neuroscience is one of the fastest-growing medical fields, scientists do not yet understand how the brain produces a conscious mind, and they continue to lack an overarching theory of the mind. Devoted to the notion of the singularity is the Institute of Electrical and Electronics Engineers' journal *Spectrum*.

94. Pierre Teilhard de Chardin, *The Phenomenon of Man*, ed. Julian Huxley, trans. Bernard Wall (New York: Harper, 1959), 258.

95. Donna Haraway, quoted in Nicholas Gane and Haraway, "When We Have Never Been Human, What Is to Be Done? Interview with Donna Haraway," *Theory, Culture and Society* 23, nos. 7–8 (2006): 140.

96. Donna Haraway, "SF: Science Fiction, Speculative Fabulation, String Figures, So Far," *Ada: A Journal of Gender, New Media, and Technology*, no. 3 (2013), doi:10.7264/N3KH0K81.

97. Rosi Braidotti, "Posthuman, All Too Human: Towards a New Process Ontology," *Theory, Culture and Society* 23, nos. 7–8 (2006), 200.

98. Ibid., 201.

99. Rosi Braidotti, *The Posthuman* (Cambridge, UK: Polity Press, 2013), 99.

100. Derrida, *Archive Fever*, 91.

101. Ibid., 19.

102. Erkki Kurenniemi, *The Future Is Not What It Used to Be*, directed by Mika Taanila (2002; Icarus Films, 2004), DVD.

103. Alfred Whitehead, *Modes of Thought* (New York: Free Press, 1968), 29.

104. Derrida, *Archive Fever*, 11.

105. Carolee Schneemann, *Imaging Her Erotics: Essays, Interviews, Projects* (Cambridge: MIT Press, 2003).

106. Fuller, *Critical Path*, 124.

107. Whitehead, *Modes of Thought*, 120–121.

108. Whitehead, *Modes of Thought*, 89.

109. Ibid., 34.

110. See Gary Genosko's essay "The Life and Work of Félix Guattari: From Traversality to Ecosophy," in Guattari, *The Three Ecologies*, trans. Ian Pindar and Paul Sutton (London: Athlone Press, 2000), 106–160.

111. Constant is a nonprofit association, an interdisciplinary arts lab based in Brussels and active since 1997. Constant "works in-between media and art and is interested in the culture and ethics of the World Wide Web. The artistic practice of Constant is inspired by the way that technological infrastructures, data-exchange and software determine our daily life. Free software, copyright alternatives and (cyber)feminism are important threads running through the activities of Constant." Nicolas Malevé and Michael Murtaugh are working on Active Archives, a platform for reuse of digital material through metadata, vocabularies, and taxonomies. For more information on the Constant Association for Art and Media, see their website: http://www.constantvzw.org/site/-About-Constant,7-.html.

112. Ibid., 67–68.

113. Erkki Kurenniemi, "Relative Life," in E. Hyvönen and J. Seppänen, eds., *Keinoelämä* (Espoo, Finland: Artificial Life Publications of Finnish AL Society, 1995), 65.

114. Derrida, *Archive Fever*, 36.

115. "Drifting Golf Balls in Monasteries: A Conversation with Erkki Kurenniemi," in Krysa and Parikka, *Writing and Unwriting (Media) Art History*, 304.

116. See www.sinkingandmelting.org. Both Paglen and Balkin come from the Bay Area in San Francisco, which also nurtured the Ant Farmers. In common with Ant Farm is their commitment to environmental justice, to challenge militarism and capitalism—and fundamentally to work through creative networks and to reinvent forms of co-creation. Balkin believes artists "must engage in visualizing and modeling alternate futures"—which is the very definition of utopia.

117. As of 2016, the archive was made up of posts from Anvers Island (Antarctica), Australia, Cape Verde, Santiago de Cuba, Germany, Greenland, Iceland, Venice (Italy), Kivalina (Alaska), Mexico, Nepal, New Orleans, New York City, Panama, Peru, Republic of Komi (Russia), California, Senegal, and Tuvalu.

118. Yusoff, "Excess, Catastrophe, and Climate Change," 1021.

119. Ibid.

120. Ibid., 1024.

Epilogue

1. Georges Bataille, "Les conséquences du non-savoir," in *Oeuvres complètes*, vol. 8 (Paris: Gallimard, 1976), 190; trans. Annette Michelson as "Un-knowing and Its Consequences," *October* 36 (1986): 80.

2. Maurice Merleau-Ponty, *Phénoménologie de la perception* (Paris: Gallimard, 1945), 494; trans. Donald Landes as *Phenomenology of Perception* (New York: Routledge, 2012), 456. Quotations are from Landes's translation.

3. Graham Harman, *Guerrilla Metaphysics: Phenomenology and the Carpentry of Things* (Chicago: Open Court, 2005), 3.

4. Quentin Meillassoux, *Après la finitude* (Paris: Éditions du Seuil, 2006), 18; trans. Ray Brassier as *After Finitude: An Essay on the Necessity of Contingency* (London: Continuum, 2008), 5. Quotations are from Brassier's translation.

5. Catherine Malabou, "The Anthropocene: A New History," lecture, Durham Castle Lecture Series, Durham University, England, January 27, 2016, quoting from Félix

Guattari, *The Three Ecologies*, trans. Ian Pindar and Paul Sutton (London: Athlone Press, 2000), 45.

6. Ted Toadvine, "The Elemental Past," *Research in Phenomenology* 44 (2014): 262–279.

7. Mark B. N. Hansen, *Feed-Forward* (Chicago: University of Chicago Press, 2014); Jussi Parikka, *A Geology of Media* (Minneapolis: University of Minnesota Press, 2015); John Durham Peters, *The Marvelous Clouds: Toward a Philosophy of Elemental Media* (Chicago: University of Chicago Press, 2015).

8. Peters, *The Marvelous Clouds*, 11–12.

9. Ibid.

10. Marshall McLuhan and Quentin Fiore, *The Medium Is the Massage* (New York: Bantam Books, 1967), 84.

11. Isabelle Stengers, in Bruno Latour and Pasquale Gagliardi, eds., *Les atmosphères de la politique*, conference proceedings (Paris: Seuil, 2006), 136.

12. Mary Louise Pratt, "Planetary Longings," paper presented in Spanish at the Learned Societies in Halifax, Canada, 2002, http://www.nyupoco.com/Mary_Louise_Pratt__Planetary_Longings.pdf.

13. Martin Heidegger, "The Origin of the Work of Art," in *Basic Writings*, ed. David Farrell Krell (New York: Harper and Row, 1977), 40.

14. Jacques Derrida and Marie-Françoise Plissart, *Right of Inspection*, trans. David Willis (New York: Monacelli Press, 1998).

15. Nicholas Mirzoeff, "The Right to Look," *Critical Inquiry* 37, no. 3 (Spring 2011): 473.

16. Heidegger, "The Origin of the Work of Art," 26.

17. Ibid., 29.

18. Ibid., 30.

19. Ibid., 22.

20. Ibid., 26.

21. Ibid., 34.

22. Ibid., 35.

23. Ibid., 40.

24. Ibid., 57.

25. Ibid., 54.

26. Ibid., 85.

27. Hannah Arendt, "Truth and Politics," in *Between Past and Future* (New York: Penguin, 1983), 241.

28. Georges Bataille, *Eroticism: Death and Sensuality*, trans. Mary Dalwood (London: Penguin, 1962), 15.

29. Maurice Merleau-Ponty, *The Visible and the Invisible; Followed by Working Notes*, ed. Claude Lefort, trans. Alphonso Lingis (Evanston: Northwestern University Press, 1968), 135.

30. Ibid., 271.

31. Ibid., 248.

32. Costas M. Constantinou, *States of Political Discourse: Words, Regimes, Seditions* (New York: Routledge, 2004), 10.

33. Ibid., 63.

34. From the film we hear: "On September 11, 1973, a military coup led by General Pinochet toppled the democratic socialist government of Chile. President Salvador Allende killed himself as troops attacked the presidential palace. Pinochet—with the backing of the CIA—rounded up students, trade unionists and intellectuals. In the aftermath of the coup, a quarter of a million people were detained for their political beliefs, 3,000 were killed or disappeared, many more were tortured."

35. Merleau-Ponty, *The Visible and the Invisible*, 194.

36. Ibid., 252.

37. Alan Angell, "The Pinochet Regime: An Accounting" *Open Democracy* 12, December 2006, https://www.opendemocracy.net/democracy-protest/pinochet _regime_4174.jspA. See also Alan Angell and Benny Pollack, eds., *The Legacy of Dictatorship: Political, Economic and Social Change in Pinochet's Chile* (Liverpool, UK: University of Liverpool, Institute of Latin American Studies, 1993).

38. Film scholars often read Guzmán's documentaries in terms of the positionality of the exilic, as he was forced to leave at the time of the coup and took up residence in France. Julianne Burton, ed., *The Social Documentary in Latin America* (Pittsburgh: University of Pittsburgh Press, 1990), and Zuzana M. Pick, *The New Latin American Cinema: A Continental Project* (Austin: University of Texas Press, 1993), are the best sources for this approach.

39. Andrew Tracy, "The Essay Film," BFI in Focus, August 2013, http://www.bfi.org .uk/news-opinion/sight-sound-magazine/features/deep-focus/essay-film.

40. Merleau-Ponty, *The Visible and the Invisible*, 264–265.

41. Toadvine, "The Elemental Past," 270–271.

42. Since the death of Pinochet in 2006, the government of Chile began supporting efforts to construct memorials out of former detention centers, creating the large Museo de la Memoria y los Derechos Humanos (Museum of Memory and Human Rights), which opened in 2010, as well as small museums and memorial walls at historically significant sites.

43. Guzmán later produced *The Pearl Button* (2015), which expands his view of history in Chile to focus on another of the country's major traumas, the genocide of the Patagonian people.

Bibliography

Abram, David. "Merleau-Ponty and the Voice of the Earth." *Environmental Ethics* 10 (2) (Summer 1988): 101–120.

Acker, Kathy. "Blue Valentine." In Michael O'Pray, ed., *Andy Warhol Film Factory*, 62–65. London: BFI Publishing, 1989.

Adams, Douglas. *The Hitchhiker's Guide to the Galaxy: So Long and Thanks for All the Fish*. 2nd ed. London: Pan Books, 2009.

Adorno, Theodor W. *Aesthetic Theory*. Ed. Gretel Adorno and Rolf Tiedemann. Trans. Robert Hullot-Kentor. Minnesota: University of Minnesota Press, 1997.

Aldgate, Anthony, and Jerry Richards. *Britain Can Take It: British Cinema and the Second World War*. London: I. B. Tauris, 1986.

Anand, Ram Prakash. *Origin and Development of the Law of the Sea*. The Hague: Martinus Nijhoff, 1982.

Anderson, Lindsay. "Postscript." Repr. In *Humphrey Jennings: Film-maker: Painter: Poet*, ed. Mary-Lou Jennings. London: British Film Institute, 1982.

Anker, Peder. "Graphic Language: Herbert Bayer's Environmental Design." *Environmental History* 12 (2) (2007): 254–279.

Ant Farm. "Ant Farm Proposal for Expo 70." *Architectural Design* (July 1969).

Ant Farm. "Embassy to the Dolphins." *Esquire* (March 1975).

Ant Farm. "Inflatocookbook." 1973. http://alumni.media.mit.edu/~bcroy/inflato-splitpages-small.pdf.

Anthony, Scott, and James G. Mansell. "Key Documents from the History of the GPO Film Unit." In Scott Anthony and James G. Mansell, eds., *The Projection of Britain: A History of the GPO Film Unit*, 98–159. London: Palgrave Macmillan, 2011.

Arendt, Hannah. *Eichmannn in Jerusalem: A Report on the Banality of Evil*. New York: Penguin Books, 1963.

Arnheim, Rudolf. "Art Today and the Film." *Art Journal* 25 (3) (1966): 242–244.

Atkinson, Harriet. *The Festival of Britain: A Land and Its People*. London: I. B. Tauris, 2012.

"The Audion." *Lee De Forest*. http://www.leedeforest.org/The_Audion.html, accessed August 5, 2016.

Auerbach, Erich. *Mimesis: The Representation of Reality in Western Literature*. Trans. W. R. Trask. Princeton: Princeton University Press, 2003.

Banham, Reyner. *Megastructure: Urban Futures of the Recent Past*. New York: Harper and Row, 1976.

Banham, Reyner. *Theory and Design in the First Machine Age*. 2nd ed. London: Architectural Press, 1960.

Banks, David. "Cyborgology: A Brief Summary of Actor Network Theory." *The Society Pages*. Last modified December 2, 2011. https://thesocietypages.org/cyborgology/2011/12/02/a-brief-summary-of-actor-network-theory/.

Barthes, Roland. *Mythologies*. Trans. A. Lavers. New York: Hill and Wang, 1973.

Bataille, Georges. *The Accursed Share: An Essay on General Economy*. 3 vols. in 2. Trans. Robert Hurley. New York: Zone Books, 1988–1991.

Bataille, Georges. *The Bataille Reader*. Ed. Fred Botting and Scott Wilson. Oxford: Blackwell, 1997.

Bataille, Georges. *Eroticism*. Trans. Mary Dalwood. London: Penguin, 1962.

Bataille, Georges. *Guilty*. Trans. Bruce Boone. Venice, CA: Lapis Press, 1988.

Bataille, Georges. *The Tears of Eros*. Trans. Peter Connor. 1961; repr., San Francisco: City Lights Books, 1989.

Bataille, Georges. *Theory of Religion*. Trans. R. Hurley. New York: Zone Books, 1992.

Baudrillard, Jean. *The Ecstasy of Communication*. Trans. Sylvère Lautringer. New York: Semiotext(e), 1988.

Bauman, Zygmunt. *Globalization: The Human Consequences*. New York: Columbia University Press, 1998.

Bazin, André. *André Bazin's New Media*. Ed. and trans. D. Andrew. Berkeley: University of California Press, 2014.

Bazin, André. "Kon-Tiki, Groënland poésie, et aventure." *Le Parisien libéré* 2371 (April 28, 1952).

Bazin, André. "Mort du documentaire reconstitué: L'aventure sans retour." *France-observateur* 106 (May 22, 1952).

Bazin, André. "Mort tous les après-midi." *Cahiers du Cinéma* 2 (7) (December 1951): 63–65.

Bazin, André. "Les périls de Perri." *Cahiers du Cinéma* 83 (1958): 50–53.

Bazin, André. *Qu'est-ce que le cinéma?* Paris: Editions du Cerf, 1976.

Beckman, Karen. "Animating Film Theory: An Introduction." In Karen Beckman, ed., *Animating Film Theory*, 1–24. Durham: Duke University Press, 2014.

Benjamin, Walter. *The Arcades Project*. Trans. Howard Eiland and Kevin McLaughlin. Cambridge, MA: Belknap Press, 1999.

Benjamin, Walter. "The Task of the Translator." In *Illuminations*, ed. Hannah Arendt, trans. Harry Zohn, 69–82. 1968; repr., New York: Schocken Books, 2007.

Benjamin, Walter. "The Work of Art in the Age of Mechanical Reproduction." In *Illuminations*, ed. Hannah Arendt, trans. Harry Zohn, 217–252. 1968; repr., New York: Schocken Books, 2007.

Berardi, Franco "Bifo." "The Neuroplastic Dilemma: Consciousness and Evolution." *e-flux Journal* 60 (December 2014).

Berg, Gretchen. "Nothing to Lose: An Interview with Andy Warhol." In Michael O'Pray, ed., *Andy Warhol Film Factory*, 54–61. London: BFI Publishing, 1989.

Berger, John. *The Sense of Sight: Writings by John Berger*. Ed. Lloyd Spence. New York: Vintage Books, 1985.

Bergson, Henri. *The Two Sources of Morality and Religion*. Trans. R. Ashley Audra and Cloudesley Brereton. Notre Dame, IN: University of Notre Dame Press, 1977.

Bezzola, Tobia. "Lights Going All Over the Place." In William A. Ewing and Todd Brandow, eds., *Edward Steichen in High Fashion: The Condé Nast Years 1923–1937*, 187–198. Minneapolis: Foundation for the Exhibition of Photography; New York: W. W. Norton, 2008.

Blankenship, Janelle. "Film-Symphonie vom Leben und Sterben der Blumen: Plant Rhythm and Time-Lapse Vision in *Das Blumenwunder.*" *Intermediality: History and Theory of the Arts, Literature and Technologies* 16 (Fall 2010): 83–103.

Bloch, Ernst. ""Nonsynchronism and the Obligation to Its Dialectics." Trans. Mark Ritter." *New German Critique, NGC* 11 (1977): 22–38.

Blum, Alan. *The Imaginative Structure of the City*. Montreal: McGill-Queen's University Press, 2003.

Bolter, Jay David, and Richard Grusin. *Remediation: Understanding New Media*. Cambridge, MA: MIT Press, 2000.

Boulding, Kenneth E. "The Economics of the Coming Spaceship Earth." In Henry Jarrett, ed., *Environmental Quality in a Growing Economy: Essays from the Sixth RFF Forum*, 3–14. Baltimore: Johns Hopkins University Press for Resources for the Future, 1966.

Bragg, Herbert E., and John Belton. "The Development of CinemaScope." *Film History* 2 (4) (1988): 359–371. http://www.jstor.org/stable/3815152.

Braidotti, Rosi. "Posthuman, All Too Human: Towards a New Process Ontology." *Theory, Culture and Society* 23 (7–8) (2006): 197–208.

Branford, Victor. *Whitherward? Hell or Eutopia*. London: Williams and Norgate, 1921.

Braudel, Fernand. *La Méditerranée et le monde Méditerranéen à l'epoque de Philippe II*. Paris: LGF, 2010.

Brenner, Neil, and Christian Schmid. "Planetary Urbanization." In Matthew Gandy, ed., *Urban Constellations*, 10–13. Berlin: Jovis, 2012.

British Film Institute. *How to Organise Film Shows during the Festival of Britain*. London: British Film Institute, 1951.

Buchanan, Brett. *Onto-Ethologies: The Animal Environments of Uexküll, Heidegger, Merleau-Ponty, and Deleuze*. Albany: State University of New York Press, 2008.

Burnett, Graham D. *The Sounding of the Whale: Science and Cetaceans in the Twentieth Century*. Chicago: University of Chicago Press, 2012.

Cadena, Marisol de la. "Runa: Human but *Not Only*." *HAU* 4 (2) (2014): 253–259.

Cahill, James. "Tracing the World: André Bazin, Jacques Cousteau, and France's Cinema of Exploration." Paper presented at the annual conference of the Film Studies Association of Canada, Brock University, St. Catharines, Ontario, May 28, 2014.

Cameron, James. "Before *Avatar* … A Curious Boy." Filmed February 2010. TED Video, 17:08. Posted March 2010. http://www.ted.com/talks/james_cameron _before_avatar_a_curious_boy/transcript?language=en.

Carpenter, E., and M. McLuhan, eds. *Explorations in Communication: An Anthology*. Boston: Beacon Press, 1960.

Cartier-Bresson, Henri. "The Decisive Moment." In Vicki Goldberg, ed., *Photography in Print: Writings from 1816 to the Present*, 384–386. Albuquerque: University of New Mexico Press, 1981.

Caulfield, Jon. *City Form and Everyday Life: Toronto's Gentrification and Critical Social Practice*. Toronto: University of Toronto Press, 1994.

Cavell, Richard. *McLuhan in Space: A Cultural Geography*. Toronto: University of Toronto Press, 2002.

Cavell, Stanley. *The World Viewed: Reflections on the Ontology of Film.* Cambridge, MA: Harvard University Press, 1979.

Chakrabarty, Dipesh. "The Climate of History: Four Theses." *Critical Inquiry* 35 (2) (2009): 197–222.

Chernilo, Daniel. "The Question of the Human in the Anthropocene Debate." *European Journal of Social Theory* 19 (June 2016): 1–17.

Cherry, Gordon E. "Planning and the Corporate State, 1939–45." In *Town Planning in Britain since 1900: The Rise and Fall of the Planning Ideal*, 87–112. Oxford: Blackwell, 1996.

Chun, Wendy Hui Kyong. "Unbearable Witness: Toward a Politics of Listening." *Differences: A Journal of Feminist Cultural Studies* 11 (1) (1999): 112–149.

Clark, Nigel. *Inhuman Nature: Sociable Life on a Dynamic Planet.* London: Sage, 2011.

Clode, Danielle. *Killers in Eden: The True Story of Killer Whales and Their Remarkable Partnership with the Whalers of Twofold Bay.* Sydney: Allen and Unwin, 2002.

Cohen, Arthur A. *Herbert Bayer: The Complete Work.* Cambridge, MA: MIT Press, 1984.

Collingwood, R. G. *Principles of Art.* Oxford: Clarendon Press, 1938.

Colomina, Beatriz. "Enclosed by Images: The Eameses' Multimedia Architecture." *Grey Room* 2 (Winter 2001): 6–29.

Colls, Robert, and Philip Dodd. "Representing the Nation: British Documentary Film, 1930–45." *Screen* 26 (1) (1985): 21–33.

Conekin, Becky E. *The Autobiography of a Nation: The 1951 Festival of Britain.* Manchester, UK: Manchester University Press, 2003.

Cosgrove, Denis. *Apollo's Eye: A Cartographic Genealogy of the Earth in the Western Imagination.* Baltimore: Johns Hopkins University Press, 2001.

Cousteau, Jacques-Yves. "Fish Men Explore a New World Undersea." *National Geographic* 102 (4) (1952): 431–472.

Cousteau, Jacques-Yves. *The Ocean World of Jacques Cousteau.* Vol. 13, *A Sea of Legends: Inspiration from the Sea.* 1973; repr., Toronto: Prentice-Hall of Canada, 1975.

Cousteau, Jacques-Yves, and Frédéric Dumas. "Photographic Essay: Underwater Wonders." *Life* 29 (22) (1950): 119–126.

Cousteau, Jacques-Yves, and Frédéric Dumas. *The Silent World : A Story of Undersea Discovery and Adventure, by the First Men to Swim at Record Depths with the Freedom of Fish.* New York: Harper, 1953.

Crunden, Robert M. *American Salons: Encounters with European Modernism, 1885–1917.* New York: Oxford University Press, 1993.

Crutzen, Paul J., and Eugene F. Stoermer. "The Anthropocene." *International Geosphere-Biosphere Programme Newsletter* 41 (2000): 17.

Darroch, Michael, and Janine Marchessault. "Anonymous History as Methodology: The Collaborations of Sigfried Giedion, Jaqueline Tyrwhitt and the Explorations Group, 1953–1955." In Andreas Broeckmann and Gunalan Nadarajan, eds., *Place Studies in Art, Media, Science and Technology: Historical Investigations on the Sites and Migration of Knowledge*, 9–27. Weimar: Verlag und Datenbank für Geisteswissenschaften, 2009.

Darroch, Michael, and Janine Marchessault, eds. *Cartographies of Place: Navigating the Urban.* Montreal: McGill University Press, 2014.

Darwin, Charles. *The Expressions of Emotions in Man and Animals.* Ed. Joe Cain and Sharon Messenger. London: Penguin, 2009.

Daston, Lorraine J., and Katharine Park. "Wonder and the Ends of Inquiry." *The Point* 8 (Summer 2014). http://thepointmag.com/2014/examined-life/wonder-ends-inquiry.

Daston, Lorraine J., and Katharine Park. *Wonders and the Order of Nature, 1150–1750.* New York: Zone Books, 1998.

Deleuze, Gilles. *Cinema 1: The Movement-Image.* Trans. H. Tomlinson and B. Habberjam. Minneapolis: University of Minnesota Press, 1997.

Deleuze, Gilles. *The Logic of Sense.* Ed. C. V. Boundas. New York: Columbia University Press, 1990.

Dennett, Daniel C. *Consciousness Explained.* New York: Back Bay Books, 1992.

Denton, Michael. "Organism and the Machine: The Flawed Analogy." In Jay Richards, ed., *Are We Spiritual Machines? Ray Kurzweil vs. the Critics of Strong A.I.*, 78–97. Seattle: Discovery Institute Press, 2002.

Derrida, Jacques. *Archive Fever: A Freudian Impression.* Trans. Eric Prenowitz. Chicago: University of Chicago Press, 1998.

Derrida, Jacques. "From Restricted to General Economy: A Hegelianism without Reserve." In *Writing and Difference*, trans. Alan Bass. Chicago: University of Chicago Press, 1978.

Derrida, Jacques, and Marie-Françoise Plissart. *Right of Inspection.* Trans. D. Willis. New York: Monacelli Press, 1998.

Dobson, Terence. *The Film Work of Norman McLaren.* Eastleigh, UK: John Libbey, 2006.

Donovan, Art. *The Art of Steampunk: Extraordinary Devices and Ingenious Contraptions from the Leading Artists of the Steampunk Movement.* East Petersburg, PA: Fox Chapel, 2011.

Doss, Erika Lee. *Looking at Life Magazine.* Washington, DC: Smithsonian Institution Press, 2001.

Dumont-Johnson, Micheline, and Le Collectif Clio. *L'histoire des femmes au Québec depuis quatre siècles.* Montreal: Éditeurs Les Quinze, 1982.

Dunnett, Hardin McGregor. *Guide to the Exhibition of Architecture, Town-planning and Building Research.* London: HMSO, 1951.

Durkheim, Emile. *The Elementary Forms of Religious Life.* Trans. J. W. Swain. New York: Dover, 2008.

Dyer, Richard, and Paul McDonald. *Stars.* London: BFI Publishing, 1998.

Easen, Sarah. "Film and the Festival of Britain." In Ian Mackillop and Neil Sinyard, eds., *British Cinema of the 1950s: A Celebration*, 51–63. Manchester, UK: Manchester University Press, 2003.

Eastlake, Lady Elizabeth. "Photography." *London Quarterly Review* (April 1857): 442–468.

Eco, Umberto. "A Theory of Exhibitions." *Dotzero* 4 (1967): 5–10.

Ecott, Tim. *Neutral Buoyancy: Adventures in a Liquid World.* New York: Grove Press, 2001.

Eisenstein, Sergei. *Eisenstein on Disney.* Ed. Naum Kleinman, trans. Alan Upchurch. New York: Methuen, 1988.

Eisenstein, Sergei. "On Stereocinema" (1947). In Dan Adler, Janine Marchessault, and Sanja Obradovic, eds., *3D Cinema and Beyond*, 20–59. London: Intellect Books, 2014.

Eley, Geoff. "Finding the People's War: Film, British Collective Memory, and World War II." *American Historical Review* 106 (3) (2001): 818–838.

Elsaesser, Thomas. "James Cameron's *Avatar*: Access for All." *New Review of Film and Television Studies* 9 (3) (September 2011): 247–264.

Evans, Gary. *In the National Interest: A Chronicle of the National Film Board of Canada from 1949–1989.* Toronto: University of Toronto Press, 1991.

"Expo 67: An Experiment in the Development of Urban Space." *Architectural Record* 140 (October 1966): 169–176.

Expo 67: Official Guide. Toronto: Maclean-Hunter, 1967.

Feldman, Seth. "The Days before Christmas and the Days before That." In Jim Leach and Jeannette Sloniowski, eds., *Candid Eyes: Essays in Canadian Documentary*, 31–47. Toronto: University of Toronto Press, 2003.

Felman, Shoshana. *The Juridical Unconscious: Trials and Traumas in the Twentieth Century*. Cambridge, MA: Harvard University Press, 2002.

Foster, Robert, Majid Ghassemi, and Alma Cota. *Solar Energy: Renewable Energy and the Environment*. Boca Raton, FL: CRC Press, 2010.

Foucault, Michel. "Behind the Fable." In *Essential Works of Foucault, vol. 2: Aesthetics, Method, and Epistemology*, ed. James D. Faubion, trans. Robert Hurley et al. New York: New Press, 1999.

Frank, Robert. *The Americans*. New York: Aperture, 1958.

Fraser, Nancy. "Rethinking the Public Sphere: A Contribution to the Critique of Actually Existing Democracy." *Social Text* 25 (6) (1990): 56–80.

Friebe, Wolfgang. *Buildings of the World Exhibitions*. Trans. Jenny Vowles and Paul Roper. Leipzig: Edition Leipzig, 1985.

Frodon, Jean-Michel. "The Cinema Planet." In Dina Iordanova, ed., *The Film Festival Reader*. St Andrews, Scotland: St Andrews Film Studies, 2013.

Frye, Northrop. *Fables of Identity: Studies in Poetic Mythology*. New York: Harcourt Brace, 1963.

Fulford, Robert. *Remember Expo: A Pictorial Record*. Toronto, ON: McClelland and Stewart, 1968.

Fuller, R. Buckminster. *Critical Path*. New York: St. Martin's Press, 1981.

Fuller, R. Buckminster. Introduction to Gene Youngblood, *Expanded Cinema*, 15–36. New York: Dutton, 1970.

Fuller, R. Buckminster. *Utopia or Oblivion: The Prospects for Humanity*. New York: Bantam Books, 1969.

Fuller, R. Buckminster. *The World Game: Integrative Resource Utilization Planning Tool*. Carbondale: World Resources Inventory, Southern Illinois University, 1971.

Gane, Nicholas, and Donna Haraway. "When We Have Never Been Human, What Is To Be Done?: Interview with Donna Haraway." *Theory, Culture and Society* 23 (7–8) (2006): 135–158.

General Idea. "Glamour." *File* 3 (1) (1975): 21–22.

Genosko, Gary. "The Life and Work of Felix Guattari: From Transversality to Ecosophy." In Guattari, *The Three Ecologies*, trans. Ian Pindar and Paul Sutton, 106–160. London: Athlone Press, 2000.

Gernsheim, Helmut, and Alison Gernsheim. *The History of Photography*. London: Thames and Hudson, 1969.

Gernsheim, Helmut, and Alison Gernsheim. *L. J. M. Daguerre: The History of the Diorama and the Daguerreotype*. New York: Dover, 1968.

Giedion, Sigfried. *Architecture, You and Me: The Diary of Development*. Cambridge, MA: Harvard University Press, 1958.

Giedion, Sigfried. *Bauen in Frankreich, Eisen, Eisenbeton*. Leipzig, Berlin: Klinkhardt & Biermann, 1928.

Giedion, Sigfried. *The Eternal Present: A Contribution on Constancy and Change*. New York: Pantheon Books, 1964.

Giedion, Sigfried. *Mechanization Takes Command: A Contribution to Anonymous History*. New York: W. W. Norton, 1969.

Giedion, Sigfried. "Space Conceptions in Prehistoric Art." *Explorations* 6 (1956): 38–57.

Giedion, Sigfried. *Space, Time and Architecture: The Growth of a New Tradition*. 5th ed. Cambridge, MA: Harvard University Press, 1967.

Giedion, Sigfried. *Walter Gropius: Work and Teamwork*. Trans. Jaqueline Tyrwhitt. New York: Reinhold, 1954.

Glassman, Marc, and Wyndham Wise. "Interview with Colin Low, Part I." *Take One* 23 (1999): 29–40.

Glassman, Marc, and Wyndham Wise. "Interview with Colin Low, Part II." *Take One* 26 (2000): 22–32.

Gluck, Mary. *Georg Lukacs and His Generation, 1900–1918*. Cambridge, MA: Harvard University Press, 1985.

Gorman, Michael John. *Buckminster Fuller: Designing for Mobility*. Milan: Skira Editore, 2005.

Gougeon, Gilles. *A History of Quebec Nationalism*. Toronto: James Lorimer, 1994.

Graham, Gerald. *Canadian Film Technology 1896–1986*. Newark: University of Delaware Press, 1989.

Griffin, Michael. "The Great War Photographs: Constructing Myths of History and Photojournalism." In Bonnie Brennen and Hanno Hardt, eds., *Picturing the Past: Media, History, and Photography*, 122–157. Urbana: University of Illinois Press, 1999.

Grinevald, Jacques. "Introduction: The Invisibility of the Vernadskian Revolution." In Vladimir I. Vernadsky, *The Biosphere*, 20–32. New York: Copernicus, 1998.

Gropius, Walter. "The Theory and Organization of the Bauhaus." In Herbert Bayer, Walter Gropius, and Ise Gropius, eds., *Bauhaus: 1919–1928*, 20–29. New York: Museum of Modern Art, 1938.

Guattari, Felix. *The Three Ecologies*. Trans. Ian Pindar and Paul Sutton. London: Athlone Press, 2000.

Gunning, Tom. "The World as Object Lesson: Cinema Audiences, Visual Culture and the St. Louis World's Fair 1904." *Film History: An International Journal* 6 (4) (1994): 422–444.

Hammond, Anne. "Impressionist Theory and the Autochrome." *History of Photography* 15 (2) (Summer 1991): 96–100.

Hansen, Miriam Bratu. *Introduction to Siegfried Kracauer, Theory of Film: The Redemption of Physical Reality*. Princeton: Princeton University Press, 1997.

Haraway, Donna. "Anthropocene, Capitalocene, Plantationocene, Chthulucene: Making Kin." *Environmental Humanities* 6 (2015): 159–165.

Haraway, Donna. "SF: Science Fiction, Speculative Fabulation, String Figures, So Far." *Ada: A Journal of Gender, New Media, and Technology*, no. 3 (2013).

Haraway, Donna, et al. "Anthropologists Are Talking—About the Anthropocene." *Ethnos* 81 (3) (May 2016): 535–564.

Hardt, Michael, and Antonio Negri. *Multitude: War and Democracy in the Age of Empire*. New York: Penguin, 2004.

Haworth, Rachel. "Patrick Geddes' Concept of Conservative Surgery." *Architectural Heritage* 11 (1) (2000): 37–42.

Hayes, R. M. *3-D Movies: A History and Filmography of Stereoscopic Cinema*. Jefferson, NC: McFarland, 1989.

Hayles, N. Katherine. "Computing the Human." *Theory, Culture and Society* 22 (1) (2005): 131–151.

Hayles, N. Katherine. *How We Became Posthuman: Virtual Bodies in Cybernetics, Literature, and Informatics*. Chicago: University of Chicago Press, 1999.

Heidegger, Martin. *The Question Concerning Technology and Other Essays*. Trans. William Lovitt. New York: Harper, 1977.

Highmore, Ben. "Between Modernity and the Everyday: Team 10." Paper presented at the conference "Team 10: Between Modernity and the Everyday," Delft, Netherlands, June 5–6, 2003. http://www.team10online.org/research/papers/delft2/highmore.pdf.

Highmore, Ben. "Machinic Magic: IBM at the 1964–1965 New York World's Fair." *New Formations* 51 (2004): 128–148.

Hollier, Denis. *Against Architecture: The Writings of Georges Bataille*. Trans. Betsy Wing. Cambridge, MA: MIT Press, 1989.

Hollow, Matthew. "Utopian Urges: Visions for Reconstruction in Britain, 1940–1950." *Planning Perspectives* 27 (4) (2012): 569–585.

Horrocks, Roger. *Len Lye: A Biography*. Auckland, NZ: Auckland University Press, 2001.

Huber, Dorothee, and Claude Lichtenstein. "Das Nadelöhr der anonymen Geschichte." In Josef Bosman and Sokratis Georgiadis, eds., *Sigfried Giedion 1888–1968: Der Entwurf einer modernen Tradition*, 85–91. Zurich: Ammann Verlag, 1989.

Huntley, John. "The Telekinema in London." In *Film Music* (National Film Music Council), vol. 9, 220–221. London: Forgotten Books, 1949.

Huyssen, Andreas. *After the Great Divide: Modernism, Mass Culture and Postmodernism*. Bloomington: Indiana University Press, 1986.

Iordanova, Dina. "The Film Festival Circuit." In Dina Iordanova, ed., *The Film Festival Reader*, 115. St Andrews, Scotland: St Andrews Film Studies, 2013.

Jackson, Kevin, ed. *Humphrey Jennings Film Reader*. Manchester, UK: Carcanet Press, 2004.

Jackson, Kevin. "The Joy of Drooling: In Praise of Len Lye." In Scott Anthony and James G. Mansell, eds., *The Projection of Britain: A History of the GPO Film Unit*, 89–97. London: Palgrave Macmillan, 2011.

Jacobs, Jane. *The Death and Life of Great American Cities*. New York: Vintage Books, 1992.

James, William. "Does 'Consciousness' Exist?" In Fredson Bowers and Ignas K. Skrupskelis, eds., *Essays in Radical Empiricism*, 1–39. Cambridge, MA: Harvard University Press, 1976.

Janssen, André. "The Production of a Future Gaze at Expo '67." *Space and Culture* 10 (4) (2007): 418–436.

Jennings, Humphrey. *Pandemonium: The Coming of the Machine as Seen by Contemporary Observers 1660–1885*. Ed. Marie-Louise Jennings and Charles Madge. New York: Free Press, 2012.

Joel, Yael. "A Film Revolution to Blitz Man's Mind." *Life* (July 1967): 2–8.

Johnson, Brian D. *Brave Films Wild Nights: 25 Years of Festival Fever*. Toronto: Random House, 2000.

Johnston, Patricia A. *Real Fantasies: Edward Steichen's Advertising Photography*. Berkeley: University of California Press, 1997.

Jones, Ben, and Rebecca Searle. "Humphrey Jennings, the Left and the Experience of Modernity in Mid-Twentieth-Century Britain." *History Workshop Journal* 75 (2013): 190–212.

Jones, Brian Jay. *Jim Henson: The Biography*. New York: Random House, 2013.

Kahana, Jonathan, ed. "Dossier: What Now? Re-enactment in Contemporary Documentary Film, Video and Performance." *Framework: Journal of Cinema and Media Studies* 50 (1–2) (2009): 46–174.

Kanngieser, Anja, and Angela Last. "Five Propositions | Critiques for the Anthropocene." *GeoCritique*. Last modified April 2016. http://www.geocritique.org/five -propositions-critiques-anthropocene.

Kaplan, Nelly. *Napoleon*. London: BFI Publishing, 1994.

Kindleberger, Charles P. *The World in Depression, 1929–1939*. Berkeley: University of California Press, 1973.

Kitch, Carolyn L. *Pages from the Past: History and Memory in American Magazines*. Chapel Hill: University of North Carolina Press, 2005.

Knutson, Susan, Kathy Mezei, Daphne Marlatt, Barbara Godard, and Gail Scott. "Versions con-verse: A Sequence of Translations." *Tessera* 6 (1989): 15–23.

Koch, Stephen. *Stargazer: Andy Warhol's World and His Films*. London: Marian Boyars, 1985.

Kracauer, Siegfried. *The Mass Ornament: Weimar Essays*. Ed. and trans. Thomas Y. Levin. Cambridge, MA: Harvard University Press, 1995.

Kracauer, Siegfried. *Theory of Film: The Redemption of Physical Reality*. New York: Oxford University Press, 1960.

Kroll, Gary. *America's Ocean Wilderness: A Cultural History of Twentieth-Century Exploration*. Lawrence: University Press of Kansas, 2008.

Kurenniemi, Erkki. "Relative Life." In E. Hyvönen and J. Seppänen, eds., *Keinoelämä*, 64–69. Espoo, Finland: Artificial Life Publications of Finnish AL Society, 1995.

Kurzweil, Ray. *The Age of Spiritual Machines: When Computers Exceed Human Intelligence*. New York: Penguin, 1999.

Kurzweil, Ray. *The Singularity Is Near: When Humans Transcend Biology*. New York: Penguin, 2005.

Latour, Bruno. "A Cautious Prometheus? A Few Steps toward a Philosophy of Design (with Special Attention to Peter Sloterdijk)." In Jonathan Glynne, Fiona Hackney, and Viv Minton, eds., *Networks of Design: Proceedings of the 2008 Annual International Conference of the Design History Society (UK), University College Falmouth, September 3–6* (Boca Raton, FL: Universal Publishers, 2009), 2–10.

Latour, Bruno. *Reassembling the Social: An Introduction to Actor-Network-Theory.* Oxford: Oxford University Press, 2005.

Latour, Bruno, and Pasquale Gagliardi, eds. *Les atmosphères de la politique.* Paris: Seuil, 2006.

Latour, Bruno, and Peter Weibel. *Making Things Public: Atmospheres of Democracy.* Cambridge, MA: MIT Press, 2005.

Law, John. "Actor Network Theory and Material Semiotics." Version of April 25, 2007. http://www.heterogeneities.net/publications/Law2007ANTandMaterial Semiotics.pdf.

Lefebvre, Henri. *Critique of Everyday Life.* Vol. 1. Trans. John Moore. London: Verso, 1991.

Lefebvre, Henri. *Writings on Cities.* Trans. Eleonore Kofman and Elizabeth Lebas. Oxford: Blackwell, 1997.

LeMenager, Stephanie. *Living Oil: Petroleum Culture in the American Century.* New York: Oxford University Press, 2014.

Leong, Melissa. "Film on Montreal Massacre Sweeps Genie Awards." *National Post,* April 12, 2010.

Levitas, Ruth. *Utopia as Method: The Imaginary Reconstruction of Society.* London: Palgrave Macmillan, 2013.

Lipton, Lenny. *Foundations of the Stereoscopic Cinema: A Study in Depth.* New York: Van Nostrand Reinhold, 1982.

Liscombe, Rhodri Windsor. "Perceptions in the Conception of the Modernist Urban Environment: Canadian Perspectives on the Spatial Theory of Jaqueline Tyrwhitt." In Iain Boyd Whyte, ed., *Man-Made Future: Planning, Education and Design in Mid-Twentieth Century Britain,* 78–98. London: Routledge, 2007.

Lord, Chip. *Ant Farm: Then and Now.* Artist talk at Jordan Schnitzer Museum of Art, Eugene, Oregon. YouTube video, 1:26:30. Posted May 2013. https://youtu.be/hIUMzJv7BhU.

Lovelock, James. *Gaia: A New Look at Life on Earth.* Oxford: Oxford University Press, 1979.

Low, Colin. "Multi-Screens and Expo 67." *Journal of the Society of Motion Picture and Television Engineers* 77 (3) (March 1968): 185–186.

Lutz, Catherine A., and Jane L. Collins. *Reading National Geographic.* Chicago: University of Chicago Press, 1993.

Lypchuck, Donna. "Exhibitionists: Toronto Tale." *Independent Eye* 13 (1) (1991): 46–53.

MacDougall, David. *Transcultural Cinema*. Ed. Lucian Taylor. Princeton: Princeton University Press, 1998.

Machu, Franck. *Un cinéaste nommé Cousteau*. Monaco: Rocher, 2011.

MacKenzie, Scott, ed. *Film Manifestos and Global Cinema Cultures: A Critical Anthology*. Berkeley: University of California Press, 2014.

MacKenzie, Scott. "Lists and Chain Letters: Ethnic Cleansing, Holocaust Allegories and the Limits of Representation." *Canadian Journal of Film Studies* 9 (2) (Fall 2000): 23–42.

Madge, Charles, and Tom Harrison. *Mass Observation*. London: Frederick Muller, 1937.

Maertens, James W. "Between Jules Verne and Walt Disney: Brains, Brawn, and Masculine Desire in *20,000 Leagues under the Sea*." *Science Fiction Studies* 22 (2) (1995): 209–225.

Magisos, Melanie. "A Dictionary of Movement: An Interview with Norman McLaren with Grant Munro." *Wide Angle* 3 (3) (1980): 60–69.

Malabou, Catherine. "The Anthropocene: A New History." Lecture in Durham Castle Lecture Series, Durham University, England, January 27, 2016.

Malm, Andreas, and Alf Hornborg. "The Geology of Mankind? A Critique of the Anthropocene Narrative." *Anthropocene Review* 1 (1) (April 2014): 62–69.

Mannheim, Karl. *Diagnosis of Our Time: Wartime Essays of a Sociologist*. London: K. Paul, Trench, Trubner, 1943.

Mannheim, Karl. *Ideology and Utopia: An Introduction to the Sociology of Knowledge*. Trans. Louis Wirth and Edward Shils. 1936; repr., San Diego: Harcourt Brace Jovanovich, 1985.

Marchessault, Janine. *Cosmic Media: Marshall McLuhan*. London: Sage Publications, 2005.

Marchessault, Janine, ed. *Mirror Machine: Video in the Age of Identity*. Toronto: YYZ Books, 1994.

Marchessault, Janine. "The Women's Liberation Front of Québec." *Public: Art/Culture/Ideas* 14 (1996): 36–48.

Marey, Étienne-Jules. *La méthode graphique dans les sciences expérimentales*. Paris: Masson, 1878.

Margulies, Ivone. "Exemplary Bodies: Reenactment in *Love in the City*, *Sons*, and *Close-Up*." In Ivone Margulies, ed., *Rites of Realism: Essays on Corporeal Cinema*, 217–244. Durham: Duke University Press, 2003.

Marien, Mary Warner. *Photography: A Cultural History*. London: Laurence King, 2002.

Marx, Karl. "The Fetishism of Commodities and the Secret Thereof." In *The Process of Capitalist Production*, vol. 1 of *Capital: A Critique of Political Economy*, ed. Friedrich Engels, trans. Samuel Moore and Edward Avcling, section 4. New York: International Publishers, 1967.

Mathews, Stanley. "The Fun Palace: Cedric Price's Experiment in Architecture and Technology." *Technoetic Arts: A Journal of Speculative Research* 3 (2) (June 2005): 73–92.

Matsen, Brad. *Jacques Cousteau: The Sea King*. New York: Pantheon, 2009.

McGuire, Scott. *The Media City: Media, Architecture and Urban Space*. London: Sage Publications, 2009.

McHale, John. *The Ecological Context*. New York: Braziller, 1970.

McLaren, Norman. *Norman McLaren on the Creative Process*. Ed. Donald McWilliams. Montreal: National Film Board of Canada, 1991.

McLaren, Norman. "Some Notes on Animated Sound as Developed at the NFB by the Card Method." In *Technical Notes by Norman McLaren (1933–1984)*, 77–82. Montreal: National Film Board of Canada, 2006.

McLaren, Will. "Air Apparent Pneumatic Structures." *Architectural Review* 235 (1406) (April 2014): 104–109.

McLuhan, Marshall. "At the Moment of Sputnik the Planet Became a Global Theater in which There Are No Spectators but Only Actors." *Journal of Communication* 24 (1) (1974): 48–58.

McLuhan, Marshall. *Counter Blast*. Toronto: McClelland and Stewart, 1969.

McLuhan, Marshall. "The Emperor's Old Clothes." In Gyorgy Kepes, ed., *The Man-Made Object*, 90–95. New York: Braziller, 1966.

McLuhan, Marshall. *The Gutenberg Galaxy: The Making of Typographic Man*. Toronto: University of Toronto Press, 1962.

McLuhan, Marshall. *The Mechanical Bride: Folklore of Industrial Man*. Boston: Beacon Press, 1951.

McLuhan, Marshall. "Our New Electronic Culture: The Role of Mass Communications in Meeting Today's Problems." *National Association of Broadcasters Journal* (October 1958): 25.

McLuhan, Marshall. *Our World: 1967 TV Experiment Links Five Continents by Satellite*, CBC television special, June 25, 1967. http://www.cbc.ca/archives/entry/our-world-five-continents-linked-via-satellite, accessed July 16, 2016.

McLuhan, Marshall. *War and Peace in the Global Village*. New York: Bantam, 1968.

McLuhan, Marshall, and Barrington Nevitt. *Take Today: The Executive as Dropout*. New York: Harcourt Brace Jovanovich, 1972.

Merleau-Ponty, Maurice. *Sense and Non-Sense*. Trans. Hubert L. Dreyfus and Patricia A. Dreyfus. Evanston: Northwestern University, 1964.

Merleau-Ponty, Maurice. *The Visible and the Invisible*. Trans. Alphonso Lingis. Evanston: Northwestern University Press, 1968.

Michener, Wendy. "Through a Multi-Screen Darkly." *Maclean's* 17 (September 1966): 57–58.

Miller, Rebecca Erin. "The Animated Animal: Aesthetics, Performance and Environmentalism in American Feature Animation." PhD dissertation, New York University, 2011.

Mirzoeff, Nicholas. "The Right to Look." *Critical Inquiry* 37 (3) (Spring 2011): 473–496.

Mong-Hy, Cédric. *Bataille cosmique: Georges Bataille, du système de la nature à la nature de la culture*. Paris: Lignes, 2012.

Monk, Philip. "Axes of Difference." *Vanguard* 13 (4) (1984): 14–18.

Moore, Jason W. *Capitalism in the Web of Life: Ecology and the Accumulation of Capital*. London: Verso, 2015.

Moravec, Hans P. *Robot: Mere Machine to Transcendent Mind*. New York: Oxford University Press, 1999.

Morin, Edgar. *Les stars*. Paris: Editions du Seuil, 1972.

Mouffe, Chantal. "Democratic Citizenship and Political Community." In Chantal Mouffe, ed., *Dimensions of Radical Democracy: Pluralism, Citizenship, Community*, 229–258. London: Verso, 1992.

Mumford, Eric. *The CIAM Discourse on Urbanism, 1928–1960*. Cambridge, MA: MIT Press, 2000.

Mumford, Eric. *Defining Urban Design: CIAM Architects and the Formation of a Discipline, 1937–69*. New Haven: Yale University Press, 2009.

Mumford, Lewis. *The Condition of Man*. New York: Harcourt, Brace, 1944.

Munson, E. S., and C. A. Warren, eds. *James Carey: A Critical Reader*. Minneapolis: University of Minnesota Press, 1997.

Munson, Richard. *Cousteau: The Captain and His World*. New York: William Morrow, 1989.

Nancy, Jean-Luc. *Being Singular Plural*. Trans. Robert D. Richardson and Anne E. O'Byrne. Stanford: Stanford University Press, 2000.

Nancy, Jean-Luc. *The Creation of the World; or, Globalization*. Trans. François Raffoul and David Pettigrew. Albany: State University of New York Press, 2007.

Nancy, Jean-Luc. *The Inoperative Community*. Ed. and trans. Peter Connor. Minneapolis: University of Minnesota Press, 1991.

National Film Board of Canada. "About the NFB: Organization." Last modified June 4, 2013. http://onf-nfb.gc.ca/en/about-the-nfb/organization/mandate/.

Nelson, George. *Problems of Design*. New York: Whitney Publications, 1957.

Neuhart, John, Marilyn Neuhart, and Ray Eames. *Eames Design: The Work of the Office of Charles and Ray Eames*. New York: Harry N. Abrams, 1989.

Nichols, Bill. "Documentary Reenactment and the Fantasmatic Subject." *Critical Inquiry* 35 (1) (2008): 72–89.

Nora, Pierre. "Memory and History: Les Lieux de Mémoire." In "Memory and Counter-Memory," special issue of *Representations* 26 (1989): 7–25.

O'Brian, John. "The Nuclear Family of Man." *Asia Pacific Journal* 6 (7) (2008): 5–6.

Ogden, C. K., and I. A. Richards. *The Meaning of Meaning*. Wilmington, DE: Mariner Books, 1989.

Ojanen, Mikko, Jari Suominen, Titti Kallio, and Kai Lassfolk. "Design Principles and User Interfaces of Erkki Kurenniemi's Electronic Musical Instruments of the 1960's and 1970's." In Carol Parkinson, Gideon D'Arcangelo, and Eric Singer, eds., *Proceedings of the 2007 International Conference on New Interfaces for Musical Expression (NIME07)*, 88–93. http://www.nime.org/proceedings/2007/nime2007_088.pdf, accessed March 28, 2014.

Pageau, Pierre. "Colin Low, an Anglophone in Quebec." *Offscreen* 16 (2) (February 2012), http://offscreen.com/view/anglophone_in_quebec.

Painlevé, Jean, Jacques-Yves Cousteau, Alain Resnais, et al. "Declaration of the Group of Thirty (1953)." In Scott Mackenzie, ed., *Film Manifestos and Global Cinema Cultures: A Critical Anthology*, 461. Berkeley: University of California Press, 2013.

Parikka, Jussi. *The Anthrobscene*. Minneapolis: University of Minnesota Press, 2014.

Parikka, Jussi. *Insect Media: An Archaeology of Animals and Technology*. Minneapolis: University of Minnesota Press, 2010.

Parks, Lisa. *Cultures in Orbit: Satellites and the Televisual*. Durham: Duke University Press, 2005.

Peters, John Durham. *The Marvelous Clouds: Toward a Philosophy of Elemental Media*. Chicago: University of Chicago Press, 2015.

Phillips, Christopher. "The Judgment Seat of Photography." *October* 22 (1982): 27–63.

Pierson, Michele. "Amateurism and Experiment: The British Film Institute's Experimental Film Fund (1952–1966)." *Moving Image: The Journal of the Association of Moving Image Archivists* 5 (1) (Spring 2005): 67–94.

Pollmann, Inga. "Invisible Worlds, Visible: Uexküll's *Umwelt*, Film, and Film Theory." *Critical Inquiry* 39 (4) (2013): 777–816.

Porter, John. "Artists Discovering Film: Post-War Toronto." *Vanguard* 13 (5–6) (1984): 24–26.

Porter, John. "Blow-Up: The Catherine Films." In Steve Reinke and Tom Taylor, eds., *Lux: A Decade of Artists' Film and Video*, 192–193. Toronto: YYZ Books and Pleasure Dome, 2000.

Porter, John. "Martin Heath's Cine Cycle: An Illustrated History." *Lola* 10 (2001): 36–37.

Postman, Neil. "The Reformed English Curriculum." In Alvin C. Eurich, ed., *High School 1980: The Shape of the Future in American Secondary Education*, 161. New York: Pitman Publishing, 1970.

Potonniée, Georges. *Histoire de la découverte de la photographie: Et Daguerre, peintre et décorateur*. Paris: Jean-Michel Place, 1989.

Pratt, Mary Louise. "Planetary Longings: Sitting in the Light of the Great Solar TV." Paper presented at a meeting of the Canadian Learned Societies, Halifax, May 2002. Available at http://www.nyupoco.com/Mary_Louise_Pratt__Planetary_Longings.pdf.

Ravetz, Alison. *Council Housing and Culture: The History of a Social Experiment*. London: Routledge, 2001.

Ray, Satyajit. *Our Films, Their Films*. New Delhi: Orient Longmans, 1998.

Rich, B. Ruby. *Chick Flicks: Theories and Memories of the Feminist Film Movement*. Durham: Duke University Press, 1998.

Riegl, Alois. *Problems of Style: Foundations for a History of Ornament*. Trans. Evelyn Kain. 1893; Princeton: Princeton University Press, 1993.

Riley, Christopher. "The Dolphin Who Loved Me: The NASA-Funded Project That Went Wrong." *Guardian*. Last modified June 8, 2014. https://www.theguardian.com/environment/2014/jun/08/the-dolphin-who-loved-me.

Robson, Kenneth J. "Humphrey Jennings: The Legacy of Feeling." *Quarterly Review of Film Studies* 7 (1) (1982): 37–52.

Ross, Kristin. *Fast Cars, Clean Bodies: Decolonization and the Reordering of French Culture*. Cambridge, MA: MIT Press, 1995.

Ross, Miriam. *3D Cinema: Optical Illusions and Tactile Experiences*. New York: Palgrave Macmillan, 2015.

Røssaak, Eivind, ed. *The Archive in Motion: New Conceptions of the Archive in Contemporary Thought and New Media Practices*. Oslo: Novus Press, 2010.

Roy, Gabrielle. *Man and His World*. Montreal: Compagnie Canadienne de l'Exposition Universelle de 1967, 1967.

Russell, Catherine. *Experimental Ethnography: The Work of Film in the Age of Video*. Durham: Duke University Press, 1999.

Rust, Stephen. "Ecocinema and the Wildlife Film." In Louise Westling, ed., *The Cambridge Companion to Literature and the Environment*, 226–240. New York: Cambridge University Press, 2013.

Rüting, Torsten. "History and Significance of Jakob von Uexküll and His Institute in Hamburg." *Signs Systems Studies* 32 (1) (2004): 35–72.

Samuel, Raphael. *Theatres of Memory: Past and Present in Contemporary Culture*. Vol. 1. London: Verso, 1994.

Sandeen, Eric J. "The Family of Man in Guatemala." *Visual Studies* 30 (2) (2015): 123–130.

Sandeen, Eric J. *Picturing an Exhibition: The Family of Man and 1950s America*. Albuquerque: University of New Mexico Press, 1995.

Schickel, Richard. *The Disney Version: The Life, Times, Art and Commerce of Walt Disney*. New York: Simon and Schuster, 1968.

Schiller, Herbert. "Communication Satellites: A New Institutional Setting." *Bulletin of the Atomic Scientists* 23 (4) (1967): 4–8.

Schiller, Herbert. "The Slide toward Violence in the Hungering World." *Bulletin of the Atomic Scientists* 23 (1) (1967): 4–6.

Schneemann, Carolee. *Imaging Her Erotics: Essays, Interviews, Projects*. Cambridge, MA: MIT Press, 2003.

Scott, Felicity. *Living Archive 7: Ant Farm Allegorical Time Warp: The Media Fallout of July 21, 1969*. New York: ACTAR, Columbia GSAPP, 2008.

Seid, Steve. "Tunneling through the Wasteland: Ant Farm Video." In Constance M. Lewallen and Steve Seid, eds., *Ant Farm 1968–1978*, 22–37. Berkeley: University of California Press, 2004.

Sekula, Allan. "The Traffic in Photographs." *Art Journal* 41 (1981): 15–25.

Shatnoff, Judith. "Expo 67: A Multiple Vision." *Film Quarterly* 21 (1) (1967): 2–13.

Shaw, Tony. *British Cinema and the Cold War: The State, Propaganda and Consensus*. London: I. B. Tauris, 2001.

Shoshkes, Ellen. "Jaqueline Tyrwhitt: A Founding Mother of Modern Urban Design." *Planning Perspectives* 21 (April 2006): 179–198.

Shoshkes, Ellen. *Jaqueline Tyrwhitt: A Transnational Life in Urban Planning and Design*. Farnham, UK: Ashgate, 2013.

Sloan, Johanne. "Humanists and Modernists at Expo '67." *Revista Mexicana de Estudios Canadienses* 13 (2007): 78–87.

Sloterdijk, Peter. *Terror from the Air* . Los Angeles: Semiotext(e), 2009.

Smiley, Logan. "TV Film/Tape in the '70s." *Print* (January 1970): 76–77.

Smith, Joel. *Edward Steichen: The Early Years*. Princeton: Princeton University Press, 1999.

Sontag, Susan. "The Decay of Cinema." *The New York Times on the Web* (February 1996). https://www.nytimes.com/books/00/03/12/specials/sontag-cinema.html.

Sontag, Susan. *On Photography*. New York: Farrar, Straus and Giroux, 1977.

Sontag, Susan. *Regarding the Pain of Others*. New York: Farrar, Straus and Giroux, 2003.

Sontag, Susan. "Regarding the Torture of Others." *New York Times*, May 23, 2004.

Spottiswoode, Raymond, and Nigel Spottiswoode. *The Theory of Stereoscopic Transmission and Its Application to the Motion Picture*. Berkeley: University of California Press, 1953.

Stackpole, Peter. "New Film World: Jules Verne Movie Produces 20,000 Headaches under the Sea." *Life*, February 22, 1954, 111–117.

Stansky, Peter, and William Abrahams. *London's Burning: Life, Death and Art in the Second World War*. Stanford: Stanford University Press, 1994.

Steichen, Edward. "Color Photography." *Camera Work* 22 (April 1908): 13–24.

Steichen, Edward. *A Life in Photography*. Garden City, NY: Doubleday, 1963.

Steichen, Edward, and Museum of Modern Art. *The Family of Man: The Greatest Photographic Exhibition of All Time—503 Pictures from 68 Countries*. New York: Museum of Modern Art and MACO Magazine Corp, 1955.

Stevens, Graham. "Pneumatics and Atmospheres." *Architectural Digest* 3 (March–October 1972): 166.

Stevens, Wallace. "Thirteen Ways of Looking at a Blackbird." In *The Collected Poems of Wallace Stevens*, 92–95. New York: Knopf, 1972.

Steyerl, Hito. "In Defense of the Poor Image." *e-flux Journal* 10 (November 2009). http://www.e-flux.com/journal/10/61362/in-defense-of-the-poor-image/.

Stoekl, Allan. *Bataille's Peak: Energy, Religion and Postsustainability*. Minneapolis: University of Minnesota Press, 2007.

Straw, Will. "Scenes and Sensibilities." *Public: Art/Culture/Ideas* 22–23 (2001): 245–257.

Sukenick, Ronald. *Down and In: Life in the Underground*. New York: Macmillan, 1988.

Survant, Tyler. "Biological Borderlands: Ant Farm's Zoöpolitics." *Horizonte* 8 (Fall 2013): 49–64.

Sutton, Gloria. *The Experience Machine: Stan VanDerBeek's Movie-Drome and Expanded Cinema*. Cambridge, MA: MIT Press, 2014.

Taylor, Diana. *The Archive and the Repertoire: Performing Cultural Memory in the Americas*. Durham: Duke University Press, 2003.

Taylor-Hochberg, Amelia. Excerpt from "Biological Borderlands: Ant Farm's Zoopolitics." *Archinect Features*. Last modified February 18, 2014. http://archinect.com/features/article/93011262/screen-print-7-horizonte.

Teilhard de Chardin, Pierre. *The Phenomenon of Man*. Ed. Julian Huxley, trans. Bernard Wall. New York: Harper, 1959.

Than, Ker. "Jacques Cousteau Centennial: What He Did, Why He Matters." *National Geographic News*, June 1, 2010. http://news.nationalgeographic.com/news/2010/06/100611-jacques-cousteau-100th-anniversary-birthday-legacy-google/.

Theall, Donald. "A Report on the Film Experiments at Expo '67." Unpublished manuscript, National Archives of Canada, 1967.

Tikka, Pia. *Enactive Cinema: Simulatorium Eisensteinese*. Helsinki: University of Art and Design Helsinki, 2008.

Trotter, David. "Stereoscopy: Modernism and the Haptic." *Critical Quarterly* 46 (4) (2004).

Tuer, Dot. "The CEAC Was Banned in Canada." *C Magazine* 11 (1986): 24–37.

Tuggle, Catherine T. "Eduard Steichen and the Autochrome, 1907–1909." *History of Photography* 18 (2) (Summer 1994): 145–147.

Turkle, Sherry. *The Second Self: Computers and the Human Spirit*. New York: Simon and Schuster, 1984.

Turner, Fred. *The Democratic Surround: Multimedia and American Liberalism from World War II to the Psychedelic Sixties*. Chicago: University of Chicago Press, 2013.

Turner, Fred. "The Family of Man and the Politics of Attention in Cold War America." *Public Culture* 24 (1) (May 2012): 55–84.

Turner, Fred. *From Counterculture to Cyberculture: Stewart Brand, the Whole Earth Network, and the Rise of Digital Utopianism*. Chicago: University of Chicago Press, 2006.

Tyrwhitt, Jaqueline. "The Size and Spacing of Urban Communities." *Journal of the American Institute of Planners* 15 (Summer 1949): 10–17.

Tyrwhitt, Jaqueline, José Luis Sert, and E. N. Rogers, eds. *The Heart of the City: Towards the Humanisation of Urban Life*. Congrès Internationaux d'Architecture Moderne 8 (CIAM 8). London: Lund Humphries, 1952.

Uexküll, Jakob von. *A Foray into the Worlds of Animals and Humans: With A Theory of Meaning*. Minneapolis: University of Minnesota Press, 2010.

Varda, Agnès, and Melissa Anderson. "The Modest Gesture of the Filmmaker: An Interview with Agnès Varda (2001)." In *Agnès Varda: Interviews*, ed. T. Jefferson Kline, 173–182. Jackson: University Press of Mississippi, 2014.

Vernadsky, Vladimir I. *The Biosphere*. New York: Copernicus, 1998.

Vernadsky, Vladimir I. "The Biosphere and the Noosphere." *American Scientist* 33 (1) (1945): 1–12.

Vernadsky, Vladimir I. "Scientific Thought as a Planetary Phenomenon: The Biosphere and the Noosphere." In David Pitt and Paul R. Samson, eds., *The Biosphere and Noosphere Reader: Global Environment, Society and Change*, 94–100. New York: Routledge, 1999.

Vials, Chris. "The Popular Front in the American Century: Life Magazine, Margaret Bourke-White, and Consumer Realism, 1936–1941." *American Periodicals: A Journal of History, Criticism, and Bibliography* 16 (1) (2006): 74–102.

Vidler, Anthony. "Whatever Happened to Ecology? John McHale and the Bucky Fuller Revival." *Architectural Design* 80 (6) (November 2010): 24–33.

Wark, McKenzie. *Gamer Theory*. Cambridge, MA: Harvard University Press, 2007.

Welter, Volker M. *Biopolis: Patrick Geddes and the City of Life*. Cambridge, MA: MIT Press, 2002.

Whitehead, Alfred North. *Modes of Thought*. New York: Free Press, 1968.

Whitehead, Alfred North. *Science and the Modern World*. Cambridge, UK: Cambridge University Press, 1926.

Whiting, Cecile. *A Taste for Pop: Pop Art, Gender and Consumer Culture*. New York: Cambridge University Press, 1997.

Williams, Raymond. "Problems of Materialism." In *Culture and Materialism: Selected Essays*, 2nd ed., 103–124. London: Verso, 2005.

Winston, Brian. *Fires Were Started*. London: British Film Institute, 1999.

Winston, Brian. *Lies, Damn Lies and Documentaries*. London: BFI Publishing, 2000.

Winthrop-Young, Geoffrey. Afterword to Jakob von Uexküll, *A Foray into the Worlds of Animals and Humans: With A Theory of Meaning*. Minneapolis: University of Minnesota Press, 2010.

Wollen, Peter. *Paris Hollywood: Writings on Film*. London: Verso, 2002.

Wollen, Peter. "Raiding the Icebox." In Michael O'Pray, ed., *Andy Warhol Film Factory*, 14–27. London: BFI Publishing, 1989.

Woods, John D. "The Living Sea by J. Y. Cousteau and James Dugan." *Royal Geographic Society* 130 (1) (1964): 153–154.

Wright, Paul. "Projecting the Festival of Britain." *Penrose Annual* 45 (1951): 60–61.

Youngblood, Gene. *Expanded Cinema*. New York: Dutton, 1970.

Yusoff, Kathryn. "Excess, Catastrophe, and Climate Change." *Environment and Planning D: Society and Space* 27 (2009): 1010–1029.

Zone, Ray. *3D Revolution: The History of Modern Stereoscopic Cinema*. Lexington: University Press of Kentucky, 2012.

Zryd, Michael. "The Academy and the Avant-Garde: A Relationship of Dependence and Resistance." *Cinema Journal* 45 (2) (2006): 17–42.

Zukin, Sharon. "Postmodern Urban Landscapes." In Scott Lash and Jonathan Friedman, eds., *Modernity and Identity*, 221–230. Oxford: Blackwell, 1992.

Index